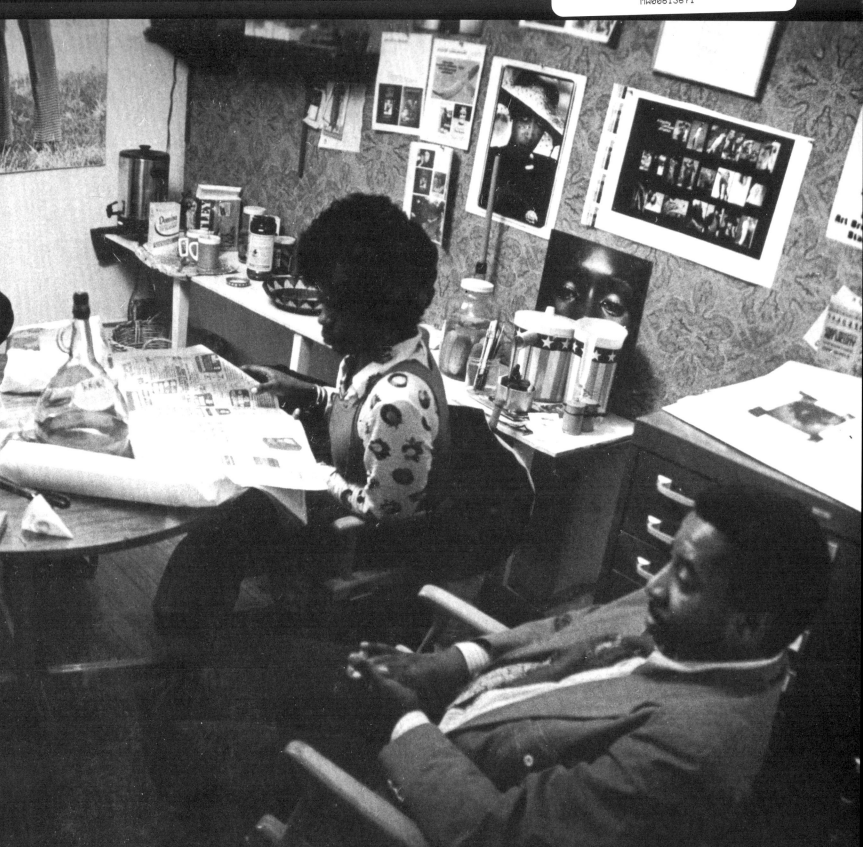

WORKING TOGETHER

LOUIS DRAPER AND THE KAMOINGE WORKSHOP

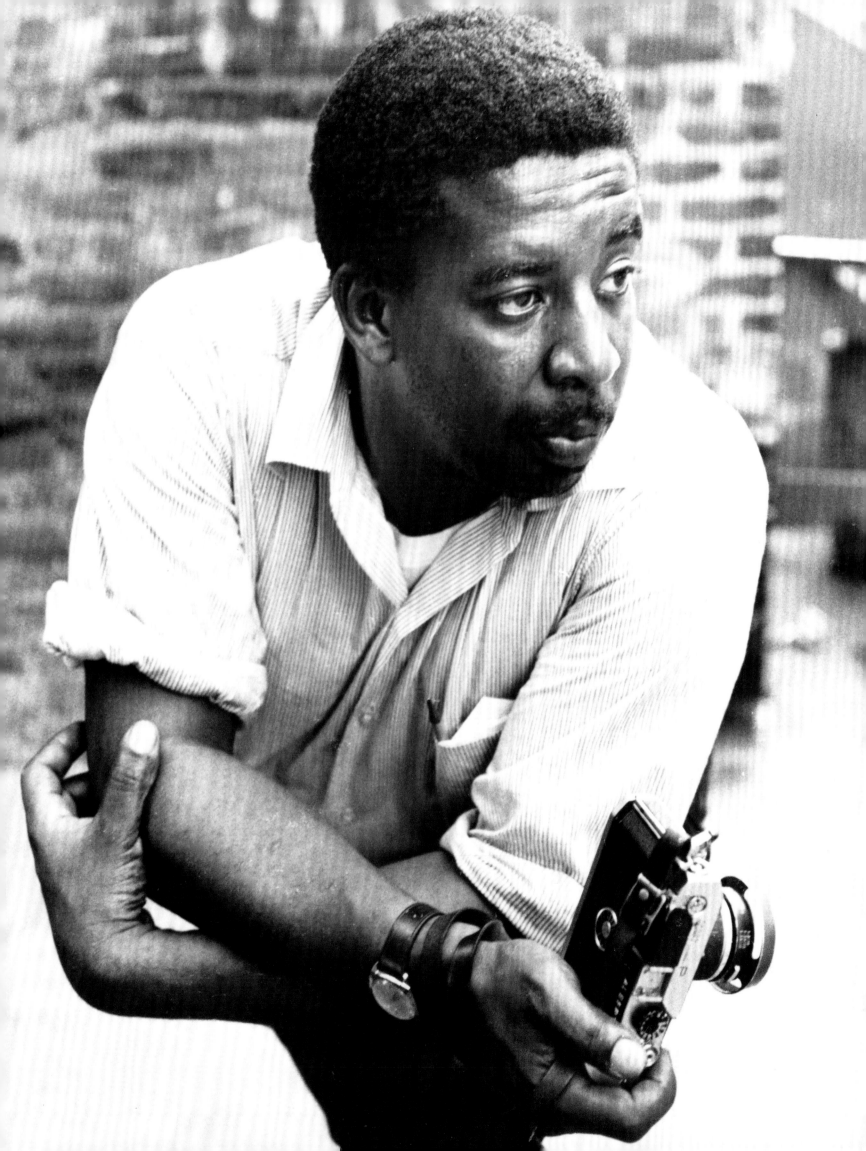

WORKING TOGETHER

LOUIS DRAPER AND THE KAMOINGE WORKSHOP

Sarah L. Eckhardt

Preface by Deborah Willis

With additional essays by Erina Duganne, Romi Crawford,
John Edwin Mason, Bill Gaskins, with contributions by
Sharayah Cochran

VMFA
VIRGINIA MUSEUM OF FINE ARTS

Distributed by DUKE UNIVERSITY PRESS

Sponsors

Altria Group

Fabergé Ball Endowment

Elisabeth Shelton Gottwald Fund

Community Foundation
for a greater Richmond

Michael Schewel and Priscilla Burbank

Wayne and Nancy Chasen Family Fund
of the Community Foundation
for a greater Richmond

Drs. Ronald A. and Betty Neal Crutcher

VMFA is grateful to the Bank of America Art
Conservation Project and the National Endowment
for the Humanities for their partnership in making
this exhibition possible.

*Marketing support for Evans Court exhibitions
is provided by the Charles G. Thalhimer Fund.*

This catalogue accompanies the exhibition

WORKING TOGETHER: LOUIS DRAPER AND THE KAMOINGE WORKSHOP

presented at

Virginia Museum of Fine Arts | Feb 1–Jun 14, 2020

Whitney Museum of American Art | Jul 17–Oct 25, 2020

The J. Paul Getty Museum | Jun 29–Sep 26, 2021

Cincinnati Art Museum | Spring 2022

ISBN 1-934351-17-8

Library of Congress Control Number: 2019955500

Produced by the Department of Publications
Virginia Museum of Fine Arts
200 N. Arthur Ashe Boulevard
Richmond, VA 23220-4007
www.vmfa.museum

Distributed by Duke University Press
905 W. Main St., Ste. 18B
Durham, NC 27701
www.dukeupress.edu

Sally Curran, Project Editor
John Hoar, Designer
Stacy Moore, Copy Editor
Frances Bowles, Indexer
Composed and typeset in FreightSans Pro
Printed on 150gsm Gardamatt
Printed by Conti Tipocolor, Florence, Italy

Contents

Director's Foreword

BY ALEX NYERGES

Louis Draper was born and raised near Richmond, Virginia, home to the Virginia Museum of Fine Arts and the capital of our Commonwealth. It is fitting that now, after Draper attended Virginia State University in Petersburg and moved to New York City in 1957, the beautiful and moving images he created will be on view in an unprecedented exhibition in his hometown. The Virginia Museum of Fine Arts is honored to organize *Working Together: Louis Draper and the Kamoinge Workshop*, an exhibition that celebrates the influential work of Louis Draper and fourteen early members of the Kamoinge Workshop—Anthony Barboza, Adger Cowans, Daniel Dawson, Roy DeCarava, Al Fennar, Ray Francis, Herman Howard, Jimmie Mannas, Herb Randall, Herb Robinson, Beuford Smith, Ming Smith, Shawn Walker, and Calvin Wilson—a collective of Black photographers established in New York City in 1963.

In 2013, the Virginia Museum of Fine Arts began its formal acquisition of Louis Draper photographs with thirteen works, followed by a generous gift-purchase of his entire archive from his sister, Nell Draper-Winston, in 2015. We remain deeply grateful that Ms. Draper-Winston selected VMFA to care for her brother's personal collection. The archive is an incredible trove of material, including more than 2,800 photographs, 42,000 negatives, 750 contact sheets, 4,400 slides, cameras and other archival publications. With the intention of building the largest and most comprehensive collection of Kamoinge Workshop photographs in the world, VMFA also continues to acquire works by members of the Kamoinge Workshop—which to date include more than 175 photographs and archival material from members. Not only does this goal bring to light the work of a Virginia-born artist, it fully aligns with our bold strategic plan initiatives to significantly increase and enrich the museum's holdings in African and African American

art, and a commitment to invest in expanding our visitor base to attract new and more diverse audiences. I would like to thank gallery directors Steve Kasher and Keith de Lellis, New York, for their assistance in securing many of these acquisitions, and Gordon Stettinius of Candela Books + Gallery, Richmond, for his collaborative spirit in sharing the story of Louis Draper with the Richmond community and beyond.

The development of this project has benefited invaluably from two significant grants: Bank of America provided support for photography conservation, and funding from the National Endowment for the Humanities allowed VMFA to digitize Louis Draper's archive in its entirety. With this incredible support, the Draper archive will be made available online concurrent with the exhibition, allowing access to these remarkable works by scholars and general audiences around the world. I would like to thank these institutions, and all who have supported this project, for their generous recognition of this important acquisition and exhibition.

Our greatest thanks are due to Dr. Sarah L. Eckhardt, Associate Curator of Modern and Contemporary Art, whose brilliant organization of *Working Together* is the result of her tremendous and dedicated work on this project. Her years-long efforts to collect, research, and build relationships with so many Kamoinge artists and their families is evident in the extraordinary selections made for *Working Together*. Dr. Michael R. Taylor, Chief Curator and Deputy Director for Art and Education, has skillfully guided the project along with Shannon Petska, Exhibitions Project Coordinator, and Courtney Burkhardt, Senior Exhibitions Manager. The exceptional work of organizing, cataloging, and preserving the Draper archive

required a team of talented staff, led by Courtney Tkacz, Archivist, and Stephen Bonadies, Senior Deputy Director for Conservation and Collections. Thanks are also due to Sally Curran, Senior Editor and Writer; our photography team, led by Travis Fullerton, Director of Imaging Resources; and John Hoar, catalogue designer, who have all contributed to this beautiful publication that accompanies the exhibition. Additional teams across the museum led by Caprice Bragg, Vice President for Board Relations and Strategic Planning; Tom Gutenberger, Deputy Director for Advancement; Jan Hatchette, Deputy Director for Communications; Hossein Sadid, Chief Financial Officer; and Kimberly Wilson, Deputy Director for Human Resources, Volunteers, and Community Service, have all contributed to the project's success. Finally, I would like to thank my colleagues at each of our venues—including Cameron Kitchin, Louis and Louise Dieterle Nippert Director, Cincinnati Art Museum; Timothy Potts, Director, the J. Paul Getty Museum; and Adam D. Weinberg, Alice Pratt Brown Director, the Whitney Museum of American Art— for recognizing the significance of *Working Together* and including this unprecedented exhibition in their programming.

Working Together: Louis Draper and the Kamoinge Workshop begins its exhibition tour here in Richmond, the place Louis Draper called home. We are privileged to share this prolific artist's archive, the exhibition it inspired, and the work of a collective of artists we so deeply admire with audiences around the globe.

Alex Nyerges
Director

PREFACE

The Sixties: Louis Draper Shaping Photography

BY DEBORAH WILLIS

I am concerned primarily with photography's questioning and re-examination of my environment. I think that is the gift that I, as a photographic artist, should give to my audience.

—Louis Draper

Images of Black subjects, whether artistic, documentary, or anthropological, are forever fixed in the popular imagination through photography. From the medium's beginning, race and gender have shaped and controlled the reception of photographic portraits, both politically and aesthetically. Black American photographers responded to their own lives and their communities in similar ways. Some evoked an emotional message that went beyond the self-representation but connected in the recharacterization of the African American experience. Louis Draper, like other Black photographers of the 1950s and 1960s, coupled his own aspirations of becoming a photographer and artist with his dreams of making photographs of Black Americans more representative than those he found in the press, museums, or art publications. Like other socially concerned Black and white photographers, he responded to political and social issues of the time and began to create images that commented on politics, culture, family, and history from internal and external points of view.

I first met Louis Draper when I was an undergraduate student in photography at the Philadelphia College of the Arts in the early 1970s. At that time, I wanted to meet photographers who were actively involved in changing the course of photo history and were imaging Black activism through new portraits of Black people. I reached out to him to let him know that I wanted to write a paper for a photo history class about Black photographers, and he responded with great enthusiasm. I knew that Draper was a founding member of the Kamoinge Workshop that had created a broad range of images of Black life that expanded visions of Black experiences. Draper described the members of the workshop in this way: "We saw ourselves as a group who were trying to nurture each other. We had no outlets. The magazines wouldn't support our work. So we wanted to encourage each other . . . to give each other feedback. We tried to be a force, especially for younger people."[1]

To consider the history of contemporary Black photography and the works of African American photographers, we must begin with the work and commitment of two entities, the Kamoinge Workshop and the *Black Photographers Annual*. These two mainstays in the pantheon of African American photography nourished, preserved, and published the works of Black photographers at a time when most were being overlooked by publishers, journalists, curators, museums, and galleries. They also understood the impact of photographic images, many of which were used as weapons against Black communities and their Black subjects' humanity. When Kamoinge began meeting officially in 1963, the photographers gathered in their homes to discuss and critique photography. Draper said, "We had come together in a rather relaxed atmosphere: our Sunday evenings usually consisting of well blended John Coltrane, Brillante wine, stewed chicken, bless the ladies, and a dash of photographs."[2]

From 1972 to 1980, the *Black Photographers Annual* published works of over eighty photographers in four separate volumes, introducing new works of individual photographers, including portfolios of Kamoinge members, as well as studio photographers who worked as photojournalists and portraitists from as early as the 1920s.

Interweaving narratives on dignity and desire, Draper's photographs deconstruct and contextualize encounters with the local public while examining the international dimension of the human and civil rights struggles at that time. These images and experiences are intertwined with the collective public memory of these struggles.

Draper was a guiding light for many photographers both Black and white—professionals and students alike—whom he encountered over the years as a mentor and a professor at Mercer County Community College in New Jersey. He conducted portfolio reviews encouraging documentary photographers and, at the same time, was a mentor to art photographers who were integrating conceptual elements in visualizing stories.

Draper's iconic image titled *John Henry*, 1960, which was made in Harlem, is a powerful depiction of Black masculinity

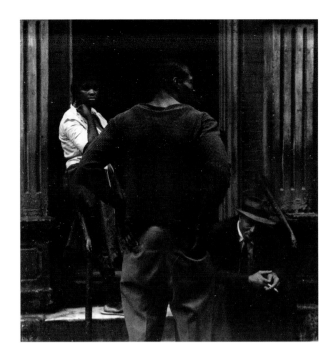

in his *Playground Series*, 1967, the shadow of a shiny metal swing makes a striking black line on an asphalt pavement. [cat. no. 112] A reflective light on the seat of the swing illuminates the darkened playground. Children are absent but the abstract image projects their presence into a memory.

"Expressing yourself is really a by-product of expressing your subject. In expressing subject there is a coming together of those experiences that shape you and cause you to select a particular kind of material with which to work," writes Draper.[3]

Draper's photographs focused on the strengths of a vibrant and well-lived environment—family, work, spirituality, and play are all central to his vision. Through his compositions of the streets of New York and West Africa, Draper revealed his passion for shaping beauty either with abstract patterns or the people he encountered. The intimacy found in his work bears witness to themes relating to beauty, community, empowerment, economics, abstraction, and the family. For Draper, representing the diversity of New York City—in all of its complexity—was his passion.

48 Louis Draper (American, 1935–2002), **John Henry**, ca. 1960s, gelatin silver print. *Virginia Museum of Fine Arts, National Endowment for the Arts Fund for American Art, 2013.149*

because of the way he composed it. [cat. no. 48] Henri Cartier-Bresson's famed decisive moment comes to mind when viewing this photograph. The title references the ballad "John Henry" and conjures the muscular Black man who labored hard and became a key figure in art, from paintings to prints to poetry. Draper's *John Henry* appears in the foreground, in front of a stoop in a doorway with his back to the camera, one hand resting on his hip, and another slightly cupping his pants pocket. He wears a thick cotton boatneck shirt with three-quarter sleeves, which accentuate his strong arms. On the steps sits an older man wearing a battered fedora, holding a lit cigarette in his left hand, while resting his right hand inside the other. He looks weary in his well-worn suit, shirt, and tie. A young woman sitting on the railing leans on her elbow, looking intently at the photographer's lens. Her light-colored blouse shines brightly outside the darkened hallway. Draper sets the mood at the end of a long work day. He clearly understands that time of day and the silence that enraptures the community, as we imagine them reflecting on their lives.

Draper's New York is starkly dramatic, whether in Harlem, in Greenwich Village, the Garment District, the Bronx, or the Lower East Side. He finds a story with his keen insight on beauty: church women in white uniforms, white diagonal lines that guide schoolchildren across a wide street. And,

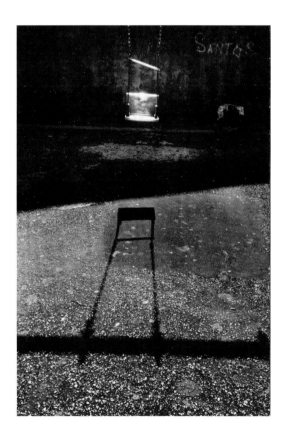

112 Louis Draper (American, 1935–2002), **Untitled [Santos], from Playground Series, NYC**, 1967, gelatin silver print. *Virginia Museum of Fine Arts, National Endowment for the Arts Fund for American Art, 2013.151*

Endnotes

1 Shawn Walker, "Preserving Our History: The Kamoinge Workshop and Beyond," *Ten.8* 24 (1987): 23.

2 Anthony Barboza and Herb Robinson, "Kamoinge: A History" in *Timeless: Photographs by Kamoinge* (Atglen, PA: Schiffer Books, 2015), 69.

3 The Louis Draper Project, https://thelouisdraperproject.wordpress.com/page/4/. Louis Draper, Artist Statement, undated (VA04.01.1.107) Among the papers of the Louis H. Draper Artist Archives, acquired from the Louis H. Draper Preservation Trust with the Arthur and Margaret Glasgow Endowment Fund. Virginia Museum of Fine Arts, Richmond.

Curator's Remarks

BY SARAH L. ECKHARDT

This project began in 2012 when Louis Draper's sister, Nell Draper-Winston, brought a large selection of his photographs to the Virginia Museum of Fine Arts. Knowing nothing about the artist, I was immediately struck by his vision. Although at that time little had been written about his work, I was, as always, grateful for Deborah Willis's foundational history, *Reflections in Black: African American Photographers from 1840 to the Present*, which enabled me to quickly place Draper within the context of the Kamoinge Workshop and the community of African American photographers working in New York in the 1960s and 1970s. Erina Duganne's chapter on the Kamoinge Workshop in her book, *The Self in Black and White*, was also key to my early understanding of the group. Thanks to the work of Draper's friend and colleague at Mercer Community College, Gary Saretzky, Draper's archive, including his papers and all of his prints, contact sheets, and negatives, had been organized into boxes and listed in an initial finding aid. The library at the University of Virginia had agreed to temporarily house the collection in 2006, but Ms. Draper-Winston needed to find a long-term institutional home. Gordon Stettinius had recently opened his photography gallery in Richmond, Candela Books and Photographs, and he agreed to represent the Draper estate while Ms. Draper-Winston looked to permanently place his archive. At Candela, I not only had the privilege of looking at hundreds of Draper's prints, but also began reading Draper's many histories of the Kamoinge Workshop. His descriptions of the collective's purpose, paired with his photographs, made abundantly clear that this story was of national significance—both art historically and politically—yet through Draper, it also had local roots in Richmond.

In 2013, VMFA acquired ten photographs and Ms. Draper-Winston gave three prints as a gift. Draper's photographs were first included in two simultaneous exhibitions at VMFA in 2014, *Signs of Protest: Photographs from the Civil Rights Era* and *Identity Shifts: Works from VMFA's Collection*. VMFA was also engaged in an effort to build a collection of civil rights photography, which was particularly timely as Richmond was in the midst of commemorating the 150th anniversary of the Civil War, as well as a the fiftieth anniversary of the civil rights movement. Draper's hometown had not only been the capital of the Confederacy in the middle of the nineteenth century, but also an important site in the legal battle against school integration in the middle of the

twentieth century. While Draper attended college, Virginia Senator Harry Byrd espoused "Resistance" to the Supreme Court ruling on *Brown v. Board of Education*. It does not seem coincidental that Draper left Richmond in 1957, at the height of Massive Resistance, to learn how to respond to these injustices with a camera. Although Draper's photographic vision took shape in New York, he clearly gained his commitment to work for equality and justice from his family and community in Virginia. His sister participated in the sit-ins organized by Virginia Union University students in 1960, protesting segregation in Richmond's department stores, and she took part in the yearlong boycotts and picket lines that resulted in the stores' final integration. Through her career in social work and her generosity in sharing her time with the community, she has been a humble yet persistent force for good in Richmond for many decades.

Ms. Draper-Winston signaled that she was ready to place Draper's entire archive with a museum in 2015. Despite interest from large institutions in other cities, she chose VMFA because of her desire for her brother's life and photographs to serve as an inspiration to young people in the place where he grew up. Every artist should have a sister so committed to his legacy. Between 2012 and 2015, Ms. Draper-Winston and her friend Cheryl Pelt had helped to organize shows of Louis Draper's photographs at the Black History Museum in Richmond and the Richmond Public Library, among many other places around Virginia. At Candela, Gordon Stettinius and his team launched "The Louis Draper Project," an online blog, and mounted a retrospective exhibition of Draper's photographs in 2014. When VMFA acquired Draper's archive, we promised to build on this ground swell of familial and community support by preserving Draper's photographs and archive and we committed, as an institution, to continuing to show his work and tell his story in a meaningful way. From the beginning, VMFA Director Alex Nyerges and Chief Curator and Deputy Director for Art and Education Dr. Michael Taylor showed enormous enthusiasm for this project and embraced it as an institutional priority. Without their total and complete support, none of this would have been possible.

While it has been an honor and a privilege to be entrusted with this story, its success ultimately relies on the voices and contributions of Draper's fellow Kamoinge Workshop members. Soon after VMFA received Draper's archive, I began to

meet Draper's second family. With each introduction and phone call to another member, their love and respect for Draper became abundantly clear. Draper's wisdom and integrity has preceded this project every step of the way, turning artists I had never met before into close allies because of their willingness to help with a project involving him. His reputation as a photographer, intellectual, and peacemaker guides this project just as it helped to shape the Kamoinge Workshop.

I am grateful to Anthony Barboza, Adger Cowans, Danny Dawson, Jimmie Mannas, Herb Randall, Herb Robinson, Beuford Smith, Ming Smith, and Shawn Walker for agreeing to participate in video recorded oral history interviews. Many of these members have had long phone conversations with me over the past two years to answer specific questions about the Kamoinge Workshop not covered in our initial oral history. I am particularly thankful for several conversations at key moments during this project with Herb Randall, whose friendship with Draper began before Kamoinge.

I am also grateful to both Shawn Walker and Beuford Smith, who visited VMFA in 2017 to speak in a program that corresponded with a rotating series of exhibitions about the Black Photographers Annual. Walker welcomed us into his home many times since 2017, allowing us to search through binders of letters, announcements, and flyers. He found a VHS tape with Carrie Mae Weems's interview with several of the members, filmed in 1982 by Al Santana, providing the only video footage we have of both Draper and Francis. Walker also found audiotapes of interviews from 1982 and 1984, as well as a recording of a Kamoinge meeting in which members discussed the group's history. He allowed VMFA to digitize all of these for research purposes, and their content helped to reveal the perspective of several now deceased members, especially Francis and Fennar. In addition, Walker generously lent photographs by Francis and Fennar, as well as a photograph of members attending the March on Washington and the original poster design for the Theme Black exhibition. I'm also grateful to Jenny Walker who provided additional support for these efforts.

Beuford Smith's good humor and gracious hospitality were much appreciated over many visits to his home as we examined contact sheets, photographs, letters, and boxes of records pertaining to the Annual and Kamoinge. Smith generously gave the museum additional volumes of the Annual and related materials, as well as photographs of Draper from the 1960s through the 1990s. He also donated a 1964 notebook filled with meeting minutes in Draper's handwriting. One page, apparently separated from the same notebook, already preexisted in Draper's archive. Now whole, these are the earliest known Kamoinge meeting minutes.

Beuford Smith, Barboza, Randall, and Robinson worked as a team following Draper's death in 2002 to help Mercer Community College and Nell Draper-Winston produce Louis H. Draper: Selected Photographs, which was published in 2015. Gary Saretzky's personal recollections and Iris Schmeisser's scholarly essay both expanded the body of knowledge about Draper and his work. Likewise, the publication of Timeless: Photographs by Kamoinge in 2016, edited by Tony Barboza and Herb Robinson, added an incredible resource on Kamoinge. Both of them have shared many insights based on their work for Timeless. In addition, Barboza scanned and emailed hundreds of images from his own collection including photographs of meetings, the opening at the Studio Museum in Harlem, and the preparations for the International Center for Photography exhibitions. He was also able to locate his artist's proof of the Kamoinge accordion-fold artist's book he made for each member in 1972 as well as a rare photograph by Calvin Wilson. Herb Robinson provided all of the photographs by his close friend, Herman Howard, and shared many memories about him, as well as Al Fennar. I was deeply saddened not to have met Fennar, who lived in Southern California and passed away in 2018. His daughter, Miya Fennar, has been a joy to work with as she identified early photographs from his collection to lend to the exhibition and shared her memories of growing up in the Kamoinge family. Through the wide and varied contributions of all of these members, I feel honored to have genuinely experienced the spirit of Kamoinge.

In 2017 the National Endowment for the Humanities awarded VMFA a significant grant to digitize these materials. The archive consists of 50,000 items, including photographs, negatives, contact sheets, slides, audiovisual materials, computer disks, and camera equipment, as well as fifteen boxes of valuable documents and publications, including significant materials about the formation and early years of Kamoinge.

Bringing this ambitious project to fruition has depended on a phenomenal team at VMFA. I am grateful to Lee Ceperich, Director, Library and Special Collections, VMFA Margaret R. and Robert M. Freeman Library, for her excitement about the Draper archive from the first time she viewed it through its acquisition and beyond. I cannot adequately thank Archivist Courtney Tkacz for her expert management of the cataloguing and digitization process, which has ensured this project's success. Assistant Archivist Margo Lentz-Meyer worked seamlessly with Photographer Sandra Sellars and together they literally laid their hands on every item in Draper's archive, offering important insights into the material along the way.

Videographer Briget Ganske has an openness to adventure and a gift for envisioning stories that made her an ideal collaborator on the oral histories filmed for this project. I am also thankful for Videographer Sharad Patel's patience editing the videos. Additional thanks go to Director of Imaging Resources Travis Fullerton and Assistant Photographer David Stover, as well as Howell Perkins, Image Rights Licensing Coordinator,

for his stalwart efforts to procure permissions for such an expansive project.

In 2018, the Bank of America Art Conservation Project awarded VMFA a grant, which enabled VMFA to treat and house a significant portion of photographs by early Kamoinge Workshop members in the permanent collection. I am grateful to Paper Conservator Samantha Sheesley and her colleagues Heather Emerson and Heather Godlewski for their expertise in preserving these works. Mary Scott Swanson, Manager of Institutional Giving and Stephen Bonadies, Senior Deputy Director of Conservation and Collections, were both instrumental in writing the Bank of America and the National Endowment for the Humanities grants.

Shannon Petska, Exhibition Coordinator, has kept all aspects of this exhibition and catalogue moving forward at a steady speed despite many obstacles, and I deeply appreciate her project management skills. I am also grateful to Courtney Freeman, Director of Exhibition Planning, and Courtney Burkhardt, Manager of Exhibitions, for their crucial oversight. In addition, I deeply appreciate the vision of Tamar Peterson, senior exhibition designer, as well as the work of Daniel Young, head of exhibition design and the exhibition design team. I would also like to acknowledge Susan Turbeville who served as exhibition registrar.

I thank Frank Saunders for his perspective, both as a photographer and as the educator for this exhibition. I am also thankful to our interpretive team, Kelsey Beckwith and Courtney Morano, in addition to Chief Educator Celeste Fetta.

Perhaps appropriately, I do not have adequate words to express my thanks to Sally Curran for editing this catalogue. Both she and the designer, John Hoar, have been patient and flexible beyond all reasonable requirements.

I am indebted to VMFA's Sydney and Frances Lewis Family Curator of Modern and Contemporary Art, Valerie Cassel Oliver, for her wisdom and mentorship. Her enthusiasm for this project and confidence in its importance provided much needed sustenance during many crucial phases of its development. Denise Bethel looked closely at the photographs and expressed infectious excitement about them. Likewise, Robert O'Mealy offered timely encouragement. Karen Gaines's path at Photography Collections Preservation Project fortuitously crossed with mine as we both simultaneously worked on separate projects relating to Kamoinge.

Sharayah Cochran, Research Assistant, left no stone unturned, often discovering critical clues that made major contributions to this project. She was a constant sounding board for many aspects of the project and I remain grateful for her valuable input. Beyond her research in VMFA's archive, the list of libraries and archives she corresponded with or visited for this project is a testament to her dedication and thoroughness. We both thank the curators, librarians, archivists, and staff at the American Society of Media Photographers; Beinecke Rare Book & Manuscript Library at Yale University; Brooklyn Public Library; Center for Creative Photography at the University of Arizona; Rare Book and Manuscript Library at Columbia University Libraries; David M. Rubenstein Rare Book & Manuscript Library at Duke University; Harold Feinstein Photography Trust; Gelman Library Special Collections Research Center at the George Washington University; Frances Loeb Library at the Harvard University Graduate School of Design; the Archives at the Museum of Modern Art; the New York Public Library Manuscripts, Archives, and Rare Books Division; Schomburg Center for Research in Black Culture; Larry and Reka Siegel; Studio Museum in Harlem; Third World Newsreel; and Virginia State University Archives and Special Collections.

I could not ask for a more congenial and generous group of scholarly contributors. Despite her impossibly full schedule, Deborah Willis quickly and enthusiastically agreed to write the preface. Bill Gaskins's unwaivering belief in the necessity of this project has been a touchstone. Erina Duganne not only wrote for the catalogue but also donated all of her taped interviews with early Kamoinge members from the early 2000s, including now deceased members Ray Francis, Al Fennar, and Louis Draper. In addition to her essay, Romi Crawford provided a helpful model for this project with *The Wall of Respect: Public Art and Black Liberation in 1960s Chicago*. John Edwin Mason has been a trusted fellow traveler on this project since we met through our mutual interest in Draper's archive in 2012. His contributions to this project far exceeded his essays and include countless conversations in which he offered important insights and sound advice.

I am also grateful to Tobias Wofford, Assistant Professor of Art History at Virginia Commonwealth University, for his constructive responses as a reader of the manuscript. The excitement several curators shared for this project led to a remarkable line-up of exhibition venues. I would like to thank Jennie Goldstein and Carrie Springer at the Whitney Museum of American Art, Mazie Harris at the J Paul Getty Museum, and Nathaniel Stein at the Cincinnati Art Museum. Museum colleagues, including Sarah Meister and Tasha Lutek at the Museum of Modern Art and Rhea Combs, at the Smithsonian National Museum of African American History and Culture helped to make possible critical loans to the exhibition.

Finally, I am grateful to my husband, Joshua, whose support for this project has far surpassed intellectual engagement and has consisted of meals, homework sessions, and school pick-ups, all played to an impeccable soundtrack, and to our three sons, Silas, Ira, and Levi, the youngest of whom has never known a world where Louis Draper and the Kamoinge Workshop were not household names.

Louis Draper's History of the Kamoinge Workshop

For nearly four decades, Louis Draper wrote many introductions
and histories of the Kamoinge Workshop. These take various forms
in his archive, from handwritten manuscripts on loose-leaf paper to
typescript drafts and published summaries. His first published history
appeared in the December 1972 issue of the James Van DerZee
Institute's *Photo Newsletter*. What follows is a reproduction of this
history, which chronicled the first decade of the Kamoinge Workshop.

The Kamoinge Workshop

"It is our endeavor to produce significant
visual images of our time. In the area of
human relationships, political and social
interactions and the spiritual world of
pure imagery, the needs are basically the
same: that being the establishment of con-
tact with self is the key, the source
point from which all messages flow. We
speak of our lives as only we can."

Four photographers were all
that made up the original Kamoinge
Workshop. It was 1963. We had
come together in a rather relaxed
atmosphere; our Sunday evenings
usually consisting of well-blended
John Coltrane, Brillante wine,
stewed chicken, bless the ladies,
and a dash of photographs. Once in
a while a most pertinent thought
might be offered just as Jim Brown
streaked downfield on a long touch-
down jaunt.

The word "Kamoinge" is derived
from the Kikuyu and represented, in
essence, an ideal. Literally trans-
lated, it reads "a group of people
acting together".

Much was expected of us as
photographers, our only criteria be-
ing the best effort within our capa-
bilities. It was assumed that we
would be regularly in attendance and
that the production of photographs
was of primary consideration. We
met as friends, which enabled us, I
think, to survive some rather severe
print criticism at times. Serious-
ness was that ingredient reserved

for the work itself, but a full
range of feelings made their way in-
to a nights conversation. Being
firmly convinced that photography
is it's own limitation, my feelings
were that the production of good
photographs is as much involved with
good music and conversation as it is
with a thorough investigation of all
other forces surrounding us. This
attitude was shared without question
and we found little opportunity for
insecurity amidst emotional flights
by a fellow member. The creative
spirit offers no precedent, con-
sequently no data sheet to a plan
of behavior.

Later in 1963 at a photo studio
in Harlem, a number of photographers
were to assemble: photographers of
many diverse backgrounds and
abilities. There was an expectancy
for exchange and a curiosity borne
of isolation and exclusion. Some-
how we all knew that this kind of
association was essential as a
means of being strengthened against
the indifference of established
photographic institutions.

(Continued on p. 4)

(Continued from p. 3)

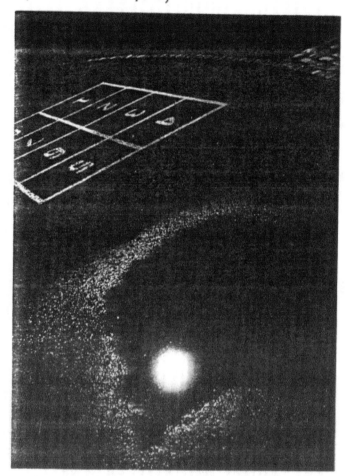

Louis Draper

The Kamoinge Workshop was present at this gathering and contributed to the organization of this body of photographers. We all needed an outlet for our work, a means of supporting ourselves and a forum of peers who would view our work with honesty and understanding.

There was much excitement at that session. Enthusiasm was high. Sensing that conditions faced by this group of photographers were, in many ways similar to our own, the Kamoinge Workshop optioned to affiliate itself and offered it's name for possible consideration. The name "Kamoinge" was adopted and the nucleus of what became the current Kamoinge Workshop was established.

We saw as our purpose, the nurtur-

ing and protection of each other; challenging each other to higher attainments. We championed each attempt as proof of our faith and evidence of our unity.

Not without a good deal of debate and much discussion, the first Kamoinge Workshop portfolio was produced. Fourteen of the fifteen photographers then comprising the workshop were included in that first portfolio. The statement issued with the portfolio read: "The Kamoinge Workshop represents fifteen black photographers whose creative objectives reflect a concern for truth about the world, about the society and about themselves", and accompanying that, "Hot breath streaming from black

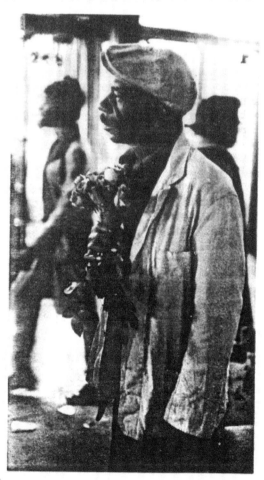

Beuford Smith

(Continued on p. 5)

(Continued from p. 4)

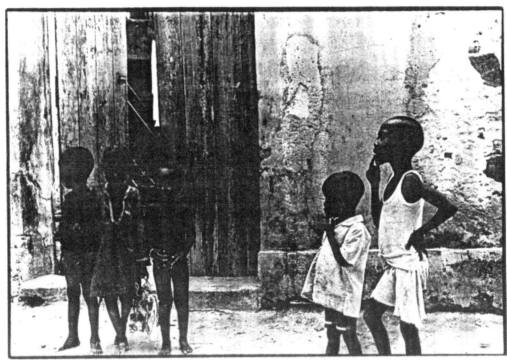

Ming Smith

tenements, frustrated window panes reflecting the eyes of the sun, breathing musical songs of the living." - Louis Draper.

In character these photographs were models for our concerns during those hectic and exciting years. The march on Washington had just taken place and many photographers had been a part of that. In many cases a direction had to be created for what had photographically been accumulated. Logical suggestions followed; a show, a book, or maybe a portfolio; something to put these energies into focus and to give that focus depth. Others had engaged themselves in self-assigned projects or those initiated by the collective body. This portfolio was a direct result of these thoughts, and while limited in production and not original photographs (offset photo copies) did, I think, set the tone for succeeding events.

Soon after, Portfolio II followed. In contrast to the first portfolio, they were original photographs, prepared in a limited edition of fifteen total portfolios. Ten of these were sent out as gifts to institutions around the world. The list included Atlanta University, the University of Mexico and Howard University. Other places were the Schomburg Collection, the Museum of Modern Art and the Museum of Negro History.

One of the most controversial, but unanimously accepted projects that the Kamoinge Workshop involved itself with was the "Final Man" theme. This was a poem written by the Jamaican poet Basil McFarlane and was the first consciously African oriented theme undertaken by the workshop. In interpretation, the poem proved to be highly challenging and as a consequence, much heated conversation and pictorial diversity ensued.

In the Spring of 1964, Edward Steichen had a large exhibition at the Danbury Academy of Art in

(Continued on p. 6)

- 5 -

(Continued from p. 5)

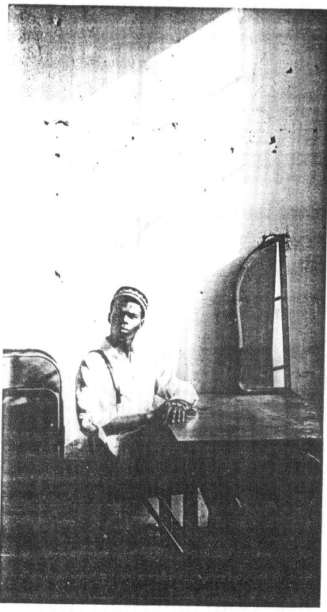

Ray Francis

Danbury, we had only a small corner of the room, and generally felt that our presentation, while adequate, was deserving of better exposure.

Soon, plans to move were afoot. As a meeting area, the studio was adequate, but inflexible. We would wait several months before that move became evident. In the interim, we used each others apartments. Here, we could have more time and occasionally prevail upon a willing wife or girl friend to whip up a stew or our staple of rice and beans.

While membership at that time was open and guests were welcomed, word got around that a photographer ran the risk of very tight jaws if he came in, made his presentation and found out that his s--- wasn't together. Member photographers faced the same hammer, as I remember. Several guests were invited to the workshop to share experiences, show photographs, or simply view our work. Some of those in attendance were S.N.C.C. photographer Tom Wakayama, playwright and poet George Bass, South African photojournalist Peter Magubine, Langston Hughes, Henri Cartier-Bresson and R.E. Martinez of Camera Magazine. It was Martinez who invited the workshop to contribute to a future issue of that publication. In the July 1966 issue of Camera Magazine, the workshop is represented by some twenty-odd pages of photographs and text.

Connecticut. Sponsored by the N.A.A.C.P., it was an effort to raise money for its local chapter. Steichen invited Roy DeCarava, at that time chairman of the group, to exhibit with him at the Academy. DeCarava, in turn, extended this invitation to the other workshop members.

One basic fact that was pointed up in this exhibition was that we needed a space to show our work. In

By now, the workshop had set up quarters in the Market Place Gallery. This we leased for a period between 1965 and 1966 and produced two group shows there. One show was entitled "Theme Black" and the other "The Negro Woman". By now the gallery, unofficially known as the Kamoinge Gallery, had begun to attract regular visitors and was fast becoming a focal point of photographic activity in the Harlem area. Exhibitions were scheduled, as work or projects by individual members were produced.

- 6 -

(Continued on p. 7)

(Continued from p. 6)

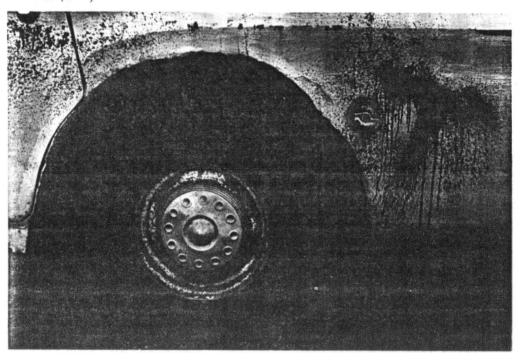

Albert Fennar

After a while this space became confining as well as some of the workshop ideas. Ray Francis, always one to make his own way, was one of the first photographers to venture out. He took a leave of absence to seek out more personal endeavors. Herbert Randall, who had just been awarded a Whitney Fellowship, took off for Mississippi. He spent the "Summer of '65" photographing and playing hide and seek with guess who?

While there were exceptions to this, the workshop had become rather dogmatic in it's outlook and showed a tendency to limited perspectives. As restlessness set in and our interests broadened, we could no longer stomach the steady diet of run-down tenements and sad-dyed tots. While often beautiful, these photographs often became an imposition rather then a commitment. In the midst of this upheaval, Roy DeCarava resigned, Albert Fennar affirmed his independence and fifteen year-old David Carter, whose spirit I will remember, kept us mindful of who else we were.

The Countee Cullen Library exhibit was the last group project by the Kamoinge Workshop for some time to come. It would be our best effort up to that time. The air bristled with anticipation. Photographers were known to have smiled coyly when queried about their expected entry into the exhibition. You can bet we were all up for this one. Having been roundly criticized for marching backward and for not being too grateful for favors bestowed, we would "reply our way".

The exhibition was entitled "Perspectives" and included every member of the workshop, even those on leave and out of town. We reserved three guest spots for Kenny Dunkley, Mel Dixon and Earl James, a former member.

The family survived, though altered by new priorities. Many of the photographers had simply outgrown the workshop as it was originally constituted, so that for the next six years it was to function on a much more multi-faceted level.

- 7 -

(Continued on p. 8)

(Continued from p. 7)

Some of us began teaching or conducting seminars, others became involved with motion pictures or commercial photography. Others journeyed out on a more personal search. In spite of this, the unity remained, for as a photographic family, we wear well. In thinking about that period now, the immediate associations conjured up are, responsiveness, wit, and a gut tenacity of large proportions.

In 1966, Jimmie Mannas and Herbert Randall went to Brooklyn to work in the human resources project "Youth-In-Action". Later Lou Draper and Ray Francis were to join them. Shawn Walker went to Cuba, Adger Cowans to Europe, and Herman Howard to the U.S. Army's "Vacation Spot" in Asia.

When Jimmie Mannas set up his production company, it offered another outlet for photographers to present their talents. Some worked with him on films, and others under his and Beuford Smith's coordination, contributed to exhibits and seminars at Notre Dame and Amherst Universities.

Without a doubt, the Kamoinge Workshop has been a most important factor in the development of young minds in photography and will continue to do this. Whether through exhibiting, lecturing, teaching or just plain rapping, the workshop has dealt a mortal blow to the efforts of slander monguls. Indeed, we are an "embarrassment of riches" to the poor of spirit and the not too swift of mental exposure. What we now know, in looking back, is that the experience has been worthwhile. That such a diverse and multi-talented group of photographers came together at that point in 1963; growing both artistically and philosophically, is eventful. Even more important; that we are still together and stronger in spirit as well as participation, echoes the theme of our recent exhibit, entitled "Alive and Well in 1972".

Louis Draper

Current members of the Kamoinge Workshop

Anthony Barboza
Adger Cowans
Daniel Dawson
Louis Draper
Albert Fennar
Ray Francis
Herman Howard
James Mannas
Herbert Randall
Herbert Robinson
Beuford Smith
Ming Smith
Shawn Walker
Calvin Wilson

The photographs used with the preceding text are all by members of the Kamoinge Workshop.

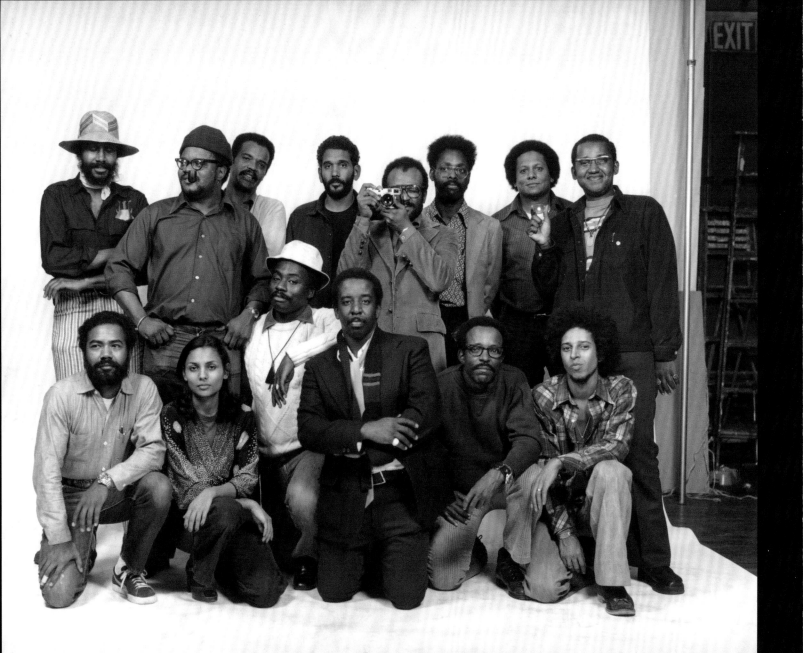

An Introduction to *Working Together*

BY SARAH L. ECKHARDT

The Kamoinge Workshop, a collective of African American photographers based in New York, was formed in 1963. In 1995, at New York University's American Photography Seminar, Louis Draper described the distinct but interrelated purposes for the Kamoinge Workshop, as well as the historical context:

> What we all felt we needed was a forum of peers who would view our work with honesty and understanding. Kamoinge would also give us the strength to continue in the face of a largely hostile and at best indifferent photographic community…. Of even greater significance (to the solidification of the Kamoinge Workshop) was the volatile political climate of the 1960s and the emerging African consciousness exploding within us. These were the forces that forged a ferocious bond among the diverse body of photographers that has lasted to this day.[1]

The members chose the group's name, Kamoinge, because it means "a group of people acting and working together" in Gikuyu, the language of the Kikuyu people of Kenya. Draper and Al Fennar had been reading Jomo Kenyatta's *Facing Mount Kenya* and found the word and translation in the book's glossary.[2] Although Kenyatta first wrote the book in 1938, it gained new cultural relevance in 1962 when a second edition was printed in the year leading up to Kenyatta's election as prime minister of Kenya. In 1963 Kenyatta led Kenya through the transition from British colonial rule to independence and went on to serve as the country's president. Kenya's independence, of course, came in the midst of the sweeping decolonization movement across the African continent from the mid-1950s through the 1960s, a timeline that is roughly analogous with the United States civil rights movement. The group's formation the same year Jomo Kenyatta became Kenya's leader not only helps to explain why *Facing Mount Kenya* would have been popular among the members in 1963, it also demonstrates the "political climate" that Draper referenced. In fact, several members of the group attended the March on Washington that year. [fig. 1.1] The collective encompassed many diverse perspectives and cultural alliances, yet their choice of that name emphasizes the larger, global zeitgeist and reinforces Draper's later description of an "emerging African consciousness exploding within us."[3]

As a community and as an ideal, Kamoinge became inextricably linked to Draper's identity and work for the rest of his life. Likewise, Draper played a key role in shaping the collective's identity by articulating Kamoinge's early vision in writing. He crafted the statements that introduced the collective's two portfolios and wrote various histories of the group for grant applications, book proposals, exhibitions, and other purposes. The concept for this exhibition and catalogue emerged not only from Draper's archive of photographs, contact sheets, and negatives but also from his manuscripts and materials related to Kamoinge. Thus his archive is a central, organizing vein for this catalogue and exhibition. Subsequent to VMFA acquiring Draper's archive, and in the spirit of Kamoinge, several other members, especially Shawn Walker and Beuford Smith, opened their own extensive archives to provide valuable material and context about the group's early years.

Working Together focuses on the first two decades of the collective and features the work of fifteen members who—including Draper—joined between 1963 and 1972: Anthony Barboza, Adger Cowans, Daniel Dawson, Roy DeCarava, Al Fennar, Ray Francis, Herman Howard, Jimmie Mannas, Herb Randall, Herb Robinson, Beuford Smith, Ming Smith, Shawn Walker, and Calvin Wilson.

While the artists had independent photography careers, they met weekly, usually on Sundays, to show each other their work. The group organized several shows in their own gallery space in the mid-1960s, in addition to exhibitions at New York's International Center for Photography and the Studio Museum in Harlem in the 1970s. They were also the driving force behind *The Black Photographers Annual*—a publication founded by Kamoinge member Beuford Smith and published by Joe Crawford—that featured the work of a wide variety of Black photographers and provided a key outlet when mainstream publications offered few opportunities for African American artists. Through all of its various activities, Kamoinge participated in and helped to shape a critical era of Black self-determination in the 1960s and 1970s. This period coincided with a pivotal shift in photography's wider cultural and institutional acceptance as a powerful artistic medium. Louis Draper's archive at the Virginia Museum of Fine Arts, combined with the oral histories of nine of Kamoinge's early members, provides firsthand

1 Anthony Barboza (American, born 1944), **Kamoinge Group Portrait,** 1973, digital print. *Virginia Museum of Fine Arts, Courtesy Eric and Jeanette Lipman Fund, 2019.249 © Anthony Barboza photog*

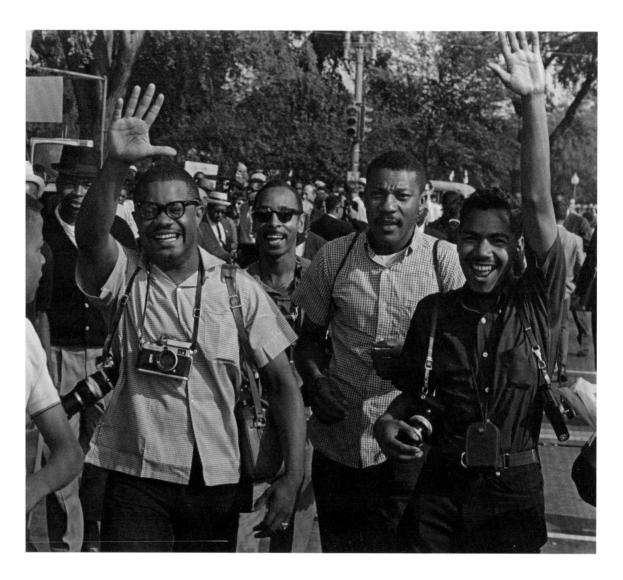

Fig. 1.1 *March on Washington*, 1963, photographer unknown, gelatin silver print. [L–R] Ray Francis, Larry Stewart, Earl James, Herman Howard.
Courtesy Shawn Walker Archive

accounts of the ways in which Draper and Kamoinge navigated critical issues around photography, race, and representation during this momentous time.

The Kamoinge Workshop operated simultaneously on different levels. As Draper's minutes make clear, it was—in the early years—a formal group that voted on new membership, recorded attendance, developed a policy on dues, and functioned as a practical photography workshop.[4] Yet when asked what Kamoinge means to them now, nearly every member from this early period answers with a variation on "family." As Draper himself summarized in an undated, hand-written loose-leaf note, "Though professional, our longstanding personal interactions within the group has forged us together as though a family."[5] Meetings were held, sometime for hours on end, every Sunday afternoon and evening in the early 1960s. The close relationships of the photographers exceeded the boundaries of the meetings, however, and conversations were carried out in studios, homes, museums, galleries, record and camera stores, and movie theaters throughout the week. No exhibition or book can fully re-create the vibrancy and complexity of such a large and interconnected group; however, *Working*

Together attempts to highlight some of the key visual dialogues among the members' photographs, while also using archival material to trace significant exhibitions and publications in the group's history.

Aside from exhibitions and publications, the core function of Kamoinge meetings was to look at one another's photographs and provide critical feedback. These were formal sessions, run very much like "crits" in graduate photography programs. According to meeting minutes, the group decided each week which one or two members would bring their work for review and discussion. Technical standards were high, and the expectations for print quality were, according to some of the younger members, daunting. However, it was the philosophical, aesthetic, and political debates sparked by individual photographers' works that occupied the center of these meetings. Almost every member recalls their arguments as heated and contentious, yet vital to their development as individual photographers and at the core of their identity as a group.

The tenor and range of these conversations were as diverse as the perspectives of the photographers

themselves. The members' roles in the conversations varied by age and experience. Three of the younger members, Walker, Barboza, and Robinson, have all used words like "college" and "university" to describe Kamoinge, and Barboza clearly cast Draper and some of the other members, as his professors: "So it was like I had professors in this group—Lou Draper—they weren't really professors, but they were my professors and this was my college."[6] According to Ray Francis, Draper's experience printing for W. Eugene Smith proved important for the whole group: "Lou Draper was my teacher. Lou had printed for Eugene Smith who was one of my idols. So Smith's style of printing became our style of printing: black blacks, black on black."[7] The portfolio reviews in Eugene Smith's New School for Social Research courses that Draper took and later served as an assistant for, "Photography Made Difficult" and "Photography Made More Difficult," also likely shaped the group's seminar-like atmosphere. Likewise, Adger Cowan's time spent studying at Ohio University's photography program, founded by Clarence White Jr., also provided an important model for formal criticism. After Roy DeCarava was invited to serve as their first president, both his photographic and teaching style exerted an enormous influence on the group, as discussed in the chapter "A History of Kamoinge (1962–82)."

However, as Barboza, Robinson, and Walker have all emphasized, this "college" extended beyond photography, delving into literature and other art forms. Barboza explains, "I was reading. And that is influential. It comes from Lou Draper. He was like a mentor to me, influencing me about looking at other things. And literature really— when you read a book, you create images in your mind of what is going on."[8] In particular, Barboza recalled reading James Baldwin's works for the first time in the context of Kamoinge in 1963 and that experience led to a newfound ability to see in a different way.[9]

Draper's archive gives a sense of his intellectual commitments, which were expansive and varied. In a typescript labeled "Bauhaus Evening Presentation," Draper explained why the abstract painter Paul Klee remained an artistic touchstone for him:

> 'Art does not reproduce the visible, but makes visible.' This was a very important revelation for me of Paul Klee's thinking. In my beginning years I was plagued by various questions about reality and how responsible I needed to be in depicting it. His statement helped me clarify my own thinking.[10]

Written in 1986, this statement doesn't provide an exact chronology for when he first encountered Klee's work, which, given his frequent visits to the Museum of Modern Art (MoMA), could have been at any point from the late 1950s forward.[11] However, the fact that he shared a copy of a small Paul Klee book (*Klee: Figures and Masks*, 1961) with Herb Randall illustrates the way the members constantly exchanged and circulated influential books, from monographs on photographers (such as André Kertész, Walker Evans, Imogen Cunningham, and Minor White) to the essays of Black intellectual luminaries like W.E.B. Du Bois and Ralph Ellison, or the poetry and fiction of Jorge Luis Borges, to name only a few.[12] The group also attended avant-garde films and analyzed scenes from Sergei Eisenstein's 1925 classic *Battleship Potemkin*, as well as contemporary films such as Luis Buñuel's 1962 *The Exterminating Angel*. Although the lexicon of Kamoinge's artistic and intellectual influences proves difficult to track comprehensively or to date chronologically, the sheer variety attests to the many layers and complexities of their group conversations.

While Klee is only one artist among dozens of influences, Draper cited his famous quote—"Art does not reproduce the visible, but makes visible"—to describe his own artistic development. Draper's individual struggle with his responsibility to depict "reality" not only gets at the longstanding tension between the documentary and abstract traditions in photography, it also illustrates the stakes of the larger art historical debate for Kamoinge. Their aesthetic and philosophical conversations about each other's photographs were completely entwined with their social and political context. Fennar later described "long, long arguments about whether or not, because a photographer is black, he has to deal with subjects that are germane to the black experience. And we never resolved it except as individuals.... There was no way we could come to some kind of group conclusion about that. No way."[13] What individual Kamoinge members sought to "make visible" is evident in their photographs and yet their meaning and relevance simultaneously remained open for interpretation and debate within the group.

The artists' practices also shifted over time. While many of the members were working in a documentary style in the early to mid-1960s, several had incorporated abstraction as at least one aspect of their practice by the mid-1970s. In 1968, after taking a history of photography course with John Szarkowski and a still life photography course with Paul Caponigro, Draper reflected on this shift in his own work in a draft of a course evaluation addressed to Caponigro:

> I began photographing as a consequence of seeing the *Family of Man* and the essays of W. Eugene Smith. I felt a need to say something in a photo-literal, journalistic manner, to "report" what was happening now with an implication of what that meant for the future—in somewhat less conceited

terms than this sounds. I have no intention of giving up this approach, at least voluntarily, but I do believe that the self-contained image, the singular, unbroken thread will satisfy another part of my world, that part which up to now has remained unfulfilled.[14]

Although Draper does not use the word "abstraction" here, his placement of "the self-contained image" in opposition to a "photo-literal, journalistic manner" suggests that a self-contained image was analogous to abstraction for him in that it did not need to have an immediate impact on "what was happening now." It is difficult to date most of Draper's work precisely, however address stamps on his earliest prints and his first publication in George Eastman House's 1959 exhibition catalogue, *Photography at Mid-Century*, make clear that he had been alternating between abstraction and a documentary style from the very beginning of his practice. His sense in 1968, however, that this aspect of his "world" had remained "unfulfilled" suggests that he had perhaps not allowed himself to give those images primacy in his body of work. He went on to explain one of the reasons he was willing to allow himself this space to develop in a new direction:

Also contributing to this is the increasing belief that people will not change significantly en masse to the degree I would like them to. Needless to say, your

course in 10 weeks has mildly upset me.[15]

His disillusionment with the idea that people could change significantly en masse reinforces the sense that he had previously held his photographs accountable to playing a role in bringing about this kind of change. While one course evaluation should not stand in for Draper's larger artistic philosophy, it serves as a powerful reminder that October 1968, six months after Martin Luther King Jr.'s assassination, was a very different political moment than 1963, when Kamoinge formed. Just as Draper's approach to photography changed, so too did that of the other members, and thus the dialogue and dynamic of the group evolved over the twenty-year period covered in this catalogue.

A Visual Dialogue

Neither checklists nor comprehensive installation photographs of any of the group's exhibitions from the 1960s remain in Draper's archive. They have yet to be found in other members' papers either.[16] Complicating matters further, Draper, as well as a few of the other Kamoinge members, did not consistently date their contact sheets and photographs at the time and sometimes only dated them later with circa date ranges that vary from two to ten years.

Causing even more confusion, Draper would frequently organize negatives and contact sheets thematically rather than chronologically to print photographs for an exhibition or a publication. The resulting gaps in information make it impossible to trace an exact chronological progression of the group's visual dialogue, with the exception of their works in *Portfolio No. 1* and *No. 2* published in 1964 and 1965, respectively, as well as in the Kamoinge Artists' Book in 1972.With the exception of the portfolios, the catalogue portion of this volume is therefore arranged in broad thematic groupings, beginning with community, civil rights, jazz, global perspectives, and abstractions.

A Few Notes on Membership and Dates

After the group's founding, new candidates for membership had to be sponsored by a current member and show a portfolio for review. This process sometimes took several meetings and many were ultimately turned away. At some point early in the workshop's formation, Draper wrote that they decided to set a size limit: "Membership was carefully screened and kept to a maximum of fifteen members."[17] Minutes from those meetings and the group's first portfolio, produced in 1964, make clear that beyond the original fifteen artists there were several artists— including David Carter, Bob Clark, Mel Dixon, Bernard

Drayton, Ernest Dunkley, Jim Hinton, Earl James, Calvin Mercer, Melvin Mills, Calvin Nophlin, Larry Stewart, and Lloyd Chauncey Westbrook—who participated in the exhibitions and attended meetings at various points in the first two years of the group's formation. Almost all of these photographers, however, had either stopped regularly attending meetings by the time the group produced and distributed a second portfolio in 1965 or only briefly participated the following year.

The group of fifteen photographers included in this exhibition (with the exception of Roy DeCarava) became known as the Kamoinge Workshop most recognized today. In 1972, when the group had an exhibition at the Studio Museum in Harlem, Barboza made individual portraits of each artist, and Louis Draper published a history of the group with a list of members in the December issue of the James Van DerZee Institute's *Photo Newsletter*.[18] (See pp. 2–7.) Barboza's portrait of the whole group the following year, not only illustrates its composition at that moment— from founding members to the two photographers who had just joined—it also consolidates into one frame the members who consistently remained a part of the group's visual dialogue. Barboza intentionally left the exit sign visible in the upper right hand corner of the photograph to symbolize the members who stayed rather than left the workshop.[19]

Fig. 1.2 Select pages from notebook of Kamoinge meeting minutes, 1964.

Virginia Museum of Fine Arts, Margaret R. and Robert M. Freeman Library, Archives, Beuford Smith Archives (SC-32), Gift of the Beuford Smith Collection SC32.01.0.001

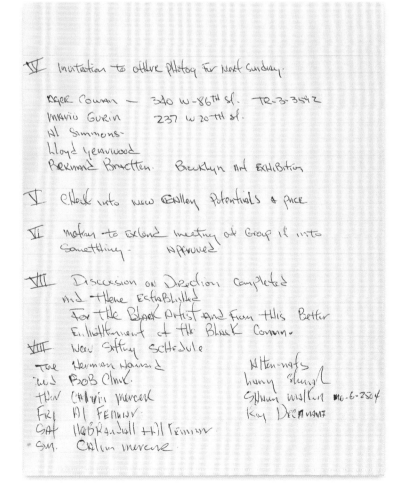

Kamoinge engaged a broader community of Black photographers throughout its history, some of whom came to occasional meetings as guests and knew the members well. However, from 1972 forward, the group kept its membership static until after it reorganized in 1992 and formally opened membership again in 1994.[20] Of the five new members who joined Kamoinge in the 1990s—Sa Rudolph, Toni Parks, Steve Martin, John Pinderhughes, and Frank Stewart—several had exhibited in group shows organized by other institutions with various members of the Kamoinge Workshop in the 1970s and early 1980s. These longstanding relationships woven throughout Kamoinge's history illustrate the ways that the members continued to collaborate with a network of African American photographers outside of the collective without expanding their official membership for over twenty years.[21]

The twenty-year period covered by the exhibition and catalogue ends in 1982 for several reasons. First, Draper began teaching photography classes at Mercer Community College in New Jersey in 1982.[22] While he had taught photography at various institutions beginning in the late 1960s and continuing throughout the 1970s, he spent the last twenty years of his life fully immersed in the vibrant community of professors and students at Mercer where he took pride in shaping a challenging photography curriculum that served as a vital part of the arts education program. At the same time, Herbert Randall moved with his family to Shinnecock Nation, Ming Smith moved to California, and other members of the Kamoinge Workshop focused on their growing photography careers and businesses. While the group never disbanded and maintained close, supportive relationships with one another throughout these years, they did not organize Kamoinge Workshop exhibitions or produce publications again until the mid-1990s.

In 1992, with Draper as president, they resumed more formal meetings and decided to drop "Workshop" from the title.[23] In 1999, under Beuford Smith's leadership as president, they applied for 501(c) status, and renamed themselves Kamoinge Inc., the group's current title. The influx of more members brought new energy and renewed discussion about the group's purpose and direction, signaling a different era for its identity. Kamoinge Inc. currently has more than thirty members and continues to meet regularly and organize exhibitions among other projects.[24] While Kamoinge Inc. carries on the legacy of the Kamoinge Workshop and continues to play an important role in the contemporary photography community, this volume explores the group's beginning.

As Deborah Willis succinctly states in her preface, the Kamoinge Workshop, as well as *The Black Photographers Annual*, remain "mainstays" in the history of contemporary Black photography and African American photography more generally. The photographs reproduced in this exhibition catalogue clearly make that case.

In 1972, A. D. Coleman, the longtime photography critic for the *New York Times*, gave the Kamoinge exhibition at the Studio Museum in Harlem a glowing review, describing the exhibition "as an embarrassment in riches." He emphasized that it was "simply, tragic" that the works by Kamoinge artists were not better known and he asked, "Why is it, then, that the Countee Cullen Branch of the New York Public Library and the Studio Museum remain the only showcases in New York for the work of black photographers?"[25] Given the depth and expanse of Draper's body of work, the cohesive vision of his photographic aesthetic, and its cultural and historical relevance, his omission from the larger (almost exclusively white) narrative of twentieth-century photography appears glaring. Likewise, any account of photography in the 1960s should be considered incomplete without an understanding of the Kamoinge Workshop's collective effort to shift photographic representations of African American culture. Draper and Kamoinge's omission is unsurprising given the overt racism that has pervaded the art world (as well as the larger culture). Large art institutions have only recently begun to acknowledge the long-term effects of this racism and the significant gaps it has produced in the histories of twentieth-century art. Forty years after Coleman described Kamoinge's lack of recognition as tragic, mainstream museums are finally beginning to collect these artists' work with urgency. And yet, to simply add works of art by African American artists to an institutional collection does not acknowledge the power of these same artists' collective responses to the conditions of their exclusion. While Coleman's question is an important starting point, it needs to be rephrased before it can be answered: Why haven't mainstream institutions attempted to better understand the contributions and legacies of the spaces African American artists and intellectuals built, such as the Studio Museum in Harlem and the Countee Cullen Branch of the New York Public Library?

The story of Draper and the Kamoinge Workshop cannot be easily inserted into current art historical narratives without first attending to the social and political circumstances that gave rise to their need to form a collective. On the one hand, Kamoinge artists maintained a near continuous formal and aesthetic dialogue with one another about the abstract traditions of artists like André Kertész, Aaron Siskind, and Minor White, as well as the documentary traditions of photographers such as Walker Evans and Dorothea Lange. On the other hand, for a period of time in the 1960s, they chose to make their images of and for the African American community while building on the legacy of African American photographers such as Roy DeCarava, P. H. Polk, Morgan and Marvin Smith, and James VanDerZee. The boundaries between their aesthetic influences and their commitment to the

community are open and porous. The balance between these two aspects of their art-making practice—the aesthetic and the sociopolitical—also varied by artist and evolved over time. It would be a mistake, however, to completely untangle one from the other.

In the following history of Kamoinge, I outline the social and political contexts that gave rise to the workshop and shaped its early purpose, as well as its later endeavors. My essay on Draper's earliest photographs argues that his political formation in a segregated South played a crucial role in his development as a photographer in New York. Romi Crawford emphasizes Kamoinge's openness to a wide array of art forms and cultures, and she uses a theory of critical sociality to emphasize how these expansive interests contradict preconceived notions about the limitations of a Black collective. Likewise, Duganne focuses on the ways in which the photographs made by Kamoinge members exceed the limiting art historical categories of street photography and abstraction. She ultimately argues that their inclusion within the larger narrative of photography in the 1960s offers a fuller and more meaningful account of the medium in that period. John Edwin Mason explores the importance of jazz to Kamoinge, not only as a subject within some of their photographs but as a structuring metaphor for their photographic process. Mason's second essay hones in on Draper's use of the phrase, "do for self," and he examines the ways in which Kamoinge's collective actions within and for their community resonate with the larger culture of self-determination during that era. Bill Gaskins offers a clear and thorough account of how the *Black Photographers Annual* grew out of the Kamoinge Workshop, meeting the needs of African American photographers who were, as he argues powerfully, willfully ignored by the white photographic establishment. Finally, Sharayah Cochran's biographies of the members emphasize their individual careers while her chronology places their collective achievements within a larger historical context.

The goal of this exhibition and catalogue is to provide as comprehensive a resource on Louis Draper and the early years of the Kamoinge Workshop as possible within the limits of a relatively small amount of space. Nonetheless, given the depth and expanse of Draper's archive alone, not to mention the large bodies of work each of the collective's members has produced, this catalogue and exhibition can only serve as a beginning point for future artists and scholars.

Endnotes

1 Louis Draper and Anthony Barboza, "Kamoinge: the Members, the Cohesion, and Evolution of the Group," Proceedings, *American Photography Institute*, National Graduate Seminar, ed. Cheryl Younger, Photography Department, Tisch School of the Arts, New York University (New York: The Institute, 1995), 114.

2 Both Lou Draper and Al Fennar have been credited with suggesting Kamoinge as a name for the group. In his 2001 interview with Erina Duganne, Fennar remembers the two of them looking through the book together.

3 Not everyone agreed on the name, as Adger Cowan has recalled: "I was the only person who didn't vote for it. I said, 'Let's keep Gallery 35 or Camera 35, then they don't know what color we are, they just know the quality of the work.' They said, 'No, Man, they have to know we are Black.'" Adger Cowans, interview with the author, April 3, 2018.

4 Draper, minutes, VA04.01.3.036-041, Louis H. Draper Artist Archives, acquired from the Louis H. Draper Preservation Trust with the Arthur and Margaret Glasgow Endowment Fund, Virginia Museum of Fine Arts Archives, Richmond, hereafter cited as LHDAA.

5 Description of Kamoinge, verso of page 2, VA04.01.3.012.

6 Anthony Barboza oral history interview, November 18–19, 2009, Archives of American Art, https://www.aaa.si.edu/download_pdf_transcript/ajax?record_id=edanmdm-AAADCD_oh_287102.

7 Ray Francis, interview with Erina Duganne, March 29, 2001.

8 Barboza, oral history interview.

9 Anthony Barboza, conversation with the author, January 15, 2019, among many other discussions about the importance of literature and Kamoinge.

10 Louis Draper, "Bauhaus Evening Presentation," 1986, LHDAA, VA04.01.5.073, VA04.01.5.073.

11 Paul Klee opened his 1920 publication, *Creative Confessions*, with the line Draper quoted: "Art does not reproduce the visible; rather it makes visible." Originally written in German, it was translated into English by the 1940s and was cited often by scholars and curators in essays and exhibition catalogues about Paul Klee from that point forward. See Paul Klee, *Creative Confession and Other Writings*, ed. Matthew Gale (London: Tate Publishing, 2013).

12 Herb Randall first discussed Draper giving him a book about Klee in a phone conversation with the author, January 21, 2019, and confirmed the title on August 20, 2019. Shawn Walker, Beuford Smith, Herb Robinson, and Tony Barboza frequently mention various photographers, books, authors, and films that were shared among the group. This brief list is not meant to be comprehensive or suggest an agreed upon hierarchy of influences, only to suggest a broad range.

13 Al Fennar, interview with two unidentified women, "Kamoinge Work Shop-A," audio recording, 1982, Shawn Walker Archives, used courtesy of Shawn Walker.

14 "Still Photography," photography class notes, New York University Institute of Film and Television, September–October, 1968, LHDAA, VA04.01.1.047.

15 Ibid.

16 Photographs and contact sheets in the archives of Anthony Barboza, Beuford Smith, and Louis Draper include images of exhibition openings from the 1970s; see VA04.04.09.068.C1, VA04.04.09.068.T1, VA04.04.09.068.T2.

17 LHDAA, VA04.01.3.016, Louis Draper, "History of Kamoinge."

18 Louis Draper, "The Kamoinge Workshop," *Photo Newsletter: James Van DerZee Institute, Inc.*, ed. Vance Allen, 1, issue 4 (December 1972): 8.

19 Anthony Barboza explained the importance of the exit sign in the photograph in two separate phone conversations with the author, June 21 and August 20, 2019.

20 LHDAA, VA04.01.3.043-048.

21 LHDAA, John Pinderhughes exhibited with Adger Cowans and Al Fennar in *Light/Textures 3* at Just Above Midtown gallery, February 13 through March 12, 1976. (VA04.01.3.195); Frank Stewart showed with Jules Allen and Beuford Smith at a photography exhibition for the National Urban League from January 21 through February 22, 1980. (VA04.01.3.166); Sa Rudolph was included in *The Black Photographer* exhibit at the Corcoran Gallery of Art from July 30 through September 17, 1977; see press release, Corcoran Gallery of Art, June 28, 1977, Series 5, Box RG5.0-2008.097, Folder 60, COR-0005-0-RG Corcoran Gallery of Art and Corcoran College of Art + Design, Corcoran Gallery of Art curatorial office records, Special Collections Research Center, The George Washington University Libraries, Washington, DC.

22 According to his various resumés in the archive, he was "instructor of photography" from 1982 to 1986; photography coordinator and associate professor by 1987; see LHDAA, VA04.01.1.090.

23 For a discussion of why they regrouped in the 1990s, see Draper, and Barboza, "Kamoinge: the Members, the Cohesion, and Evolution of the Group," 115–17.

24 "Members," Kamoinge: The Continuing Legacy of an African American Photographic Collective, accessed June 21, 2019, https://kamoingeworkshop.squarespace.com/members.

25 A. D. Coleman, *New York Times*, October 22, 1972, D39.

2 Kamoinge Workshop Portfolio No. 1, 1964, gelatin silver print, sheet: 14 x 11 in. (35.6 x 27.9 cm). *Museum of Modern Art, Purchase, SC1964.6.1, .3–.14*

The reproduction rights were not available for SC1964.6.1.2. The image can be see at www.moma.org.

The Kamoinge Workshop represents fifteen black photographers whose creative objectives reflect a concern for truth about the world, about the society and about themselves.

"Hot breath streaming from black tenements, frustrated window panes reflecting the eyes of the sun, breathing musical songs of the living."—Louis Draper

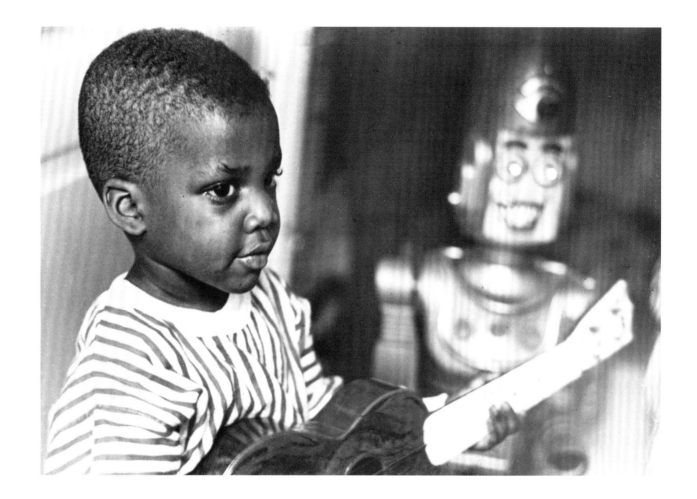

2.1 Bob Clark

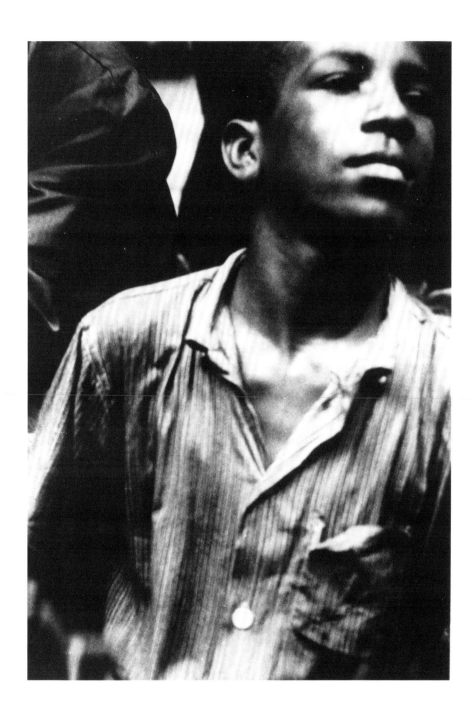

2.2 Louis Draper

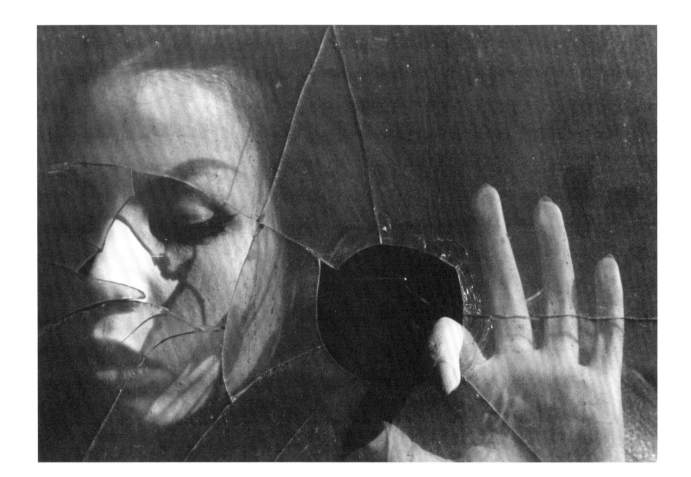

2.3 Albert Fennar

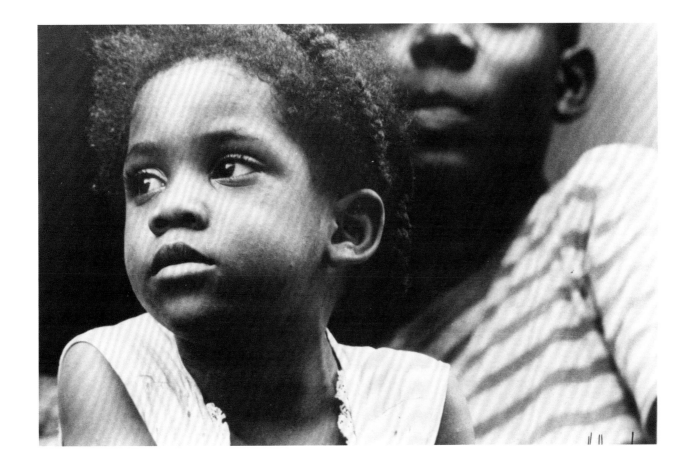

2.4 Herman Howard

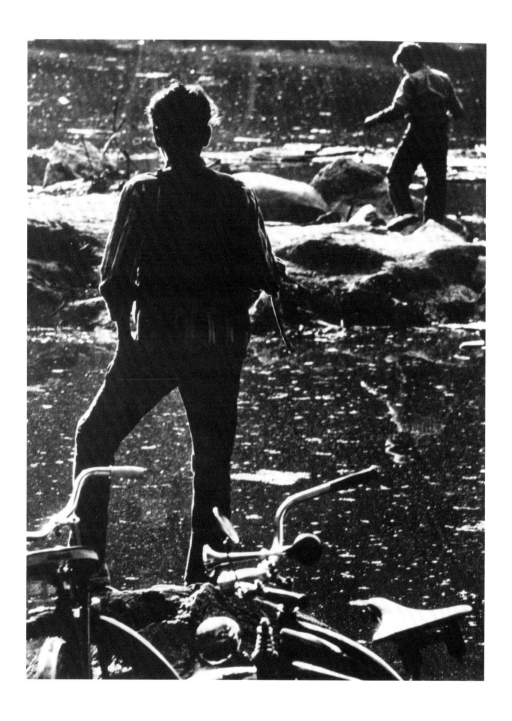

2.5 Ray Francis

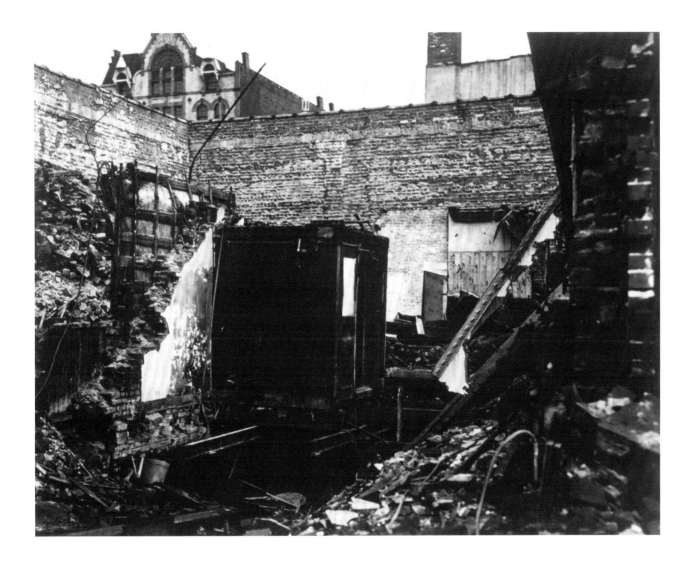

2.6 Calvin Mercer

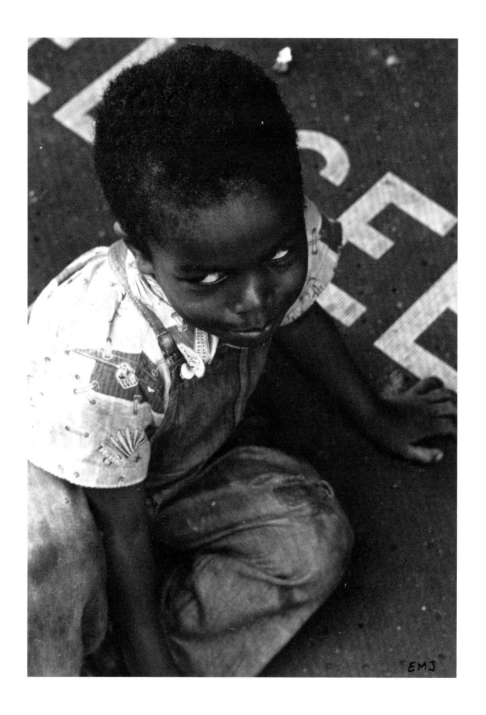

2.7 Earl James

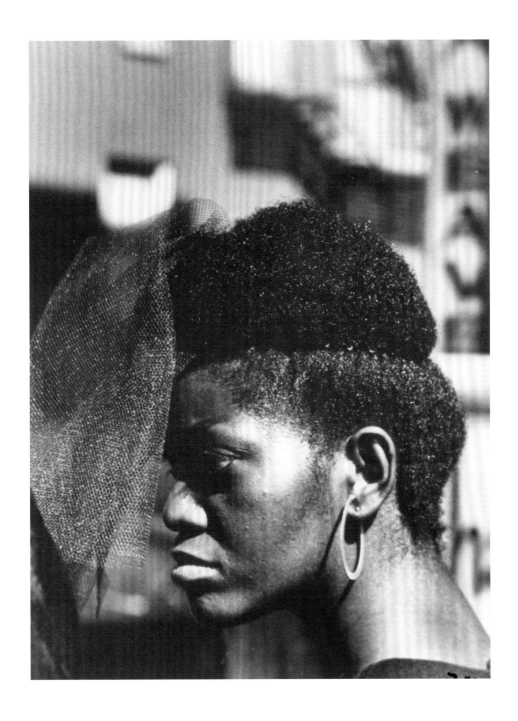

2.8 James Mannas

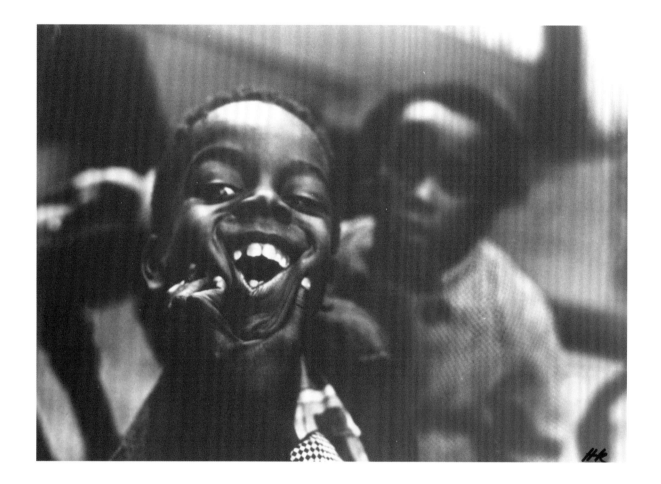

2.9 Herbert E. Randall

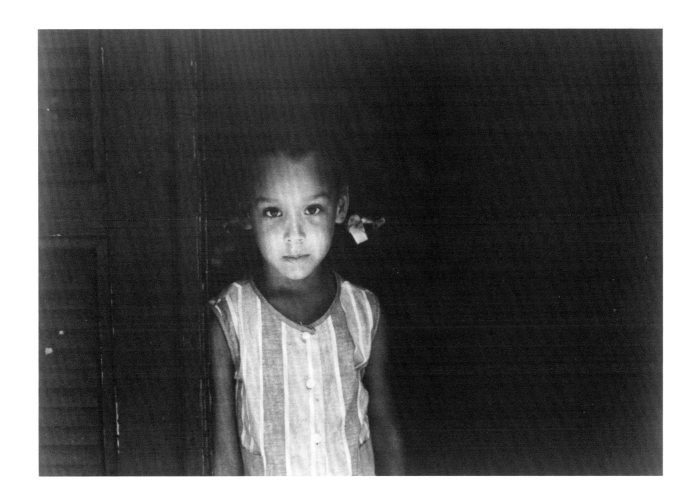

2.10 Melvin Mills

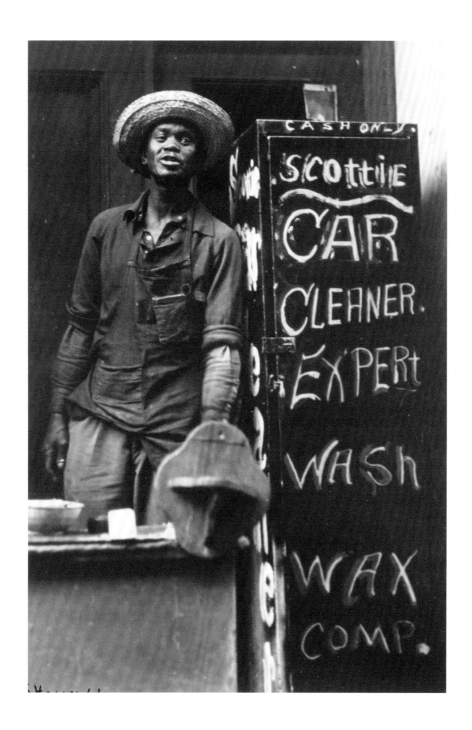

2.11 Shawn W. Walker

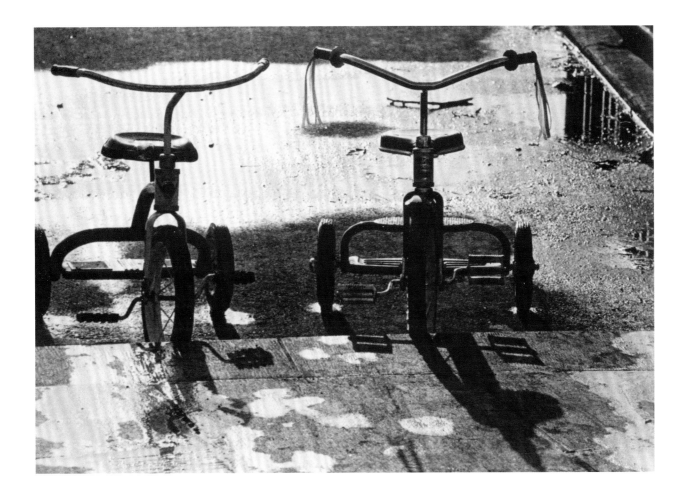

2.12 Larry Stewart

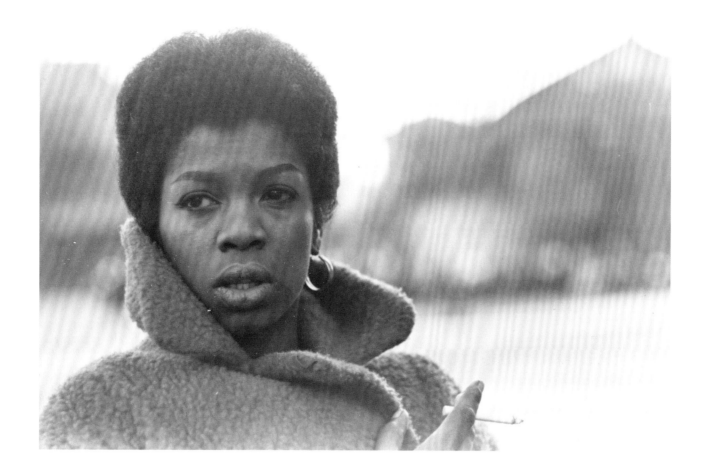

2.13 Calvin Wilson

3 Kamoinge Workshop Portfolio No. 2, 1965, gelatin silver
print, sheet: 14 x 11 in. (35.6 x 27.9 cm). *Museum of Modern Art,*
Gift of the Kamoinge Workshop, SC1965.2.1–.11
Cover photograph by Shawn Walker

The Kamoinge Workshop represents a group of black photographers whose creative objectives reflect a concern for truth about the world, about the Society and about themselves.

Evidence?

To the contrary.

African Kings ruled the palaces of dinosaurs

Ten neon generations past have I conquered, to be here

Chained, crammed in.

The ship, its memory, my infancy.

And death but a single gasp —

With a lash, the umbilical cord raised,

brought down the whip –

I am non-descript;

Cosmic savior, bastard offspring resembling hope,

caresses the genitals of Zeus

Thought, action enmeshed, unable to function,

All

Illegitimate passions

Hovering like fog

Religion, fermenting mysterious shadows, images,

Dancing unobtrusively in cadence, mockingly

sinister —

Fear, self hate, eroded by despair, the face,

A terrible grimace shrouding itself in silence,

 Barren — methodically fruitless.

Who sanctions this violent dismemberment —

Reaps the barren, crusty smell of denial —

Archaeological masks, drums, look clumsily

 On museum walls,

Hung twisted awe-struck,

Witness to this absurdity.

Louis Draper

3.1 Anthony Barboza

3.2 David Carter

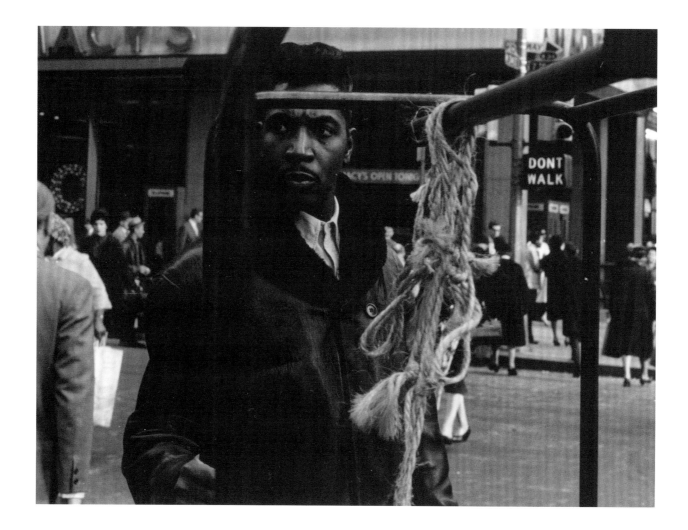

3.3 Louis Draper

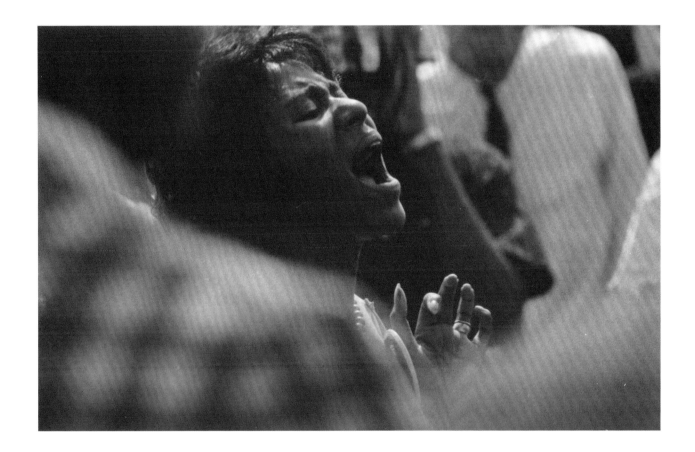

3.4 Ray Francis

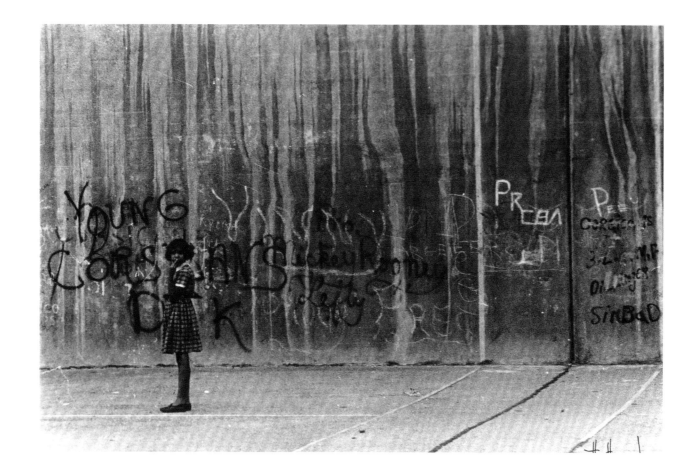

3.5 Herman Howard

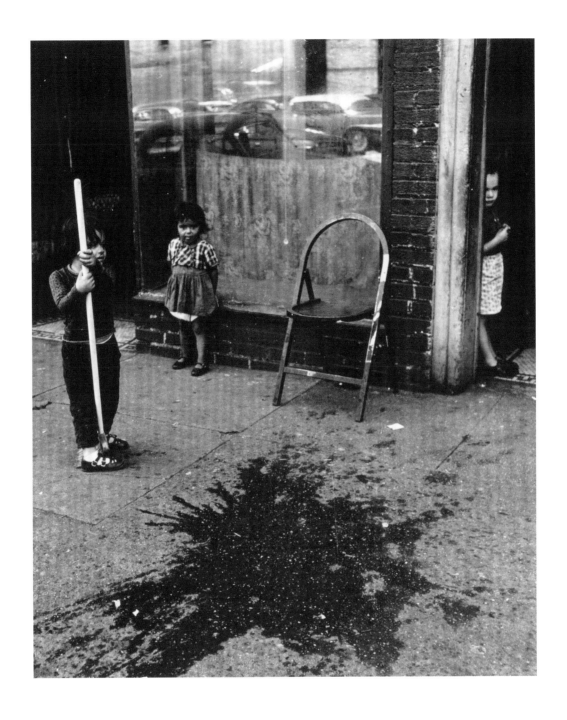

3.6 James Mannas

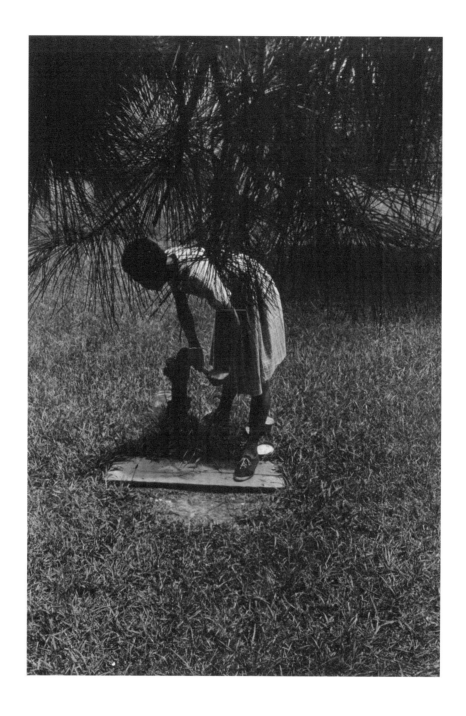

3.7 Herbert Randall

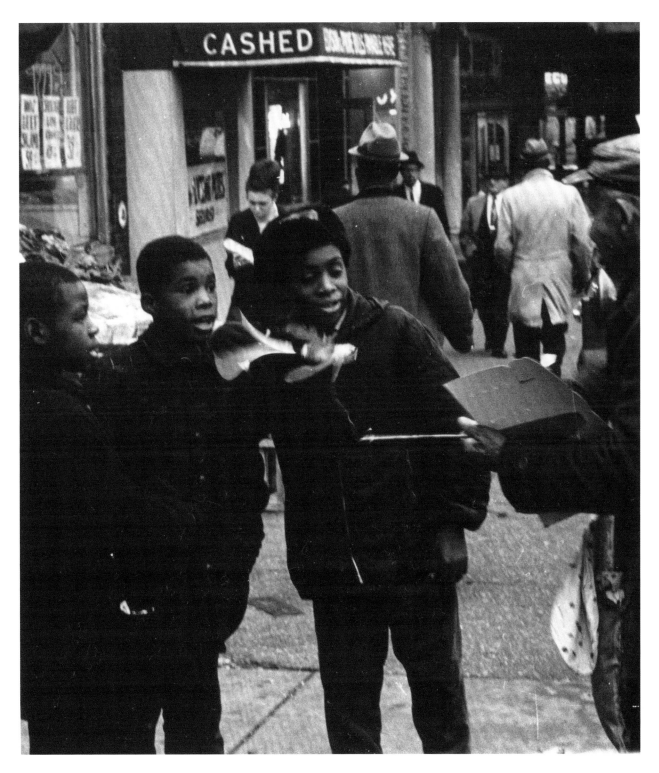

3.8 Herb Robinson

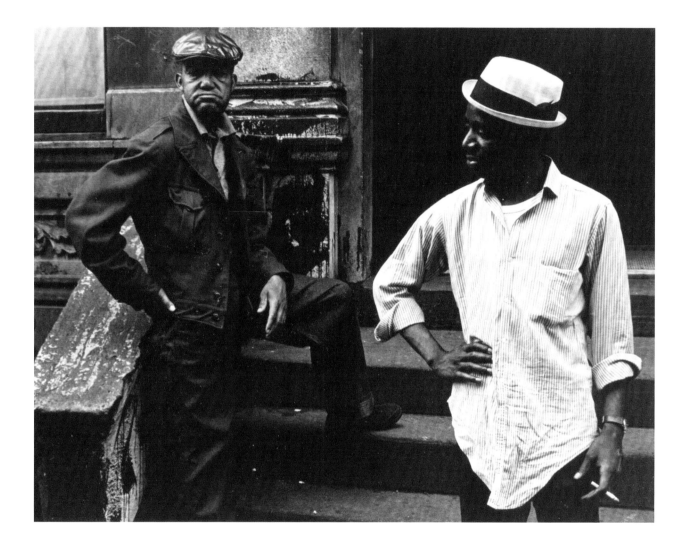

3.9 Shawn W. Walker

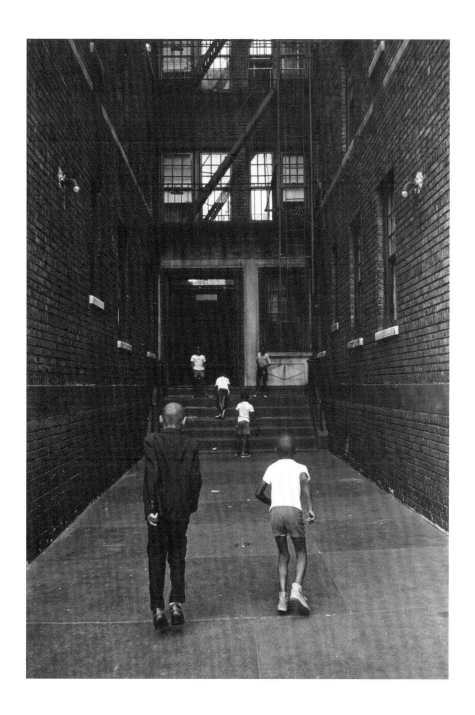

3.10 Calvin Wilson

Minutes Sunday 15 1964

Dues Voted on
 Accepted 100% Vote Approval
 Amount of Dues. As pere members
 $100 Employed members
 25 unemployed members
motion For where money is to Be Deposited
 Saving Account approval 75% Voted

motion Voted on and approved For Gallery
 To recieved
 $\frac{1}{3}$% For pictures sold
 $\frac{1}{10}$% " Portfolio
 For pictures Tld %s ayes none.
 $\frac{1}{3}$ Gallery
 $\frac{1}{3}$ artist
 $\frac{1}{3}$ workshop. Funds
motion For membership To Be closed To any
 new members For at least 6 mos. Accepted
 Voted
Open policy to Guest to come in
and Be a part of Discussion and Display
there works
any member wishing To Bring a Guest artist
must Present this Before member to apount
a Day For Guest To Sit in

A History of the Kamoinge Workshop (1962–82)

BY SARAH L. ECKHARDT

Thus it is valid to state that the Kamoinge Workshop, while operating within an arena of negation, was primarily forged in an atmosphere of hope and not despair.[1]

—Louis Draper

An audio recording of an October 1984 Kamoinge meeting highlights the difficulty in consolidating a singular narrative of a collective's history. Draper, Walker, Fennar, Robinson, and—later in the meeting—Francis had gathered at Walker's home to draft a brief chronology of Kamoinge's history for the purpose of producing a packet about the group to send out when applying for grants or exhibition proposals.[2] They set out to type a straightforward list by date but soon abandoned the typewriter for handwritten notes as it became increasingly difficult to synthesize everyone's different impressions and perspectives. The dialogue is rich in beautiful, detailed memories and humor, yet they occasionally struggle to recall exact dates of central early events, such as their first meeting.[3] Draper repeatedly states that he will check his own meeting minutes at a later time. While Draper's archive provides documentation for many of Kamoinge's activities—including some of the early minutes—it lacks other materials that they were looking for during the meeting to answer questions about their history, leaving the details of a few events difficult to discern.[4] [fig. 2.1] The conversation also reveals the ways in which the political realities of the present, as well as cultural shifts in language, shape our interpretations of even the recent past. At several points, the members talk about how language changes over time. Draper comments specifically on how strange it is to say the word "Negro" after reading out loud one of their exhibition titles from 1965 and Herb Robinson says the word reminds him of seeing an old film with subtitles. Later, Walker and Fennar refer to Draper specifically as their "Griot": a traditional figure in West African culture described variously as a storyteller, poet, and historian.[5] Draper responds, in his typically humble style, with his thoughts on the unreliable nature of memory itself. When comparing different versions of Draper's histories across time and cross-referencing them with archival documents, there are occasional discrepancies in dates. Likewise, none of the histories consulted for this volume, whether archived documents or personal memories, is infallible. What follows is an attempt to weave together as many different threads of the story from as many sources as possible. Pieced together from multiple perspectives, the various narratives of the Kamoinge Workshop converge far more often than they diverge.

As Draper outlined in most of his histories of Kamoinge, the collective formed out of a merger of two separate groups, each of which had begun out of friendships between photographers. Draper met Herbert Randall first in 1958. Soon after moving from Virginia to New York in 1957, Draper took a photography class taught by Harold Feinstein. Randall took a class by Feinstein shortly after Draper and a mutual friend of theirs, Alvin Simon, introduced them to one another.[6] Randall lived on the Lower East Side and recalls that, among other things, they would go to exhibitions at Helen Gee's Limelight Gallery, as well as exhibitions at the Museum of Modern Art (MoMA).[7] Randall left New York in 1959 after he was drafted and was stationed in Germany through 1961. When he returned, he met Al Fennar and Jimmie Mannas because they all worked at a Slide-a-Chrome store processing film.

Randall introduced Fennar to Draper at MoMA where they met to see the Robert Frank and Harry Callahan exhibition. On view from January through April of 1962, the MoMA exhibition not only helps to date the beginning of the friendships that would grow into the Kamoinge Workshop, it also provides instructive visual context. While Kamoinge has been overwhelmingly associated with street photography, abstraction was always a crucial part of the conversation. The juxtaposition of Robert Frank's documentary style, including "The Americans" body of work, next to Callahan's abstractions mirrored the aesthetic range already present in Draper, Randall, and Fennar's well-developed photographic practices.

After joining the air force in the 1950s, Al Fennar was stationed at the Yokota Air Force base in Japan and was assigned to the photographic interpretation unit deciphering images from reconnaissance flights and had access to the photography labs.[8] An exhibition of Eikoh Hosoe's photographs opened his eyes to the possibilities of photography as a fine art and, after his exposure to Japanese photographers, he returned to New York with an abstract photographic aesthetic and a deep commitment to Japanese art and culture. While he was not the only Kamoinge member

Fig. 2.1 Earliest meeting minutes from Louis Draper's archives. *Virginia Museum of Fine Arts, Margaret R. and Robert M. Freeman Library, Archives, Louis H. Draper Archives (VA-04), Acquired from the Louis H. Draper Preservation Trust with the Arthur and Margaret Glasgow Endowment Fund, VA04.01.3.036.*

who made abstract images, his consistent use of abstraction as a mode of seeing played a particularly important role within the group's dialogues.

Draper, Randall, Fennar, and Mannas soon began having informal get-togethers on Sunday evenings in 1962, at some point naming themselves Kamoinge.[9] Mannas and Shawn Walker had grown up together on the same block in Harlem on 117th Street, and Walker's Uncle Hoover, who was a photographer, taught them both how to use a camera. Walker had studied photography in high school but recalled that he had given up on it for a few years when Mannas told him about an upcoming meeting of Black photographers and encouraged him to attend.[10]

Simultaneously, Draper joined another group of photographers who also formed in Harlem in 1962, naming themselves Group 35 because all of the members used small, 35mm cameras. Ray Francis, one of Group 35's founders, began photographing after he received a camera for his fifteenth birthday, but recalled "becoming serious about the medium" after meeting Louis Draper in 1961.[11] Francis worked at Uptown Camera Exchange, which he described as the only camera shop in Harlem, putting him in the perfect position to meet other photographers who lived nearby.[12] In addition to Francis and Draper, Group 35 included Herman Howard, Earl James, Calvin Mercer, and Mel Dixon.[13] Cowans recalls that Ray Francis invited him to give "instruction and advice" to the younger members of Group 35 early in its formation because of the expertise he had gained studying at Ohio University, the first major university to grant a degree in fine art photography.[14] Draper served, in Francis's words, as a "conduit" between Kamoinge and Group 35 because he attended both groups.[15] In one of his later histories, Draper noted that it was actually Francis who suggested bringing the two groups together: "Ray Francis may have been the moving force for this gathering…Ray gave the soundest rationale for our coming together as a group. He said that we were working in isolation, unaware of one another's presence. He felt that the nurturing and sharing we could give each other as a group was critical to our growth and development."[16] They met in a studio shared by Larry Stewart and Tommy Commer, and Stewart became part of the group for the first year. The exact date of this meeting isn't recorded, but Ray Francis remembered it as the spring of 1963, and he and Al Fennar both recalled that several members of the group attended the March on Washington with Roy DeCarava in August 1963.[17] [fig. 1.1]

Group 35 agreed to adopt Kamoinge Workshop as the name of the new, larger group. (This may be the reason there remains so much confusion over who came up with the name: Kamoinge was essentially chosen as a title twice—first by the smaller group of Louis Draper, Al Fennar, Herbert Randall, and Jimmie Mannas, and again when someone in

that group suggested the name to the Group 35 members.) Although Draper did not record Adger Cowans being at this initial meeting of the two groups in his histories of Kamoinge, Cowans remembers being present when the name was chosen because he argued against the decision to take an African name. As a result, he chose not to return for several months. During the first year, Herbert Robinson joined through his close friend Herman Howard; and Anthony Barboza, one of the youngest members, recalls that he joined after his aunt asked Cowans to mentor him.[18] Beuford Smith would not join until May 1965 after Roy DeCarava invited him to a meeting, and Danny Dawson and Ming Smith were both invited by Draper to join the group between 1970 and 1972.

Roy DeCarava

There is a general consensus among the founding Kamoinge members that although Roy DeCarava was not at the group's earliest meetings of the workshop, they sought him out as their first leader early in their formation.[19] [fig. 2.2] The group had connections to DeCarava through several avenues. While Louis Draper later recalled that Langston

Fig. 2.2 *Portrait of Roy DeCarava*, n.d., Herman Howard (American, 1942–1980). *Collection of Herb Robinson. Permission courtesy, Herb Robinson*

Hughes put him in contact with DeCarava, Ray Francis remembered meeting DeCarava while they were both taking photographs in Central Park and DeCarava asked him about his camera.[20] Already an established artist whose work had been included regularly in photography exhibitions at MoMA since the mid-1950s, DeCarava played a crucial role for many in the younger generation of African American photographers in New York. In particular, early Kamoinge members often cite as a touchstone DeCarava's photographs in the 1955 book he collaborated on with the poet Langston Hughes, *The Sweet Flypaper of Life*. Beyond their aesthetic influence, the images in the book expressed DeCarava's commitment to making images within the African American community. In 1952 DeCarava received a Guggenheim fellowship, allowing him a year's leave from his job to photograph. In his application essay, DeCarava had expressed his desire to take photographs that communicated "the strength … the dignity" of African American people in Harlem, offering "the kind of penetrating insight and understanding" he felt only an African American photographer could provide.[21] Written more than a decade before Kamoinge formed, DeCarava's early vision guided and shaped the collective's early conversations about its shared identity.

It is clear from one of Draper's undated histories, likely the earliest, that DeCarava served as chairman of the group until October 1964, after which the group changed its leadership titles and roles and Mannas became president (formerly titled chairman). At that time, DeCarava became director of the workshop, a role he would fill until June 1965.[22] In the intervening two years, however, his willingness to mentor the Kamoinge Workshop members, who were almost all fifteen to twenty years his junior, proved important to the group's definition of its purpose.

In the same undated handwritten history of Kamoinge in which Draper outlined DeCarava's title as chairman, Draper credits Francis and DeCarava for their leadership in identifying the isolation of Black photographers as a reason to unite. Draper wrote that they were "well acquainted with the barriers which prevented black photographers a voice within the usual communications; the national publications, galleries, and schools which were (and still are) largely closed to them."[23] Draper further explained that these "barriers" produced "the sense of alienation which dampened their creative spirit."[24] Yet, Draper emphasized that "with all the untapped talent amidst them, there was no reason why it should not be developed and expressed. Thus it is valid to state that the Kamoinge Workshop, while operating within an arena of negation, was primarily forged in an atmosphere of hope and not despair."[25] Draper emphasized later in the same draft, "There was an air of intense excitement. We wanted to sense a purpose other than individual acclaim; we wanted to serve."[26] In another history, likely written much later, Draper summarized the purpose they settled on in their earliest meetings: "Our

objective—to nurture, encourage, and protect each other—to challenge one another to higher attainment."[27]

American Society of Magazine Photographers and the Context of the Civil Rights Movement

DeCarava appears to have quickly connected the Kamoinge Workshop with his own professional network, which included Edward Steichen, who had just completed his fourteen-year tenure as MoMA's curator of photography. Steichen's 1955 exhibition and book, *The Family of Man* (which included DeCarava among the 273 photographers featured), had been enormously influential in Draper's decision to become a photographer. Alongside DeCarava's *The Sweet Flypaper of Life*, it held a central place in the pantheon of diverse photographic resources the members discussed.

By 1963, Steichen was an honorary member of the newly formed Equal Rights Committee at the American Society for Magazine Photographers (ASMP), on which DeCarava also served. In September 1963 and February 1964, the ASMP held two meetings of particular significance to Kamoinge members.[28] The first was titled "The Role of Photographers in Civil Rights" and the second was titled "The Negro Revolution." A comparison of transcripts from the meetings illustrates how the tone and content of the conversation shifted significantly between September and February.

At the September 24 meeting, ASMP invited Henry Lee Moon of the National Association for the Advancement of Colored People (NAACP) and Marvin Rich of the Congress of Racial Equality (CORE) to speak about the use of and need for images of the civil rights movement. The men emphasized that they were speaking as leaders within the movement and not as photographers. In addition, the civil rights photographer Robert Adelman and Steichen both gave impassioned pleas to increase the number of photographers covering the movement and to expand the scope and depth of the stories being told. Adelman emphasized the need for connecting the images of the more dramatic and violent news stories with the larger context of systemic racism:

> The Negro in America has been systematically degraded, first by slavery and then under segregation. They've endured and some of them have flourished, but lots of them are living in deplorable circumstances and anyone who considers himself an American is implicated in their suffering. This is a story that really hasn't been told at all, and I would hope this organization would concern itself perhaps in some way, to depict the current honest story about what is happening in America today, to renew a basic concern with the future of our nation and redemption.[29]

Later in the same program, Adelman emphasized again that until very recently, "by and large, the Negro was invisible in America." In concert with Adelman, Steichen proposed to the ASMP that they help to organize "a brigade of photographers" that would model itself after the Farm Security Administration of the 1930s with the intent of producing "an historic record of America, without parallel." Despite a conversation about the need for more nuanced and dignified representations of African Americans, as well as more photographers to make them, none of the speakers or respondents connected these issues with the lack of African American photographers in the ASMP or on the staffs of mainstream newspapers and magazines.[30]

On Roy DeCarava's prompting (according to the statement of one of the African American photographers who presented), the ASMP decided to have a second meeting addressing the issue of discrimination within their own field.[31] An ASMP press release in October of 1963 announced a second panel titled "The Negro Revolution: An Exploratory Discussion of the Problems and Possible Solutions in the Communications Media."[32] Originally scheduled for November 26, 1963, it was presumably rescheduled for January 29, 1964, because of the assassination of President John F. Kennedy on November 22.[33] The exchanges at this meeting were decidedly tenser than those at the first. According to the minutes, "The meeting opened with the playing of taped statements by Negro photographers relating their experiences in the communications media."[34] Beginning the meeting using recordings rather than statements made in person sheds light on the fact that, with the exception of a handful of photographers including Roy DeCarava and Gordon Parks, the ASMP had to go outside the organization to learn the perspective of African American photographers. The chairman of the Equal Rights Committee, Chris Corpus, explained that these recordings were made at meetings in Chicago and New York. He noted, "Here in New York, Roy DeCarava, one of our members, held a meeting with Negro photographers. About fifty attended the meeting."[35] The recordings and any notes or minutes that may have been taken at these meetings do not appear to have survived, thus it is not clear when the New York meeting took place or whether Kamoinge members were represented among the recorded voices played at the January 29 meeting. Elton Fax's chapter on Roy DeCarava in *Seventeen Black Artists* clearly states that Kamoinge members attended the meeting of fifty African American photographers organized by DeCarava and that a contentious debate occurred between DeCarava and Gordon Parks regarding the depth of discrimination in the field. Although we don't know exactly what was said, Louis Draper later summarized this moment as a key turning point: "Gordon Park Sr.'s favorable remarks on behalf of the ASMP were not helpful and, indeed, led to a bitter exchange between Parks and DeCarava. Kamoinge left this gathering vowing to do for self."[36] The minutes of the January ASMP meeting, which began with a summary of the preceding

Chicago and New York meetings, provide a crucial context for understanding Kamoinge's internal discussions about their direction in the following months.

From the start, the January 29 forum on "The Negro Revolution" seemed doomed to fail. ASMP President Ben Rose opened by questioning whether discrimination existed at all: "The purpose of this meeting is to examine whether we really do have discrimination in the advertising agencies and the editorial field and, if so, to what extent it exists. Also, to explore whether there are other reasons for the retardation of Negro opportunity in this field and I think the third aim of this meeting should be to develop machinery for assisting the Negro in these areas."[37] In his report as chairman of the Equal Rights Committee, Corpus summarized the perspectives of African American photographers from Chicago: "All of them feel discrimination." He added of the New Yorkers: "Essentially these men agreed with the views of the Chicago men, with a few exceptions." By and large, the white ASMP leaders and photographers were willing to admit that some sort of discrimination existed generally; yet, they felt that their own organizations were not biased. Garret Orr, former president of the Art Directors Club (ADC), a nonprofit member organization that gives awards for "excellence in creative communications," said bluntly, "Let me put it this way, in the Art Directors Club itself I do not think we have a problem of discrimination." He then followed up with an emphasis on the way "talent" had an ability to transcend differences: "But it doesn't matter whether they are white or colored, man or woman. It's talent which is the thing that stands above race, color, creed, sex, or anything else. This is what the employer or employers will have to be shown." The "assistance" most of the white industry leaders agreed to offer focused repeatedly on setting up committees that would work on providing more educational and apprentice opportunities for African American photographers. The established Black photographers at the meeting were clearly frustrated by the ASMP leaders' assumption that Black photographers needed help improving their portfolios and making connections. They did not seem willing or able to understand that "talented" Black photographers were already presenting work equal to that of their white colleagues and were nevertheless experiencing blatant discrimination.[38]

DeCarava's response to the evening's discussion reframed the problem and put the onus back on the hiring practices of the white community:

> There are many statements here that appeared to me to reflect the general confusion, not only about Negroes but about history, about life and about people.... We have racism, and racism, I think, is the problem that none of us are willing to accept. But it is a fact, it exists. It has existed from the signing of the Constitution when the Bill

of Rights was signed alongside with the Rights of Slave States to exist—long before the Civil War. And we still have a problem! So I think the problem, ladies and gentlemen, is for the white community to do something. The main subject is what are we going to do about giving Negroes jobs? Mr. Wolf talked about "lousy portfolios" and "lousy photographers" but lousy photographers are working—they happen to be white. As a principle of democracy, I would like very much to see some lousy Negro photographers work.[39]

Later in the discussion, after Gordon Parks—in an apparent attempt to make peace—reiterated a willingness to offer help with portfolios and emphasized talent as the central issue, Randy Abbott echoed DeCarava's frustration: "Last year I attended the same type meeting listening to Mr. Parks. . . . Mr. Parks said that if you try you will succeed. . . . The problem is not with me . . . it's with the people that control the jobs and the people that control the jobs haven't let the doors open." While Parks's influential photo-essays about the civil rights movement in *Life* magazine had given him an enormous platform to reach white Americans, he was also aware that his prominent position risked distancing him from the African American community he sought to represent. He had reflected on this paradox before in a May 3, 1963, essay on his experience shadowing Malcolm X for *Life* that accompanied his photo-essay on the Nation of Islam, "What Their Cry Means to Me: A Negro's Own Evaluation."

> I wondered whether or not my achievements in the white world had cost me a certain objectivity. I could not deny that I had stepped a great distance from the mainstream of Negro life, not by intention but by circumstance. In fulfilling my artistic and professional ambitions in the White Man's world, I had had to become completely involved in it. . . . Many times I wondered whether my achievement was worth the loneliness I experienced, but now I realize the price was small. This same experience taught me that there is nothing ignoble about a black man climbing from the troubled darkness on a white man's ladder, providing he doesn't forsake the others who, subsequently, must escape the same darkness.[40]

Parks's metaphor helps to clarify the source of tension between DeCarava and Parks: if the ASMP functioned as a crucial rung on the "White Man's" ladder, to continue Parks's metaphor, Parks trusted it to support the weight of the Black photographers coming up behind him. DeCarava and many of the other photographers at the ASMP meeting attested to their own experience trying to step on the rung only to find it broken. Their different perspectives on the issue led Parks and DeCarava to develop different

professional tactics and mentorship styles that would continue to influence the next generation of photographers. While the tension between the two artists is often alluded to indirectly in scholarship, Draper's decision to record it in Kamoinge's history suggests it was a significant turning point in the group's trajectory.[41]

In a badly faded copy of the original (in which key words and phrases are no longer legible), a portion of one of Draper's early handwritten histories summarizes the group's reaction to this meeting and suggests there were a series of follow-up meetings with *Harper's Bazaar* and *Newsweek*:

> As a result of these meetings it was decided that whatever was to be accomplished would have to result thru the efforts of the minority group photographers to create markets and audiences for themselves.[42]

Various descriptions of this breakdown in communication between the ASMP and the photographers led Elton Fax to describe the Kamoinge Workshop's founding as a response to these failed conversations led by DeCarava, a narrative that Peter Galassi then repeated in his essay on Roy DeCarava in the Museum of Modern Art's 1996 retrospective catalogue of his work.[43] Draper's various histories and the founding members' oral histories all consistently date Kamoinge's formation nearly a year earlier in 1963, at the very least as a social alliance of Black photographers. Yet Draper and Walker's later memories of the ASMP meeting as a major event suggests that it functioned as a defining moment in the group's development. As Draper summarized in the 1984 conversation about Kamoinge's history, "It seems to me that the ASMP thing was significant because it was the first real political act that we took."[44]

The ASMP meetings likely informed Kamoinge's decision to formally discuss and articulate their purpose in the following months. In a 1987 article Walker recalled DeCarava's role in these early conversations: "From what I can remember, he asked us what kind of organization we wanted — did we want to be a camera club, or did we want to develop a Black artistic force in the community?"[45] By March 1964, Kamoinge had already undertaken an ambitious course of action that would continue through June 1965. Written in Draper's hand, under March 29, 1964, section III, Draper notes emphatically, "Direction of Workshop Discussion Still Open for Debate!" By April 14, section VII, Draper had written, "Discussion on Direction Completed and Theme Established for the Black Artist and From this Better Enlightenment of the Black Community."[46] [fig 1.2.] Deciding to be for Black artists and the Black community meant that the artists intentionally united the two main issues around representation that the ASMP's Equal Rights committee had discussed separately: the types of images

being made of the African American community and the identity of the artists who make them. Kamoinge added a third commitment: that the images *of* the African American community were also being made *for* the community.

Exhibitions in 1964 and 1965

As they formally debated their direction, Kamoinge produced their first portfolio of fourteen photographs and mounted their first exhibition in Harlem. [fig. 2.5] The group's first recorded meeting minutes, dated "Sunday 15, 1964" (most likely March 15, based on the dates of the weekly minutes in the rest of the notebook), include rent paid to a "Mrs. Glasgow" at 139th Street; a dues-paying structure (one dollar for employed members and twenty-five cents for unemployed members); and the percentage of photograph sales to benefit the gallery, artist, and workshop (one-third each). [fig. 2.1] In addition, one-tenth of each portfolio sale was to be contributed to the gallery. The group also voted to stop new memberships for at least six months.[47] Thus the debate over the workshop's direction in their March and April minutes of 1964 is intermingled with lists of collected dues to pay the rent for a gallery they secured for a month, as well as the schedule for various members to sit in the gallery during open hours, plans for a closing party, and the status of remaining portfolios after the exhibition closed.[48] Draper had delivered a set to the Schomburg branch of the New York Public Library in February 1964,[49] and Roy DeCarava had sold one to John Szarkowski, the curator of photography at the Museum of Modern Art on April 10, among other institutions.[50]

The "Mrs. Glasgow" mentioned in Draper's minutes was Adele Glasgow, a close friend of Langston Hughes who had assisted the poet with research and other tasks over the years. She, along with Ramona Lowe, had opened the Marketplace Gallery in 1959. It was originally located on

Seventh Avenue and 135th Street but had moved to 139th Street by the time Kamoinge rented it for their exhibition. The Marketplace Gallery not only showed art; Glasgow and Lowe also invited speakers such as W. E. B. DuBois and Hughes to give lectures and readings.[51] Draper may have initially met Hughes when he attended a reading by the poet in the first location of the Marketplace Gallery, where he took many pictures. Draper marked his contact sheets containing the images of this event "1959–60," suggesting that Draper first met Hughes and Glasgow several years before Kamoinge's formation. Likely at about the same time as Kamoinge formed in 1963, Draper had begun renting a room in Langston Hughes's building on 127th Street. Draper cited Hughes as "a very solid part of my life— very important in my development."[52] While Draper lived in the writer's building, he held several different portrait sessions with the poet. [fig. 2.3] Illustrating their mutual sense of humor, Draper helped Hughes make his 1965 Christmas card in which a headless Hughes holds his own smiling head in his hand.[53] [figs. 5.6 & 5.7] Draper also remembered that Hughes's home served as a gathering point for intellectuals and leaders from around the world, allowing Draper to meet figures such as Alex Quaison-Sackey, the ambassador from Ghana who served as president of the United Nations from 1964 to 1965 and whom Draper described as "my idol—so elegant and eloquent. He defined African policy in the UN." Thus at the height of Kamoinge's early activities, Draper lived at the center of a cultural and intellectual network where he recalls that Hughes not only encouraged him to read about African history, but also provided opportunities for him to meet leaders who were shaping its future, reinforcing Draper's global perspective. Other Kamoinge members, such as Mannas and Walker, recall Hughes's importance as a mentor and remember that, in this early period of Kamoinge's formation, Hughes offered to look at their prints and comment on them.[54]

In May, Steichen invited DeCarava, who in turn invited Kamoinge, to participate in an exhibition hosted by the NAACP in Danbury, Connecticut, where Steichen lived, as part of a fundraiser for the organization. The members' description of this exhibition paints a striking aesthetic contrast in which Steichen presented a retrospective of his own career in one room, including his early nineteenth-century Pictorialist images, while in an adjacent space, Kamoinge presented a group show of the collective's work ranging from street photography to nudes.[55]

That summer some of the members who lived in Harlem documented the aftermath of the July riots. Roy DeCarava, on assignment for *Newsweek*, posed Walker, Francis, and Draper for a close-up of their faces, which became the cover of the magazine's August 3, 1964, issue headlined "Harlem: Hatred on the Streets." [fig. 2.4] At a lecture in 1995, Draper recalled:

Fig. 2.3 *Langston Hughes*, 1966–67, Louis Draper (American, 1935–2002), gelatin silver print.
Virginia Museum of Fine Arts, Margaret R. and Robert M. Freeman Library, Archives, Louis H. Draper Archives (VA-04), Acquired from the Louis H. Draper Preservation Trust with the Arthur and Margaret Glasgow Endowment Fund, VA04.03.1.102.P2

We were caught up in the riots in very strange ways. This picture (you're seeing) is supposedly of three angry revolutionaries. Harlem was so dangerous at the time that most of the photographers who would normally do this, mainly the white photographers, didn't want to come up to make photographs of what was going on. Reluctantly *Newsweek* hired Roy DeCarava. They needed a cover. Roy knew that we would do it for him. He asked us to sit and look angry for him. We were having a ball. It was a hot, muggy day and we were kidding around until the white art director chided. "You boys don't look angry enough." We got pissed and Roy got his picture.[56]

The irony of the *Newsweek* cover echoes the experience the members just had with the ASMP several months earlier. Their inability to express the stereotypical anger expected by a white art director of three Black men in Harlem turns into an unexpected success when they react to his genuine racism. The absurdity of the initial "angry revolutionary" construct only grows more absurd when paired with Ray Francis's memory (his face is in the center of the cover) that he had been playing chess at Columbia University when the riots started.[57] Repeatedly, the price of admission into the mainstream media for Black photographers were assignments limited by racial stereotypes that resulted in editorial choices and captions that highlighted those same stereotypes. On February 25, 1965, the group's photographs were featured in a television program on WNET titled "100 Days after the Riots." Unfortunately, no copies of the program have been found to analyze who made the editorial choices and how Kamoinge's photographs were treated in this context. Kamoinge's thematic choices for its next two exhibitions in 1965, *Theme Black* and *The Negro Woman*, [figs. 2.6 & 2.7], convey the group's commitment to multiplying representations of Black subjects outside the constraints of the white media and displaying those images within the African American community.

Although most of the Kamoinge members would, rightly, resist the label of civil rights photographer—which conjures violent images of fire hoses and attack dogs in the popular imagination—Draper's histories emphasized that the collective formed in the midst of the civil rights movement in part to make another kind of image to add to the visual dialogue—the kinds of images lacking from the national conversation:

> This was at the height of civil unrest across the country and a year before the massive civil resistance in Harlem. Cognizant of the forces for change revolving around Kamoinge, we dedicated ourselves to "speak of our lives as only we can."

Fig. 2.4 *Newsweek* magazine cover, August 3, 1964, featuring photograph by Roy DeCarava. [L–R] Shawn Walker, Roy Francis, Louis Draper.
VMFA, Margaret R. and Robert M. Freeman Library, Archives, VA04.01.3.122

> This was our story to tell and we set out to create the kind of images of our communities that spoke of the truth we'd witnessed and that countered the untruths we'd all seen in mainline publications.[58]

Many of the members' photographs from this period consisted of everyday images of African Americans, which, when seen together as a collective body of work, offered a sense of dimension and diversity not available in the media, even from sympathetic civil rights photographers.[59]

Herb Randall was the only member of Kamoinge to travel into the South with civil rights activists. In the summer of 1964, he decided to use the John Hay Whitney fellowship he had just received to accompany Student Nonviolent Coordinating Committee (SNCC) members to Hattiesburg, Mississippi, where they organized voter registration drives and taught Freedom School sessions (three-week classes held in community churches). Although Randall photographed alongside the SNCC volunteers, he did not report to the SNCC leaders and thus was free to make his own images without assignments. Upon request, he made a press image of his friend Rabbi Arthur J. Lelyveld after he had been beaten with a tire iron. As a rule, however, Randall did not publish the violence he documented that summer. Instead, his photographs focused on the African American community within Hattiesburg—meetings and church services, as well as quiet images of children playing or reading.[60] [cat. no. 85] His approach in Hattiesburg illustrated Kamoinge's intent to make photographs that countered the prevailing images in the news. Although Randall missed the riots in Harlem and

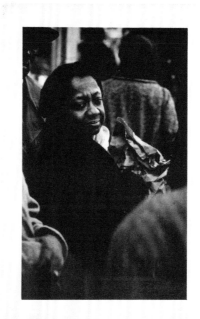

Top left: Fig. 2.5
Announcement for
Kamoinge Workshop's
1964 exhibition. *Photographs
& Prints Division, Schomburg
Center for Research in Black
Culture, The New York Public
Library*

Top right: Fig. 2.6
Announcement for
Kamoinge Gallery
exhibition *The Negro
Woman*, June 1965.
*VMFA, Margaret R. and Robert
M. Freeman Library, Archives,
Louis H. Draper Archives,
VA04.01.3.188*

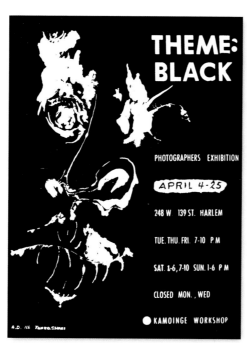

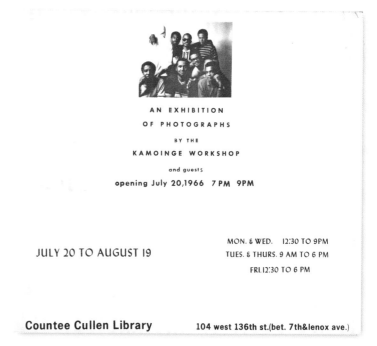

Fig. 2.7 Announcement
for *Theme Black* exhibition,
April 1965. *Courtesy of Shawn
Walker archive*

Fig. 2.8 Announcement for
Perspective exhibition at
Countee Cullen Library, 1966.
*VMFA, Margaret R. and Robert
M. Freeman Library, Archives,
VA04.01.2.004*

DeCarava's *Newsweek* assignment, his alternate experience in Mississippi, and the danger he endured to get there, informed Kamoinge's perspective on the civil rights movement when he returned in the fall of 1964.

Draper's meeting notes stop in late April 1964 and pick back up on April 4, 1965, with "First show opens."[61] While they had apparently rented Marketplace Gallery for a month in 1964, they had secured an ongoing lease by April 1965. The group recalls that they renamed it the Kamoinge Workshop Gallery, if only unofficially, while they rented it during this time.[62] At the same meeting they opened *Theme Black*, they were already making plans for a second exhibition, which they voted to title *The Negro Woman*. [figs. 2.6 & 2.7] It is not clear whether Draper had taken minutes in the intervening year and later lost them, or whether he only began taking minutes again from April through June of 1965 because it was an unusually productive period for Kamoinge, as had been March and April of 1964.

Leading figures within the international photography world took notice of their activities. On April 18 Cartier-Bresson visited *Theme Black*, signing his name and writing his Magnum Photo address on Draper's notebook page mixed with meeting minutes.[63] Draper later credited Langston Hughes for inviting Cartier-Bresson to the exhibition.[64] The two had been friends since they met in the midst of the Spanish Civil War. According to various Kamoinge members, Cartier-Bresson not only looked at their photographs and attended their meeting, but also stayed late into the night for hours of conversation.[65] Cartier-Bresson served on the advisory board of the art photography magazine *Camera*, which was based in Switzerland but published in multiple languages. He must have recommended that Romeo Martinez, who was *Camera*'s editor from 1956 to 1964, visit the exhibition because in a conversation that Eugene Smith taped at his loft on May 1, Martinez invited Smith to accompany him to Harlem the next night to see the group's work, explaining that he had already visited the gallery twice.[66] In the midst of the conversation, Smith describes Draper as "a personal friend who is a great photographer," but it is not clear that Smith ever visited the gallery.[67] On May 2, Draper noted that "Martinez will be here on May 9, 1965. He wants five photographs from each photographer. Contact each photographer about meeting." Although he was no longer editor, Martinez appears to have commissioned the members to produce a portfolio for the magazine that would appear in the July 1966 issue, albeit produced by a different editor.[68] [fig. 2.9]

On May 2 Draper also recorded that Beuford Smith attended his second meeting and would bring more photographs to the next meeting. Draper also recorded that Jimmie Mannas walked out of a meeting after a policy argument with Ray Francis, whom Draper recorded was serving as the current president.[69] On June 6 Beuford Smith is listed as a dues-paying member for the first time, which matches Smith's memory that he officially joined Kamoinge on the day DeCarava resigned.[70] As Draper matter-of-factly wrote down in the minutes, "Roy DeCarava has decided to resign as Director of Workshop. He will not be available anymore Sundays." Directly below, he also recorded: "Decision made by members present to disband the gallery. We will inform Mrs. Glasgow on the 15th of June."[71]

Beginning in 1972, Draper tended to frame these earlier decisions vaguely in terms of needing more space for growth. "After a while this space became confining as well as some of the workshop ideas." He further explained, "While there were exceptions to this, the workshop had become rather dogmatic in its outlook and showed a tendency to limited perspectives. … Many of the photographers had simply outgrown the workshop as it was originally constituted, so that for the next six years, it was to function on a much more multi-faceted level." Nearly forty years later, Ray Francis's descriptions of DeCarava's departure had a poetic quality: "We looked to him almost like a father figure. We put the mantle of Fathership on him, not him on us. At a certain point, what you had were like 12 spirits.… And you know they had to be free, they had to do their own thing."[72] Their need for artistic freedom did, it seem, also relate to the limitations of the gallery. As several members recall, Mrs. Glasgow reported that some of the residents who lived nearby objected to at least one of the nudes in *The Negro Woman* exhibition. Walker remembers that not all of the members agreed on the artistic merit of the photograph in question (which happened to be his), but they were unified in their resistance to censorship.[73]

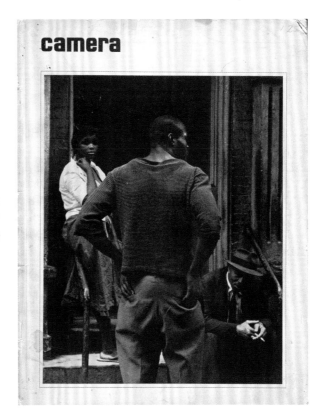

Fig. 2.9 *Camera,*
July 1966. *VMFA,*
Margaret R. and Robert M.
Freeman Library, Archives,
VA04.02.2.005

Fig 2.10 Announcement for the The Studio Museum of Harlem The Kamoinge Workshop exhibition, 1972, *VMFA, Margaret R. and Robert M. Freeman Library, Archives, VA04.01.3.191*

Fig. 2.11 Announcement for Kamoinge exhibition at the International Center for Photography, 1975, *VMFA, Arthur and Margaret Glasgow Endowment Fund. VMFA Archives, Richmond, Virginia, VA04.01.3. 205*

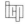

Whatever the specific reasons for DeCarava's departure and the closing of the gallery, it marked for Draper the end of the formative period in the collective's history and, in a 1982 interview with Carrie Mae Weems, he wanted to make sure a distinction was made between the early period of the group and its activities after 1965:

> The actual time with Kamoinge was the formative years: mid-1962 through 1965, during the period where we developed, formed a philosophy, and for a brief time operated a gallery where we showed our own work. I think we had three shows if I am not mistaken. That is a period where we functioned as a workshop, where we had regular meetings, where we collected dues, where we formulated manifestos, and the like. Then there is that other period, the byproduct of that, which is still ongoing and so I think when you talk about the Kamoinge Workshop you have to talk about it in two phases. You have to talk about the actual workshop, the functioning, the day-to-day operation and then you have to talk about the spirit that was generated by that formative period and that will continue with us. That is such an important part of our lives that there is no way of erasing that. Whatever we do, to some extent, reflects that. Many of us are certainly richer because of it. So I would like to make that distinction.

After 1965 the group met less frequently and Draper appears to have stopped taking minutes, suggesting that they returned to a less formal structure. Beuford Smith recalls that Draper served as president from this period until the 1990s, Walker remembers Draper as the "unspoken leader," and Barboza doesn't recall a formal leadership model at all from the late 1960s forward, although he does remember that they continued to hold votes on all major decisions.[74] These differing memories of how the collective operated during these years likely reflects that few of the founding members were interested in traditionally defined leadership roles imbued with power. Instead, as Randall summarized, Draper was consistently committed "to getting the group to move to its potential."[75] Each member contributed his own skill sets and resources, whether it was organizational ability, technical skills, or studio space.

Their get-togethers ebbed and flowed based on projects and exhibition opportunities. The group mounted an exhibition in 1966 at Countee Cullen Library, entitled *Perspective*, but didn't exhibit together again in New York until their show at the Studio Museum in Harlem in 1972, followed by an exhibition at the newly opened International Center for Photography (ICP) in 1975 curated by Cornell Capa. [figs. 2.8, 2.10 & 2.11]

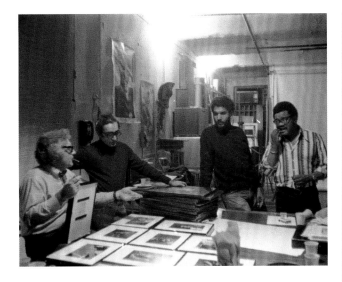

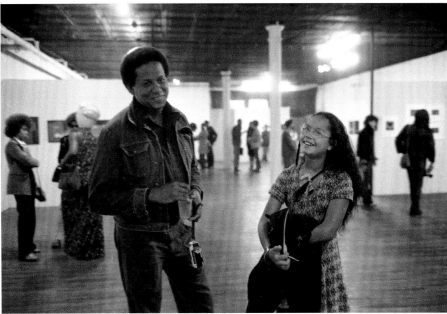

Before the Studio Museum of Harlem was founded, the Countee Cullen branch of the New York Public Library functioned as a key cultural center for artists in Harlem and one of the few places to exhibit art outside of smaller, privately operated galleries such as the Marketplace Gallery. Edward Spriggs began serving as the second director of the Studio Museum in Harlem a year after it opened in 1968. His vision for the institution was crucial to ensuring that it was accessible to the community and dedicated to showing the work of Black artists. It quickly became a dynamic place where artists coalesced. A filmmaker himself, Spriggs treated photography as a vital artistic medium and supported the formation of the Collective Black Photographers in 1971, a group of nearly fifty photographers who met at the Studio Museum and worked on projects that served the neighborhood.[76] Draper was chairman of the collective in 1972 as he worked with Spriggs on the arrangements for Kamoinge's exhibition at the Studio Museum. According to Draper's notes, Spriggs allowed Kamoinge full artistic control of the selection and installation of their work while the Studio Museum took care of the invitations, publicity, opening, and logistics. Titled *The Kamoinge Workshop*, the exhibition opened in October 1972. Each artist had ten photographs and twenty-six feet of wall space.[77] It was their largest exhibition to date. [fig. 2.13]

Cornell Capra opened the ICP in 1974 and invited the Kamoinge Workshop to have an exhibition during the institution's first year. [fig. 2.12] The fact that Kamoinge showed at the Studio Museum and the ICP not long after each institution's founding demonstrates how the group maintained a place at the forefront of two cultural shifts: the empowerment of Black artists in the midst of the Black Arts Movement and the increasing acceptance and appreciation of photography as a fine art. These two exhibitions, however, also mark the last time they exhibited together as the Kamoinge Workshop until the 1990s.

Barboza had been drafted into the navy at the end of 1964 and recalls that, when he returned from the service in 1968,

the group was not meeting regularly. He missed the community and support and convinced the group to resume regular meetings. As his own commercial studio practice took off quickly, he was able to rent larger spaces that became one of the group's gathering places. (See endpapers).

By the early 1970s, many of the members found studio spaces near one another on 38th Street near Sixth Avenue, a somewhat legendary block in the history of photography because it had been the location of Eugene Smith's studio from the late 1950s through the late

Left: Fig 2.12 Kamoinge Meeting with ICP Cornell Capa at Barboza's Studio, 1974. [Capa far left, Dawson and Francis far right] *Photos on this page by and courtesy of Anthony Barboza*

Right: Fig. 2.13 Kamoinge Workshop Exhibition at Studio Museum in Harlem, October 1, 1972. [Al and Miya Fennar]

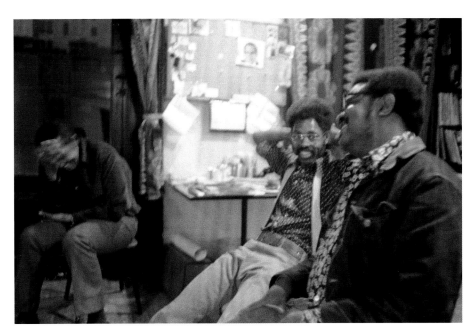

Fig. 2.14 Kamoinge Meeting, Beuford Smith's Apt. May, 1973, [L–R: Walker, Robinson, and Francis]

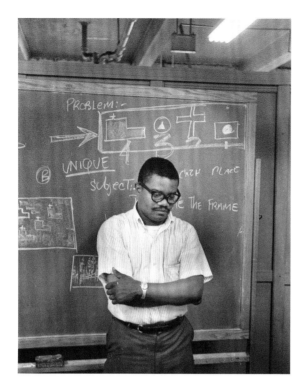

Fig. 2.15 Ray Francis teaching, ca. 1966–68, photo by Louis Draper. *VMFA, Margaret R. and Robert M. Freeman Library, Archives, VA04.03.1.075.P4*

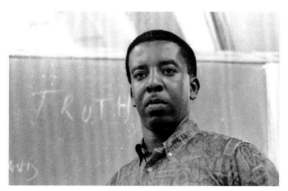

Fig. 2.16 Louis Draper (American, 1935–2002) at the Bedford-Stuyvesant Youth-In-Action, ca. 1966–68. *VMFA, Margaret R. and Robert M. Freeman Library, Archives, VA04.03.1.075.T1*

1960s and thus a gathering point for photographers and curators, as well as jazz musicians. Roy DeCarava took over Smith's loft in 1969, and when he moved to Brooklyn in 1972, he passed it on to Beuford Smith. [fig. 2.14] By 1975, Herb Robinson established his own commercial studio in a building nearby, sharing the same floor as Northlight Studios, a space shared by Ray Francis, Lou Draper, Herman Howard, Danny Dawson, and a mutual friend, Darryl Sevad. Shawn Walker had his studio across the street, and their spaces were so close that Walker's and Robinson's sons, who were close in age, could play together. By this time Fennar was working fulltime for NBC and didn't have a studio near the others; however, Robinson recalls that Fennar helped him build his darkroom.[78] They each developed their own expertise from lighting still lifes to fashion photography, and the close proximity allowed them to help one another if they encountered technical challenges. Between his various teaching jobs in the 1970s, Draper also worked as an assistant for both Robinson and Barboza. Yet, Robinson recalled that they maintained a crucial distinction between their "day jobs" and their fine art practices. Despite their shared daily lives and involvement

with one another's commercial careers, Kamoinge meetings remained a separate intellectual space where they only showed and discussed what they considered their fine art photographs.[79] It was during this period that many of the members began experimenting with increasingly abstract and poetic images of shadows and reflections, among other subjects.

Education and Mentorship

Aside from exhibitions and members' individual photography careers, "the spirit of Kamoinge," as Draper termed it, infused several different kinds of ambitious projects that smaller groups of members carried out from the late 1960s through the early 1980s. Perhaps the most consistently overlooked contribution that Kamoinge members made was their dedication to teaching and mentoring youth. In the press release for their 1972 exhibition at the Studio Museum in Harlem, the director, Edward Spriggs, stated, "It is not unusual that whenever we hear of a photographic or film project, involving the youth in Harlem, to find a Kamoinge member involved—their talents and commitments are so broad!"[80]

From 1966 through 1968, Jimmie Mannas, Ray Francis, Herb Randall, and Lou Draper all worked for the federally funded Neighborhood Youth Corps as part of the Bedford-Stuyvesant Youth in Action program training teenagers in all aspects of photography from using cameras and composing images to developing film and making prints in the dark room.

Draper's contact sheets contain images of him with Francis in front of chalkboards. In one frame a board is filled with technical information, but in another frame Draper stands next to the word "truth" scrawled in huge print.[81] [figs. 2.15 & 2.16] The image is remarkable for distilling a moment of transference. In 1964, the group had chosen to open its first portfolio with a statement: "The Kamoinge Workshop represents fifteen black photographers whose creative objectives reflect a concern for truth about the world, about the society and about themselves."[82] [cat. no. 2] Although "truth" is an abstract and universal word, Kamoinge's use of it becomes clearer and more specific in the context of their images: their portfolios of photographs were proof of their written thesis. In their classes, Francis and Draper (as well as Randall and Mannas) not only taught technical information but also conveyed Kamoinge's core philosophy that photographs had the capability to express "truth." Several decades later, while reflecting on the phrases "Black experience" and "Black aesthetic," Ray Francis explained, "I had no black aesthetic out in front of me. I had Roy. Roy taught us truth."[83] While the concept of a Black aesthetic and Kamoinge's photographic definition of truth are not interchangeable, the relationship between these terms is

terms is illustrated by Kamoinge's effort to equip a younger generation with the technical and philosophical knowledge to make their own representations of their communities.

Mixed into Draper's contact sheets are several frames of a protest in which people carry picket signs that read, "Community Control of Community Schools" and "New York City Board of Ed Mississippi Style."[84] Although Draper did not record which event he documented, the photographs were made at Intermediate School 201 building in East Harlem. The demonstrations in front of I.S. 201 related to the series of protests against New York City's segregated schools that began on February 3, 1964, with an estimated 450,000 students boycotting the public schools, while parents and teachers joined in peaceful demonstrations. The boycott was one of the largest civil rights protests during the era. And while it did not result in large-scale desegregation, it did inspire further protests and community efforts, especially in Harlem and Bedford-Stuyvesant, where parents demanded more control over hiring and curriculum development in local schools.[85] In 1969, likely as a result of what became known as the community control movement, the New York City Board of Education hired Ray Francis and assigned him to Intermediate School 201, which was a complex of five schools.

I.S. 201 became well known throughout the city because, as a *New York Times* article explained, in 1968 it was one of three "small decentralized demonstration districts set up to test limited community control of local schools."[86] According to the article, "a locally elected governing board was given limited jurisdiction" and their first act was to hire a young African American principal, Ronald Evans, who had grown up in Harlem. By 1970, as a direct result of Evans's efforts, 60 percent of the teachers were African American. Although it is not clear how Francis was hired, his assignment likely reflects Evans's ambitious vision for the school. Francis served as director of the Multi-Media Project, and worked with Draper, Randall, and Calvin Wilson. As part of a larger team, they combined photography and film to generate programming, which was broadcast to close-circuit televisions in all five schools as part of the larger effort to reshape the school's curriculum to reflect the students' community. In addition, they taught the students skills relevant to television production, still and motion photography, and darkroom procedures.[87]

While there are no available records of what this educational programming looked like beyond descriptions in a booklet for the program, it's clear that from 1970 to 1974, Draper, Francis, Randall, and Wilson had an audience of over 1,300 fifth to eighth grade students. [fig. 2.17] On the one hand, the photographs and films they made to support the middle school educational curriculum were most likely different from the fine art photographs the artists showed in their Kamoinge exhibitions. On the other hand, the I.S.

Fig. 2.17 Intermediate School 201 (New York, NY). Multi-Media Project, 1971, Pictured (top to bottom): Ray Francis, Herb Randall, Louis Draper.
Virginia Museum of Fine Arts, Rare Book Collection, Gift of Herbert Randall, 30804006614688.

201 project demonstrated their radical commitment to the community and reflected the artists' belief in the power of visual literacy to effect change, which was directly connected to Kamoinge's original mission.

Film School & Global Perspectives

In the late 1960s, several Kamoinge members expanded their artistic reach by adding film to their repertoire. While Kamoinge members appreciated foreign films and discussed them frequently at meetings, Walker was the first member to study film, followed soon after by Mannas and Draper, who met Danny Dawson at New York University's film school.

Walker recalls attending an underground, avant-garde film screening in 1967 where he found experimental films by Andy Warhol, Jonas Mekas, and D.J. Pennebaker frivolous.[88] He left determined to do better. He began taking film courses at the Free University, an experimental leftist school that operated from 1965 to 1968. Filmmaker Alan Siegel had just begun teaching a film workshop in the fall of 1967 and valued Walker's perspective as one of the only African American students in the class. Several members of the workshop, including Walker, traveled to Washington, DC, to film the March on the Pentagon in October 1967. When they realized how their footage of soldiers hitting student protesters with batons differed from what the national television programs

Fig 2.18 *Lou Draper in Senegal*, 1978, printed 2019 (Anthony Barboza, American, born 1944), gelatin silver print. *Virginia Museum of Fine Arts, Arthur and Margaret Glasgow Endowment, 2019.9*

aired, they organized a meeting in December 1967 to pool their footage and produce a documentary about what they had witnessed. Released in 1968, it was titled *No Game*. From this collective effort, the Newsreel, later known as the Third World Newsreel, emerged as a key countercultural organization that relied on filmmakers who were committed to covering what the mainstream media did not.[89] Walker became good friends with Siegel and went on to cover local events for the Newsreel including *I.S. 201 and Report from Newark* (Newsreel #10) and *Community Control* (Newsreel #24). Siegel also made sure Walker traveled with the organization to Cuba in 1968, when the Newsreel crew went to the Isle of Pines (now Isla de la Juventud), to film the planned transformation of the Presidio Modelo, a notorious prison, into a school for a documentary titled *Isle of Youth*.[90] [cat. nos. 88 & 89] When Walker returned to the United States three months later, he found he had been listed as a radical by the U.S. government and could not find work. Before leaving, he had been traveling as a cameraman through the southern United States with WNET's *Black Journal*, but the job was no longer available when he came back.[91] Nevertheless, Walker exhibited the photographs from Cuba when he participated in Kamoinge exhibitions; although he recalls that when a shipment of Kamoinge photographs returned from the group show at Notre Dame University in 1969, only his Cuban photographs were missing.

In 1968, *Esquire* sent Cowans to Brazil to do an essay on revolutionary underground filmmakers. Although the assignment ultimately fell through, he stayed in Brazil for several weeks and took an interest in the mix of African and Portuguese cultural influences. The following year, Cowans traveled to Suriname where he lived among the Ndyuka people for several months. Descendants of enslaved Africans brought to Dutch colonial territories in the seventeenth century, the Ndyuka formed communities along the Tapanahony River after escaping into the rainforests. By the time Cowans had arrived, they had maintained their independence in isolation for several hundred years. Although it was not published at the time, he returned home with a large body of work.[92] [cat. no. 91]

Through a contact at Bedford Stuyvesant's Youth in Action program, Mannas had learned about scholarships to New York University's new Institute for Film and Television. After Mannas joined the program, he encouraged Draper to apply.[93] Although Draper did not go on to become a filmmaker, he did begin writing screenplays at NYU, though he never produced or published them.[94] Draper met Dawson in NYU's program and invited him to join Kamoinge.[95] The program offered a history of photography course taught by MoMA curators John Szarkowski and Peter Bunnell.[96] Draper also took a film

Szarkowski and Peter Bunnell.[96] Draper also took a film still class with Paul Caponigro.[97]

Mannas's film career took him to Guyana in 1971, where he worked with the Ministry of Information as both a photographer and filmmaker until 1976. Guyana had gained its independence from Britain in 1966 and, under Forbes Burnham's Afro-Guyanese leadership of the People's National Congress (PNC), the country became a republic in 1970. Together with Hamley Case and Brian Stuart-Young, Mannas wrote and filmed *Aggro-Seizeman*, Guyana's first film consisting of an all-Guyanese cast that was released in 1975.[98] Walker, Howard, and Dawson visited Mannas in Guyana and assisted him on films. At some point Mannas also held a Kamoinge exhibition in Guyana, which was likely related to his activities teaching photography and film for the Ministry of Information, as well as helping to build darkrooms, all while making his own significant body of photographs of Guyanese subjects.[99] [cat. nos. 27, 93 & 94] Meanwhile, Herb Robinson, who had been born in Jamaica, returned to Kingston for his first time as both an adult and a photographer in 1973, making a series of images there. [cat. no. 90]

In 1972, Barboza's career as a fashion photographer led him to go on international trips. *Tuesday* magazine sent him to Mexico and then to Senegal, where he traveled with Ming Smith, who was the model for the assignment. They both found time to take photographs in Dakar and Goree Island, making images that were featured that year in the Studio Museum in Harlem's exhibition of Kamoinge's work.[100] [cat. nos. 97 & 98] Inspired by their first trip, they returned to Africa in 1973 visiting Egypt and Ethiopia. In 1978, Barboza hired Draper as his assistant for an *Essence* magazine assignment in Senegal. [fig 2.18] Draper made several images of children there that he exhibited as an integral part of his body of work for the rest of his career. [cat. nos. 99 & 100] Barboza also passed along another assignment in Senegal to Walker so that he could travel to Africa for the first time.[101]

Although Draper's trip to Africa came fifteen years after Kamoinge chose to name itself with a word from the Gikuyu people of Kenya, his visit, along with the travel of other Kamoinge members, reinforced the group's global perspectives.

Legacy with Younger Photographers: *The Black Photographers Annual* and the International Black Photographers

These international perspectives registered in two different platforms that Kamoinge members established in the 1970s: Beuford Smith founded the *Black Photographers Annual* in 1973, which published photographs of all kinds of subjects, including images of artists' global travels; and after Jimmie Mannas's return from Guyana, several Kamoinge

members started the International Black Photographers late in 1978. Neither endeavor was officially a part of the workshop's activities, yet each grew out of Kamoinge's initial ambitions to serve and support Black artists, and both had a nucleus of Kamoinge members at its core.

From at least 1965, when Kamoinge began corresponding with *Aperture* publisher Michael Hoffman, until 1972, when Draper wrote a prospectus for a Kamoinge publication, the group had discussed producing a book-length project.[102] Funding, however, never materialized, and the group had yet to realize their goal when, in 1973, Beuford Smith met Joe Crawford. [103]

As Bill Gaskins discusses at length in his essay, the *Annual* was an immediate success. The four volumes published over the next seven years came to symbolize more than "the most beautiful black book ever produced" as one of its advertisements claimed. Many younger artists, such as Jules Allen (a current Kamoinge member), thought of the *Annual* as the realization of a community in book form.[104] He recalls moving from San Francisco to New York seeking the kinds of artistic relationships represented in the *Annual*'s pages. As the *Annual* circulated among young photographers, artists beyond Allen, such as Marilyn Nance and Dawoud Bey, sought out the community that Kamoinge had engendered. Nance took classes taught by Beuford Smith,[105] and Dawoud Bey remembers Draper meeting with him in diners and at his studio to look at and talk about his work.[106] Allen, Nance, and Bey all appeared in the fourth volume of the *Annual* in 1980, among many other younger photographers.

In the *Annual*'s second volume, the editors expanded their focus beyond just contemporary photographers and introduced another layer to the publication's mission: recovering and preserving the work of earlier generations of Black photographers. Accompanying a portfolio of the Alabama photographer P. H. Polk's work from the 1930s, Joe Crawford announced this commitment in his introduction to an interview with the artist:

> In the area of photography, as in most areas, the early contributions of Afro-Americans have somehow been overlooked by the *historians*. The results of the exclusion in the arts is clear: the Black community has been forced to be content with a view of itself presented them by others. The Black community has been robbed of the opportunity to see itself through the eyes of its own artists. The situation is unlikely to improve unless Blacks take it upon themselves to search out and publicize the works of the Black artist.[107]

Volumes 3 and 4, which continued to publish the work of younger photographers, also featured portfolios of historic

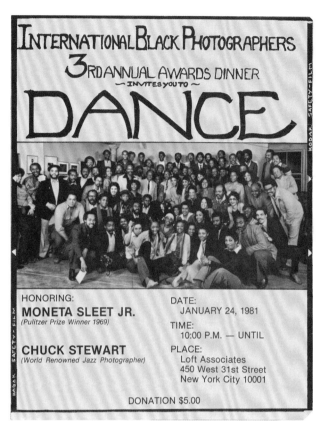

Fig 2.19
Announcement for
the International
Black Photographers
Third Annual Awards
Dinner Dance, 1981,
VMFA, Margaret R. and
Robert M. Freeman
Library, Archives, Louis
H. Draper Archives,
VA04.01.3.232

Fig 2.20 International
Black Photographers
newsletter, winter 1981,
VMFA, Margaret R. and
Robert M. Freeman Library,
Archives, VA04.01.3.229

figures such as James VanDerZee, Addison Scurlock, and
Hamilton Smith, among luminaries such as Gordon Parks,
Moneta Sleet, and Roy DeCarava.

Following the success of the *Annual*'s first three volumes,
several members of the Kamoinge Workshop, including
Jimmie Mannas, Beuford Smith, and Shawn Walker, joined
with other photographers in the community to throw a
dinner honoring two of these elder photographers: James
VanDerZee and Roy DeCarava.[108] The organizers named them-
selves the International Black Photographers (IBP). Eighty
photographers attended the inaugural dinner in 1979, with each
attendee presenting two photographs in a related exhibition.[109]
[cat. no. 4] Over the next four years, these dinners became
an annual event, offering tributes to "outstanding elders of
Black photography" including P.H. Polk, Gordon Parks, Chuck
Stewart, Moneta Sleet Jr., Morgan and Marvin Smith, and
Richard Saunders. [fig. 2.19] Barboza's portraits of these
huge, multigenerational gatherings illustrate how crucial this
photography community was in both honoring the work of
elders and encouraging the next generation. [cat. nos. 5, 6 & 7]

After the dinners in 1979 and 1980, IBP began publishing
what they intended to be a quarterly newsletter in the win-
ter of 1981. [fig. 2.20] It started with an explanation of the
group's genesis written by Cheryll Greene, who was the ex-
ecutive editor of *Essence* magazine. Her column marks the
first history of Kamoinge written by someone outside of the
group, and she directly linked IBP's formation to Kamoinge's
beginning in 1963: "International Black Photographers is a
new organization, but it grows out of one founded 17 years
ago."[110]

Thus, just as Kamoinge began IBP in an effort to honor the
photographers that came before them and preserve their
histories, the first newsletter of IBP framed Kamoinge as a
significant contributor to the culture of the two previous
decades, suggesting that Kamoinge was itself shifting into
a historical position. Greene ends the article with a quote
citing Jimmie Mannas's ambitious vision for IBP's future,
which was in many ways a reiteration of Kamoinge's earli-
est goals but on a much broader, international scale:

> We want to continue to honor our outstanding
> photographers, and there will be a third tribute
> dinner in January. But now we must build a
> membership organization so that we can provide a
> communication channel, through this newsletter,
> and a way for our work to be shown, through a
> gallery, and a way for our work to be preserved,
> through an archive, and so that we can also be
> an advocacy group for Black photographers.
> And, we're interested in communicating with
> photographers all over the Third World.[111]

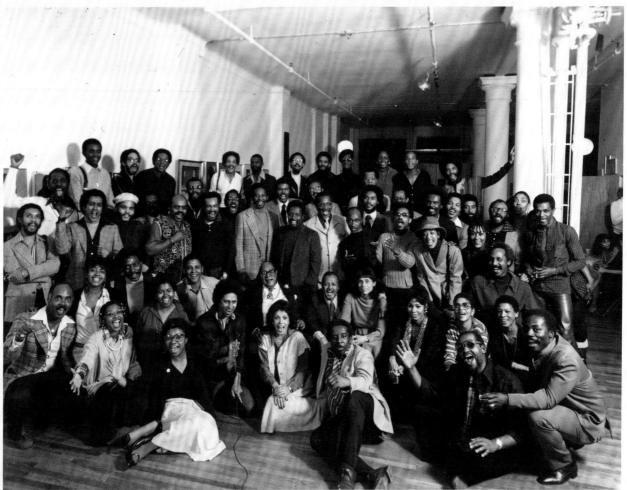

1st annual Black Photog. Dinner Honoring Roy De Carava & James VanDerZee 1979 NYC *A. Barboza*

4 Anthony Barboza (American, born 1944),
1st Annual Black Photographers Dinner
Honoring Roy DeCarava and James VanDerZee, NYC, 1979,
gelatin silver print. *Virginia Museum of Fine Arts,* Arthur and Margaret
Glasgow Endowment, 2017.38 © Anthony Barboza

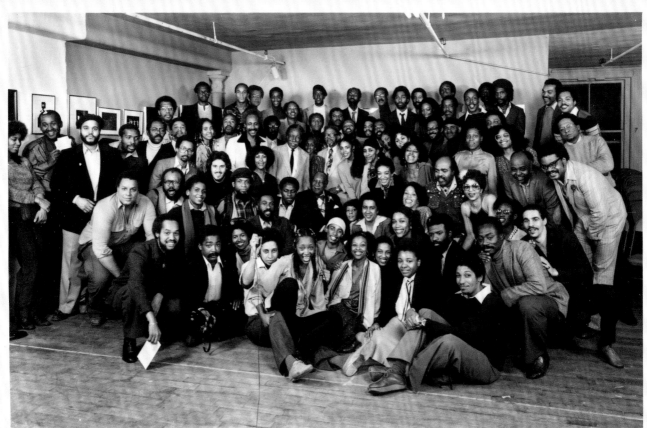

2nd Annual Black Photog. Dinner Honoring Gordon Parks & P. H. Polk. #2 1980 N.Y.C. A. Barboza

5 Anthony Barboza (American, born 1944),
**2nd Annual Black Photographers Dinner honoring
Gordon Parks and P. H. Polk,** 1980, gelatin silver print.
Virginia Museum of Fine Arts, Arthur and Margaret Glasgow Endowment,
2017.39 © Anthony Barboza

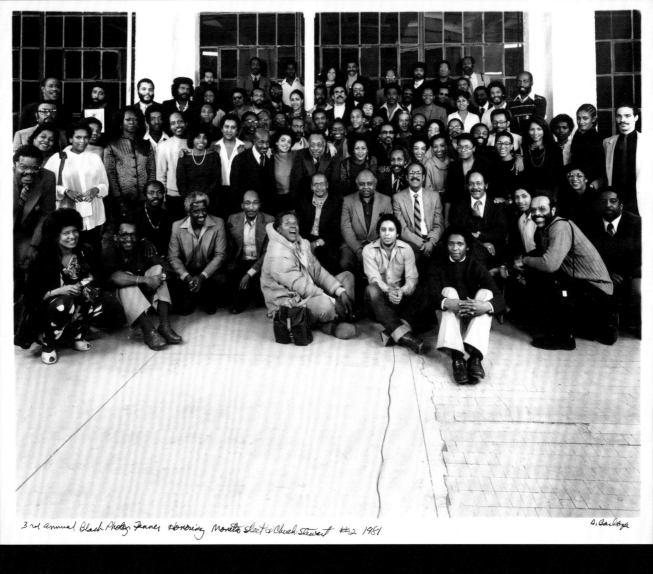

3rd annual Black Photog. Dinner Honoring Moneta Sleet & Chuck Stewart #2 1981

A. Barboza

6 Anthony Barboza (American, born 1944),
3rd Annual Black Photographers Dinner Honoring Moneta Sleet and Chuck Stewart #2, 1981, gelatin silver print. *Virginia Museum of Fine Arts,* Arthur and Margaret Glasgow Endowment, 2017.40

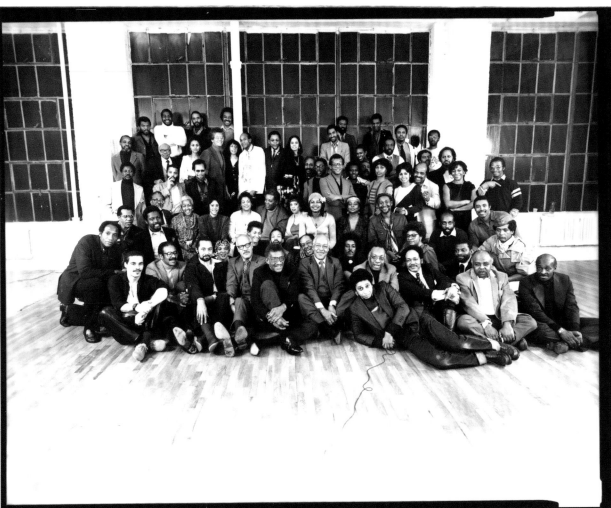

4th Annual Black Photog. Dinner Honoring Smith Bros. & Richard Saunders #1 1982

A. Barboza

Despite the incredible success of IBP's dinners for several years in the early 1980s, the organization's broader ambitions proved unsustainable. Only two issues of the newsletter were ultimately produced and the archive never came to fruition. Yet, the newsletter's emphasis on reconstructing and preserving a history of Black photography through a central archive underlines the efforts during this period to build a cohesive narrative of African American photography.

When IBP honored Morgan and Marvin Smith in 1982, Draper recorded and transcribed a long and thorough interview with the twin brothers about their studio practice and experiences in Harlem since the 1930s.[112] In the early 1970s, Barboza, encouraged by Draper's early advice that he should learn the history of African American photography, had begun to collect the work of late-nineteenth century through early twentieth century photographers such as J.P. Ball in Cincinnati. Several Kamoinge members volunteered with the James VanDerZee Institute; and Beuford Smith, through his work editing the *Annual,* helped P. H. Polk preserve his photography by working with him to make prints from his negatives.[113]

In 1978, Carrie Mae Weems sought out the artists who had produced the *Annual.*[114] As she later explained in an interview with Adger Cowans:

> Well for me, as a young artist, discovering the Kamoinge Workshop was very significant. It was a very important group for me and I very carefully studied everybody's work, and then I wrote letters to a lot of the men who were in the group. That's how I also became aware of Ming Smith's work; she was one of the few women in Kamoinge at that time.[115]

She began a film project interviewing Black artists from P. H. Polk to Roy DeCarava in 1982. In the midst of this larger project, she recorded a group interview with Louis Draper, Tony Barboza, Ray Francis, Shawn Walker, and Beuford Smith about Kamoinge's history. Although only part of the early VHS footage remains, it serves as the first recorded oral history of Kamoinge. Weems used the interview as the research basis for a conversation published that year in the California-based photography publication *Obscura,* "Personal Perspectives on the Evolution of American Black Photography: A Talk with Carrie Mae Weems." Weems took Kamoinge's cultural significance a step further than Cheryll Greene's description published the year before by specifying why they were important. Weems stated:

> It is crucial to note that particularly during the first three years, Kamoinge saw itself as an extension of the black community. To this degree much of the work from this period is documentary in form, reflecting a social and political consciousness. The Kamoinge Workshop also signified the first steps taken by black photographers to come together and form a comprehensive group that would address in photographic terms the description of being black in America.[116]

Although Weems first describes their work as primarily "documentary in form," she is careful to acknowledge the group's inclusion of differing aesthetic approaches later in the interview:

> Even though many members of the Kamoinge Workshop were socially aware and deeply concerned with documenting the black experience they all produced a variety of types of works, including abstractions. Actually, there was always a battle going on in the group regarding which road to take realism or abstraction.

Weems's version of Kamoinge's history distills a critical moment in the group's reception because it illustrates the way in which she translated her understanding of the collective into something of "a useable past," not only for her own photographic practice, but also for the next generation of Black photographers.[117] It was also during this period that Deborah Willis began her heroic scholarly efforts to write a comprehensive history of African American photography. To Weems and Willis, and a host of other artists and scholars who came of age in the 1970s, Kamoinge's cultural importance remains self-evident. Yet their work is only now beginning to gain wider recognition.

Endnotes

1 This quote is taken from a handwritten page (VA04.01.3.018) among the papers of the Louis H. Draper Artist Archives, acquired from the Louis H. Draper Preservation Trust with the Arthur and Margaret Glasgow Endowment Fund, Virginia Museum of Fine Arts Archives, Richmond, hereafter cited as LHDAA.

2 Audio recording, October 1984. Thank you to Shawn Walker for sharing this audio tape from his archive. Although the Kamoinge Workshop organized few exhibitions in the 1980s, this tape illustrates that they continued to meet and think about how they would frame the group for potential exhibition venues.

3 For example, everyone remembered that they had three exhibitions in the Kamoinge Gallery that they ran, but no one remembered the first one, which was in April 1964 and can be documented in the Schomberg archives by an exhibition announcement [fig. 2.5], as well as meeting minutes recently donated to VMFA's archives by Beuford Smith. Also, no one could remember the exact date of the group's first joint meeting, and no documentation of the group's first several meetings have surfaced to date.

4 The early meeting minutes in Draper's archives are not complete, perhaps because the role of secretary rotated or simply because some of the minutes were lost.

5 Audio recording, October 1984, courtesy Shawn Walker Archives. Later in the same conversation, they also praised Ray Francis for his recall and described Draper and Francis together as Griots. It is apparent from listening to several different recorded oral histories that Francis readily gave descriptive and poetic yet accurate oral histories of the group. Francis, however, does not seem to have committed these memories to paper. By contrast, Draper wrote extensively on behalf of the group.

6 Simon was a writer and photographer who contributed to leftist publications during the late 1950s and 1960s, including *The Worker, The New Horizons for Youth, Umbra,* and *American Dialog.* See David Grundy, *A Black Arts Poetry Machine: Amiri Baraka and the Umbra Poets* (London: Bloomsbury Academic, 2019), and Bill Mullen and James Edward Smethurst, *Left of the Color Line: Race, Radicalism, and Twentieth-Century Literature of the United States* (Chapel Hill & London: University of North Carolina Press, 2003).

7 Herb Randall, phone conversation with author, January 21, 2019.

8 Al Fennar, interview with Erina Duganne, March 22, 2001.

9 Although Draper's various histories don't record Shawn Walker at these first meetings, Herb Randall clearly recalls Walker joining their smaller informal get-togethers and Walker remembers being there when the group was named. Shawn Walker, "Preserving our History: The Kamoinge Workshop and Beyond," *Ten-8 Photographic Magazine* (1987), 21. Herb Randall, phone conversation with the author, January 21, 2019. Shawn Walker, interview with the author, June 7, 2017.

10 Jimmie Mannas, interview with the author, June 28, 2018. Herbert Randall, phone conversation with the author, January 21, 2019. Carrie Mae Weeks, "Personal Perspectives on the Evolution of American Black Photography: A Talk with Carrie Weems," *Obscura* 2, 1982.

11 Ray Francis biography page, LHDAA, VA04.01.3.150.

12 Ray Francis, interview with Erina Duganne, March 29, 2001.

13 Francis biography page, LHDAA, VA04.01.3.150.

14 Adger Cowans, email with author, October 4, 2019

15 Anthony Barboza, Louis Draper, Ray Francis, and Shawn Walker, interview with Carrie Mae Weems, 1982; see also Ray Francis, interview with Alex Harsley, undated, uploaded January 18, 2013, accessed June 21, 2019, https://www.youtube.com/watch?v=ELtfNHOj524.

16 LHDAA, VA04.01.3.018E.

17 Louis Draper and Anthony Barboza, "Kamoinge: the Members, the Cohesion, and Evolution of the Group," *Proceedings, American Photography Institute National Graduate Seminar,* ed. Cheryl Younger, Photography Department, Tisch School of the Arts, New York University (New York: The Institute, 1995), 114; LHDAA,

VA04.01.3.003; "KW 1 10-20-84-B," audio recording, courtesy Shawn Walker Archives..

18 Adger Cowans, interview with the author, April 3, 2018; Anthony Barboza, interview with the author, April 5, 2018.

19 Mannas specifically recalled that Roy DeCarava joined the group after five or six meetings from their initial meeting; see "Kamoinge Work Shop," audio recording, 1982, and "Kamoinge Work Shop 1 10-20-84," audio recording, 1984, courtesy Shawn Walker Archives, and Ray Francis, interview with Erina Duganne, March 29, 2001.

20 Lisa S. Remer, "Lou Draper Remembers Langston Hughes," *College Voice,* Mercer Community College, November 21, 1985, 2; Francis, interview with Erina Duganne; Walker, "Preserving our History," 24.

21 Peter Galassi, introduction to *Roy DeCarava: A Retrospective* (New York: Museum of Modern Art, 1996), 19.

22 Handwritten history of Kamoinge, LHDAA, VA04.01.3.016, 8.

23 Handwritten page, LHDAA, VA04.01.3.018.

24 Handwritten history of Kamoinge, LHDAA, VA04.01.3.016, 1.

25 Handwritten page, LHDAA, VA04.01.3.018.

26 Handwritten history of Kamoinge, LHDAA, VA04.01.3.016, 2.

27 Handwritten history of Kamoinge, LHDAA, VA04.01.3.013, 2.

28 According to ASMP minutes, Chris Corpus was Chairman of the Equal Rights Committee; see Charles E. Rotkin, ed., "The Negro Revolution: Minutes of the American Society of Magazine Photographers, held January 29, 1964 in New York City," *American Society of Magazine Photographers Bulletin* (January–February 1964).

29 "The Role of the Photographer in Civil Rights: Minutes of the Membership Meeting of the American Society of Magazine Photographers, held September 24, 1963 in New York City," Edward Steichen Archive, IX. B. 22, Museum of Modern Art Archives, New York.

30 Ibid.

31 Bert Miles stated, "This meeting is a milestone in the history of our industry. I would like to thank ASMP and especially the Civil Rights Committee, which picked up the interest sparked by Roy DeCarava; see Rotkin, "The Negro Revolution."

32 American Society of Magazine Photographers, "The Negro Revolution," Press Release, Edward Steichen Archives, IX.B.22, Museum of Modern Art Archives, New York.

33 Email correspondence with ASMP Executive Director Thomas R. Kennedy, September 3, 2018.

34 Rotkin, "The Negro Revolution."

35 Ibid.

36 Louis Draper, handwritten draft of history, ca 1998, LHDAA, VA04.01.3.018D.

37 Rotkin, "The Negro Revolution."

38 Ibid.

39 Ibid.

40 Gordon Parks, "What Their Cry Means to Me—A Negro's Own Evaluation," *Life,* May 31, 1963, 31.

41 Twenty years later, in a conversation about Kamoinge's history recorded in 1984, Walker still recalled Gordon Parks's presence at the meeting and was able to paraphrase DeCarava's quote almost verbatim—substituting "mediocre" for "lousy"—when remembering that one of the white photographers blamed the lack of jobs for African American photographers on "mediocrity." As he described, "And Roy's comment to that was, 'Why don't you give some mediocre black cats jobs like you give some mediocre white cats jobs.' I never forgot that statement. That sort of crushed that whole thing … Roy pointed out, 'You guys have a lot of mediocre white guys that are making a dollar too.' You can't get around that fact"; see "Kamoinge Workshop 1 10-20-84," audio recording, courtesy Shawn Walker Archives.

42 LHDAA, VA04.01.3.016.

43 Elton C. Fax, "Roy DeCarava" *Seventeen Black Artists* (New York: Dodd, Mead & Company, 1971), 183. Galassi, introduction to *Roy DeCarava,* 32.

44 "Kamoinge Workshop 1 10-20-84 A," audio recording, courtesy Shawn Walker Archives.

45 Walker, "Preserving our History," 24.

46 Kamoinge notebook, gift of Beuford Smith, SC32.01.0.001.

47 Kamoinge meeting minutes, LHDAA, VA04.01.3.036.

48 Since Kamoinge rented the gallery only for the month of the exhibition, as opposed to several months as they had in 1965, and because they did not title it anything other than the Kamoinge Workshop, Draper and the group often forgot about this exhibition in their later chronologies and histories and mistakenly recorded *Theme Black* as their first exhibition.

49 See handwritten note on exhibition flier, Box 1, Kamoinge Workshop Portfolios 1 and 2, Photography and Prints Division, Schomburg Center for Research in Black Culture, New York Public Library [fig. 2.5].

50 Dated receipt, curatorial file for Kamoinge Portfolio I, Drawings and Prints Study Center, Museum of Modern Art, New York.

51 George B. Murphy (1906–1986), letter to Ramona Lowe, February 3, 1960, W.E.B. Du Bois Papers (MS 312), Special Collections and University Archives, University of Massachusetts Amherst Libraries, mums312-b151-i300.

52 Mercer County Community College, "Lou Draper Remembers Langston Hughes," news release, November 11, 1985, LHDAA, VA04.01.1.128, 1. Draper recalls living in the building when he photographed Margaret Danner for a Motown album cover in 1963. Suzanne E. Smith, *Dancing in the Street: Motown and the Cultural Politics of Detroit* (Cambridge: Harvard University Press, 2009), 108, 281; Wendy S. Walters, "Blackness in the Present Future Tense: Broadside Press, Motown Records, and Detroit Techno," in *New Thoughts on the Black Arts Movement,* ed. Lisa Gail Collins and Margo Natalie Crawford (New Brunswick, NJ: Rutgers University Press, 2006), 123.

53 Contact sheet, LHDAA, VA04.03.1.102.T1. This contact sheet shows photographs used to make a composite image for Hughes's Christmas card. See also, "Langston Hughes—Christmas Greeting," 1965, Folder 10993, Box 454, Langston Hughes Papers, Beinecke Rare Book and Manuscript Library, https://brb-dl.library.yale.edu/.

54 Although not directly related to Kamoinge, the jazz musician Randy Weston recalls that Hughes and Glasgow played a similar role in the early 1960s for a group of musicians that also met regularly The Market Place Gallery; see Randy Weston and Willard Jenkins, *African Rhythms: The Autobiography of Randy Weston* (Durham, NC: Duke University Press, 2010), 84–91.

55 "Kamoinge Workshop," audio recording, ca. 1982, courtesy Shawn Walker Archives; see also Anthony Barboza and Herb Robinson, eds., "Kamoinge: A History," in *Timeless* (Atglen, PA: Schiffer Publishing, 2015), 75.

56 Barboza and Draper, "Kamoinge: the Members, the Cohesion, and Evolution of the Group," 114–15.

57 Audio recording labeled, "Kamoinge Workshop 1 10-20-84," courtesy of Shawn Walker Archives.

58 LHDAA, VA04.01.3.018D, Draper, 2–3.

59 For more about the lack of civil rights photographs published at the time that depict the dignity and agency of African American subjects, see Martin A. Berger, *Seeing Through Race: A Reinterpretation of Civil Rights Photography* (Berkeley: University of California Press, 2011).

60 See Herbert Randall and Bob M. Tusa, *Faces of Freedom Summer* (Tuscaloosa and London: University of Alabama Press, 2001).

61 Kamoinge meeting minutes, April 4, 1965, LHDAA, VA04.01.3.037.

62 "Kamoinge Workshop 1 10-20-84," audio recording, courtesy Shawn Walker Archives.

63 Notebook page, LHDAA, VA04.01.3.038. In addition, next to the box drawn around Cartier-Bresson's name and address, Draper apparently went back to write "Visited Gallery, Talked, Listened."

64 Remer, "Lou Draper Remembers Langston Hughes," 2.

65 Barboza and Robinson, "Kamoinge: A History," in *Timeless*, 75.

66 Martinez commented to Smith that the artists were opening a small show on *The Negro Woman*, which did not actually open until June 6, so it is possible that he misunderstand the opening date or that he was specifically going to review the works that would be in the show the next month; see discs RL10012-CD-1663 and RL10012-CD-1664, W. Eugene Smith Reference CD Collection, David M. Rubenstein Rare Book & Manuscript Library, Duke University.

67 Ibid.

68 Remer, "Lou Draper Remembers Langston Hughes,"2. Unfortunately, Martinez was not the editor who oversaw the framing and layout of the issue when it was published in July of 1966, and the next editor, Allan Porter, made choices that were a later source of much consternation for Kamoinge; see Erina Duganne's extensive discussion of this topic in her chapter "Beyond the Negro Point of View," The Kamoinge Workshop's 'Harlem' Portfolio" in *The Self in Black and White: Race and Subjectivity in Postwar American Photography* (Hanover, NH: Dartmouth College Press, 2010).

69 Photocopy of notebook page, LHDAA, VA04.01.3.039.

70 Beuford Smith, interview with the author, June 7, 2017.

71 Kamoinge meeting minutes, June 6, 1965, LHDAA, VA04.01.3.041. Despite Draper's meeting minutes, it is not clear when the members actually closed the gallery. In at least one history written in 1972, Draper recalled that it closed "due to a shortage of space" in the spring of 1966, but most members remember that it closed directly following *The Negro Woman* exhibition.

72 Francis, interview with Erina Duganne.

73 Fennar, interview with Erina Duganne; Walker, interview with the author.

74 Beuford Smith, interview, June 7, 2017, and phone conversation, May 2, 2019, with the author; Walker, phone conversation with the author, May 2, 2019; Anthony Barboza, phone conversation with the author, May 2, 2019.

75 "Collective Black Photographers," *Inside Out: The Place to Look for the Places to Go* 1, no. 6 (April 17-30, 1972), LHDAA, VA04.01.1.212.

76 Notes about Studio Museum Exhibition, April 1972, Beuford Smith Collection (SC-32), Gift of Beuford Smith, VMFA Archives, Richmond, Virginia, SC32.01.0.004; Notes about Studio Museum Exhibition, September 1972, Beuford Smith Collection (SC-32). Gift of Beuford Smith. VMFA Archives, Richmond, Virginia, SC32.01.0.005.

77 Randall, phone conversation with the author.

78 Herbert Robinson, phone conversation with the author, May 30, 2019.

79 Ibid.

80 Studio Museum in Harlem, "160 Photographs by Kamoinge Workshop at Studio Museum," press release (1972), Courtesy of the Archives of the Studio Museum in Harlem.

81 Negative sheet, LHDAA, VA04.03.1.075.T1.

82 Kamoinge Workshop Portfolio No. 1, LHDAA, VA04.07.2.001.

83 Francis, interview with Erina Duganne. Shawn Walker put it in similar terms, stating, "Roy was one of the first senior photographers I met who photographed Black people as a conscious effort and a lifelong work. For us his work symbolized the Black aesthetic"; see "Preserving our History," 24.

84 Negative sheet, LHDAA, VA04.09.006.T1.

85 Daniel Perlstein, "Community Control of Schools," *Encyclopedia of African American Education, Volume 1*, ed. Kofi Lomotey (Los Angeles: Sage, 2010), 180–82. For further reading, see Daniel Perlstein, *Justice, Justice: School Politics and the Eclipse of Liberalism* (New York: Peter Lang Publishing, 2004).

86 "At I.S. 201, 'We've Turned the Corner," *New York Times*, July 1, 1970:47.

87 See *Intermediate School 201 Arthur A. Schomburg Complex, Community Education Center* (New York: IS 201, 1971), Gift of Herbert Randall. Margaret R. and Robert M. Freeman Library, Virginia Museum of Fine Arts.

88 Walker, interview with the author, June 7, 2017.

89 Cynthia A. Young, *Soul Power: Culture, Radicalism, and the Making of a U.S. Third World Left* (Durham, NC: Duke University Press, 2006), 104–5; Toru Umezaki, *The Free University of New York: The New Left's Self-Education and Transborder Activism* (New York: Columbia University Press, 2013), 206.

90 Thank you to Alan Siegel, JT Takagi, Rosely Torres, and Livia Camperi of Third World Newsreel for letting me know about additional TWN films with Shawn Walker's name in the credit line, including *Resist with Noam Chomsky* (Newsreel #1), *Garbage* (Newsreel #5), and *Columbia Revolt* (Newsreel #14). In addition, I am grateful for their willingness to facilitate the digitization of *Isle of Youth*.

91 Walker, interview with the author, June 7, 2017.

92 Adger Cowans, *Art in the Moment: Life and Times of Adger Cowans* (Beverly Hills: Noah's Ark Publishing Service, 2018), 44–52.

93 Mannas, interview with the author, June 28, 2018.

94 The Louis H. Draper Artist Archives contain two full manuscripts, "Marisol" (a science fiction screenplay for television) and "Curfew" (a fiction screenplay about civil unrest following the murder of a black teenager by police).

95 Negative, Danny Dawson and Paul Caponigro class, LHDAA, VA04.04.09.150.T1.

96 Contact sheet, LHDAA, VA04.04.09.153.C1.

97 Contact sheet, LHDAA, VA04.04.09.149.C2.

98 "Filmmaking in Guyana," *Black Creation Annual 1974–75*, 17.

99 See Jimmie Mannas and Terence Roberts, *Guyana … Back Then* (New York: New Image Media, 2016).

100 Anthony Barboza, oral history interview, November 18–19, 2009, Archives of American Art, Smithsonian Institution, Washington, DC, November 18–19, 2009.

101 Walker, phone conversation with the author, 2019.

102 The group corresponded with Michael Hoffman, *Aperture*'s publisher, who had recently taken over much of the day-to-day responsibilities from Minor White in December of 1965 and January of 1966; see LHDAA, VA04.01.3.087–088. Draper's 1972 notebook also includes an extensive list of publishers, in LHDAA, VA04.01.2.090.

103 Smith, interview with the author, June 7, 2017.

104 Jules Allen, conversation with the author, April 3, 2019.

105 Marilyn Nance, conversation with the author, 2019.

106 Dawoud Bey, interview with Valerie Cassel Oliver and the author, April 26, 2019.

107 Joe Crawford, "P. H. Polk … *A Kind of General Practitioner*," in *Black Photographers Annual* (New York: Black Photographers Annual, Inc., 1974), 2:68.

108 In addition to Walker, Beuford Smith, and Mannas, Amanda King and Sandy Baker were listed as founders. By the summer of 1981, Mannas served as president, Walker as vice president, Tony Barboza as treasurer, and Kalima Soham as secretary, according to the *Newsletter*. Several more Kamoinge members became board members; the September 1981 minutes list Draper, Cowans, and Fennar attending a board meeting with Ken Barboza (Tony Barboza's brother) and Kwame Brathwaite, a contemporary who coined the term "Black is Beautiful" and had founded the Grandassa Models in the 1960s. In addition to Cheryll Greene, several other women contributed to the organization, including Gylbert Coker, a curator and historian who led the effort to establish the IBP archive, and Fern Logan, who later served as secretary.

109 Cheryll Greene, "International Black Photographers, Where We're Coming From," *The International Black Photographer Newsletter* I (Winter 1981): 2.

110 Ibid, 1.

111 Ibid.

112 Typed interview transcript, LHDAA, VA04.01.5.067.

113 Smith, interview with the author, June 7, 2017.

114 A note on the "Timeline" portion of Carrie Mae Weems's website reads, "Meets the men associated with The Black Photographers Annual, becomes assistant to Anthony Barboza"; see http://carriemaeweems.net/index.html.

115 Carrie Mae Weems, "The Oral History Project: Adger Cowans," *Bomb*, July 30, 2014, accessed June 24, 2019, https://bombmagazine.org/articles/adger-cowans/.

116 Clippings from Carrie Mae Weems, "Personal Perspectives on the Evolution of American Black Photography: A Talk with Carrie Mae Weems," *Obscura*, 1982, LHDAA, VA04.01.3.006.

117 Although the phrase "useable past" has become ubiquitous, it originated with Van Wyck Brooks, in "On Creating a Usable Past," *The Dial* (April 11, 1918): 337–41. Brooks wrote about the need to develop an American literary history, asking, "If we cannot use the past our professors offer us, is there any reason why we should not create others of our own?"

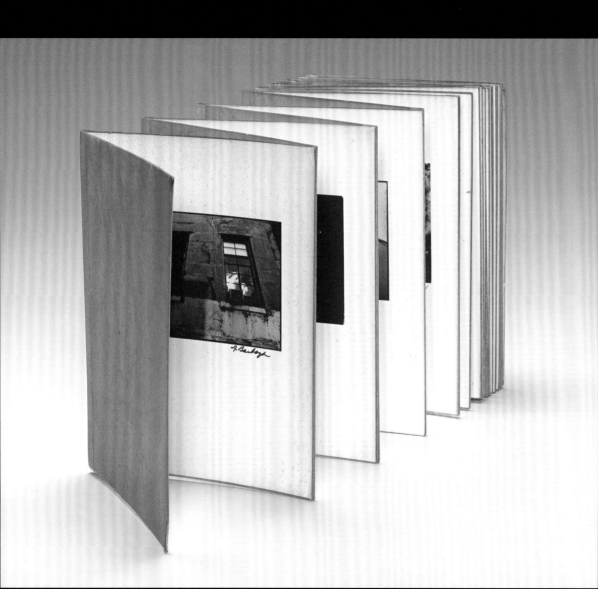

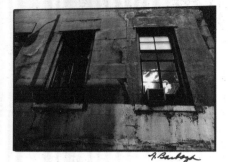

A. Barboza

Adger W. Cowans

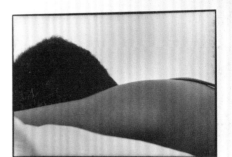

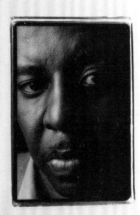

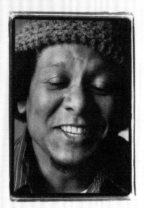

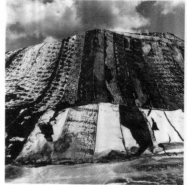

A. Fenner

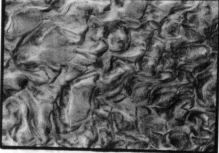

R. Francis

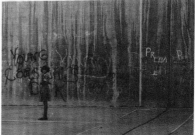

H. Howard

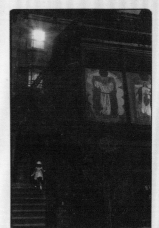

H. RANDALL

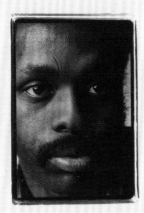

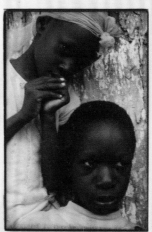

HERB ROBINSON

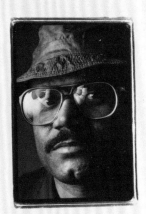

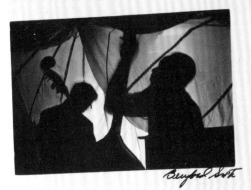

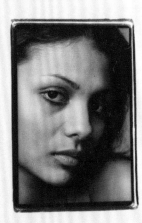

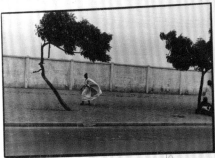

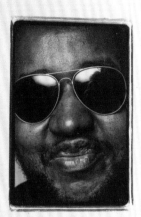

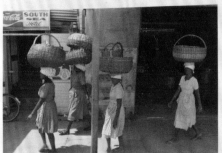

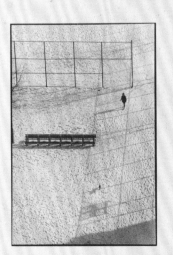

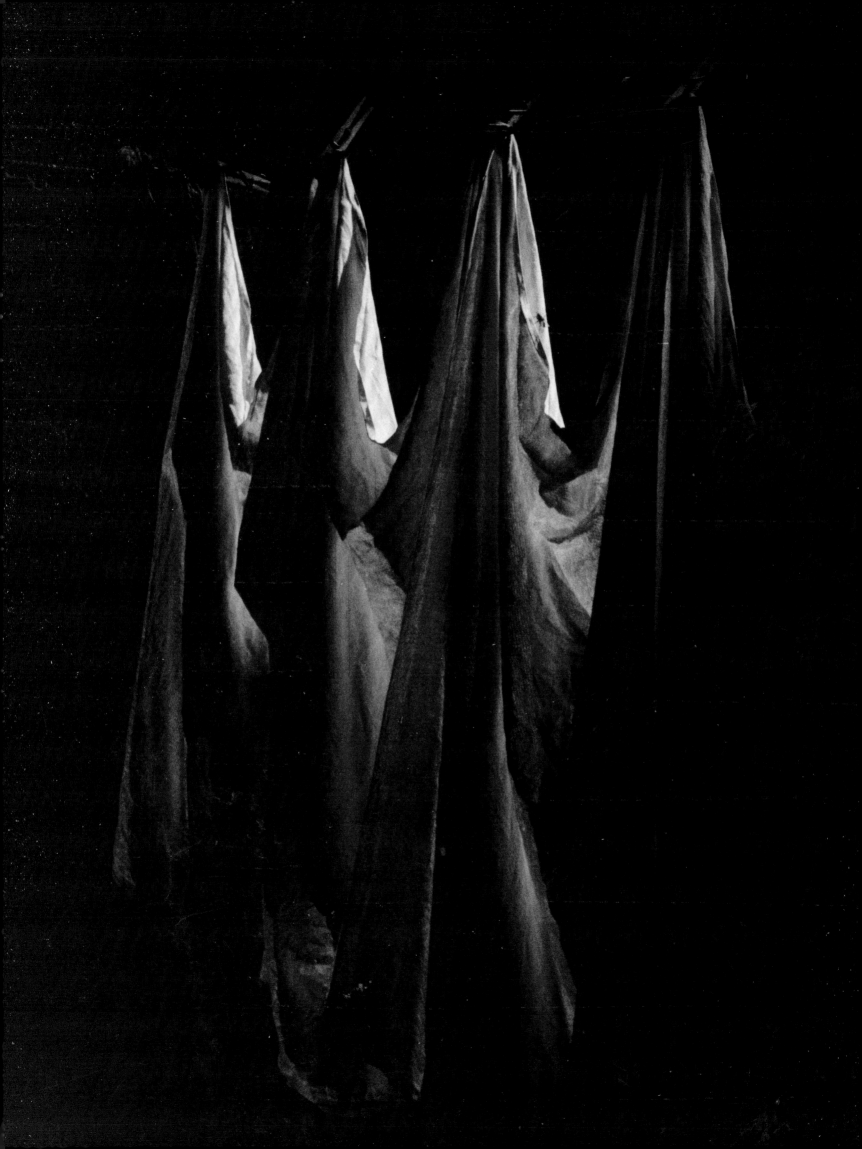

Before Kamoinge: Louis Draper's Artistic Formation

BY SARAH L. ECKHARDT

Among the things I found out about myself was that I had an interest in people and that I was intrigued by the varying moods of and complexities of light.

I also came to realize that there were things about this world that I hated and that these too were valid statements to be made with a camera. I hated injustice.…

Most of all, I began to understand that what I felt had worth; that I could make strong statements about the world in visual terms and that often these images did in fact move people emotionally. I had power. I was a force. I learned that this power had to be harnessed. It was not mine to flaunt or possess selfishly. It was given to me for the purpose of sharing.[1]

—Louis Draper

Congressional Gathering, taken between 1959 and 1961, represents one of the earliest images we have by Louis Draper.[2] [cat. no. 65] A dramatically backlit cloth forms four points where clothespins attach it to a line. Given its context in a series of images about light and transparency, it could have been just another study of these elements. It is preceded on the negative strip by images of curtains (with flowers and butterflies printed on them, no less). [fig. 3.2] Formally, it also relates to a 1958 photograph he made of light falling across a wrinkled bedsheet, which was published in George Eastman House's 1959 exhibition *Photography at Mid-Century*. [figs. 3.1 & 3.9]

There is much that we don't know about the circumstances surrounding the photograph: whether the cloth was even a sheet or a large dish towel or whether he found the scene or staged it.[3] Draper offered plenty of clarity, however, when he chose to publish it under the title *Congressional Gathering*, with the addition of *KKK* in one publication and (*Greenwich Village*) in another.[4] It is a singular image for Draper both because we know of only one exposure and because he never gave another image such an overtly political title to guide the viewer to an unequivocal interpretation of his subject.

Despite its singularity, this photograph offers insight into a critical period in Draper's formation as an artist and, perhaps more importantly, because Draper himself returned to it, including it in Kamoinge Workshop exhibitions and in surveys of his photographs as late as 1989, when he could choose as few as five works to represent his career. In the context of his early contact sheets, it clearly provides evidence of the way he

alternated between abstraction and street photography from the beginning of his time in New York. But in the context of the historical events that took place in the mid to late 1950s, while he was a high school and college student in Virginia, it offers insight into his mindset when he arrived in New York in 1957. Draper's archive makes evident that his early and close analysis of US political representation—and more specifically congressional power over civil rights—accompanied his growing belief in the importance of visual representation. *Congressional Gathering* effectively bridged the political identity that Draper formed in the South with the artistic ability that he developed in the North. This essay traces that path, which ultimately led to his deep and lifelong commitment to the Kamoinge Workshop.

New York, Facing South

Draper's position as a photographer in New York observing the civil rights movement unfold in the South was not unique. Roy DeCarava and Langston Hughes's 1955 collaborative book, *The Sweet Flypaper of Life*—which nearly every early member of Kamoinge has credited for its crucial influence—begins with DeCarava's close-up photograph of a child's eyes looking out at the viewer. Beneath this photograph, Hughes starts the book's narrative on the cover with the main character, Sister Mary Bradley, in Harlem "at 113 West 134th Street" resisting a telegram from the Lord's messenger boy that said "Come Home":

> "For one thing," said Sister Mary, "I want to stay here and see what this integration the Supreme Court done decreed is going to be like."[5]

65 Louis Draper (American, 1935–2002), **Congressional Gathering,** ca. 1959, gelatin silver print. *Virginia Museum of Fine Arts, Arthur and Margaret Glasgow Endowment, 2015.278*

Fig. 3.1 "3 Important
Negatives," Congressional
Gathering, digital positive
from negative strip.
*Virginia Museum of Fine Arts,
Margaret R. and Robert M.
Freeman Library, Archives,
Louis H. Draper Archives
(VA-04), Acquired from
the Louis H. Draper
Preservation Trust with
the Arthur and Margaret
Glasgow Endowment Fund,
VA04.04.09.034.T1*

Fig. 3.2 Untitled
(bedsheet), 1958,
contact sheet printed
after ca. 1967, Louis
Draper (American,
1935-2002). *VMFA,
Margaret R. and Robert M.
Freeman Library, Archives,
VA04.04.09.043.C2*

Since integration has been, ages without end, a permanently established custom in heaven, the messenger boy replied that her curiosity could be satisfied quite easily above. But Sister Mary said she wanted to find out how integration was going to work *on earth* first, particularly in South Carolina which she was planning to visit once more before she died. So the messenger boy put his wire back in his pocket and departed.[6]

The Sweet Flypaper of Life takes its title from a line near the end of the book when Sister Mary again declares her insistence on staying in this world, "I done got my feet caught in the sweet flypaper of life—and I'll be dogged if I want to get loose." Although it is Sister Mary who wants to live and see for herself how integration in the South will work, it is the eyes of her grandchild, Ronnie Bell, in Harlem that look at the reader, as if she too is watching what will take place with school integration. Thus, a poetic photography book about life in Harlem turns the reader's attention first to the South. Likewise, this essay begins by turning first to Draper's childhood growing up in the segregated schools of Virginia.

Growing up in Virginia, 1935–56

Louis Hansel Draper was born on September 24, 1935, in Henrico County, Virginia, just a few miles beyond the eastern border of Richmond city. His sister, Nell Draper-Winston, was born on his birthday two years later, arriving—as he never let her forget—during his party.[7] As his only sibling, Nell has provided, through an oral history and conversations with the author, memories of their shared childhood as well as family photographs. [figs. 3.3–3.6] These recollections have been vital to shaping the early years of his biography and providing the context of the community and family in which they grew up.

His parents, Hansel and Dorothy (Taylor) Draper, had grown up just a few blocks apart from each other in the nearby neighborhood of Church Hill, in the East End of Richmond, and had been, in Nell's words, "high school sweethearts." According to Nell, they provided a very nurturing environment:

> Well, our parents were very, very caring. Also, we were a close, close family. We played board games together. Got out there and played baseball. Before you knew it—the neighborhood kids, everybody was there in the yard playing. They taught Louis and me family values of love and respect for one another and for others, and that kind of carried over.[8]

Their mother sang in their church choir at New Bridge Baptist, and their father, who was a mail carrier after World War II, was also an amateur photographer.[9] In addition to photographing his own children, he was always happy to take pictures of kids in the neighborhood when their parents asked.

The Drapers lived one street over from Dorothy's parents (Nell and Lou's maternal grandparents) in Bungalow City, a 1920s African American suburban development named for the style of the houses.[10] Lou and Nell returned to Church Hill frequently to visit their relatives, some of whom still lived in the homes where their parents had grown up. Their father's sister, Aunt Thelma, was an usher at the Robinson Theater, a movie theater on Q Street between 29th and 30th Streets, named for actor/dancer Bill "Bojangles" Robinson, a native of Richmond. Their mother's Aunt Harriet lived directly across the street from the theater. Nell's memories of the relationship between the two locations illustrates how closely both sides of the family were interwoven into the neighborhood, whose streets were lined with primarily late nineteenth-century row houses:

Back then the windows on the houses came right down to the floor. Lou and I loved to lie on the floor of my Aunt Harriet's house and look out the living room windows because when my Aunt Thelma would open the theater door to talk to my Dad, we could watch the movie through the window. We could see the film from that distance.[11]

In addition to their fascination from afar, they watched the "serials"—mostly "cowboy pictures"—inside the theater, on many Saturdays.

On his regular returns home from New York, Lou took photographs—both in the 1960s and in the 1980s—of his father in his mom's cousin's barbershop on Q and 29th Streets, the same location where their Aunt Harriet's house had been before it was torn down.[12] As Nell recalls, her dad enjoyed being there because it was a social gathering place.[13] As one man reported in the pages of *Richmond Afro-American* in 1952, "There is a saying that if you stand at 29th and Q streets long enough, you will see everybody in Church Hill."[14] A current Church Hill resident still recalls that Billy Alexander was "everyone's barber."[15] Although it is not evident to the casual viewer, Draper's light-filled color image of his father sitting in the barbershop, smiling familiarly at his son, located him geographically in the center of their close-knit community. [fig. 3.5]

While Draper moved frequently all over the New York area for nearly his first three decades in the city—from Greenwich Village to Harlem to Brooklyn to the Bronx to New Jersey—his family stayed in the same house and attended the same church, and his dad went to the same barber for most of the rest of Draper's life. Even if he made few images in Richmond beyond photographs of family, the community that shaped him as a child and young adult arguably played a significant role in shaping his perceptions of the communities he photographed throughout the rest of his career. The injustices he experienced in segregated Richmond, however, must have also informed his deep-rooted desire to bring about change.

His father, Hansel Draper, was drafted into the Army two days before Christmas in 1943.[16] [fig. 3.4] Nell remembers that while their dad was away during World War II, her mother decided to send the children to a private school in downtown Richmond, despite a long bus commute. The neighborhood public school for African American children they had been attending was barely heated. Nell remembers their mother trying to make sure they were warm enough:

> She used to bundle us up and feed us a hot breakfast, but the boys would have to go out during the day to collect kindling wood to start fires in the wood-burning stove, and Lou kept getting colds.

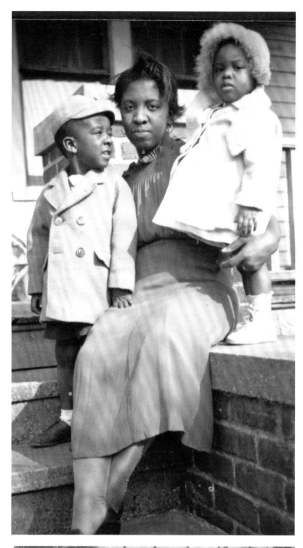

Fig. 3.3 Lou and Nell with their Mother on porch; photograph taken by Hansel H. Draper, ca. 1938. *Courtesy of Nell Draper-Winston*

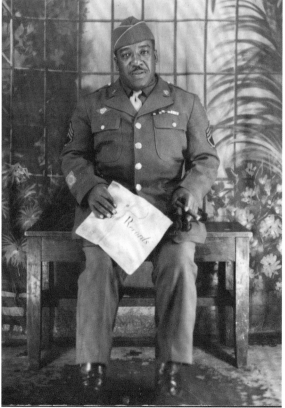

Fig. 3.4 Hansel H. Draper in Military Uniform, 1945. *Courtesy of Nell Draper-Winston*

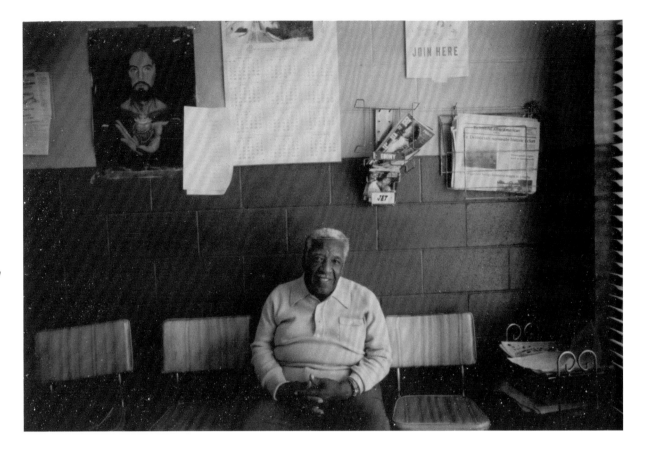

Fig. 3.5 Hansel H. Draper, ca. 1985, colorslide by Lou Draper. *VMFA, Margaret R. and Robert M. Freeman Library, VA04.03.3.107.S1*

The teachers there were great, that wasn't the issue. They were the kind of teachers that came to your home. Miss Emma Jones was our first-grade teacher and we loved her. But we just did not have the facilities we should have had. White kids would throw tomatoes at our school bus, things like that.[17]

Their new school, Van de Vyver Institute, founded in 1888 and attached to St. Joseph's Church, was one of the first African American Catholic churches and schools in the South. It was located in the heart of Richmond's affluent African American business district, Jackson Ward.

Nell remembers that Lou, who would have been about nine years old, shepherded her and other neighborhood children on the Seven Pines bus, which went down Nine Mile Road from Henrico County into the city. They got off on the corner of 8th Street and Broad Street, where they would then walk another ten blocks to 1st Street and Duval, reversing their trip at the end of the day. Broad Street was the racial dividing line in downtown Richmond, with African American stores and businesses on the north side of the street and white ones on the south.

In November 1943, a little less than a year before Lou and Nell began riding the city bus to school, the editor for the *Richmond Times-Dispatch*, Virginius Dabney, called for an end to segregated buses, specifically because of the daily racial tension it caused on Broad Street.[18] Dabney's effort

failed due to the readers' backlash, and Nell and Lou continued to travel to and from school in the very conditions Dabney pointed out. Recently, when Nell reflected on her brother's photograph *Congressional Gathering*, it clearly brought back the memory of their time riding the city bus home from school in downtown Richmond:

> When we attended Van de Vyver, getting on the bus at 8th and Broad, the white men would dig their elbows into our faces to hold us back while the white women got on. They didn't say anything to you, they just let you know that you come on here last. They weren't wearing hoods, but you could visualize them wearing a sheet at night.[19]

In February 1944, *The Crisis* magazine, published in New York by the National Association for the Advancement of Colored People (NAACP), reported extensively on the *Richmond Times-Dispatch* letters to the editor from both readers who supported the repeal and the staunch segregationists who couched their protest in protectionist terms "for the good of the whole community." A letter written from a solider in support of ending segregation perhaps best expressed the Draper family's situation while their father served in the army, and they navigated the segregated buses: "What better opportunity exists to show the hundreds of thousands of Negroes in our armed forces that in fighting Hitler, they are not fighting against themselves at the same time."[20] Virginia legislators let the opportunity pass.

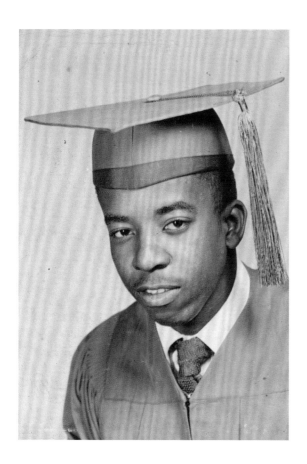

camera. I felt obligated to learn how to use it."[22] At first, he mostly made images of events around campus.[23] But his fortuitous discovery of Edward Steichen's 1955 photography catalogue for the Museum of Modern Art's *The Family of Man* exhibition changed his direction completely. [fig. 3.7] As he described:

> For some reason somebody had left a copy of *The Family of Man* on a bed. I lived in the dorm with four other people, none of whom owned up to it. So, I have no idea to this day who left that copy on my bed. But that was the first beginning of my photography education. I read it practically all night. Instead of studying for my exam, I read *The Family of Man*. I was just enthralled by that book.[24]

The Family of Man is still recognized as a twentieth-century photography landmark. In it, Steichen thematically arranged 503 images by 273 photographers to emphasize universal connections across different cultures from around the world.[25]

At the end of Steichen's photographic celebration of humanity in the *The Family of Man* exhibition, he famously included an enormous, backlit transparency of a hydrogen bomb explosion, placed in its own dark room for contemplation. It was the framing device that was meant to make utterly clear the underlying thesis uniting all of the positive images of people: our divisions will destroy us. Draper never saw the exhibition and Steichen chose not to publish an image of the bomb in the catalogue. Arguably, however, Draper didn't need such an obvious framing devise to understand the need for humanizing photographs. His passion for photography as an art form developed against the backdrop of some of the most dramatic and tumultuous years of the civil rights movement and its backlash in Virginia. *The Family of Man* delivered visually compelling images that conveyed a message of unity exactly as Virginia entered into Massive Resistance, a period from roughly 1956 through the early 1960s in which the state legislators doubled down on what were already oppressive segregation laws.

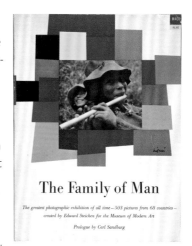

When the Draper siblings each reached the age for high school, they had to undertake a longer bus commute to attend Virginia Randolph High School, about twenty miles from their home before Interstate 64 cut a direct path across the county. Named for the teacher and social worker who founded it, the school had been established as Henrico County's first high school for African Americans in 1915. By 1949, when Draper began attending, it was still the only public high school for African Americans in a huge county that spanned 245 square miles. As Nell recalled, "We spent a lot of time on that bus." By comparison, Highland Springs High School, the white public school in the town next to their community, was about two miles from their home, as had been the white public elementary school they could not attend. The distance Draper traveled to attend segregated schools surely informed his response to the growing momentum behind the fight for school integration, while it also reflects his parents' unwavering commitment to their children's education. [fig. 3.6]

In 1953, Draper enrolled at Virginia State College (now University), a historically Black college in Petersburg, Virginia, a half hour drive south from his family home in Richmond. He was a history and journalism major. As a junior, in fall 1955, he started out as a reporter on the school newspaper, *The Virginia Statesman*, but by his senior year in fall 1956, he was listed as a cameraman for the paper.[21] This marks the period when he began taking photographs. As he remembered, "I wrote home to my father that I was on the school paper. He sent me this

For the rest of his career, Draper described the book as a revelation and a turning point. He left Virginia State abruptly in his final semester.[26] He connected this decision directly to the path he took after reading *The Family of Man*:

Until that time, I was really floundering around, I had no clue as to what I wanted to do. I'm a Senior and I'm majoring in history, but I have no idea about how I want to use it. Anyway, this book sort of solidified things for me. From it I learned that I really wanted to be a photographer. So then I went to the library and read everything that I could get my hands on. Many of [the photographers'] works that I admired were living in New York, so then what I concentrated on was trying to get to New York. I dropped out, as I just wanted to go to New York. That was the only thing that mattered to me."[27]

A brief examination of the historical context in which he made this dramatic decision might help to explain its urgency, and illustrate how much he had already learned as a history major at Virginia State.

Both a 1956 notebook that Draper saved and a column that he wrote for his college's newspaper offer insight into the ways he observed the political events happening in the final few months before he left Virginia in February 1957.[28] Paging through the notebook's contents offers a sense of his intellectual development in this final year of college. The opening page starts with a list of photographic assignments—portrait requests, places to meet, and notations on time of day, as well as f-stops. The rest of the notes cover an array of topics, including Virginia history; a half-completed comparison of the "conservative" versus "liberal" schools of thought represented by Booker T. Washington and W. E. B. DuBois; a list of Negro Renaissance key concepts and literary works; and notes on the mining industry in the Belgian Congo and the demographic make-up of several cities in South Africa.[29]

Mixed in between Harlem Renaissance authors and vocabulary terms for an economics class is a list titled "Standing Committees of the 84th Congress" which was the congress then in session. On it, Draper denotes the name of each committee in the House, the name of each chairman, and their state. He wrote "Negro" next to William L. Dawson of Illinois (the first African American to chair a committee and one of only three African Americans in the Eighty-Fourth Congress) in darker pencil and "Dem" next to Howard K. Smith of Virginia and drew a rectangle around "Rules," the name of Smith's committee. On a separate page, under "Senate," he has also written "Dem" in darker pencil next to Harry F. Byrd of Virginia and Walter F. George of Georgia. His notation of "Dem" on only three names stands out given that the majority of the leaders on this list were Southern Democrats (he put asterisks next to all of the Republicans); however, his notation makes more sense as a kind of symbol for emphasis if we take into consideration that the three people he marks as "Dem" were all integral to the "Southern Manifesto." Formally titled the Declaration

of Constitutional Principles, the Southern Manifesto was a document condemning the *Brown Versus Board of Education* ruling as a violation of individual states' rights. As historian John Kyle Day writes in the introduction to *The Southern Manifesto: Massive Resistance and the Fight to Preserve Segregation*:

> Today, the Southern Manifesto is justifiably viewed as the single worst episode of racial demagoguery in the era of postwar America (1948–1973). Yet, at the time, most members of the Southern Congressional Delegation boasted that they played a part in the statement's drafting, while many claimed that they had conceived of the project in the first place."[30]

In his notebook, Draper marked the committee leaders of this Southern Congressional Delegation as if he was making notations on a baseball game score card. His close observations are worth tracing, although a fuller context of political events that unfolded in Virginia at that time is needed to make sense of their implications.

The Southern Manifesto took its lead from Virginia Senator Harry Byrd's legislative promotion of Massive Resistance to school integration at the state level. Virginia eventually implemented the legislation, named the Stanley Plan after Governor Thomas B. Stanley. At the federal level, Howard W. Smith, Chairman of the House Rules Committee and also a Virginian, introduced the Southern Manifesto in a speech to the House of Representatives in March 1951. Senator Walter F. George of Georgia then introduced the bill in the Senate. A combined ninety-nine congressman and senators signed it. Unsurprisingly, almost all of them represented the states from the former Confederacy. Draper's interpretation of all of this becomes crystal clear a few pages later in his notebook. Following a page containing a list of fourteen pointers for "Some ways to start a paper," he begins the next page under the heading "Standing Committees, Dec. 7, 1956" and apparently reminds himself of his professor's writing instructions: "Don't be stingy with adjectives and adverbs." Next, he appears to have taken notes from the January 1956 *Congressional Quarterly*, which summarizes the make-up of the 84th Congress:

> By virtue of his position, a chairman can exert great influence in determining the action his committee takes on a particular bill. Of 36 chairmanships, 22 will be held in new congress by representatives from 11 Southern states. Rules committee can vote to keep a bill from going to floor for action.

Below this summary of the southern chairmen's political power, Draper wrote, "Satan wears a Confederate Suit (coat, hat, or flag). Title of Paper." If, as John Kyle Day

points out, the Southern Manifesto has now been "largely forgotten by the public at large," the title of Draper's paper reminds us of how deeply he felt the implications at the time.[31]

A column he wrote in the school newspaper a month earlier demonstrates that this title was not isolated from the rest of his thinking. He titled the column "How Come Department," and began with a question about the Suez Canal crisis: "How come in this turbulent stage of man's development, with the threat of "A," "H," and possibly "U" bomb war, that the United States was caught off guard in the Israeli invasion of Egypt?" He ends the column by placing southern politicians in this global context:

> How come southern politicians can't forget the glory that was once theirs and realize that they are partly responsible for the present sub-zero status of the United States in the eyes of many countries. Are they too busy protecting their cultural heritage? From what I understand this so-called heritage didn't come about until lately. For the greater part of their American existence they had their hands full with the Indians and other hostile forces.[32]

For Draper, the Unites States' failures abroad were inseparable from their failures at home. In the face of nuclear annihilation, which felt particularly real during the Suez Canal crisis, Draper exposed the thinly veiled rhetoric of "cultural heritage" as a particularly dangerous distraction.

This "so-called heritage" registered itself visually all over Richmond, the former Capital of the Confederacy, through the city's many monuments to Confederate heroes. And these visual representations of the Confederacy—bronze and stone embodiments of the "Confederate suit (coat, hat, flag)" referenced in Draper's title—were not merely symbolic in Richmond in 1956. The legal basis of Virginia's Massive Resistance, which became the basis of the Southern Delegation's promotion of the Southern Manifesto, was directly modeled on the Confederate legal strategy of "interposition": a doctrine that argues a state's "sovereign" power to reject the authority of the federal government on constitutional grounds. The word "interposition" and its use by the Confederate States of America in 1865, would have been widely known in 1956 because the editor of the *Richmond News Leader*, James Kilpatrick, ceaselessly campaigned in the newspaper's pages for current leaders to embrace the legal strategy and used the Civil War as an example. Moreover, Virginia's Governor Stanley hosted meetings in Richmond with other southern governors that year to coordinate a southern coalition that would organize against integration in unison.[33] In short, by 1956 Richmond was at the center of the legislative fight to shut down the civil rights movement, and Draper had definitely noticed.

We often learn the history of the civil rights movement through violent images such as Charles Moore's now iconic photograph of a fire hose turned on nonviolent protestors in Birmingham. [fig. 3.8] These kinds of images—as important and persuasive as they are—do not convey the pervasive

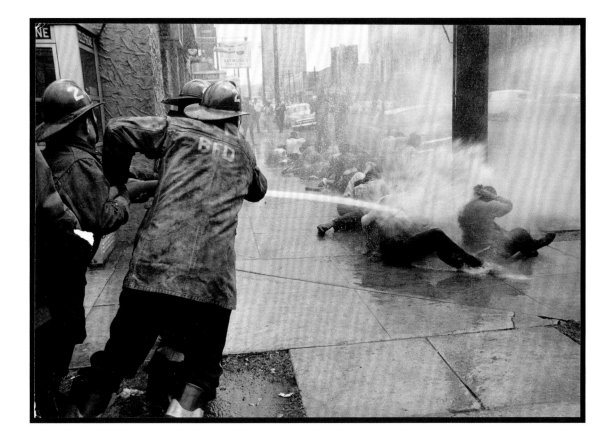

Fig. 3. 8 *Alabama Fire Department Aims High-Pressure Water Hoses at Civil Rights Demonstrators*, 1963, Charles Moore (American, 1931–2010), gelatin silver print. *Virginia Museum of Fine Arts, Arthur and Margaret Glasgow Endowment, 2016.154*

hypocrisy of leaders who cloaked violence in the lofty rhetoric of preserving "racial harmony" through a "Southern way of Life."[34] As Draper was well aware, in Virginia the commitment to white supremacy was no less virulent than it was in Alabama, Georgia, and Mississippi. Yet the Virginia Assembly also derided vigilante justice and mob violence, even passing legislation in 1953 specifically outlawing cross burning in an effort to thwart the Ku Klux Klan's encroachment in the commonwealth. Before Senator Harry Byrd advocated to give Virginia's governor the power in 1956 to shut down schools rather than integrate them, he had, as governor of Virginia himself in 1928, signed into law the most progressive anti-lynching law in the South.[35] These two pillars of his legislative career were not necessarily paradoxical; rather they both worked to consolidate and legitimize white supremacy within the commonwealth's legal system.

Sixty miles southwest of both Richmond and Petersburg, the small town of Farmville, Virginia, was the epicenter of the national legal battle for school integration and the southern resistance to it. A student strike at Robert Russa Moton High School in 1951 led to the school becoming one of the five plaintiffs in *Brown, et al v. Board of Education, et al*. In fact, of the 167 students listed in the case, 117 were from Virginia.[36] Barbara Johns, the leader of the Moton strike, was the same age as Louis Draper. As his sister Nell remembers, the story filled the local newspapers as it continued to unfold.[37] After the 1954 Supreme Court decision sided with the students, white leaders in Farmville, as well as other parts of Virginia, quickly formed an organization in response, the Defenders of State Sovereignty and Individual Liberty, which successfully influenced Virginia's legislative reaction for several years. The Defender's president, Robert Crawford, made a

statement in 1955 in the *New Republic* that echoes Senator Byrd's legislative philosophy: "If this community should suffer just one incident of Klanism, our white case is lost. No matter who starts it, the whites will be blamed. We must not have it."[38] In Virginia, the leaders of the legislative movement that became known across the South as Massive Resistance were at pains to shun the image of the Ku Klux Klan as a threat to their legitimacy.

Of course, the very need to warn against "Klanism" substantiates its presence as a real possibility within the community. Draper's sister remembered that the danger was always there, "It didn't have to be burning a cross like they did in Alabama for you to be aware of how present they were, but they did burn crosses here too."[39] A cross was burned in Richmond in 1955 in front of the home of Oliver Hill, the prominent civil rights lawyer who had represented the students from Moton High in Farmville in the case that would become *Brown v. Board of Education*.[40]

Draper's 1959 image, *Congressional Gathering*, offers a near universal visual message to anyone with the most general understanding of the horrible violence committed by the Klan during the civil rights movement; yet his chosen title might also offer a very specific criticism of Virginia's representatives and their influence on the nation. To equate Congress with the KKK was to refuse to participate in the states' rights charade that was the Southern Manifesto and to acknowledge the violence inherent in the values of the southern representatives protecting their racist legal system.

A few months after Draper came up with his title, "Satan Wears a Confederate Suit," and placed a square around

Fig. 3.9 George Eastman House *Photography at Mid-Century: Tenth Anniversary Exhibition*, 1959. *VMFA, Margaret R. and Robert M. Freeman Library, Archives, Louis H. Draper Archives, VA04.02.1.001*

Fig. 3.10 *Boy Playing Drum*, 1959–60, Louis Draper (American, 1935–2002), gelatin silver print. *VMFA, Margaret R. and Robert M. Freeman Library, VA04.04.09.007.P1*

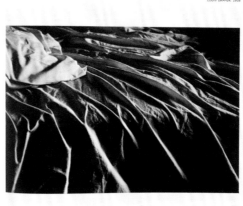

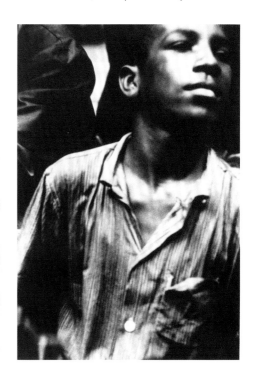

"Rules" by Howard Smith's name in his notebook, the Virginia congressman attempted to use his position as the chairman of the Rules Committee to shut down the 1957 Civil Rights Act. Smith would continue to argue for segregation in white supremacist terms for several more years as he maintained his position as chair of the House Rules Committee. On the eve of John F. Kennedy's inauguration in January of 1961, CBS televised an interview with Smith specifically to explain to the American people what Draper had already figured out in 1956:

> Powerful, little known to the public, a man whose action, or inaction, can mean the success or failure of the new administration. Once the House Rules Committee was a dry paragraph in a dull civics book. Today it is the focal point of national controversy and tomorrow a new President must reckon with its power.[41]

The interviewer (also named Smith), asked the congressman, "What's objectionable about integration? Why is segregation good?" Congressman Smith replied with particularly reprehensible language, on television:

> Well, of course that runs back over generations, back to the days of slavery. The Southern people have never accepted the colored race as a race of people who had equal intelligence and education and social attainments as the white people of the South.

The interviewer went on to ask Smith a question that echoed Draper's college newspaper column five years earlier:

> Do you have no concern that discrimination or even battles, like that in New Orleans, over discrimination, may hurt our standing with all the new nations that are being born all over the world, in a world in which 80% of the people are nonwhite? Don't these quarrels imply that white people think they are superior to people of color, and doesn't this offend these people we need to get along with?"

To which Congressman Smith replied,

> I think that for some time our Government has been paying too much attention to what other people think rather than what the American people think. . . . The idea of racial intermixture is abominable to us and we don't think it ought to happen.[42]

It is difficult to overemphasize that Smith, in the midst of a program pointing out his congressional power, broadcast these statements on a nationally televised program. These were not statements he was caught making in a private conversation but rather position statements he wanted understood publicly as he prepared to spar with a new president and administration. Smith's language in 1961 makes what Draper had already understood five years earlier about the Southern Manifesto that much more explicit. His close analysis of the congressional standing committees, especially the rules committee, indicates how specifically he had thought about the machinations of power and representation.

Between the observations he made in his 1956 college notebook and his photograph titled *Congressional Gathering*, however, Draper had to learn how to "make strong statements about the world in visual terms." According to Draper, this happened through the photography workshops he took after he arrived in New York:

> Often the instructor would point out in one of my photographs or in those of a classmate something that seemed synonymous with that photographer's inner being. From this kind of critical evaluation, a uniqueness of vision surfaced and I became, by my own admission, an individual.[43]

Photography Workshops with Harold Feinstein and Eugene Smith, 1958–61

After Draper left Virginia State and Richmond in 1957, his parents helped him settle in New York, where he first lived at the Sloan House YMCA[44] and attended classes at New York Institute for Photography.[45] However, he found these classes unhelpful and in 1958, he signed up for a class with Harold Feinstein titled "Esthetics, Techniques, and Other Concepts in Photography" after seeing it listed as a notice in Jacob Deschin's photography, "Camera View" column in the *New York Times*.[46] As Draper recalled, Feinstein was a nurturing figure. The cost of the course covered ten classes which were taught in the artist's studio, but Feinstein felt he had more to cover and added classes without charging any additional fees.[47] It is within the context of Feinstein's workshop that Draper most likely made both of the photographs dated 1958 that were chosen for Beaumont Newhall's *Photography at Mid-Century*, which opened in November 1959. In June, the Eastman House had placed an open call for submissions in publications like the *New York Times* and *Popular Photography* for a juried exhibition celebrating the museum's tenth anniversary.[48] Artists were permitted three submissions, and Draper chose his photograph of bedsheets and a portrait of a boy. Appropriately, both poles of Draper's photographic practice—abstraction and street photography—were represented the first time his photographs were published, and/or exhibited. [figs. 3.9 & 3.10]

Draper's connection with Feinstein proved enormously important, since through his workshop, Draper not only gained one mentor but also a second, Eugene Smith. Perhaps more than any other photographer, Draper spoke about Smith's early influence on his work often. In a late 1960s or early 1970s photograph by Beuford Smith of a Kamoinge meeting, Draper holds open Eugene Smith's 1951 "Nurse Midwife" photo essay from *Life* magazine, while standing next to Beuford Smith's sequence of images made as a response in 1968 to Martin Luther King's assassination. [figs. 3.11 & 3.12] Draper's comparison suggests that Smith's essay continued to function something like a gold standard for Draper long after he studied with him.[49]

Widely considered the "master" of the photo-essay form, Eugene Smith had been one of *Life*'s most famous photographers for essays such as "Country Doctor" (1948) and "Nurse Midwife" (1951), before he left the magazine in 1955 over arguments about editorial control. In 1957 he also left his family in a New York suburb and moved into the city where he took over a lease from Feinstein on a loft at 821 Sixth Avenue. Famously known as the "Jazz Loft," because of all of the musicians who stayed there, Smith wired several floors with microphones and recorded four thousand hours of audio tapes over seven years.[50] Some fifty hours of these contain recognizable recordings of or about Draper during the years he worked as Smith's assistant and student.

Smith and Feinstein were good friends in the years when Draper attended their workshops, and Feinstein invited Smith to visit his class, just as Feinstein would later also stop by Smith's loft after Draper began taking his course for the New School for Social Research in 1960, "Photography Made Difficult."[51] On one of these visits, Smith discusses his students' work with Feinstein, singling out Draper as "one of the finest talents I have known. First time I ever saw his pictures, he left a portfolio up here...he opened the portfolio and eight feet away, or six feet...[it was] beyond my power to say anything else than, 'My god, that's beautiful!'" Feinstein replies, "He is wonderful."[52] In another recording, Smith affirms his compliment directly to Draper, who apparently did not think Smith's praise had been genuine.[53] As Smith looked at early versions of Draper's playground series, he was intrigued by the energy present in seemingly static images, observing that "the swing still vibrates."[54] [fig. 3.14] He asked Draper to explain his symbolism in his photographs of playground slides.[55] Although most of Draper's answers are inaudible, he primarily talks about conveying a theory of dualism. Like Draper's 1956 notebooks, his recorded conversations with Smith also illustrate his global perspective. In one conversation with Smith about revolutions, Draper moves from Fidel Castro and the promise of education in Cuba to the Mau Mau uprising in Kenya.[56]

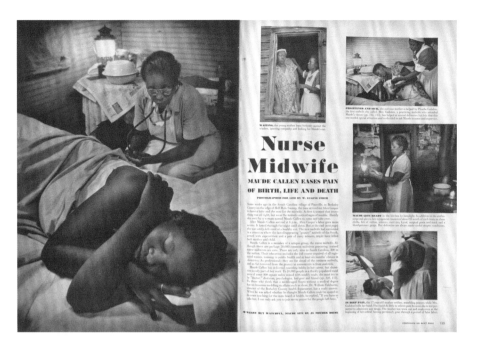

Fig. 3.11 "Nurse Midwife" article in *Life* magazine, Dec. 3, 1951, featuring photographs by Eugene Smith. *Virginia Museum of Fine Arts Library, 30804006634058*

Fig. 3.12 Lou Draper holding open "Nurse Midwife" photo essay in *Life* magazine, standing in front of Beuford Smith's 1968 series of photographs, at Adger Cowans's Studio, ca. 1970s. *VMFA, Margaret R. and Robert M. Freeman Library, Archives, Beuford Smith Archives (SC-32), Gift of the Beuford Smith Collection, SC32.02.0.007*

Draper's presentation to Smith's class of his photo essay project documenting the construction of the Lincoln Center also provides ample evidence of his desire to photograph racial inequality. As he explained while presenting his photographs, one of the unions on the site was integrated and the other did not allow African Americans. Draper theorized that racial tension and inequality in the treatment of the workers and their access to higher level assignments, caused inefficiencies on the job and slowed progress. Despite Smith's earlier praise for Draper's playground series, he stated in the class that Draper's Lincoln Center portraits failed, most likely because he couldn't get close enough to the site to make interesting photographs. Smith suggested that Draper would need a press pass from the American Society of Magazine Photographers to gain adequate access. The irony, which seemed lost on Smith in the conversation, is that the ASMP discriminated against African American photographers as much as the segregated unions Draper wanted to photograph.[57]

Draper's later recollections of Smith range from a defense of Smith's sophisticated understanding of writers such as James Baldwin, Langston Hughes, and Paul Robeson to a frustration with Smith's obliviousness to the actual racism Draper experienced on the streets of New York. Ben Maddow's 1985 biographical essay on Smith spurred Draper to write detailed memories of his time with Smith, because he felt a need to counter Maddow's claim that despite Smith's immense library, no one ever saw him read[58]:

> I remember him for daring at the time to have literature among his vast book collection that spoke deeply of Afro-American experiences by authors from that segment of our culture whose words were eloquent and challenging rather than conciliatory. He had even dared to read these books—Baldwin, Robeson, Hughes.

> Smith was able to talk with me intelligently about the substance of these books, sometimes quoting or referring to passages to illustrate a point—on bottom still, pulling said book from the shelf and reading a passage to illustrate his point.[59]

Yet a few paragraphs later, Draper recalls being enraged by a favor "Gene" asks of him: to walk his white, female assistant, Carol Thomas, up the street:

> I escorted Carol Thomas a few blocks up the street to get cigarettes from a 6th Avenue bar—the hostility going there and returning from people was so thick I could have sliced it with a straight razor. I think she felt it but we never brought it up in discussion. But I remember being enraged— I had been asked to do this as a favor to Gene.[60]

On the one hand, Smith read James Baldwin and discussed the substance of these "eloquent and challenging" words with Draper. Yet, on the other hand, Smith failed to see or understand the racism Draper faced in New York, which Baldwin had written about. Reflecting on his first trip to the South in 1958, Baldwin wrote:

> It must also be said that the racial setup in the South is not, for a Negro, very different from the racial setup in the North. It is the etiquette which is baffling, not the spirit. Segregation is unofficial in the North and official in the South, a crucial difference that does nothing, nevertheless, to alleviate the lot of most Northern Negroes.[61]

Eugene Smith's Photographs of the KKK

Smith had witnessed racism in its most extreme and iconic form when he went to South Carolina to research his photo-essay on nurse-midwives in 1951. Before he settled on the heroic figure of Maude Callen, he stumbled upon a notice for a Ku Klux Klan meeting in a small town taking place at night, which he attended so that he could photograph it. Smith later wrote to his mother,

> I admit the KKK meeting was a strong dose of poison to receive at the beginning. The leaders spoke in warped vicious hatred that disregarded truth almost completely, while the majority of the "common folks" who agreed spoke out of ignorance warped by the ravings of the leaders. And were the majority right when they stood by and watched them crucify the Lord? The majority are not necessarily right. They are told, and to some degree they then repeat, and it is because of this the obligation of my profession lays so heavily upon my conscience to weigh and balance all that I photograph and all that I ultimately state in public.[62]

The images he made of burning crosses and Klan members lifting their hoods were never published in *Life* or associated with the "Nurse Midwife" essay, even though they effectively set the backdrop for it. Instead, Smith first showed them in an exhibition in fall 1957 at Limelight Gallery in New York.[63] During an era when there were few places to see fine art photography other than the Museum of Modern Art, Helen Gee's Limelight Gallery provided a rare venue for photographers to gather and collectors to purchase work (a market she pioneered). A photograph taken by James Karales in Harold Feinstein's archive documents that Smith had chosen photographs of the Ku Klux Klan rally he had attended in South Carolina in 1951 and paired it with a close-up portrait of an African American man.[64] Smith then published the series of photographs in April 1958 in the ASMP's photography magazine, *Infinity* as well

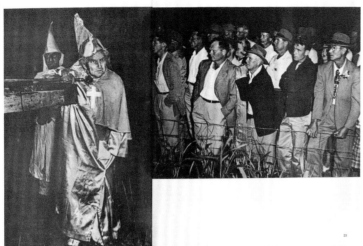

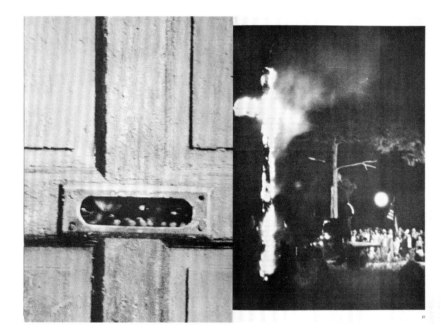

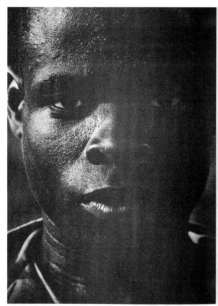

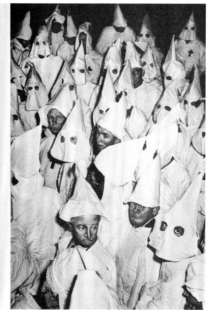

as in a portfolio of images in the *Second Coming Magazine* in March 1962.[65] [fig. 3.13]

It is difficult to imagine that Draper did not see Smith's exhibition as soon as he moved to New York. As he recalled of this early period,

> It was a time absent of art photography, collectors, and hostile gallery owners who glare rather than welcome you into their showplaces—Thank God for Helen Gee and Larry Siegel.[66]

Yet even if Draper had missed seeing the photographs in the 1957 exhibition or in *Infinity*, he likely saw them in Smith's loft, a space which Draper describes as lined with "5 x 7's clipped to endless tracks of wire extending from one end of the loft floor to the other" on both floors of the loft.[67] From 1957 forward, Smith included the series of KKK images in books and exhibitions that surveyed his career.[68]

Draper's photograph *Congressional Gathering* stands in stark contrast to his mentor's series of images about a Klan meeting, which Smith could attend under the cover of his own whiteness. Smith documented a specific rally, capturing a moment in which a few of the men nearest the foreground of the frame reveal their faces as they lift their hoods, and their leader in the center looks as if he has been caught off guard by the camera's flash. In another image, the enormous burning cross dominates the composition as the Klan figures form a ghostly white circle around it. Although powerful and eerie, Smith's photographs are within the photojournalistic tradition: they record a historical event that had taken place years before.

Draper instead conjures the specter of the Klan from a humble cloth hanging on a clothesline in Greenwich Village. The negative reveals how much Draper worked in the darkroom to burn out details, such as a windowsill and bricks in the background, while simultaneously dodging the curves and points of the fabric to produce the luminous glow that makes the cloth peaks appear to be figures facing light. By chance, a large fly had landed on the third pointed peak, exactly where one would expect an eyehole in a Klan robe. Draper's skill as a printer attests to why Smith, whose darkroom standards were notoriously high, chose Draper as an assistant. It also helps to explain why so many of the Kamoinge members—from Ray Francis to Ming Smith—recalled the importance of their darkroom printing sessions with Draper to their own development as a photographer.

The print also signifies how early in his career Draper broke out of the limitations of traditional photojournalism. Informed by his keen political awareness of what was happening, he infuses the photograph with a symbolism that exceeds the boundaries of an individual Klan rally.

Perhaps more remarkable are the differing ways Smith and Draper sequenced their images. In his 1957 exhibition and subsequent publications, Smith chose to divorce the images of the Klan from the context of the "Nurse MidWife" assignment in South Carolina during which he witnessed the rally. Instead, Smith substituted a generic, anonymous portrait of a Black man in the midst of the Klan pictures to create narrative tension. On the one hand, this juxtaposition of unrelated photographs would have been understood immediately in the late 1950s in the context of the civil rights movement and the national headlines about the violence of the Klan. On the other hand, the specificity of Smith's Klan photographs as documents of an actual rally paired with a seemingly random image of an African American man taken out of any kind of context arguably undermined Smith's point. The moral arc of the visual construct becomes too obvious when an image of one man is made to stand in as a symbol for the vulnerability of his entire race.

Draper almost exactly reversed this equation when he included *Congressional Gathering* in a series of photographs he bound together in a book like format presumably during the same time he was working with Smith. [fig. 3.14] Consisting of only five images, the sequence contains three images of children and two nearly abstract photographs. In the tradition of *The Family of Man*, Draper appears to have intentionally chosen children of three different ethnicities. The series begins with a photograph of a young girl looking into the distance, facing an empty page. It is followed by a young boy huddled next to an abandoned car covered in graffiti, again facing an empty page. In the middle, *Congressional Gathering* faces a photograph of a boy playing stickball. Finally, the sequence ends with an almost completely abstract image of empty swings, which Smith noted, "still vibrates with humanity, still vibrates with emotion."[69] Precisely because Draper makes no claims as a witness or a documentary photographer, his symbolic photograph of the Klan appears to hover over the rest of the images, haunting American childhood everywhere.

As he did with *Congressional Gathering*, Draper returned to the image of the boy playing stickball, which he titled *Boy and H, Harlem* [cat. no.25], often throughout his career. He even stored the two negative strips next to each other in an archival sheet titled "3 Important Negs."[70] In a swath of light framed by deep shadows on either side, a boy walks away from the letter "H" prominently written on a wall with a square painted around it. Although difficult to decipher at first glance, the shape of a stick hanging down from the boy's hand offers a crucial clue to the meaning of the letter: presumably H stands for home plate and the square marks the strike zone. No other players are visible, but the boy appears to be participating in a stickball game—an urban version of baseball adapted for city environments such as the confines of a concrete courtyard. Like *Congressional*

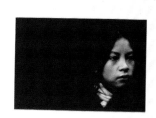

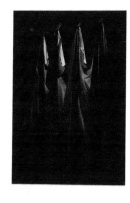

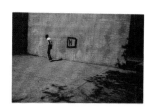

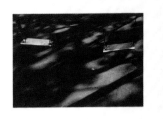

Left:
Fig. 3.13 W. Eugene Smith (American, 1918–1978), images in the *Second Coming Magazine* 1, no. 3, March 1962, 21–7

Right:
Fig. 3.14 Draper's handbound book of photographs, ca. 1960s, *VMFA, Margaret R. and Robert M. Freeman Library, Archives, VA04.07.1.003*

Gathering, the negative for the image reveals how deeply Draper burned in the shadows on both sides of the boy, transforming light shadows into a foreboding frame that appears to be encroaching on him. Draper's contact sheet with the image of the boy crouched by the abandoned car contains several frames of the child happily playing with other boys; yet, Draper chose the frame in which the boy pouts forlornly. While Draper took a variety of images during this period, he chose to print dark, somber photographs about childhood, including his playground series of distinctly ominous swings and slides.

On January 29, 1959, Virginia's Supreme Court and the United States District Court for the Eastern District of Virginia ruled in two separate cases that the state's school closure law was unconstitutional. The inability of the governor to shut down schools that attempted to integrate effectively ended Massive Resistance.[71] A major legal victory for integration, it also provided the occasion for Virginia Governor J. Lindsay Almond to deliver a speech equating school integration in Washington, DC, with "Satanism, sex,

immorality, and juvenile pregnancy."[72] He called for "the people of Virginia to stand" with him despite "recent judicial deliveries." Thus the 5 percent of African American students who attended integrated schools between 1959 and 1964 faced open hostility. Images of six-year-old Ruby Bridges made the national news in 1960 when federal marshals escorted her into an all-white elementary school in New Orleans. An earlier image from Charlottesville, Virginia, taken in 1959 of a young boy in a similar situation, emphasizes the loneliness of this responsibility. He appears to shoulder the burden of integration alone as a group of white boys happily run past him, seemingly ignorant of his isolation. [fig. 3.15] It is difficult to separate Draper's photographs of children in New York City from the context of these images that were being broadcast nationally from the South.

In 1957, the same year that Draper moved from Virginia to New York, James Baldwin came home from Paris to Harlem, specifically so that he could make a trip to the South. Although he had lived in Paris for the previous nine years, he was drawn back to the United States, as

Fig. 3. 15 Untitled, (Venable ES, Charlottesville, VA), 1959, unknown artist, gelatin silver print. *Virginia Museum of Fine Arts, Gift of Richard and Andrea Kremer, 2016.504.*

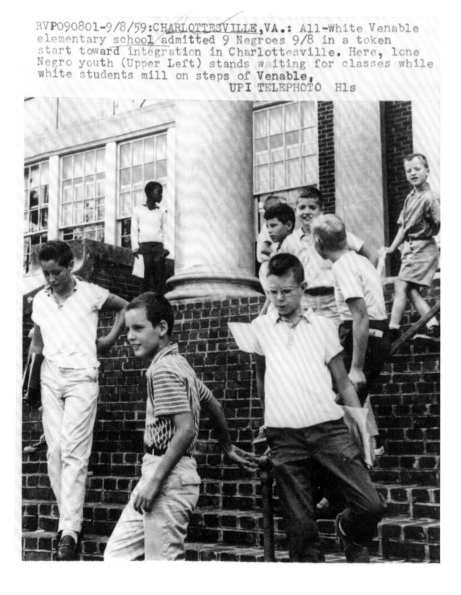

he recalled in a 1972 autobiographical essay "Take Me to the Water" in *No Name in the Street*, by photographs of African American students walking through hostile crowds to attend school.[73] As he wrote in his 1958 essay for *Harper's Bazaar*, "The Hard Kind of Courage":

> The South had always frightened me. How deeply it had frightened me—though I had never seen it—and how soon, was one of the things my dreams revealed to me while I was there. And this made me think of the privacy and mystery of childhood all over again, in a new way. I wondered where children got their strength, in this case, to walk through mobs to go to school.[74]

Baldwin would continue to reflect on the experience in two additional essays in *Partisan Review* in 1959 and 1960, culminating in their publication together as a collection of essays, *Nobody Knows My Name* in 1961.[75]

Baldwin filled the pages of these essays with searing descriptions of the hypocritical delusions of southern leaders, yet he almost always returned to the similarities between the North and the South and their interconnectedness. At the end of "Letters from the South," he prophesied that ultimately Southern political leaders' "inability to tell the truth" will lead to an "implacable Negro resistance" that will "spread to every metropolitan center in the nation which has a significant Negro population. And this is not only because the ties between Northern and Southern Negroes are still very close. It is because the nation, the entire nation, has spent a hundred years avoiding the question of the place of the black man in it." [76]

For both Hughes in *The Sweet Flypaper of Life* and Baldwin in his essays from the late 1950s, the education of children in the South held enormous implications for children in the North, as well as for everyone in the nation.

Draper did not produce photojournalistic essays about school integration. Yet to borrow Smith's term, his images of children and playgrounds in New York from 1959 to 1961 "still vibrate" with its historical context. *Congressional Gathering* marks a significant period when Draper broke with a strictly photodocumentary tradition to form a hybrid photographic practice in which he imbued seemingly ordinary images with political and cultural symbolism. At once multivalent and specific, depending on the cultural context and the viewer, his photographs, as he learned, "move people emotionally." The Kamoinge Workshop offered the community through which he would continue to develop this visual language while also addressing the discrimination he and other Black photographers faced.

Endnotes

1 Louis Draper, "Who am I?—EG102," typed manuscript and handwritten draft summer, 1986, Louis H. Draper Artist Archives, VA04.01.4.018, VA04.01.5.078. This archive was acquired from the Louis H. Draper Preservation Trust with the Arthur and Margaret Glasgow Endowment Fund, Virginia Museum of Fine Arts, Richmond, Virginia, and hereafter cited as LHDAA.

2 Draper signed and dated the back of one print 1959, however, he also dated it ca.1961 in Deborah Willis, *An Illustrated Bio-Bibliography of Black Photographers 1940–1988* (New York: Garland, 1989), 246.

3 At some point, the strip of five negatives (including the frame of *Congressional Gathering*) was separated from the other negative strips from the same roll.

4 Complete titles for the photograph are *"Congressional Meeting," Greenwich Village, New York, New York* in Willis, *Illustrated Bio-Bibliography, 246*, and *KKK (Congressional Gathering)*, as listed on a handwritten checklist titled "Prints from Stockton and J&J [Johnson & Johnson] Exhibit [Enter the City: Photographs by Louis Draper] Spring 1989," LHDAA, VA04.01.2.056.

5 Willis, *Illustrated Bio-Bibliography*, 92.

6 Roy DeCarava and Langston Hughes, *The Sweet Flypaper of Life* (New York: Simon and Schuster, 1955), cover-3.

7 This is one of his sister's favorite stories to tell and clearly a part of their lifelong bond.

8 Louis Draper: The Character of Everyday People, A Conversation with Nell Draper-Winston," *Blackbird*, Virginia Commonwealth University, accessed February 4, 2019, https://blackbird.vcu.edu/v14n1/gallery/draper_l/interview_page.shtml

9 Nell Draper-Winston, interview with the author, January 17, 2019. Draper-Winston explained that her father had applied for a mail carrier position before WWII and had been denied, but after he returned from serving in the army "they couldn't refuse him."

10 Ibid. According to Nell, her grandparents bought their house in 1929 from a Sears Roebuck catalogue. Her mother lived with them until she married Hansel, with whom she rented then bought a home in the neighborhood.

11 Draper-Winston, interview with author, and "Louis Draper," *Blackbird*. Although Nell recalled that the 1985 photograph was "Bill Alexander's barbershop," it had likely passed by 1985 to his son Leon, who took over the shop after his father passed away.

12 Nell recalls that Lou came home about twice a year: at Christmas time and in the summer, especially for June Jubilee, a local music festival. See "Lewis Draper," *Blackbird*.

13 Ibid. As Nell recalled, people like Douglas Wilder would casually drop by. Wilder's law practice was around the corner, and he had also grown up in the neighborhood, on the corner of P and 28th Streets, facing Fourth Baptist, the church Lou and Nell's grandparents attended. Because it was such a close-knit community, residents of Church Hill took particular pride in Wilder when he became the governor of Virginia in 1990, the first African American governor in the United States since Reconstruction. For more on Douglas Wilder's memories of growing up in Church Hill, see "Museum Leaders in Training (M.LiT) conversation with Governor Douglas Wilder," December 14, 2017, accessed March 1, 2019, https://www.youtube.com/watch?v=B9ocNX4gj1k&t=32s.

14 *Richmond Afro-American*, March 29, 1952, quoted in Michael Eric Taylor, "The African-American Community of Richmond, 1950–1956" , University of Richmond, 1994), 23, accessed February 4, 2019, https://scholarship.richmond.edu/masters-theses/1081.

15 James Wright, facility manager at the Robinson Theater, in conversation with the author, January 19, 2019.

16 Draper-Winston, interview with the author. According to Nell Draper-Winston, Hansel Draper was stationed in New Orleans throughout his service from 1944 through 1945. Despite being served papers to go overseas three times, the orders were rescinded each time and he never left the United States during the war.

17 Ibid.

18 Virginius Dabney, "To Lessen Race Friction" *Richmond Times Dispatch*, November 13, 1943. Summarized in "Virginians Speak on Jim Crow" Crisis, February 1944: 47. Dabney's campaign against bus segregation is also mentioned in Taylor, "The African-American Community of Richmond," 190.

19 Draper-Winston, phone conversation with author.

20 "Virginians Speak on Jim Crow," *The Crisis*, February 1944, 48.

21 Each issue of *The Virginia Statesman* contained a plate crediting staff roles and titles. Draper's name first appears among the staff list in Vol. 27, No. 1 (October 7, 1955) and in subsequent issues through Vol. 28, No. 10 (May 24, 1957). Likewise, his photograph appears in Virginia State's 1957 yearbook, despite the fact that he did not graduate. Bound copies of *The Virginia Statesman* are held in the Johnston Memorial Library Special Collections and Archives at Virginia State University.

22 Louis Draper, interview with Erina Duganne, March 24, 2001.

23 Ibid.

24 Ibid.

25 Despite its enormous popular success, *Family of Man* has continued to sustain scholarly criticism because of Steichen's attempt to universalize the human experience while working from a decidedly white American perspective, sometimes choosing images that essentialized and exoticized the very cultures he set out to exalt. [See Eric J. Sandeen, *Picturing an Exhibition: The Family of Man and 1950s America* (Albuquerque NM: University of New Mexico Press, 1995).] Yet the overwhelming emphasis on cultural multiplicity and equality combined with the modernist aesthetics in the work of many featured photographers must have been refreshing to Draper. Furthermore, the exhibition and its catalogue marked a turn in the debate over photography's status as an art form, a point examined in Aline B. Saarinen's *New York Times* exhibition review "The Camera Versus the Artist," February 6, 1955, X10. The review sparked further debate in the next week's issue, which featured published letters to the editor. Among the concerned readers was artist Ben Shahn. (See "In the Mail: Artist Versus Camera: Writers Take Exception To Some Statements On the Problem," *New York Times*, February 13, 1955, X15.) Almost forty years later, Steichen's successor John Szarkowski noted how the exhibition affected his own father's understanding of photography as art in the essay "The Family of Man," in *The Museum of Modern Art at Mid-Century: At Home and Abroad* (New York: Museum of Modern Art, 1994), 35.

26 In an early job application for the job of "Substitute Clerk," Draper lists his time at Virginia State College from September 1953 through February 1957. He lists his major as History and Journalism and checks "no" next to the question, "Did you graduate?" This is the only record within the archive that notes the month he left college. Although the application is undated, he appears to list his jobs in reverse chronological order backward from the most current on top to the earliest on bottom. He only puts 1958 on the bottom job, suggesting the job at which he was "employed" at the time "since March 13," was in 1959. See job application form, LHDD, VA04.01.1.001.

27 Louis H. Draper, interview with Erina Duganne, March 24, 2001.

28 "The Spiral" composition book, LHDAA, VA04.01.1.044. His 1956 notebook begins in the spring semester of his junior year and ends in December of his senior year.

29 Ibid, unnumbered pages.

30 John Kyle Day, *The Southern Manifesto: Massive Resistance and the Fight to Preserve Segregation* (Jackson, MS: University of Mississippi Press, 2014), 3.

31 Ibid.

32 Louis Draper, "How Come Department," *The Virginia Statesman*, 28, no. 4 (November 21, 1956): 4.

33 Day, *Southern Manifesto*, 13

34 Ibid., 83.

35 Associated Press, "Adopt Byrd Anti-Lynching Bill," *New York Times*, February 18, 1928, 6.

36 Katy June-Friesen, "Massive Resistance in a Small Town," *Humanities* 34, no. 5, September/October 2013, accessed March 1, 2019, https://www.neh.gov/humanities/2013/septemberoctober/feature/massive-resistance-in-small-town.

37 Draper-Winston, interview with the author.

38 Haldore Hanson, "No Surrender in Farmville, Virginia," *The New Republic*, October 10, 1955, 11-15.

39 Nell Draper Winston, phone interview with author, January 18, 2019.

40 United Press, "Klan Symbol Reappears: Fiery Cross Placed at House of Negro Lawyer in Richmond," *New York Times*, August 11, 1955, 43.

41 Many online sources place Smith's statement in the context of Congressional debates over the 1957 or 1964 Civil Rights Acts (see Susan Breitzer, "Civil Rights Act of 1964," *Encyclopedia Virginia* Virginia Foundation for the Humanities, January 31, 2012, accessed January 11, 2019, https://www.encyclopediavirginia.org/Civil_Rights_Act_of_1964#start_entry). However, the statement originates from a television interview. The CBS Report, "The Keeper of the Rules: Congressman Smith and the New Frontier," aired on January 19, 1961, and the entire script of the interview was formally entered into the Congressional Record on January 31, 1961. See 87 Cong. Rec. 1497–498 (1961), accessed January 25, 2019, https://www.govinfo.gov/content/pkg/GPO-CRECB-1961-pt2/pdf/GPO-CRECB-1961-pt2-2-1.pdf.

42 Ibid.

43 Draper, "Who am I?—EG102," LHDAA..

44 Draper-Winston, interview with the author.

45 Typed resume, LHDAA, VA04.01.1.072.

46 Draper, interview with Erina Duganne; Typed resume, LHDAA. For an example of the ads for Feinstein's courses, see "Course by Feinstein," *New York Times*, July 13, 1958, X13.

47 Harold Feinstein, interview with Erina Duganne, January 28, 2005.

48 Of the 253 artists represented in the exhibition, half were chosen from the open submission process while the other half were individually invited or recruited from agencies and magazines such as Magnum and Life. See Mandy Malazdrewich, "Photography at Mid-Century: A Description of George Eastman House's Tenth Anniversary Exhibition" (master's thesis, Ryerson University, 2011), 25.

49 Jimmie Mannas, interview with the author, June 28, 2018; Shawn Walker, interview with the author, June 7, 2017; and Ming Smith, interview with the author, February 26, 2018. Draper gave darkroom lessons to Kamoinge members and thereby passed on the printing techniques that he developed while working and studying with Smith.

50 Smith made audio recordings in his loft at 821 Sixth Avenue in New York, capturing sounds that ranged from his own conversations to jazz musicians practicing in the building. The University of Arizona's Center for Creative Photography houses Smiths original tapes, which were digitized as part of research efforts for Sam Stephenson's *The Jazz Loft Project* (New York: Alfred A. Knopf, 2009). Duke University's Rubenstein Library now holds the audio copies as part of the W. Eugene Smith Reference CD Collection.

51 Typed resume, LHDAA, VA04.01.1.072.

52 Herb Randall, interview with author, January 21, 2019. Randall also confirmed that Smith and Feinstein would serve as guests in each other's classes. This is apparent in the Eugene Smith recordings of his class "Photography Made More Difficult" when Feinstein visits the class as he and Smith discuss students' work before the students arrive. See disc RL10012-CD-1424, W. Eugene Smith Reference CD Collection, David M. Rubenstein Rare Book & Manuscript Library, Duke University.

53 W. Eugene Smith Reference CD Collection, RL10012-CD-1480. During the conversation Smith asserts, "I'll be goddamned if I don't work up any enthusiasm unless I like it. It's too hard to work up enthusiasm … I also wouldn't go about pressing my kindness upon other people … when you weren't around, by telling the other people that I liked your pictures, too. I would say that 'Lou was a, a big drip!' if I didn't like them."

54 Ibid., RL10012-CD-1479.

55 Ibid., RL10012-CD-1480.

56 Ibid., RL10012-CD-1537, RL10012-CD-1538.

57 Ibid., RL10012-CD-1534, RL10012-CD-1535, RL10012-CD-1536.

58 Ben Maddow, "Through a Lens Darkly," *New York Times Sunday Magazine*, August 25, 1985, 30.

59 Handwritten draft "For W. Eugene Smith Article," LHDAA, VA04.01.5.081. Despite the title of Draper's essay, no evidence suggests it was published.

60 Ibid.

61 James Baldwin, "Nobody Knows My Name: A Letter from the South," *James Baldwin, Collected Essays* (New York: The Library of America, 1998), 203.

62 Smith's letter to his mother dated April 15, 1951, quoted in *Let Truth Be the Prejudice: W. Eugene Smith, His Life and Photographs*, ed. Ben Maddow (New York: Aperture, 1985), 124.

63 See Helen Gee, *Limelight: A Greenwich Village Photography Gallery and Coffeehouse in the Fifties: A Memoir* (Albuquerque: University of New Mexico Press, 1997).

64 Judith Thompson, "The Jazz Loft, The Limelight, The friendship: Harold Feinstein and W. Eugene Smith," Harold Feinstein, accessed February 4, 2019, https://www.haroldfeinstein.com/harold-w-eugene-smith-the-jazz-loft-and-helen-gees-limelight-gallery/.

65 The issue of *Infinity* highlighted photography documenting events and life during the Segregation Era. See W. Eugene Smith, "IV … And Some Conclusions," *Infinity* 7, no. 4 (April 1958): cover, 12–13. Smith's photos were later published as "Portfolio: Ku Klux Klan photographs by W. Eugene Smith," *The Second Coming Magazine* 1, no. 3 (March 1962): 21–27.

66 LHDAA, VA04.01.5.081.

67 For W. Eugene Smith Article," see LHDAA, VA04.01.5.081. During a conversation recorded by Smith in spring of 1960, the photographer references his KKK photographs, asking Draper and Carole Thomas (Smith's partner and assistant) if they have any prints available to view. See RL10012-CD-3804, W. Eugene Smith Reference CD Collection.

68 In addition to Maddow's *Let Truth Be the Prejudice: W. Eugene Smith, His Life and Photographs,* see *W. Eugene Smith: His Photographs and Notes*, ed. Lincoln Kirstein (New York: Aperture, 1969) and *W. Eugene Smith: Master of the Photographic Essay* (New York: Aperture, 1981).

69 W. Eugene Smith Reference CD Collection, RL10012-CD-1479.

70 The third negative is an image of a jacket draped over a fence, which he appears to have stopped printing in the mid-1970s. VA04.04.09.034.T1, Louis H. Draper Artist Archives (VA-04).

71 The 1964 Supreme Court Decision *Griffith v. Prince Edward County* would finally re-open the schools in Prince Edward County, where the student walkout at Russa Moton High School in 1951 had led to the 1954 *Brown v. Board of Education* decision.

72 J. Lindsay Almond School Integration Speech, January 20, 1959 (WRVA–386), WRVA Radio Collection, Accession 38210, Library of Virginia, Richmond, Virginia.

73 Baldwin specifically recalled seeing the photographs of Dorothy Counts in 1956, but as Lynn Orilla Scott recently pointed out, that event did not take place until September 1957, after he was already in the United States. See Scott's essay "Challenging the American Conscience, Re-Imagining American Identity: Baldwin and the Civil Rights Movement," in *A Historical Guide to James Baldwin*, ed. Douglas Field (New York: Oxford University Press, 2009), 143.

74 "A Hard Kind of Courage" appears as "A Fly in Buttermilk" in Baldwin, *James Baldwin: Collected Essays,* 187.

75 He published the book's namesake, "Nobody Knows My Name: A Letter from the South" in the winter issue of *Partisan Review* in 1959, the year Draper made *Congressional Gathering*. Interestingly, Draper's alternate date for the work ca. 1961 is the year Baldwin republished the essay in the collection of essays, *Nobody Knows My Name.*

76 James Baldwin, "Nobody Knows My Name: A Letter from the South," *James Baldwin, Collected Essays*, 207.

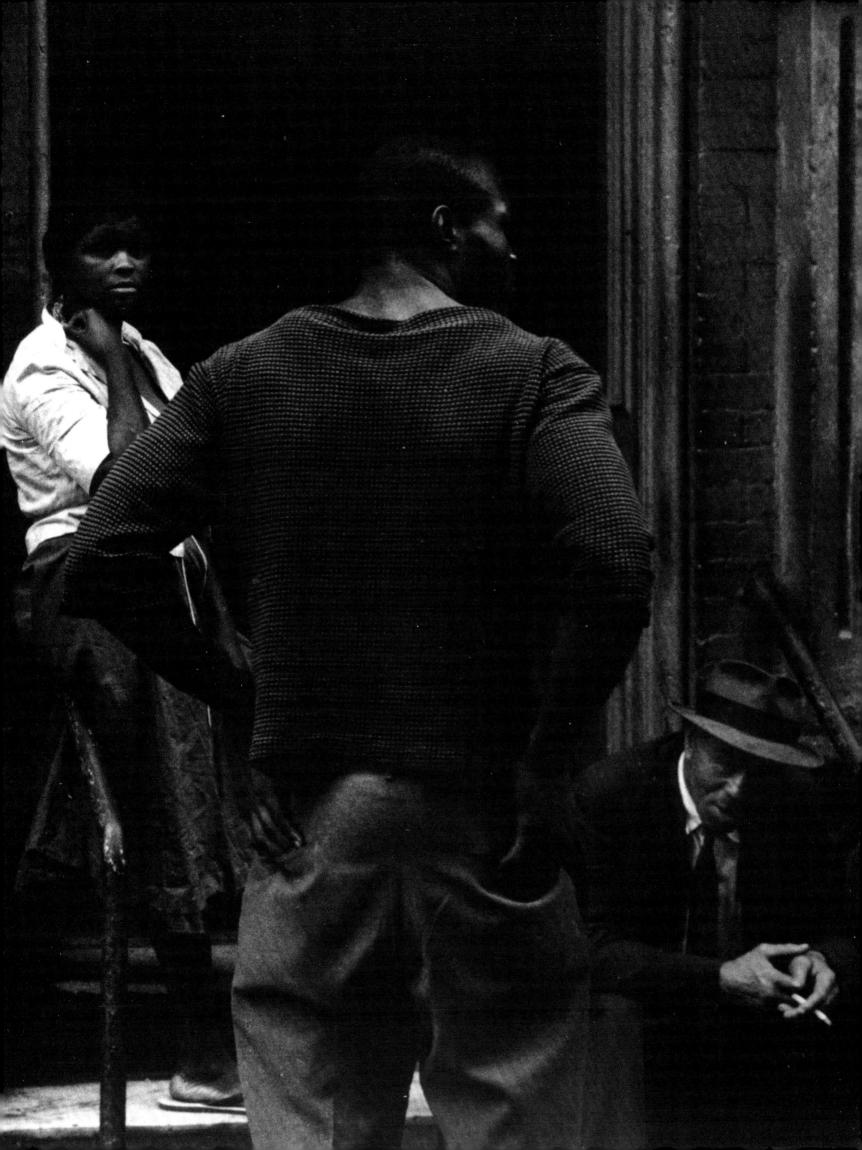

Unlearning Street Photography from the Kamoinge Workshop

BY ERINA DUGANNE

I never gave them indication. Most of them were done anonymously. I don't know that he recognized that I was making the picture. At that time, I was pretty skilled at capturing people unaware of the situation.[1]

—Louis Draper

This statement from Draper about a photograph that he took in the early 1960s of an African American man guiding a hand truck in New York City's Garment District seems to epitomize the art of street photography. [fig. 4.1] Often traced to Henri Cartier-Bresson's foundational concept of the "decisive moment," street photography is said to depend on the speed and mobility of a handheld camera—such as a Leica—which enables, as Cartier-Bresson argued in his 1952 book of the same name, "the simultaneous recognition, in a fraction of a second, of the significance of an event" and the "precise organization of forms which give that event its proper expression" [fig. 4.2].[2]

Another pivotal figure within the history of street photography is Garry Winogrand, whose instinctive and formally fortuitous approach was championed in the 1960s and 1970s by John Szarkowski, the director of the Department of Photography at the Museum of Modern Art (MoMA), as exemplary of modernist art photography [fig. 4.3].[3] However, though he wandered the same New York City streets at the same time as Winogrand, serendipitously taking pictures that would later be edited to find the singular "decisive moment" frame, Draper's photographs are conspicuously absent from the discourse surrounding street photography.[4]

Draper is not the only African American photographer missing from these narratives. Even though Kamoinge Workshop member Shawn Walker has identified street photography as "one of the most important things about the group,"[5] other members of the African American photography collective, of which Draper was a founding member, have also gone unnoticed. What accounts for this oversight? The canonization of street photography as a modernist and, necessarily, realist art practice of spontaneous and chance interaction between a photographer and an urban public space is largely to blame.[6] To explore street photography as more than a series of accidental aesthetic encounters snatched from city life, this essay looks at a selection of images by three members of

the Kamoinge Workshop: Louis Draper, Beuford Smith, and Anthony Barboza. Rather than argue that their photographs should be inserted into the canon, it focuses,

Fig. 4.1 *Untitled,* 1965, Louis Draper (American, 1935–2002). *Museum of Modern Art, Gift of the Kamoinge Workshop (SC1965.2.3) © 2019 Estate of Louis Draper*

Fig 4.2 *Behind the Gare Saint-Lazare*, 1932, Henri Cartier-Bresson (French, 1908–2004). *Museum of Modern Art, Gift of the photographer, by exchange © 2019 Henri Cartier-Bresson/ Magnum Photos*

Left: **48** Louis Draper (American, 1935-2002), **John Henry,** 1960s, gelatin silver print. *Virginia Museum of Fine Arts, National Endowment for the Arts Fund for American Art, 2013.149*

Fig. 4.3 *New York City*,
1968, Garry Winogrand
(American, 1928–1984),
gelatin silver print.
Virginia Museum of Fine Arts,
Gift of an anonymous donor,
82.201.6 © The estate of
Garry Winogrand, courtesy
of Fraenkel Gallery,
San Francisco,

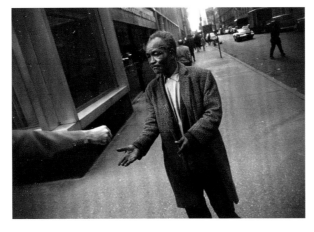

Fig. 4.4 Negatives from
Garment District NYC:
Lincoln Center, 1960–61.
Virginia Museum of Fine Arts,
Margaret R. and Robert M.
Freeman Library, Archives,
Louis H. Draper Archives
(VA-04), Acquired from
the Louis H. Draper
Preservation Trust with
the Arthur and Margaret
Glasgow Endowment Fund,
VA04.04.09.011.T1

more critically, on how they attend to the social and
political dimensions of the street photography that has
been overlooked in most art-historical considerations
of the genre. Its concern, in other words, is how photo-
graphs by the Kamoinge Workshop help us to unlearn
prevailing assumptions about the look and purpose of
street photography.

Constructions

In their introduction to *Bystander: A History of Street
Photography*, curator Colin Westerbeck and photographer

Joel Meyerowitz argue, "Among the properties particular
to the medium that street photography explores and ex-
ploits, by its nature, are instantaneity and multiplicity."[7] In
making this assertion, Westerbeck and Meyerowitz broadly
put forward certain assumptions about street photography
and the medium of photography. For these authors, street
photography—whether a singular frame or a sequence
of more open-ended pictures—is an inherently realist art
medium that emphasizes photography's capacity not only
for speed and mobility but also instantaneity. In making this
distinction, the authors overlook the possibility of the street
offering itself as a site that "could be rendered, not merely
observed,"[8] as photography historian Katherine Bussard
notes in *Unfamiliar Streets: The Photographs of Richard
Avedon, Charles Moore, Martha Rosler, and Philip-Lorca
diCorcia*. Bussard refers to the idea that street photography
is more than a chance and fleeting encounter between a pho-
tographer and an urban subject. Instead, it is a construction
formed as a result of certain creative constraints that a
photographer establishes either in advance of taking the pic-
ture or, in the case of Draper, afterward in the darkroom.

The photograph that Draper took in New York City's
Garment District—a roughly rectangular swatch of
Manhattan between West 35th and 42nd Streets and
Seventh and Ninth Avenues—may have been snapped
anonymously, but its framing was anything but acci-
dental. Draper clarifies, "I really composed these pho-
tographs with a sort of aesthetic integrity. The frame
meant something to me. I didn't always see it. But the
point was to incorporate only those things in the frame
that needed to be there. To be aware of that. It wasn't
random except that sometimes or another I missed
something."[9] In this statement, Draper attests that his
street photographs were the product of intentionality,
not happenstance. He sought out particular subjects,
such as "people at work" in this instance, and carefully
and deliberately framed them to emphasize this theme.
The contact sheet, which includes the full frame of
Draper's photograph, is instructive for understanding
this purpose. In the negative, much more of the urban
setting of the Garment District is visible, including Macy's
department store, as well as shoppers busily crossing
the street. [fig. 4.4] In printing the negative, however,
Draper cropped out most of these details so that the
main focus of the image is the Black subject, whose right
hand holds onto the metal armature of his hand truck.
In so doing, Draper used his street photograph to high-
light the Garment District's African American workers, as
opposed to its commercial products.

Sociologist Roger David Waldinger explains that because of
"competition with skilled white ethnics," African American
men were often forced to work "in relatively low-prestige,
low-paying jobs such as shipping clerks, helpers, and push

boys, who pushed racks of clothes through the streets of the Garment District." While these low-skilled jobs might have once been a way "to learn the rudiments of skilled work, and move up the ladder,"[10] by the early 1960s, when Draper took this photograph, African American men were increasingly looking for work elsewhere. As one Harlem resident told social scientist Kenneth Clark and his Harlem Youth Opportunities researchers around this same time: "You want me to go down to the Garment District and push one of those trucks through the streets and at the end of the week take home $40 or $50 if I'm lucky. Come off it. They don't have animals doing what you want me to do. There would be some society to protect animals if anybody had them pushing these damn trucks around."[11] Yet, despite the hardships of this menial labor job, which had historically not been protected by the unions, Draper's photograph does not convey any of the destitution or debasement mentioned above. Likewise, because the commercial aspects of the Garment District are notably diminished in the picture—even the hand truck is empty of clothes—we are encouraged to see this man, depicted from the chest up, not in terms of his position in the "urban underclass"[12] but as an individual.

Such recognition, however, would have gone unnoticed if Draper had photographed the man serendipitously within the commercialism and spectacle of the Garment District's crowded streets. For us to see this African American laborer as an individual, Draper needed to not only diminish the urban setting, but also to frame the man in a manner that emphasized his psychology. Draper explains, "I didn't want to make them anonymous people pulling carts and so forth. I was trying to get at something about a thought pattern or some internal thing that they were about as individuals." Draper's isolated placement of his subject in the center foreground of his composition, carefully framed by the metal armature of his hand truck, enhances this goal. With coiffed hair, a contemplative look, stylish jacket, and mustache, the Black subject in this photograph cannot be reduced to a nameless and devalued "push boy." Instead, he is an individual with whom Draper invites us to engage with on distinctly psychological not economic terms. Draper continues, "At that time, I was pretty skilled at capturing people unaware of the situation. Not because I wanted to expose anything. In fact, I was looking for the humanistic elements."[13]

A second photograph that Draper also took in the Garment District suggests a similar concern [cat. no. 49]. From the aforementioned contact sheet, it is clear that Draper likewise significantly cropped out the commercial aspect of the Garment District so that the African American laborer forms the main focus of the picture. But unlike the previous photograph, the subject in this image is an older man, his face visibly worn by age, who gazes intently forward, with arms outstretched, as he pushes a hand truck down the

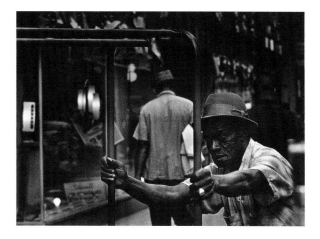

49 Louis Draper (American, 1935–2002), **Untitled (Garment District, NYC),** 1960–61, gelatin silver print. *Virginia Museum of Fine Arts, National Endowment for the Arts Fund for American Art, 2013.148*

street. The more explicit representation of physical labor notwithstanding, because the truck that the man pushes, like the picture itself, is empty of garments, Draper's focus, again, is not the commercial aspects of the Garment District per se but the particularities of the individuals who work on these streets. By tightly cropping his print, Draper encourages us to engage with this man, depicted from the chest up with a stylish fedora on his head, one-on-one. This slowed-down contemplation would be impossible if Draper had represented the fleeting reality of the Garment District, where the individuality of this man would be overshadowed by the spectacle of urban consumerism. By isolating him from the immediacy of the street, Draper reorients our engagement with the subject and encourages us to consider what he may be thinking, dreaming, even yearning for as he partakes in the drudgery of his menial labor work. This kind of psychological encounter was not something that Draper could leave to the haphazard observation mandated by a "decisive moment" approach; rather, its rendering necessitated the tools offered by the darkroom.

Draper's understanding of the significance of the darkroom owes much to his mentor and teacher, photographer Harold Feinstein. In 1958, Draper enrolled in the private workshop, "Esthetics, Techniques and Other Concepts in Photography," Feinstein held in his New York City loft at 747 Sixth Avenue. Feinstein famously taught his students to "photograph where you are involved."[14] In addition to this personal approach, Feinstein imparted to students the importance, as photography critic A. D. Coleman more recently explains, of "the process of printmaking in photography as a creative activity."[15] Here Coleman refers to Feinstein's contribution as both a master printer and experimenter, especially in the darkroom.

The streets of New York City, particularly Coney Island, were Feinstein's frequent subjects in the 1940s and 1950s, when Draper was enrolled in his class. This focus has led many scholars to align Feinstein with the "New York School," a group of street photographers based in the city in the 1930s through the 1950s, who, according to photography curator Jane Livingston, were united in their use of

"the methods of documentary journalism—small cameras, available light, a sense of fleeting and the candid."[16] But like Draper, Feinstein fits uneasily within this group of New York-based street photographers. This incongruity is largely a consequence of Feinstein's belief that photography is an imaginative, not imitative, medium and therefore should not be limited to the transitory subject that lies in front of the camera at the moment of exposure—essentially a "decisive moment" approach. Instead, Feinstein advocated using the darkroom to turn the negative into an expressive print that reflects the artist's unique creative vision.

Feinstein taught his students and wrote detailed tutorials in such periodicals as *Modern Photography* and *Popular Photography* about the creativity of the darkroom printing process, which included not only dodging, burning, and cropping but also photomontage.[17] Feinstein's photograph *Boardwalk Sheet Music Montage, Coney Island* (1950), exemplifies this approach [fig. 4.5]. For the photograph—a slightly different version of which initially appeared in 1952 in Jacob Deschin's influential *New York Times* photography column—Feinstein masked off a series of negatives that he took while walking along the boardwalk of Coney Island.[18] Then, in

Fig. 4.5 *Boardwalk Sheet Music Montage, Coney Island*, 1950, Harold Feinstein (American, 1931–2015). Copyright Harold Feinstein. Photography | haroldfeinstein.com

the darkroom, he printed the frames stacked on top of each other on a single sheet of paper to create the effect of a musical score in which the people become the notes, and the benches and sidewalk railing become the tablature paper. In so doing, Feinstein uses the form, shape, and design of the people sitting and walking along the boardwalk to construct an image of Coney Island as a place that brought individuals of diverse backgrounds together in a harmonious or, in this case, musical whole. Sadly, however, this egalitarian image of Coney Island would not last; not long after Feinstein took this picture, the park increasingly fell into disrepair and racial strife.[19] Draper's effort to construct a humanistic picture of the Garment District's African American laborers was likewise short lived, as he quickly found its streets "too chaotic" and the people who worked there "not all that happy being photographed."[20] Still, even if their subjects were fleeting, there was nothing instantaneous about their approaches to these New York City urban centers.

Abstractions

Because of street photography's assumed immediacy, as well as its fortuitous nature, many consider it a

fundamentally realist art medium. Street photographs, in other words, are by nature documentary. They describe an urban context as it appears in front of a camera, without artifice or artistic intervention. This does not necessarily mean that street photographs are literal representations. They can—as is the case with many of the photographs that Roy DeCarava took in the streets of New York City—function as a system of image-making that works metaphorically. Take DeCarava's seminal 1959 photograph, *Man with portfolio*. [Image can be viewed online at vmfa.museum] Much of the image in this tightly cropped composition is unclear. The only identifying features of the man carrying a portfolio behind his back, as he walks down the street, are his fingertips and the legs of his black trousers. Likewise, all that we see of the woman who walks toward him is one of her legs, a shoe, and some of her patterned dress. Through these meticulously framed fragments, DeCarava asks us to navigate between these two subjects. But, like the abstract reflection on the man's portfolio case, which appears prominently in the center of the composition, their relationship is opaque at best.[21]

Even though the meaning of *Man with portfolio* is ambiguous, DeCarava was adamant that the image itself was realistic. Unlike the abstract compositions of his contemporary Aaron Siskind, many of which depict close-ups of peeling paint and torn posters as well as graffiti that he encountered along the streets of such cities as New York and Chicago [fig. 4.6], DeCarava did not remove the social context from his photographs or tightly crop his subjects so as to eliminate their associative capacities and offer a seemingly pure way of seeing, unconstrained by habit or convention.[22] Though interested in the formal devices of framing and the detail, DeCarava remained committed to photography's *descriptive* potential. This dedication to realism, or to photography as a *representational* image-making system, however, did not come from a desire to establish the medium's aesthetic autonomy, as John Szarkowski would argue, in the 1960s and 1970s, in relation to the street photographs of Garry Winogrand.[23] For DeCarava, this allegiance to photographic description necessarily extended beyond the framing edges of his pictures to the social world and, more specifically, to his experiences living as an African American in the United States. DeCarava explains, "Black people tend to be more realistic about life and don't have the same kind of illusions as other people in this society, so part of the Black aesthetic is that sense of realism."[24]

Here DeCarava echoes a refrain often associated with the artists of the Black Arts Movement (BAM). Attempting to situate themselves as separate from the universally accepted values of the white cultural mainstream, BAM supporters like Larry Neal advocated the development of a "Black aesthetic," which consisted of artworks judged for their social consideration, made for and of Black people

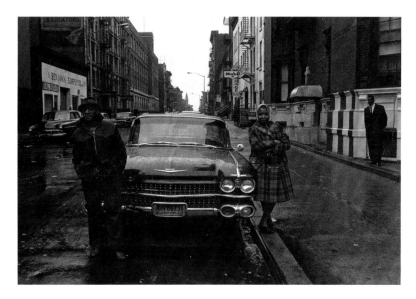

(community), and reflective and supportive of the Black Revolution.[25] Although the artworks of BAM are often assumed to be *representational* in their pursuit of a "Black aesthetic," as African Americanist Margo Natalie Crawford argues in her book, *Black Post-Blackness: The Black Arts Movement and Twenty-First-Century Aesthetics*, BAM artists did not necessarily renounce abstraction.[26] This was not the case for DeCarava, who steadfastly maintained: "Black art deals with the human condition of black people and refrains from abstraction."[27]

During his brief tenure as director of the Kamoinge Workshop, DeCarava's commitment to a Black realist photographic practice, especially one taken up in the street, was influential to many of the workshop's members. Some, like Albert Fennar, even went so far as to emulate this approach. [cat. no. 54] Fennar recalls, "There was one period of time during this period when Roy was with the workshop where I consciously went out and tried to change my approach to photography. I went into the street and photographed Harlem." But, as a photographer who tended to favor abstraction [cat. no. 122], Fennar quickly discovered this realist style "didn't really suit me."[28] Because of this incongruity, there has been a tendency to discuss the photographic practice of the Kamoinge Workshop in terms of the binary of realism and abstraction. For instance, the flyer for their 1972 exhibition at the Studio Museum in Harlem paired a realistic street photograph by Draper with an abstract composition by Fennar. [fig. 4.7] In 1982, artist Carrie Mae Weems perpetuated this division in an interview that she conducted with the editors at *Obscura*, in which she stated, "There was always a battle going on in the group regarding abstraction or realism."[29] Fennar has propagated this rift by saying, "I [was] insulted and told many times that my work is just not

relevant. I remember this one guy whose name I will not mention. He wanted to see Black people. He thought my work was too abstract; it didn't deal with social issues."[30] Besides assuming that abstraction is necessarily anti-Black and, by extension, antipolitical, another consequence of this oppositional framework is that it upholds the conventional belief that for street photography to be political, it must be realist. But, if we look at the role of abstraction within the Kamoinge Workshop more broadly, it becomes clear that this style was never incompatible with a political approach to the street.[31]

Despite the tendency to distinguish the Kamoinge Workshop in terms of either realism or abstraction, the actual practice of many of its members was much more fluid. The workshop's *Portfolio No. 2*—one of Kamoinge's earliest efforts to produce a coherent body of work as a collective— notably included an abstract composition by David Carter [cat. no. 3.2]. Abstract compositions can also be found within the overall practice of other Kamoinge members, including Anthony Barboza, Draper, and Ming Smith. The

Left: Fig 4.6 *New York, 1951*, 1951, Aaron Siskind (American, 1903–1991), gelatin silver print. *Virginia Museum of Fine Arts, A. Paul Funkhouser Fund, 2009.340* © *Aaron Siskind Foundation*

Right: **54** Al Fennar (American, 1938–2018), **Caddy,** 1965, gelatin silver print. Courtesy of *Miya Fennar and The Albert R. Fennar Archive*

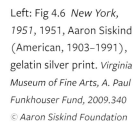

132 Al Fennar (American, 1938–2018), **Salt Pile,** 1971, gelatin silver print. *Collection of Shawn Walker*

Fig. 4.7 Announcement for the Studio Museum in Harlem *The Kamoinge Workshop* exhibition, 1972, *VMFA, Louis H. Draper Artist Archives. Acquired from the Louis H. Draper Preservation Trust with the Arthur and Margaret Glasgow Endowment Fund. VMFA Archives, Richmond, Virginia, VA04.01.3.191*

prominence of abstraction within these members' larger photographic production suggests that for them, this approach represented not a retreat from the social world but, rather, what art historian Darby English described as a form of "aesthetic independence." In his book *1971: A Year of Color*, English argues that for African American modernists working in the late 1960s and early 1970s, the formal experimentation of abstraction "was politically crucial as another way of responding, through art, to pressures in the historical present."[32] Though English's subject matter is African American painting not photography, I would argue that abstraction offered a similar form of artistic freedom to the members of Kamoinge. Working in the same "historical present," when documentary photographs, especially those that circulated in the print media and in books such as Talcott Parsons and Kenneth B. Clark's *The Negro American*, tended to pathologize African Americans as well as depict them in monolithic and overly simplistic terms, abstraction offered "another" way to overcome the claims proffered by such realist representations.[33]

The same holds true for the realism of street photography. Beginning with his tenure as director of the Photography Department at the Museum of Modern Art (MoMA) in 1962, John Szarkowski turned to street photography to set forth the terms for a distinctly modernist form of art photography. For Szarkowski, as he explains in the catalogue to his seminal 1964 exhibition *The Photographer's Eye*, "The central act of photography, the act of choosing and eliminating, forces a concentration on the picture's edge—the line that separates in from out—and on the shapes that are created by it."[34] Given Szarkowski's formalist interest in the medium, it would logically seem that he would be an advocate of abstraction. But, in fact, as photography curator Christopher

Phillips explains in his influential essay "The Judgment Seat of Photography," "Szarkowski's concern with locating photography's formal properties signaled no incipient move toward abstraction. The formal characteristics he acknowledged were all modes of photographic description."[35] This distinction is especially apparent in the street photographs of Diane Arbus, Lee Friedlander, and Garry Winogrand, whose realist style Szarkowski showcased in his influential 1967 exhibition *New Documents* at MoMA. Calling these photographers "new documentarians," Szarkowski supported their images for expanding the vocabulary of photographic description and translating the world into pictures as opposed to furthering a social cause: "Their aim has been not to reform life, but to know it"[36] [fig. 4.3]. For the members of Kamoinge, then, making abstraction a component of their street photography offered "another" way to challenge the limitations set forth by Szarkowski's formalist agenda and especially the ways in which it cut off ties to the social world.

Beginning in the second half of the 1960s, Kamoinge member Beuford Smith began to take tightly cropped photographs of wall posters and peeling paint that he encountered on the streets of New York City [figs. 4.8 & 4.9]. Upon first glance, many of these images resemble the abstract compositions that Aaron Siskind also took along the streets [fig. 4.6]. But though similar in appearance, Smith, like his mentor, Roy DeCarava, did not share Siskind's desire to eliminate the associative capacities of his photographs. In contrast, what mattered for Smith was being able to identify the Black content in these images, whether it was a Yoruba statue or the musical group the Platters. At the same time, unlike DeCarava, Smith did not believe that adopting an abstract approach necessarily diminished the social and political value—or Black aesthetic—of his pictures. In fact, Smith would later align this series of photographs, and especially those he took of hip-hop posters beginning in the 1990s, as exemplary of a Black aesthetic [fig. 4.10].[37] As Smith explains, "what I want to do with that kind of photography is to open up a new genre as far as the black aesthetic goes."[38]

To create these images, however, he needed "another" approach. In his previous street photography, wall posters had been of no interest to him. This indifference was not from his lack of seeing these objects but rather because he was looking at them realistically. Smith explains, "I was never interested in photographing posters. Al Fennar changed my way of thinking, to considering them abstractly." Here Smith attests to the importance of Fennar's abstract approach for changing the terms of his street photography practice. Smith continues, "Fennar really influenced me in terms of abstract photography. He has really played an important part in my photography in terms of those kinds of photographs. When I take abstract images, Al Fennar is looking over my shoulders."[39] For Smith, then, the formalism of abstraction offered an artistic freedom or "another" way of looking at

his urban surroundings and their Black content. Abstraction also, most significantly, gave him "another" means to contribute to the Black aesthetic as a category that is necessarily open, individual, and experimental in nature. As Smith reiterates: "The black aesthetic for me comes from my culture and background. I came from the Midwest thirty years ago. My uncle had a farm and I used to milk cows. I don't know if that comes across in my pictures, but I hope it does."[40]

Fictions

Beside a realist approach of spontaneous and chance interaction, street photography has also been defined as a fine art practice. Many use the qualifier *fine art* to distinguish street photography from both documentary photography's evidentiary and sociopolitical tendencies, as well as the illustrative purposes of photojournalism. The positioning of street photography as a fine art was equally important for members of Kamoinge. However, they did not evoke this distinction because "their primary goal," as photography curator Lisa Hostetler writes about the genre, "is expressive and communicates a subjective impression of the experience of everyday life in a city."[41] For the Kamoinge members, making art photography was decidedly political. This is because, in 1960s and 1970s when they were photographing in the streets of New York City, there was a general dearth of representations of African Americans, both

so-called non-art photography and, most especially, fashion photography. Because fashion photographs are understood to have only a commercial value—their principal function is the display or selling of clothes and accessories—these pictures are largely absent from the history of street photography.[43] Yet, if we explore street photography as not only a realist art practice of spontaneous and chance interaction but also as a series of fictions that have been deliberately posed in the street, a richer dialogue and more dynamic discourse begins to emerge with respect to the genre's political function. The fashion photographs that Kamoinge member Anthony Barboza took for *Essence* magazine in the streets of Harlem are central to this reconfiguration. [fig. 4.11]

Barboza began to work for *Essence* shortly after its launch in May 1970. One of his earliest fashion shoots for the magazine was called "Rappin'." Published in *Essence* in 1971, the two-page spread includes a series of seven photographs that Barboza took of a group of men attempting to pick up two women leaving the Baron Lounge Jazz Club at 132nd Street and Lenox Avenue in Harlem. For this shoot, Barboza directed the models, all sharply dressed in name-brand attire and accessories, to act out a sequential narrative of a group of men gathered on the street, who notice two women leaving a jazz club and attempt to pick them up as they walk by. But rather than stage this social interaction in a studio setting, he had the models act out the scene in the actual

Left: Fig 4. 8 Beuford Smith (American, born 1941), *Dizzy Izzy*, 1969, gelatin silver print. *Virginia Museum of Fine Arts, National Endowment for the Arts Fund for American Art, 2019.246* © *Beuford Smith/ Césaire*

Center: Fig 4.9 *The Platters*, 1970, Beuford Smith (American, born 1941), gelatin silver print. *Courtesy of Beuford Smith* © *Beuford Smith/Césaire*

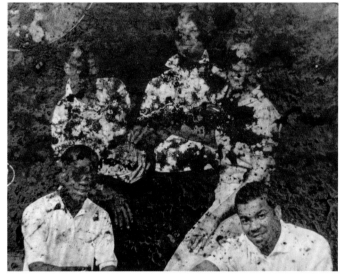

in the mainstream mass media and in the fine art world. In addition to this invisibility, when African Americans were represented, especially within the tradition of documentary photography, these images tended to depict African Americans, as Carrie Mae Weems explains, using the example of photographer Bruce Davidson's controversial 1970 MoMA exhibition *East 100th Street,* "as hopeless, powerless victims who are socially and economically depressed."[42]

Still, one of the problems with insisting that street photography is a fine art, is that it obscures the political potential of

streets of Harlem so that the images, taken "on the fly,"[44] in the words of Barboza, appear more relatable to the readers of *Essence*. The caption, which appears as the eighth image in the sequence, reiterates this intent. Written from the point of view of the men, the text not only colorfully describes their actions and thoughts—"Hey, let's hit on them two sisters before they get away. What you mean? You know they got to dig on us 'cause we're lookin' mighty fine"—but also what designer clothes they and the women are wearing, where these items could be purchased, and at what cost. In so doing, the text works to heighten the

Right: Fig. 4.10 *Nephertiti*, 1985, Beuford Smith (American, born 1941), gelatin silver print. *Virginia Museum of Fine Arts, National Endowment for the Arts for American Art, 2019.248* © *Beuford Smith/Césaire*

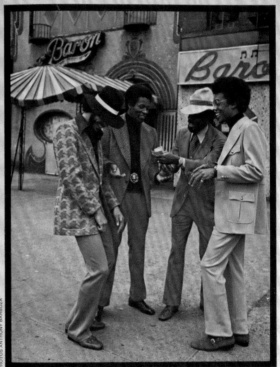

PHOTOS ANTHONY BARBOZA

RAPPIN'...

Hey, man, you know the difference between a white street corner and a black street corner? Well, theirs is mainly for crossin', and ours is mostly for laying back in the cut clee-e-an, watchin' them fine mamas swivelin' by, and doin' a whole lot of rappin'. Look at my man (far left) togged down in his Bill Blass vines—grey, beige, and navy sports jacket with greige duck pants and navy cotton snap–front shirt. Jacket and pants, $125. At Bonwit Teller, New York; I. Magnin, all stores; Scarborough's, Austin/Highland, Texas. What about the brother there (center left)? He ain't short-stopping in his uncut cotton cord printed jacket, $85, and slacks, $30, by Eagle. At B.& B.Lorry's, Jamaica, N.Y.; Kosin's, Detroit; Howard's, San Francisco. And, my main man (far right)—he don't play, got himself one of them Treviera Polyester knit suits so if it rains, he won't be shame. Suit for Cricketeer by Joseph & Feiss, $85. At Abraham & Straus, Brooklyn; Carson, Pirie, Scott, Chicago; Gordin's, Los Angeles. And then there's me—what more can you say when you're ready? I call this my "Deuce and a Quarter plus Ten," out of Cercutti flannel with a vest. Now ain't that class? Suit by Ralph Lauren for Polo, $235. Shirt's by Polo, too; $25. At Bloom-ingdale's, New York; Neiman Marcus, Dallas; Polo Shop, Beverly Hills. Yeah, man . . . we definitely some clean muthas! Shoes, tie, and belt by Bill Blass. Socks by Royce. Sweaters by Merrill Sharpe. Hats by Dimitri of Italy.

Fig. 4.11 *"Rappin'" series,*
Essence magazine, August 1971,
photographs by Anthony Barboza.

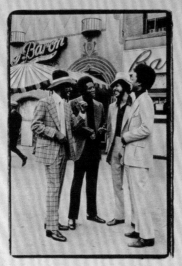
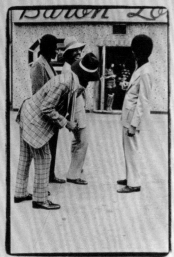
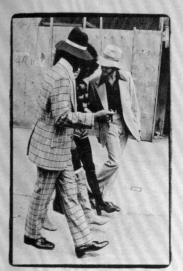
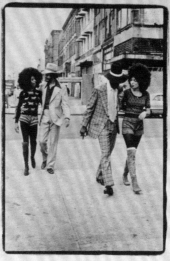
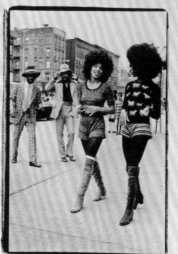
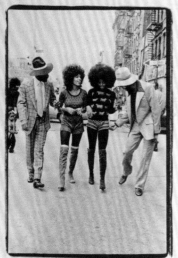
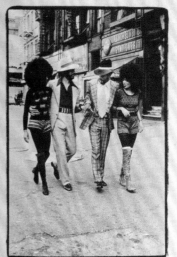

...and more RAPPIN'! O-o-oh wh-e-e! I just knew if we hung out long enough some fine little hot pants wearin' mamas would come this way! Check them two just comin' out of the Club Baron. Wonder if the're any more like them inside . . . probably turnin' on to the soulful sounds the Baron always has to offer. Yeah, I know. Ain't Irene Reid there this week? She sure is heavy. You gotta dig on her new side; get it man, it'll put you in a mellow, mellow groove. Hey, let's hit on them two sisters before they get away. What you mean? You know they got to dig on us 'cause we're lookin' mighty fine—Bill Blass-ing it all the way: your two-piece boss plaid tweed (and that vest you left at the pad), $195. And my ba-a-d navy and cream plaid, single-breasted job with straight cut pants, $175. At Bonwit Teller, New York; I. Magnin, all stores; Scarborough's, Austin/Highland, Texas. Yeah man, they're definitely diggin' on us. Hats by Dimitri of Italy. Socks by D'Orsay. All other accessories by Bill Blass.

I'll take the one in the animal print sweater and striped shorts. Boots by Olaf Daughters. Ain't she fine? Yours ain't bad either, brother; them hot pants and Aztec print sweater sure fittin' where they supposed to. Boots by Famolare. Hot pants sets by Great Times. Hair and makeup by Nila Viyela. O.K., which one you like? Me, this mama here suits me fine. Let's stroll back on down to the Baron and catch a little more of Irene before we tighten up these sisters for real! It can't be wrong 'cause it sounds so-o-o righteous.

reader's identification with and desire for the lifestyles acted out in Barboza's fashion photographs. As photographer Michael Edelson explains in an article about the "unreal actuality" of Barboza's fashion photographs: "Advertising photography is the creation of the reality of a non-real world for which we can all strive…. The job of the photographer is to make the unreal reasonably real and certainly within grasp of all."[45]

Though other fashion photographers, including Richard Avedon, have staged their images in the street, Barboza came to this approach largely through his involvement with the Kamoinge Workshop. As Barboza reflects: "Because the members of Kamoinge were mainly street photographers before they went into other areas, that's how I came up with the idea."[46] But Barboza, who recalls being "basically very shy when I was a kid,"[47] always had trouble with the implicit aggressiveness of this approach. Staging his street photographs offered a way to overcome having to approach people anonymously in the street. More importantly, it presented "An unapologetic demonstration of street photography as a controlled art," as Bussard explains with respect to Avedon's work, "one that necessarily requires us to reconceive the work's process and eventual context."[48] It is indeed the context of *Essence* that gives Barboza's staged street photographs their political import.

Essence was launched with the promise to be "from a Black perspective" and to "delight and to celebrate the beauty, pride, strength, and uniqueness of all Black Women."[49] For the first three years of its publication, at least, this narrative about African American womanhood was "very much influenced by and engaged with," as interdisciplinary scholar Noliwe Rooks explains, "the cultural and political movements that called for Black power."[50] Barboza's 1971 fashion spread "Rappin'" aligns with this political agenda. The attractive young female models, whom Barboza selected for his shoot, both wear their hair in Afros. This hairstyle, which became symbolic of revolutionary Black womanhood, especially through the activist figures of such Black Panther Party members as Kathleen Cleaver and Angela Davis, would have served to build self-esteem in readers by functioning "as a corrective to mainstream media images," as Black feminist scholar Kimberly Nichele Brown explains, "that either disregarded or denigrated the beauty of black women."[51] At the time of Barboza's fashion spread, African American women appeared only rarely, if at all, in white publications. Moreover, when they were depicted, it tended to be in terms of the oppressive and demoralizing stereotypes of the mammy, the matriarch, the sexual siren, and the welfare

mother or queen.[52] In staging his fashion photographs on the streets of Harlem, Barboza challenged these mainstream constructions of Black female identity by making readers feel that they, too, could be "revolutionary."

In challenging mainstream stereotypical depictions of Black womanhood, Barboza's "Rappin'" without a doubt empowered as well as emboldened African American women. At the same time the fashion spread celebrates black womanhood, it also falls prey to contradictions within Black nationalism and particularly the renegotiation of African American gender relations that occurred alongside the rise of Black power in the 1960s and 1970s. This inconsistency is most apparent in Barboza's posing of his models. With the exception of the first still, in which the men converse with each other on the street, the main focus of the men's attention in the subsequent six stills is the two attractive women who leave the jazz club and walk down the street. While this beholding serves to celebrate Black womanhood, there are moments when this affectionate look veers on objectification. This slippage is most apparent in the second and third stills when the women appear unaware of the men's singular gaze as well as in the fourth still when one of the men reaches out to touch the shorts of the female model who walks next him. Barboza most certainly intended these actions to glorify Black women. Still one cannot help but ask whether this gendered looking also addresses certain ambiguities within Black female nationalism that tended to uphold rigid constructions of masculinity and femininity by portraying Black womanhood as a necessary (and frequently sexualized) accessory to Black manhood.[53]

This inconsistency within Barboza's sequence of photographs attests that his images hold more than commercial value. They not only sold clothes but opened a space in which the intricacies of a Black nationalist womanhood could be debated. This awareness would be lost, however, if fashion photography is excluded from the genre of street photography. To understand more fully the social and political ramifications of street photography, especially in relation to the gender politics of Black nationalism, we need to acknowledge these fictional realities as much as the actual realities that transpired along New York City's streets. Together, then, these constructed, abstracted, and fictional photographs by the Kamoinge Workshop tell a more complicated story about African American encounters on the street, one that exceeds rather than depends on the instantaneity and immediacy of the "decisive moment" as well as the instinctual and modernist snapshots celebrated in street photography's aestheticized canon.

Endnotes

1 Louis Draper, telephone interview with the author, October 29, 2001.

2 Henri Cartier-Bresson, introduction to *The Decisive Moment* (New York: Simon and Schuster, 1952). The original French edition is *Images à la sauvette* (Paris: Verve, 1952).

3 See John Szarkowski, *Winogrand: Figments from the Real World* (New York: Museum of Modern Art, 1988).

4 Additional correlations between Draper and Winogrand include both being featured in exhibitions at Larry Siegel's gallery Image, which was open in New York City from 1959 to 1962, and, in 1973, both receiving awards from the Creative Artists Public Service grants program. Notably Draper's photographs were not included in the 2014 exhibition *The Image Gallery Redux: 1959–1962, held at the Howard Greenberg Gallery in New York.*

5 Shawn Walker, "Preserving Our History: The Kamoinge Workshop and Beyond," *Ten.8* 24 (1987), 24.

6 Major monographs on postwar street photography include Colin Westerbeck and Joel Meyerowitz, *Bystander: A History of Street Photography* (Thames and Hudson, 1994); Kerry Brougher and Russell Ferguson, *Open City: Street Photography since 1950* (Oxford: Museum of Modern Art, 2001); and Lydia Yee and Whitney Rugg, eds., *Street Art, Street Life* (New York: Aperture, 2008).

7 Westerbeck and Meyerowitz, *Bystander*, 34.

8 Katherine Bussard, *Unfamiliar Streets: The Photographs of Richard Avedon, Charles Moore, Mart ha Rosler, and Philip-Lorca diCorcia* (New Haven: Yale University Press, 2014), 150.

9 Draper, interview with author.

10 Roger David Waldinger, *Still the Promised City? African Americans and New Immigrants in Postindustrial New York* (Cambridge: Harvard University Press, 1996), 147; see also Daniel Soyer, ed., *A Coat of Many Colors: Immigration, Globalization, and Reform in New York City's Garment Industry* (New York: Fordham University Press, 2005).

11 Kenneth B. Clark, *Youth in the Ghetto* (New York: Harlem Youth Opportunities Unlimited, Inc., 1964), 16–17.

12 For a good overview of this term, including its controversies, see Christopher Jenks and Paul E. Peterson, eds., *The Urban Underclass* (Washington, DC: The Brookings Institute, 1991).

13 Draper, interview with author.

14 Harold Feinstein, "Harold Feinstein," in *U.S. Camera Annual 1958* (New York: U.S. Camera Publishing, 1957), 116. Draper discovered Feinstein's workshop through an advertisement in Jacob Deschin's photography column in the *New York Times*. See Jacob Deschin, "Courses," *New York Times*, February 2, 1958, X20.

15 A.D. Coleman, "Seeing the Life in Which We Live: The Photographs of Harold Feinstein," *Photo Technique: Variations on the Photographic Image* 34, no. 5 (September/October 2013): 40.

16 Jane Livingston, *The New York School: Photographs, 1936–1963* (New York: Stewart, Tabori and Chang, 1992), 259.

17 See Harold Feinstein, "How and Why Three Photographs Became One," *Modern Photography* (June 1957): 55–62; and Harold Feinstein, "How Creative Printing Transformed THIS into THIS," interview with John Durniak, *Popular Photography* (October 1957): 86–91.

18 See Jacob Deschin, "Music Score," *New York Times*, September 7, 1952, X15.

19 For more on the history of Coney Island, see Louis J. Parascandola and John Parascandola, *A Coney Island Reader: Through Dizzy Gates of Illusion* (New York: Columbia University Press, 2015).

20 Draper, interview with author.

21 For more on this photograph and Roy DeCarava's metaphorical approach to photography, more broadly, see, Erina Duganne, *The Self in Black and White: Race and Subjectivity in Postwar American Photography* (Hanover, NH: University Press of New England, 2010).

22 For more on Aaron Siskind's abstract photography, including its relationship to his documentary practice, see Carl Chiarenza, "Form and Content in the Early Work of Aaron Siskind," *The Massachusetts Review* 19, no. 4 (Winter 1978): 808–33; Deborah Martin Kao and Charles A. Meyer, eds., *Aaron Siskind: Toward a Personal Vision, 1935–1955* (Chestnut Hill, MA: Boston College Museum of Art, 1994); and Joseph Entin, "Modernist Documentary: Aaron Siskind's Harlem Document," *Yale Journal of Criticism* 12 , no. 2 (1999): 357–82.

23 See, for instance, John Szarkowski's 1967 exhibition *New Documents: Diane Arbus, Lee Friedlander, Garry Winogrand* and his 1978 exhibition *Mirrors and Windows: American Photography Since 1960.*

24 Roy DeCarava, interview with Joe Walker, in *The Black Photographers Annual, Volume 3,* (Brooklyn, NY: Black Photographers Annual, Inc., 1976), 63.

25 Steeped in the politics of Black Power, BAM represented the cultural wing of African American liberation struggles in the 1960s and 1970s; see Addison Gayle, ed., *The Black Aesthetic* (New York: Anchor Books, 1971) and LeRoi Jones and Larry Neal, eds., *Black Fire: An Anthology of Afro-American Writing* (New York: William Morrow, 1968).

26 See Margo Natalie Crawford, *Black Post-Blackness: The Black Arts Movement and Twenty-First Century Aesthetics* (Urbana: University of Illinois Press, 2017).

27 DeCarava, in *The Black Photographers Annual*, 64. Although DeCarava advocated a realist approach, his exploration of a "Black aesthetic" in his photographic practice took up both the collective and individual aspects of African American identity; see Erina Duganne, "Transcending the Fixity of Race: The Kamoinge Workshop and the Question of a 'Black Aesthetic' in Photography," in *New Thoughts on the Black Arts Movement*, ed. Lisa Gail Collins and Margo Crawford (New Brunswick, NJ: Rutgers University Press, 2006), 187–209.

28 Albert Fennar, interview with the author, March 22, 2001.

29 Carrie Weems, "Personal Perspectives on the Evolution of American Black Photography: A Talk with Carrie Weems," *Obscura* 2, no. 4 (1982): 12.

30 Fennar, interview with the author.

31 Although made before the founding of the Kamoinge Workshop, Louis Draper's 1959 photograph, *Congressional Gathering* is yet another example.

32 Darby English, *1971: A Year in the Life of Color* (Chicago: University of Chicago Press, 2016), 140.

33 Published in 1966, *The Negro American* included thirty-two photographs by Bruce Davidson. Arranged in four groups of eight images, each group was intended to describe a different aspect of African American people and culture: what they look like, the conditions under which they live, how they make a living, and their involvement in the civil rights movement. For more on Davidson's photographs, see Duganne, *The Self in Black and White.*

34 John Szarkowski, *The Photographer's Eye* (New York: Museum of Modern Art, 1966), 9. Szarkowski further develops his formalist agenda in his, *Looking at Photographs* (New York: Museum of Modern Art, 1973); John Szarkowski, "A Different Kind of Art," *New York Times Magazine*, April 13, 1975, 16, 64–68; and Szarkowski, *Mirrors and Windows.*

35 Christopher Phillips, "The Judgment Seat of Photography," *October* 22 (Autumn 1982), 57.

36 John Szarkowski, *New Documents* [unpublished wall label], 1967, Exhibition Files, Museum of Modern Art Archives, New York. Though considered by many a landmark exhibition today, no catalogue was produced at the time. On its fiftieth anniversary, the Museum of Modern Art published *Arbus Friedlander Winogrand: New Documents, 1967* (New York: Museum of Modern Art, 2017), further cementing its canonical status.

37 In 1998, Beuford Smith received an Aaron Siskind Foundation grant for his wall poster series.

38 Beuford Smith, interview with Lou Draper, January 17, 1999, in *Artist and Influence*, ed. James V. Hatch, Leo Hamilton, and Judy Blum (New York: Hatch-Billops Collection, 1999), 18:164.

39 Beuford Smith, interview with the author, March 1, 2001.

40 Smith, *Artists and Influence*, 164.

41 Lisa Hostetler, "Street photography," *Grove Art Online*, January 22, 2014, https://doi.org/10.1093/gao/9781884446054.article.T2254150.

42 Weems, "Personal Perspectives," 17. For more on Davidson's East 100th Street, see Duganne, *The Self in Black and White.*

43 Katherine Bussard's discussion of Richard Avedon in her, *Unfamiliar Streets*, is a notable exception and has provided an important model for my argument.

44 Anthony Barboza, "Anthony Barboza in Conversation with Bill Gaskins," *Nka Journal of Contemporary African Art* 37: (November 2015): 19.

45 Michael Edelson, "The Four Faces of Barboza," *35mm Photography* (Spring 1977): 47.

46 Barboza, "Anthony Barboza in Conversation," 19.

47 Anthony Barboza, "Barboza: The Music of Ourselves," interview with Val Wilmer, *Ten.8* 28 (1988): 26.

48 Bussard, *Uncertain Streets*, 21.

49 "Publisher's Statement," *Essence Magazine*, May 1970, 13. *Essence*, however, was not the first popular magazine for African American women. See Noliwe Rooks, *Ladies' Pages: African American Women's Magazines and the Culture That Made Them* (New Brunswick: Rutgers University Press, 2004).

50 Rooks, *Ladies' Pages*, 144.

51 Kimberly Nichele Brown, *Writing the Black Revolutionary Diva: Women's Subjectivity and the Decolonizing Text* (Bloomington: Indiana University Press, 2010), 73. In addition, the inaugural issue of *Essence* featured both a cover model who wears an Afro as well as an article entitled "Dynamic Afros."

52 For more on these stereotypes, see Jacqueline Bobo, *Black Women as Cultural Readers* (New York: Columbia University Press, 1995). For their relationship to *Essence*, see Jennifer Bailey Woodard and Teresa Mastin, "Black Womanhood: 'Essence' and its Treatment of Stereotypical Images of Black Women," *Journal of Black Studies*, 36, no. 2 (November 2005): 264–81.

53 For more on these contradictions, see Brown, *Writing the Black Revolutionary Diva.*

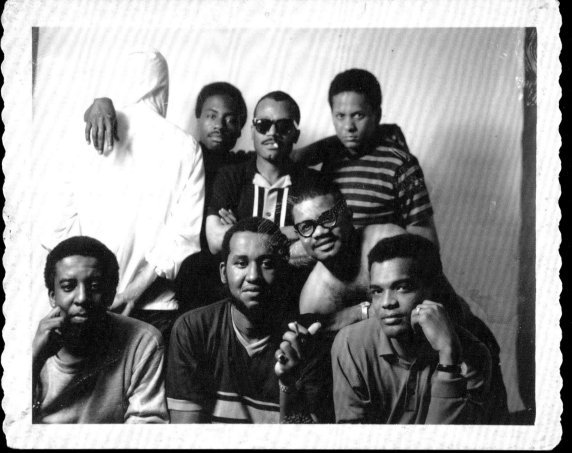

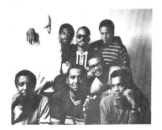

AN EXHIBITION

OF PHOTOGRAPHS

BY THE

KAMOINGE WORKSHOP

and guests

opening July 20,1966 7 PM 9PM

JULY 20 TO AUGUST 19

MON. & WED. 12:30 TO 9PM

TUES. & THURS. 9 AM TO 6 PM

FRI.12:30 TO 6 PM

Countee Cullen Library 604 west 136th st.(bet. 7th&lenox ave.)

Reading Between the Photographs: Serious Sociality in the Kamoinge Workshop

BY ROMI CRAWFORD

A fundamental and timely question emerges alongside the task of interpreting the Draper/Kamoinge archival materials. What exactly is the art historical and cultural significance of the Kamoinge Workshop? This is one of the questions that propels the formal production of the Draper archive at the Virginia Museum of Fine Arts, as well as the making of the *Working Together* exhibition, both of which initiate the first comprehensive investigation of the phenomenon that was the Kamoinge Workshop.

The amassed photographs, letters, meeting notes, interviews, documents, and ephemera that make up the archive and the exhibition beg close and rigorous consideration because, in addition to the artistic output, these items undergird the Kamoinge experience and are crucial to interpreting its import. The documents delineate an inextricable connection between the Kamoinge Workshop's art historical merit and its social values, which were not organized solely around race. Rather, Kamoinge is a Black collective of the 1960s and '70s that declares and evidences a versatile sense of sociality as part of their potential. It mattered that this group of Black photographers worked collectively not because of the implied shared ethics, but because they derived pertinent genres of sociality—social processes and practices, variously formal and informal, that they took seriously and that were crucial to their evolution and productivity as artists. Black art collectives such as Kamoinge often expose such a *serious sociality* and are born in moments when the desire and need to produce, regardless of mainstream validation or recognition, is overwhelming.

In this essay, serious sociality is the looming interrogatory prompt. It concerns Kamoinge's ability to produce an art sphere by and for themselves through the process of collective endeavors—creating exhibitions, group shoots and critiques, portfolio reviews, a gallery space, and publications. As such, the archive materials and firsthand accounts by artists who comprised Kamoinge serve as the primary means to consider the workshop's unique significance as a collective. Privileging the Draper archival materials and *Working Together* oral histories in this way brings new insight and helps to discern the group's acuity, especially in regard to two aspects of their artistic practice. First is their commitment to

collectivity, evidenced through the founding of the Kamoinge Workshop and the modes of serious sociality, especially those that are pedagogical, entrepreneurial, and fraternal, which follow from this project. This even informs their name, which is the East African Kikuyu word for "a group of people acting together." Second is their in-take and embrace of other artistic media and varied art traditions. Kamoinge offers an informative example of openness or expansiveness—their interest in other art forms, histories, cultures, and genders, as a condition or an a priori of Black collective practice, debunks quick and naïve assumptions about the conceptual limits of Black collectives and Black collectivizing. In effect, the Kamoinge group had a built-in obligation to a wide-ranging perception of a Black aesthetic and social possibility. While Kamoinge was a collective of photographers descended from Africans, what they drew from was not predicated on formal or cultural restraints. It is instructive that Black collectives such as Kamoinge are more open and responsive than they are often perceived to be. The group had a wide-ranging set of preoccupations and interests; some were direct and clear engagements with African American culture, but this did not constitute a boundary for what they absorbed and drew from in their pursuit of a Black photographic aesthetic.

Also at stake in this essay is Kamoinge's gender dynamic. Though populated by men, the group invited a woman—Ming Smith—to join the group within several years of its inception. While the Black men who comprised the first iteration of the Kamoinge Workshop expressed their sense of fraternity, gender inclusion followed from and was a signpost of their adaptability.

Group Shoots, Group Critiques, and Other Ways of Knowing

In a 2001 interview with Erina Duganne, Kamoinge member Albert Fennar recounts a group shoot:

> I remember one time when we rented a van. I can't remember all the people who went, Louie, Shawn, and we drove to a town, Kingston, New York, and we got out of the van and walked around and took

Fig. 5.1 Group Portrait, 1965-66, Polaroid photograph. *Virginia Museum of Fine Arts, Margaret R. and Robert M. Freeman Library, Archives, Beuford Smith Archives (SC-32), Gift of the Beuford Smith Collection, SC32.01.0.003*

Fig. 5.2 Announcement for *Perspective* exhibition at Countee Cullen Library, 1966. *VMFA, Louis H. Draper Artist Archives (VA-04). Acquired from the Louis H. Draper Preservation Trust with the Arthur and Margaret Glasgow Endowment Fund. VMFA Archives, Richmond, Virginia, VA04.01.2.004*

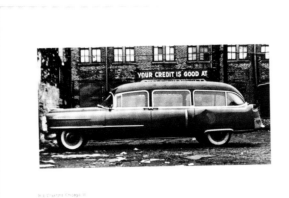

Fig 5.3 Page 30 from *The Black Photographers Annual*, Volume 2. Photo by Bob Crawford (American, 1939–2015). *The Black Photographers Annual, Volume 2, 1974, Virginia Museum of Fine Arts Library, 30804005685978*

photographs of this town. We got chased out of that town too. People saw this group of five or six guys running around with cameras shooting houses and people and stuff and they called the cops. And the cops came.[1]

The dramatic outcome of this group shoot, with the arrival of the cops, may have preempted its intent. Shawn Walker, a founding and ongoing member of Kamoinge, also recounts shoots that occasionally took place after Kamoinge meetings, when several of the photographers, most of whom lived in Harlem at the time, would venture out to take images together. Shooting in concert such as this perhaps would be the apotheosis of a collective photography practice, but it was rare, and some members have no recollection of taking part in such outings.[2] The group shoot, however infrequent, is an important Kamoinge mytho-type nonetheless. Couched in it are expectations of a collective photo-making practice ultimately challenged by the troubling reality in 1970 (and the present) for Black men mobilizing as a group in public space, much less with cameras, carefully eyeing persons or things. In the case of Kamoinge, the group shoot is a mytho-construct, more concept than reality perhaps. It offers a critique of the prevailing societal mores with an imagining of Black collectivizing in the effort to make art that was as impractical (socially) as it is hopeful.

Other aspects of the Kamoinge meetings, during which members would variously vote on new members, critique prints, discuss work and assignments, eat, drink wine, listen to jazz, and decide upon next steps for exhibitions and networking, also speak to the level of committed communality in Kamoinge. Above all, the act of offering critiques

of each other's work stands out as "a very important part of the meeting." A member recounts, "The meeting was for that. People would share what they were doing." Often the feedback was so passionate that there was "criticism and fights and insults."[3]

The Kamoinge workshop formalized their methods and procedures for working together more fervently than other Black photography cohorts and schools. For example, the Black photographers in Chicago, sometimes referred to as the Chicago School, had a similar focus on Black culture during the late 1960s and '70s.[4] Several of them—Billy Abernathy, Bob Crawford, Robert Sengstacke, and Ted Gray—were included in issues of the *Black Photographers Annual* produced by Kamoinge members [fig. 5.3]. They often shot at the same locations and occasions (such as the Bud Billiken Parade and the Wall of Respect) in Chicago, but were a looser, more informal cohort than a clearly defined collective as Kamoinge was.

Kamoinge, on the other hand, had a more veritable structure. They met on Sundays—often for much of the day—paid dues, took meeting notes, established policies, voted on decisions, etc.

Meeting notes from 1964 reveal the simultaneously casual and official management style of the group. Simple handwritten jottings served as a formal record of their financial obligations, gallery protocols, and guest policies. Meetings were laid back; they had a conscious intention to manufacture comradeship even as they navigated the professional, aesthetic, and technical aspects of a photography practice. Collectivizing was their strategy to combat what Draper described as their isolation and exclusion within the field at large. He states, "There was an expectancy for exchange and a curiosity borne of isolation and exclusion. Somehow we all knew that this kind of association was essential as a means of being strengthened against the indifference of established photographic institutions."[5] Notes found in Draper's archive, which reveal vote tallies and indicate the members' standing vis-à-vis dues and active involvement, also attest to the Kamoinge Workshop's function as a formal collective at the level of decision and policy-making. Such machinations point to Kamoinge's business or entrepreneurial edge, an aspect of their sociality that led to their opening a gallery space, creating portfolios, and their involvement in publishing the *Black Photographers Annual*.

The nonbusiness, artistic, aspects of Kamoinge aspired towards formality as well. Several members speak of an assignment of sorts from the well-respected Black photographer Roy DeCarava. DeCarava, an early member of Kamoinge, who resigned and stopped attending the Sunday workshops in 1965, gave the group the assignment of responding to the poem *Final Man*, by Jamaican poet Basil

McFarlane, through the medium of photography.[6] In addition to this erudite formal prompt, there were printing tutorials, often with Lou Draper, a master printer of the group. They also set aside time for critiques of each other's work and portfolios that were passionate and hard hitting. This type of formal pedagogical guidance, which they shared with each other on matters of aesthetics and technique, was so profound that Shawn Walker likened it to studying at the "finest university of art that you could go to."[7] Anthony Barboza also notes that "for me my college was Kamoinge."[8] For many of the Kamoinge members who did not attend college or art school, the workshop setting served as an important intellectual and scholarly space, where they set the agenda for a bespoke curriculum, determining what they needed to know and how best to attain that knowledge.

The Kamoinge Workshop was envisioned with significant learning as well as social functions built into it. Its official name, privileging "workshop" over association or alliance reinforces this. It was also predicated on real, if not perfect, relationships, which meant adapting to the skill sets and deficits of the various members—filling gaps in knowledge, sharing technical skills, offering criticism, making do with the materials on hand, etc. Lou Draper, one of the group's more skilled darkroom technicians, was known to have trained many of the members in printing techniques, often working on the floor where he had his enlarger. Ming Smith remembers how he once helped her create a makeshift negative holder from torn pieces of cardboard, which ushered in her signature "raggedy edge" style.[9] [cat. no. 112] The pedagogical and critique methods honed in the collective encouraged the Kamoinge photographers to both adapt to and experiment with their limitations, both social and material. Often, as in the case with Ming Smith, the innovations derived from such trials gave the members' work a unique imprint and helped it stand out.

Fennar, like Walker, confirms the extent to which the Kamoinge Workshop created a supportive learning environment.

> Besides being in this group we also saw each other in-between meetings and that's when a lot of the technical information was shared. And certain members had a wider knowledge of the technical aspect of photography than others and certainly Ray Francis was one of those people. He was like a walking encyclopedia of technical. He would give us formulas for developers and stuff like that. He knew what he was talking about. I learned a lot of stuff from him. Louie was another person who knows about the technical. But I don't think that we took up a lot of time at the meetings with the technical stuff.[10]

The pedagogical, or the school piece, was another dimension of Kamoinge's serious sociality, as was the entrepreneurial. The Kamoinge Workshop, which many of the photographers described as engendering a sense of brotherhood, family, and comradery, was also about the business of making photography shows and opening galleries or learning photographic techniques.

Draper, in his brief history of Kamoinge published in the December 1972 Photo Newsletter of the James Van DerZee Institute (see pp. 2–7), describes the scene of the early Kamoinge meetings:

> Four photographers were all that made up the original Kamoinge Workshop. It was 1963. We had come together in a rather relaxed atmosphere: our Sunday evenings usually consisting of well-blended John Coltrane, Brilliante wine, stewed chicken, bless the ladies, and a dash of photographs. Once in a while a most pertinent thought might be offered just as Jim Brown streaked downfield on a long touchdown jaunt.[11]

This description does not detract from the seriousness of their endeavor as a photography collective. He goes on to describe the meetings.

> It was assumed that we would be regularly in attendance and that the production of photographs was of primary consideration. We met as friends, which enabled us, I think to survive some rather severe print criticism at times. Seriousness was that ingredient reserved for the work itself, but a full range of feelings made their way into a nights' conversation.[12]

Fraternizing was as endemic to the Kamoinge Workshop as the urgency of the work. For Kamoinge, sociality and seriousness were related, even continuous, processes in their art making.

The full gamut of feelings and emotions enlivened the Kamoinge Workshop meetings to the point that it even compromised a few marriages and relationships.[13] Walker, Barboza, and Draper once experimented with a macrobiotic diet which was so radical that it shifted their consciousness and had an impact on their energy levels.[14] They later realized that this monastic regimen was not necessarily conducive to their level of activity. This and other undertakings point to a serious investment in their social experiences and collective enlightenment, which matched the seriousness that they brought to the work itself.

122 Ming Smith (American, birthdate unkown), **Untitled [Harlem, NY]**, gelatin silver print. *Virginia Museum of Fine Arts, Adolph D. and Wilkins C. Williams Fund, 2016.239*

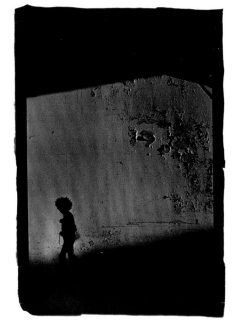

Group Shots

Group shots (or portraits) are another aspect of collectivization evidenced in the Draper/Kamoinge archive. This refers to when the photographers took images of themselves as a group. If the "group shoot" is predicated upon Kamoinge taking photographs collectively, however spuriously, then the "group shot" is about recording the collectivity of Black photographers that made up Kamoinge. The experience of their collectivity is evidenced in the documents from workshop meetings and interviews with Kamoinge artists. It is also evidenced through the representation of the collective. Their collectivizing is documented through their imaging of the group itself. One of the earliest images of a fully instantiated iteration of the Kamoinge Workshop is by Ray Francis from 1966.

Group shots, such as Francis's, which was made for a group show at the Countee Cullen Library in Harlem, solidified and affirmed Kamoinge's presence as a collective. Each of the Kamoinge photographers had a unique style and vision and was involved in varied occupational pursuits. Some were filmmakers, some shot for the fashion industry, some taught at New York area colleges and universities, and some were publishers. They valued their respective professional paths and forays, yet their value as a collective is nonetheless evident in the group shots. As Walker states, "As individuals they were good representatives of what it [Kamoinge] was as a group."[15] The 1966 image of an early phase of Kamoinge is not unlike those by Anthony Barboza that come later in the 1970s. Barboza's group shot from 1973 affirms the cohort in an equally simple and straight pose of them clustering in a group. Like the earlier image it corroborates their interest in establishing a record of their association and their associatedness. [cat. no. 1]

As a cohort of Black men—Jimmie Mannas, Beuford Smith, Ray Francis, Al Fennar, Lou Draper, Shawn Walker, and Herb Randall (Earl James's back is turned because he was no longer officially part of the group)—the photographers used the image to acknowledge and visualize their presence as a collective.[16] [figs. 5.1 & 5.2] In the Barthian sense, they are at once "the observed subject and the subject observing."[17] With the realization of the group shot, they are able to observe themselves while maintaining the stance of Black photographers observing Black people in a way that, as Walker states, the world had not seen insofar as it "only had white people's views of who we were."[18]

Their committed connectivity to each other is even more evident in the accordion-style group shot created by Anthony Barboza in 1972. [cat. no. 2] Barboza recalls that each artist chose their own image. Herb Randall remembers that some brought their negatives to Barboza's studio where they used his darkroom and paper to print fourteen copies of their own photographs. Others, like Herb Robinson, remember printing their images in their own separate darkrooms.[19] Barboza then used his portraits of them and their prints to construct fourteen books, which he distributed as Christmas presents to each member. Each book has fourteen portraits taken and printed by Barboza and fourteen prints taken and printed by each of the members. This process, complex and arduous even to explain, reveals the generosity and connectivity of the group's formation, as well as the stakes of their individualization. This beloved artist book is a compellingly unique group shot. Its break with the norms of a real time and space group shot and articulates a more conscious method for making a group shot. That these were Christmas gifts also conveys the Kamoinge group's ability to organize around personal as well as social, worldly, and occupational concerns. This

141-154 [L-R, top] *Anthony Barboza, Adger Cowans, Danny Dawson, Lou Draper, All Fennar, Ray Francis, Herman Howard* [L-R, bottom] *Jimmie Mannas, Herman Randall, Herb Robinson, Beuford Smith, Ming Smith, Shawn Walker, Calvin Wilson,* 1972, Anthony Barboza (American, born 1944), gelatin silver prints. *Virginia Museum of Fine Arts, National Endowment for the Arts for American Art, 2017.162–.175* © *Anthony Barboza photog*

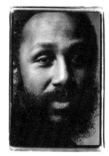
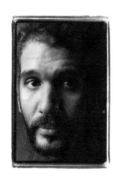
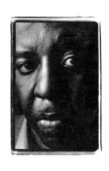
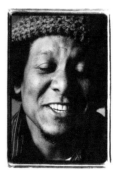
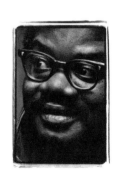
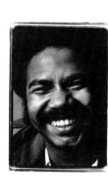
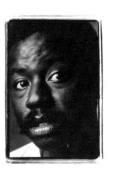
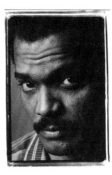
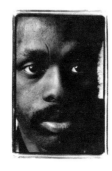
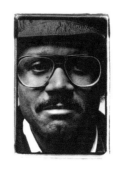
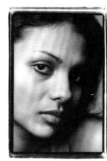
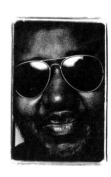

resonates with a statement by Draper at the front of the first Kamoinge *Portfolio*, which states: "The Kamoinge Workshop represents black photographers whose creative objectives reflect a concern for truth about the world, about the society and about themselves."[20]

Barboza's is a patchwork-style composite group shot. This style connects their photo practice to other forms, including film and quilt works. The black borderline intermediates both the individual photographers in the group shot as well as the photographers' connectivity to other forms. It resolves their commitment to group making and photo making that is adaptive and integrative. [cat. nos. 141–154]

In fact, the Kamoinge group was also recorded in another form in 1982, when artist and photographer Carrie Mae Weems made a film about the Kamoinge Workshop. The interview and dialogue footage also bears out the collective presence of the Kamoinge group.

These instances of the group shot clarify the group in that historical moment and also later. The weight is on both the social implications of how the photograph was produced as well as its historical or post-event value. This means that the group shot photo event meets the needs of the lived experience of collectivizing, even as it transcends the lived experience. It enables and also fastens that moment of sociability among the faction that partakes in it—in this case the Black photographers who were part of the Kamoinge Workshop. The Kamoinge group shots were another take on the self-portrait but for a self that was open to its deferral, to a social that was of equal if not greater, magnitude.

"Bless the Ladies"… Enter Ming Smith

The Kamoinge Workshop was very much of its time and place. Its ethos of Black culture was on the early side of, and even predated, the Black nationalist and liberation movements that were spurred on by the deaths of Malcolm X and Dr. Martin Luther King Jr. and prevalent during the late 1960s and early 1970s across the country, but aligned with these struggles just the same.

Similarly, the gender ethos reflected in the practices of the Kamoinge Workshop also lines up, for the most part, with the predominant perspectives on gender that marked the period. Gender equity was a burgeoning topic, but more a conversation than a reality in 1963, when Kamoinge was founded. That same year, the Equal Pay Act for women was signed into law by John F. Kennedy and the next year, the Civil Rights Act, which prohibited discrimination based on sex as well as race by employers, was signed. *Roe v. Wade*, which established women's legal right to an abortion was not decided until a decade later in 1973. Kamoinge

emerged in the throes of gender and race turbulence and on the cusp of some strides for women and Black Americans. It was born in, and of, the social politics of the time, even as many of the members struggled to assert an aesthetic vision that was not wholly bound up in and determined by those politics. It is less than surprising then to come across a Lou Draper comment, "bless the ladies," when acknowledging the women (presumably wives and girlfriends of the Kamoinge members) who prepared the meals for their meetings, a statement which may be interpreted as supportive of and also condescending to women.

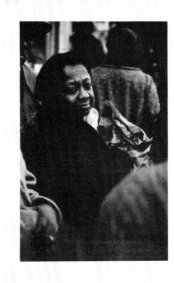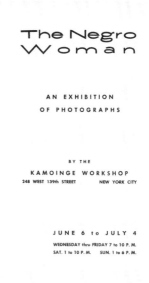

"Bless the ladies" sums up perfectly the Kamoinge group's intentions to be supportive of Black women, even if it also exposes the shortfall of those good intentions. There are some compelling data points for this interpretation, both worth taking into further account. First, in 1965, just a few years into its founding, the Kamoinge Workshop conceived and produced an exhibition titled *The Negro Woman* and second, an invitation was extended to photographer Ming Smith to join the group in 1972. [fig. 5.4]

The Kamoinge Workshop meeting notes tell a fuller story about the conceptual process of *The Negro Woman* exhibition. Like most Kamoinge decisions, the group voted to determine a frame for the show. They selected from a short list of titles that included "Yemaya," "The Black Woman," "Woman," and "The Negro Woman." A record of the tallies reveals the following vote: "Yemaya"-1, "The Black Woman"-2, "Woman"-2, "The Negro Woman"-4. This archival record is astounding for the insight it offers into the racial and social phase in which the Kamoinge group worked. While they drew from African history and language in naming the group, they did not select "Yemaya"—the name of a goddess in the Yoruba

Fig. 5.4 Announcement for the Kamoinge Gallery exhibition *The Negro Woman*, 1965. *VMFA, Margaret R. and Robert M. Freeman Library, Archives, Louis H. Draper Archives, VA04.01.3.188*

Fig. 5.5 Kodak ad from *Ebony* magazine, June 1972

culture—as the title for the show. It also reveals an important and often ignored temporal cusp when Black Americans let go of the Negro ascription altogether in lieu of Black or African American. By 1970 even national publications such as *Negro Digest* had changed its title to *Black World*. Fennar recalls that the group discussed the logic for calling the exhibition *The Negro Woman*, and that there must have been reasons, but that it "dates" the show.[21]

The title exposes other temporal edges as well, such as the potential gender-social transformations and their resonant complexities. In effect, the decision to select "The Negro Woman" instead of "The Black Woman" or "Woman" options speaks to the ill timing of both of these possibilities at a societal level. Americans, including Black Americans, were on the verge of, but not fully ready for the provenance of Blackness in 1964–65. In fact, declarations of Black over Negro were most fervent post-1966, so it is not surprising that by 1973, when Kamoinge member Beuford Smith and Joe Crawford published a journal devoted to Black photographers, they were poised to assert Black and framed it as the *Black Photographers Annual*. Similarly, in 1965, the Kamoinge group decides to slow down the social potency of the "Woman" title, as the rights that were slowly being offered to the American "woman," in a general sense, were not necessarily the rights afforded to Black women, nor the world's women at that time. Erring against such an essentializing title makes good sense. The final title selection, *The Negro Woman*, falls short of expectations perhaps, but in doing so it registers the reality of race and gender in the United States circa 1965. The thresholds of change that this archival document relay are pertinent edges and unavoidable blockages along the route to progress. They reflect the stage of racial-social and gender-social transformation during which the Kamoinge group was working and relay crucial information about this stage of their development as Black male artists, open to complicating their ecosystem.

Even more critical than the information afforded in the Draper archive about the title of the *The Negro Woman* exhibit is a notation from the same meeting that states: "Vote Passed that we will do a show on Black Women as a tribute to them." This note uses the phrase "Black Women" to describe what has been decided on as the "Negro Woman" exhibition. The slippage here reinforces that the group was on the brink of revising their take on the racial nomenclature and, perhaps, gender as well. The comment also offers the reasoning behind making a show on the Black woman "as a tribute to them."

Does the attempt to produce a tribute to Black women lead to wanting to work with Black women, of letting women, or at least a Black woman, into the collective?

The Negro Woman exhibition that took place in 1965 may have pushed the bounds of good form for some and veered into a realm of Black erotica. Soon after, and likely because of the show, the group abandoned their gallery space. Al Fennar describes the possible complication:

> That street, I guess that neighborhood is called Striver's Row, which means that it's a middle class street with some fine old brownstones. There were a lot of people on that street who were middle-class people who belonged to churches. A lot of women. They were all organized in that block. And they came to the gallery and they took offense at this one photograph. And they said that we would appreciate if you would remove that photograph from the exhibition. We didn't like that at all, so we decided to leave that place and closed down shop and left. We were renting the space. It was a basement gallery. A lot of really good things happened there.

While the Shawn Walker nudes in the show may not have suited the taste of the entire group, they decided as a group to vacate the space if it meant having to expurgate the exhibition by removing his work. In this instance the Kamoinge group practices collective decision-making as a way of combatting censorship of an individual artist's right to freely make and show their work.

Despite its snags, *The Negro Woman* exhibition was a "tribute" of sorts to the Black woman when there were few acknowledgements of the sort in film, art, music, or literature. The exhibition can also be interpreted as a precursor to the arrival of a woman in the workshop. Or, the Black woman show presaged the entrance of the first Black woman in the Kamoinge Workshop.

Ming Smith was the first woman to join Kamoinge. She was invited into the collective in 1972 by Lou Draper after sharing a portfolio and image that he admired of two young girls excitedly pulling recent purchases out of a shopping bag.[22] She eventually came to a meeting and, like other major events within Kamoinge, the group agreed upon her admittance. Smith worked as a model in New York, after studying microbiology and chemistry at Howard University, and had

intended to pursue a medical school path. However, her father was an amateur photographer, and she always took photos and loved shooting, though she had less interest in printing and the darkroom.[23]

In fact the camera was pitched as an object towards Black women a good deal in the late '60s and '70s. Brands such as Yashicha and Kodak produced advertisements geared toward Black female consumers in publications such as *Ebony* and *Jet*. [fig. 5.5]

An ad from 1973, a year after Smith joined Kamoinge, reflects how Black women were signaled as casual photographers of the everyday. Ming Smith was among the Black women who always had a camera with her and took photos all the time, but she states that she became a photographer when she joined Kamoinge.[24] In addition to learning to print from Draper, Smith concedes that she learned the language and world of art in the Kamoinge Workshop, so much so that she had her first solo exhibition at a Black-owned hair salon in Harlem.

Smith diversified Kamoinge without having a clear intention to do so. Like others who refer to the group in terms of a brotherhood, Smith admits that they were like brothers to her.[25] Her involvement in Kamoinge is significant for various reasons. While she saved it from being an all-boys group, their invitation also changed the perception she had of herself from someone who took photos to someone who was an artist.[26]

Smith had a special connection to Black musicians and writers that came in part by way of her marriage to experimental saxophonist David Murray. In fact, the first person to purchase one of her photographs was Amina Baraka, whom she knew because Amina and Amiri Baraka made a record with Murray.[27] While her frequent travel with Murray in the United States and abroad derailed her attendance at Kamoinge meetings for long periods, it also afforded Smith wider terrain for her photo making. Images of Sun Ra and sites on the continent of Africa, as well as other places are indicative of Smith's access to subjects beyond Harlem and New York.

Like female artists and professionals in other fields, Smith describes her photo career as one that was "folded" into her life as a wife and mother. She did not plan to interrupt the all-male dynamic of the group. Rather, like the other members, she found a way to use the group to hone and evolve a photographic practice that met her individual needs and interests as an artist. The extent to which she veered away on occasion and was "off campus," but still a part of Kamoinge, ultimately supported her independence as a woman and as an artist with a unique imprint on the form and methodologies that suited her practice.

"Merry Christmas from Langston Hughes"

Kamoinge was a highly permeable Black collective. The group was close-knit, and they limited whom they let in, but on another level their intake was wide-ranging and diverse. Because the Kamoinge Workshop was a pedagogical space for the members, they used it as an opportunity to cull from a swath of cultural and aesthetic references, including film and literature. The attention to light and shadows, which distinguishes the work of Shawn Walker, Ming Smith, Albert Fennar, and others, was in part due to their study of chiaroscuro in Italian painting. Walker points out their appreciation and close investigations of Rembrandt in a 2018 interview. Roy DeCarava's notably dark prints and photographs address light and its absence in their own way. The group also paid close, studious attention to film. Russian filmmakers in particular were important to them because they recognized the significance of shadows to the language of the film. Anthony Barboza's list of films that he and Lou discussed and the rest of the group watched, or referred to, demonstrates their study of other forms in their pursuit of a Black photographic style.

List of films viewed and discussed by Kamoinge Workshop members and compiled by Anthony Barboza, with additions by Shawn Walker.

DIRECTORS	FILMS
Michelangelo Antonioni	*The Adventure* (1960), *The Night* (1961), *Eclipse* (1962)
Ingmar Bergman	*The Virgin Spring* (1960), *Cries and Whispers* (1972), *The Magic Flute* (1975)
Luis Buñuel	*The Exterminating Angel* (1962), *That Obscure Object of Desire* (1977)
Vittorio DeSica	*Bicycle Thieves* (1948), *Umberto D* (1952)
Sergei Eisenstein	*Battleship Potemkin* (1925), *October: Ten Days That Shook the World* (1928)
Federico Fellini	*8½* (1963), *Juliet of the Spirits* (1965), *Amarcord* (1973)
Costa-Gavras	*Z* (1969), *Missing* (1982)
Alfred Hitchcock	*The Lodger: A Story of the London Fog* (1927), *The 39 Steps* (1935), *The Lady Vanishes* (1938)
Shohei Imamura	*The Insect Woman* (1963)
Akira Kurosawa	*Rashomon* (1950), *Seven Samurai* (1954), *Yojimbo* (1961), *Rhapsody in August* (1991)
Nagisa Oshima	*In the Realm of the Senses* (1976)
Yasujirō Ozu	*Tokyo Story* (1953)
Pier Paolo Pasolini	*Accattone* (1961)
Roman Polanski	*Repulsion* (1965), *Tess* (1979)
Gillo Pontecorvo	*The Battle of Algiers* (1966)
Satyajit Ray	*Pather Panchali* (1955), *Aparajito* (1956), *The Chess Players* (1977)
Hiroshi Teshigahara	*Woman in the Dunes* (1964)
Luchino Visconti	*The Leopard* (1963), *Death in Venice* (1971)

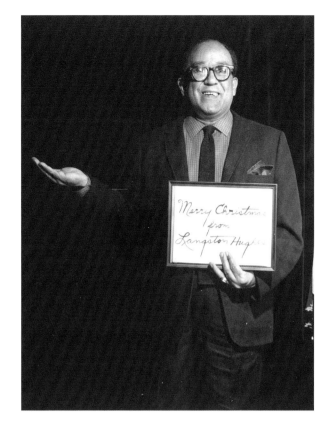

Fig. 5.6 *Langston Hughes*,
1966–67, Louis Draper
(American, 1935-2002),
*VMFA, Margaret R. and
Robert M. Freeman Library,
Archives, Louis H. Draper
Archives, VA04.03.1.102.P1*

Fig. 5.7 Langston Hughes,
Christmas Greetings.
*Langston Hughes Papers.
James Weldon Johnson
Collection in the Yale
Collection of American
Literature. Beinecke Rare
Book and Manuscript Library.
The Langston Hughes Estate,
permission of Harold Ober
Associates*

In addition to film, Draper's archive attests to the groups'
connectivity to poets and writers. This is underscored in
the *Black Photographers Annual* publications that included
prefaces by Black writers such as Toni Morrison and
James Baldwin.[28]

Baldwin writes in his introduction to Volume 3:

> This book is a testimony—I am tempted to call it a
> testimony service—and, like all truthful witnessing
> it is beautiful and frightening, devastating and
> ennobling.[29]

According to Beuford Smith, connections to Baldwin and
Morrison came through Joe Walker, who had been the
bureau chief of *Muhammad Speaks*.[30] While Draper does
not seem to be the person responsible for contracting
Baldwin and Morrison, he read Baldwin, Paul Robeson, and
Langston Hughes and wrote about discussing them with
Eugene Smith. His relationship with Langston Hughes, who
authored *The Sweet Flypaper of Life* with Kamoinge mem-
ber Roy DeCarava in 1955, links Kamoinge to a longer
history of informal, nonetheless serious, Black collectiv-
izing, including that which was signaled in the networking
practices of the Black artists and writers associated with
the Harlem Renaissance.

Lou Draper lived on the first floor of the same Harlem build-
ing where Hughes resided, and they formed a friendship
as neighbors. Several contact sheets in the Draper archive
from 1965 to 1967 are portraits of Hughes, including one in
which Hughes holds up a card that reads "Merry Christmas
from Langston Hughes." [figs. 5.6 & 5.7] The image is
provocative for its adamant ordinariness. Nonetheless, it
speaks to important intersections between Black artists and
writers, between the Harlem Renaissance and 1960s Black
Arts movements. It also relays a great deal about the realm
of serious sociality previously addressed in this essay.

Equally illuminating is what the archive discloses about the
Kamoinge Workshop's interest in contemporary art, espe-
cially painting. The Museum of Modern Art (MoMA) was a
notably rich, even if unresolved, site for their explorations.
Photographs of paintings and each other while in MoMA's
painting galleries offer some insight into their ongoing
probe of abstraction. An image from Draper's archive
shows the salient relationship of abstract painting, like
historic and experimental film, to their aesthetic. MoMA
itself was also relevant to their vision. DeCarava helped
them procure a portfolio review with John Szarkowski,
who likened Fennar's work to that of Goya's *Giant* series.[31]
Entry into the MoMA collection followed. To date, Ming
Smith, Roy DeCarava, Louis Draper, and Albert Fennar all
have photographs in the collection, yet there was not a full-
on commitment to Kamoinge as a collective.

Painting, film, literature, poetry, music, African history, spir-
itualism, and more figured into the Kamoinge Workshop. In
addition to these different forms and themes, various modes
of serious sociality, including those that were pedagogical,
entrepreneurial, and familial, were exemplified by the

Kamoinge Workshop. Its sense of receptivity was widespread and universal, borrowing from a range of options for both artmaking and lifemaking. Black collectivity, such as that practiced by Kamoinge, is often mistakenly seen as a limiting or narrowly focused endeavor, when in fact, it addresses serious sociality that is motivated by racial alignment. Perhaps it is contained in that sense, yet it is also a highly receptive space, open to all, that potentiates its objective, which for Kamoinge was to make and disseminate art.[32]

Serious sociality also addresses the moment when the personal and social are in dynamic relation to the aesthetic labor, in this case photography, helping to produce an artistic outcome from the holdover effects of that social experience. It is a critical space that comes in the pause, or break, from the clear and obvious work, and gives attention to the flows of affective life in which that work is also contained. The sense of joy expressed on Hughes's face in the Christmas card—smiling and open to sitting for a lighthearted and joyful portrait—is demonstrative of Black serious sociality. It lets in the life of the art form—its circulating references, tangential persons, and everyday joy and sorrow. The image of Hughes is a mere residual of the Kamoinge project, a scrap in the Draper archive that clearly animates Kamoinge's aberrant flows and currents. In effect, the Kamoinge Workshop reveals the

receptivity of Black collective spaces to a range of such references and influences.

One document in the Draper archive that articulates the group's purpose has a handwritten comment added at the very end— a punctuation of sorts. It reads, "Though professional, our long-standing personal interactions within the group has forged us together as though a family." This addendum sums up the agility of the Kamoinge Workshop in embracing all in the pursuit of their art—literature, film, painting, music, African history, European art, abstraction, women, everyday life, etc. Theorist Henri Lefebvre states that "Social space implies a great diversity of knowledge." [33] As such, the Black serious sociality and collective-making evidenced in Kamoinge are predicated more upon openness than closedness and avail more forms of knowledge than is often credited.

Fig 5.8 *The Colossus*, 1818, Francisco de Goya (Spanish, 1746–1828). *Metropolitan Museum of Art, Harris Brisbane Dick Fund, 1935, 35.42*

Though professional, our long-standing personal interactions within the group has forged us together as though a family.

Fig. 5.7 Draper's handwritten note on the back of a draft of one of his histories of Kamoinge, ca. 1990s. VMFA, Margaret R. and Robert *M. Freeman Library, VA04.01.3.012*

Endnotes

1 Erina Duganne, interview with Fennar, 2001.
2 Several Kamoinge members, including Shawn Walker, Beuford Smith, and Anthony Barboza, recall going out to shoot with at least one additional member, on the Lower East Side of New York or in Harlem.
3 Duganne, interview with Fennar, 2001.
4 See *Two Schools* exhibition catalog.
5 *Photo Review*, Van DerZee Institute, 3.
6 A note about his impending departure, DeCarava will not attend Sunday workshops, is logged in the June 1965 meeting notes.
7 Sarah Eckhardt, interview with Shawn Walker, 2018.
8 Eckhardt, interview with Barboza, April 2018.
9 Eckhardt, interview with Ming Smith, April 2018.
10 Duganne, interview with Fennar, 2001.

11 "The Kamoinge Workshop," In *Photo Newsletter*, The James Van DerZee Institute
12 *Photo Review*, The Van DerZee Institute
13 Shawn Walker states in a 2017 interview that a few marriages were disrupted.
14 Eckhardt, interview with Walker, 2017.
15 Eckhardt, interview with Walker, 2017.
16 The title of the exhibition was "Perspective: An Exhibition of Photographs by the Kamoinge Workshop
17 Roland Barthes, *Camera Lucida*, 10
18 Eckhardt, interview with Walker, 2017.
19 Interviews with the various members, 2018–2019.
20 Lou Draper, *Portfolio 1*.
21 Duganne, interview with Fennar, 2001.
22 Ming Smith describes this image in the interview with author, April 2018.

23 Ibid.
24 Ibid.
25 Ibid.
26 Ibid.
27 Ibid.
28 It is likely that Joe Walker brokered the relationship with these authors.
29 James Baldwin, *The Black Photographers Annual*, Volume 3, Introduction, 1976.
30 Eckhardt, interview with Beuford Smith, 2018.
31 Ibid.
32 Fennar, interview, 2001.
33 Henri Lefebvre, *The Production of Space*, 73.

The Sounds They Saw: Kamoinge and Jazz

BY JOHN EDWIN MASON

One of the things about the founding members, particularly, is that pretty much all of us were jazz fanatics.

—Shawn Walker[1]

In 1980 or 1981, Louis Draper, the Kamoinge Workshop's most prolific chronicler, jotted down notes about jazz. They fill ten pages of a cheap, spiral-bound notebook—the sort that high school and college students use. Draper kept it when he was working as a production assistant on the film *Losing Ground*. Technical details about the movie compete for space with notes about "Bird" and "Prez," the jazz world's nicknames for the already legendary saxophonists Charlie Parker and Lester Young. Although Draper organized the notes in a coherent chronological order, identifying key moments in the lives of the two musicians, the notes' irregular spacing on the page and the nonchalance of Draper's handwriting suggest the improvisational freedom of a jazz solo.

It is not clear why Draper made the notes or what he intended to do with them. It is probably not a coincidence, however, that he kept the notebook while he was taking courses in filmmaking and screenwriting. Was he working on a screenplay? If so, the roll call of nightclubs and recording sessions in the notebooks could have been a list of potential scenes in a movie. That is, he might have been seeing the sound of jazz with his mind's eye and thinking about ways to show it to an audience. Whatever the notebook's purpose, one thing is clear: it grew out of his lifelong love for jazz.

Draper shared that love with his brothers and sisters in Kamoinge. From the very beginning, jazz was the workshop's soundtrack, but it was much more than the background music at meetings. Jazz was one of the bonds that held the organization together. Kamoinge founding member Shawn Walker says, "All of us were into the music, and I think that's what really made us so tight. It's because all of us loved jazz." They were, in his words, "jazz fanatics."[2] They were also photographers who found both inspiration and subject matter in the music. Cameras in hand, they devised ways to see that which cannot be seen, to make something as intangible as a sound wave as substantial as a photographic print.

Although jazz is an essential part of the artistic practice of most of Kamoinge's members, the approaches that they take

to it are as diverse as the music itself. Jazz was an indispensable, recurring theme in the photography of Roy DeCarava, who served as both a mentor to the workshop's members and its first director. DeCarava, as we shall see, believed that Black people had a special affinity for the improvisational element of jazz. He saw the music and the musicians who made it part and parcel of everyday African American life, and his photographs reflect that understanding.[3] Jazz was at the core of Shawn Walker's personal identity long before he began to photograph it. When he was a young man, he says , his peers "made me feel like an outsider. . . . I couldn't run, couldn't jump, couldn't play ball, couldn't do any of those things. So that kept me from really being one of the crew." Jazz, in the form of a borrowed Thelonious Monk album, helped him to separate his sense of himself from the judgment of his peers. "I played this Monk thing, and it was like a revelation. It made me very clear that I did not have to give in to the rest of the guys. Ok, this is me."[4]

Ming Smith, who joined the organization in 1972, came to jazz later in life than most of the other members, but it became crucial to her personally and professionally. For a number of years, she was married to David Murray, a prominent saxophonist. She says that "the style of my photography" came to be "informed by the music" that he and other jazz musicians played. The improvisation that is inherent in jazz showed her "a way of expressing [myself], whatever that might be."[5] Daniel Dawson, who also joined Kamoinge in 1972, but whose involvement in jazz and photography goes back much farther, argues that the relationship between music and the visual arts in Black cultures goes beyond the inspiration artists find in it. "They're inseparable," he says. Dawson traces this bond back to an African conception of art. "Because if you look at African American art or any kind of African art, it's holistic.... The visual art is inseparable from the musical art.... And even though we've lost the African linguistic elements that tie that together, we haven't lost that in our lives."[6]

The highest standards of excellence that we had in the black community were the musicians.

—Daniel Dawson[7]

101 *Two Bass Hit, Lower East Side* (detail), 1972. , Beuford Smith (American born 1941), gelatin silver print. *Virginia Museum of Fine Arts, Arthur and Margaret Glasgow Endowment, 2017.36*

During much of the twentieth century, jazz was at the heart of American and African American culture. Writer Ralph Ellison, one of the most astute observers of American society, claimed that its culture was "jazz-shaped."[8] The music remains a vital force in the United States and around the world. It is no surprise, then, that jazz plays a prominent role in the lives of Kamoinge members, as well as the art that they make. The photographers who joined the workshop during its first decade came of age in an era when the music and the musicians who played it were at the peak of their visibility and cultural significance. The importance of jazz was no secret, of course, as Graham Lock and David Murray (no relation to the saxophonist) have pointed out. "The central role that Black music has played in twentieth-century culture (African American, American, and global)," they write, "has been noted by writers and critics from W. E. B. Du Bois to Amiri Baraka."[9]

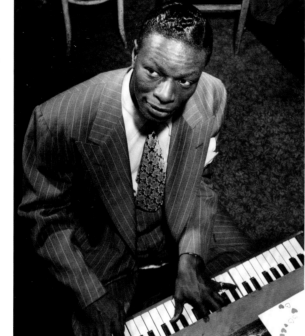

Fig 6.1 *Nat King Cole, New York, June, 1947*, William Gottlieb (American, 1917–2006). *Virginia Museum of Fine Arts, Kathleen Boone Samuels Memorial Fund, 2014.232*

It is not hard to find examples of the cultural influence of jazz and other African American music. In France, composer Maurice Ravel incorporated elements of jazz into some of his best-known pieces, while Henri Matisse made jazz the subject of many of his paintings. Neither the Great American Songbook—the songs of Irving Berlin, George and Ira Gershwin, Cole Porter, Duke Ellington, and many others—nor the poetry of the Beats is imaginable without jazz. Within the African American community, the impact of the music was felt from the beginning of the twentieth century to its end—from the Harlem Renaissance to the Black Arts Movement, from W. E. B Du Bois and Langston Hughes to Toni Morrison, Ntozake Shange, and beyond.

The symbiotic relationship between Black music and the arts was and is especially visible in the marriage of jazz and

photography. In part that is because photographers of the 1940s and 1950s, such as William Gottlieb and Herman Leonard, created an image of jazz musicians that lodged itself deeply, and perhaps permanently, into American and global culture. [fig. 6.1] The image, as K. Heather Pinson describes it, has become a cliché. It conjures up "a well-dressed African American man playing an instrument, most likely a saxophone or trumpet, with smoke wafting about the stage on which he is playing at a nightclub. . . . He would exude confidence, individualism, and defiance—the perfect example of artistic genius." This and similar familiar images make up "the standard repertoire of jazz photography," she says. The clichés spread widely, as nightclubs, magazines, and the musicians themselves used them for marketing and publicity. But a danger was latent within them, as Pinson notes. By reducing jazz "to that which can be read, deciphered, and appropriated quickly," photographs like these can give viewers the illusion of knowledge without the substance.[10]

The Kamoinge photographers recognized the problems inherent in reducing the imagery of jazz to a series of clichés. Daniel Dawson, for instance, says that Kamoinge's "mission . . . was to present African American culture in its fullest view," not as a series of overly familiar, prepackaged images. They understood that photographs "are constructions that talk about culture," and that can be used to validate or invalidate particular cultures. "We were using photography," he says, "as a tool to validate our culture."[11] For him and the other members of Kamoinge, validation meant seeing beyond the clichés. They were determined to create more expressive ways of depicting the musicians and of making their music visible.

Kamoinge members' jazz photographs are diverse, visually delightful, and far from being literal renderings of their subjects. In Beuford Smith's *Two Bass Hit, Lower East Side, 1972*, for instance, two string bass players are seen from the rear, in silhouette, and are unidentifiable [cat. no. 101]. While referencing and evoking jazz, the photograph is also about the interplay of the shapes that the silhouettes of the men and their instruments create and the image's shifting tonalities of black and gray. Much the same can be said of Anthony Barboza's *Okra Orchestra, Brooklyn, NY* (n.d.). [cat. no. 102] The silhouettes of musicians and horns create shapes that seem almost to be a collage in gray scale. Herb Robinson refused to reproduce a stereotype, even in the seductive setting of a nightclub. In his portrait of Miles Davis, *Miles, Vanguard*, 1960s, virtually all details are lost in the extreme contrast between deep blacks and brilliant whites, yet the man remains recognizable. Much is suggested in the image; little is actually seen.

Kamoinge photographers created fresh visual approaches to jazz because they came to the music with interests and concerns that were distinctly different from the

photographers who created the clichés. DeCarava, for instance, refused to separate jazz from everyday African American life, as Richard Ings points out. That insistence shaped *The Sound I Saw: Improvisation on a Jazz Theme*, a book that Ings calls "DeCarava's crowning achievement as a photographer and African American artist." The photographer interspersed "pictures of jazz performances and jam sessions with photographs taken in the streets and homes of Harlem [which enabled him] to make suggestive visual connections between jazz and everyday life."[12] *Couple Dancing*, 1956, for instance, is a quiet, yet warmly romantic photograph that shows the torsos of a well-dressed couple who are apparently doing a slow dance, arm in arm, hip to hip. Shadows obscure their faces and every detail of the setting. DeCarava implies the presence of musicians, but allows them to remain unseen. It is an extraordinary image of an everyday moment, animated by jazz. [Image can be viewed online at vmfa.museum]

Adger Cowans's *Momma's Ohio Piano*, ca. 1965, captures an quotidian scene that evokes deep connections in the Black community between family, faith, and music [cat. no. 104]. The piano, which occupies most of the frame, is an old upright, with a fringed cloth dustcover on its top. Six photographs, one of which is obscured, line the dustcover from edge to edge. Three of the photographs are portraits of men, one of whom wears a military uniform. On the far left is a large formal portrait of a woman in a white wedding gown. In the middle is a portrait of a man and a woman, perhaps newly married or newly engaged. A cornet shares the top of the piano with the portraits. A copy of *Ebony* magazine and sheet music for the hymn "Bless This House" are visible below on the piano's music stand. The photograph is an image of middle-class domesticity, on the one hand, and a token of the inseparability of music and everyday Black life, on the other.

For Kamoinge's members, jazz musicians were not merely icons of style, as they often were for jazz lovers, or alluring subject matter, as they were for many photographers. They were also paragons of artistic and racial achievement. Daniel Dawson explains:

> Our highest models of artistic creation were the musicians. They weren't necessarily the visual artists. We were all influenced by [photographers such as] Eugene Smith and Cartier-Bresson and Roy DeCarava and Gordon Parks. But our strongest influences were Miles Davis and Duke Ellington and Thelonious Monk and Charlie Parker and John Coltrane. The highest standards of excellence that we had in the Black community were the musicians.

> In practical terms, it meant that the standard of excellence was inside our own community. We didn't have to be validated by some external force.[13]

Shawn Walker agrees, saying that "the one thing I understood from jazz was how good you could be."

> Whenever you think you've reached a plateau, go to a set and you realize, "Oh, fuck," did he really play that? Did he do that? I didn't know you could do that on a horn. . . . You've got to be awed by that. I want to do it with my camera.

> Jazz musicians were the vanguard of our culture.[14]

If jazz musicians and the music that they made served as models of artistic achievement for the Kamoinge photographers, and if jazz and photography were inseparable for them, can we see jazz in *all* of the photographs that they made? When the subjects of the photographs are musicians, in performance or in repose, as in Ming Smith's *Sun Ra space I* and *Sun Ra space II* (both printed ca. 1978), the answer is "yes." [cat.nos. 109 & 110] The images' rough grain and blurred details seem to recall the disciplined cacophony of Sun Ra's "Arkestra." Similarly, the flowing curves of Mahalia Jackson's gown and solidity of her body, in Herb Robinson's *Mahalia Jackson*, 1969, seem to reflect the power and grace of her singing voice. [cat. no. 103] But when Dawson said that jazz and photography are inseparable, he did not add "only when musicians are in the frame." He and the other Kamoinge photographers affirm that jazz inhabits all of their work. How, then, do we see it?

> Making something out of nothing. . . .
> I think that's like jazz.
> —Ming Smith[15]

Robert O'Meally has written about Ralph Ellison's and Albert Murray's analysis of Romare Bearden's paintings and collages, which were sometimes literally about jazz and at other times, only metaphorically so. The latter works—those in which "iconic jazz figures, titles, and explicit references" were absent—perplexed them. How could they discern the influence of jazz in the look of this work? The answer, they thought, could be found in "Bearden's *process* of making art." He made his collages, in particular, through the process of improvisation—working with shapes and colors to create new works of art in the moment.[16] Painting and collage require techniques that are very different from photography, but the process of making photographs is a good place to look for the presence of jazz. That is because it is during the act of making pictures when Kamoinge photographers most clearly see the connections between their art and the music they love.

As we have seen, DeCarava felt that Black people had a natural affinity for both jazz and photography. Lifetimes of negotiating "a hostile racist environment," he believed, made them natural improvisers. The accurate assessment

of, and the appropriate response to, threatening situations—on the fly—were the keys to survival in a racist society. Improvisation was also at the heart of jazz and photography, he argued. The act of creation was immediate in both art forms. Just as jazz musicians improvised new music in the moment, in response to their sonic environment, DeCarava felt that photographers created new images in an instantaneous response to their physical environment.[17]

DeCarava's insights apply most directly to street photography, a genre in which many of the Kamoinge photographers excelled.[18] Ming Smith thinks her proficiency as a street photographer depends on her skills as an improviser. "Street photography, I feel like that's really my talent, my strong point. Making something out of nothing. . . . I think that's like jazz. . . . You follow your instincts. It's not very cerebral."[19] Shawn Walker draws a direct analogy between a jazz musician's improvisation and his photography.

> The way we approached photography was improvisation. I know what I'm going to play, but I don't know the notes I'm going to play. I'm going to 125th Street, I know I'm going to shoot, but I don't know exactly what I'm going to shoot. And if I shoot it, I don't know whether I'm going to get it or not.[20]

What does an improvised photograph look like? Sometimes it is clear that the camera has frozen a fleeting moment in time. Beuford Smith's *Bed-Stuy, Brooklyn*, 1970, is an example. [cat. no. 118] A man, seen from above, seems to be dancing with his shadow, half on the sidewalk and half in the street. Because the man is caught in a graceful, yet precarious stance, his static image almost seems to move. Sometimes the fluid geometry of the composition gives the image a sense of motion. The circular forms of the wide-brimmed hats that the two central figures wear in Shawn Walker's *Family on Easter, Harlem, NY*, 1975, create a visual energy that makes the photograph dynamic. Unlike Smith's shadow dancer, the figures in Walker's photograph are momentarily motionless. Yet they are also not in repose. Walker, like Smith, has captured life on the fly.

But a good street photograph requires neither motion nor rumors of motion. The seeming absence of movement gives DeCarava's *Graduation*, 1949, much of its power. The small figure of a young Black women, dressed in a white gown, occupies the center of the frame. She stands in a sunny triangle of the sidewalk. Shadows surround her on three sides, directing the viewer's attention to the place where she stands. Although DeCarava caught her in the act of walking—in another second or two, she would have been lost in shadows—motion is not the point of the image. A quiet stillness is. Any sense of movement is also largely absent from Ming Smith's *America Seen through Stars and Stripes, New York City, New York*, printed ca. 1976. An African American woman, wearing white, stands with her back to the window of what might be an office building or a bank. [cat. no. 70] She holds her chin high. Three American flag banners hang vertically on the far side of the window. In the window, the reflections of the sidewalk and street and of cars and passersby can be seen. Smith has captured a moment in time—one that perhaps expresses the racial "pain" that she sometimes felt when photographing.[21]

It is probably impossible for an image of a Black person and the American flag not to carry a political burden. Smith's photograph resonates with Gordon Parks's famous portrait of Ella Watson, the "government charwoman" whom he posed in front of an American flag, with her mop and broom, in 1942. [fig. 6.2] Smith's photograph lacks the bitter irony of Parks's, but it is suggestive nonetheless of the tension between the promises of American democracy and the reality of American racism. *America Seen through Stars and Stripes* is an improvisation, in black and white, on the meaning of American.

> Home is somewhere where your heart rests easy. This is not that place.
>
> —Daniel Dawson

Jazz is part of what summoned Kamoinge members to Africa and to African diaspora communities in the Caribbean and Latin America. As Daniel Dawson says, the 1960s and '70s were "a revolutionary time, full of pride for African American and African culture." Many members of the workshop traveled in pursuit of work and "in search of somewhere more likely to call home." They also set out to explore the roots of African American culture, the most important of which, Dawson believes, lay in Africa. When Kamoinge photographers embraced a holistic concept of the arts, he says, they understood that the "validating philosophical root is African."[22]

The improvisational process was as much a part of Kamoinge members' artistic process in Africa as it was in the United States. Louis Draper's *Soccer Game, Dakar, Senegal*, 1978, for example shows three boys engaged in play. [fig.6.3] The

Fig. 6.2 *American Gothic, Washington, D.C.*, 1942, Gordon Parks (American, 1912–2006) *Photograph by Gordon Parks. Courtesy and copyright The Gordon Parks Foundation*

122

faces of the two central figures are turned upward and bathed in sunlight, as they presumably follow the flight of an unseen ball. Draper catches them in mid-stride, arms akimbo, as they trace the arc of the ball's descent. The boy on the right wears a dark shirt and light trousers; the boy on the left exactly the opposite. A sunlit white wall on the right and dark shade on the left frame the boys and create a collage-like background. The image is about many things at once—childhood games, the interplay of light and shadow and geometric forms, and an encounter between an African American photographer and an everyday moment on the west coast of Africa.

Quiet and repose characterize Anthony Barboza's photograph *Fadioth Senegal*, 1979, despite its having been made in a busy outdoor market. Nearly a dozen women, dressed in dramatically patterned clothing, and at least three children inhabit the frame. One of the women bends over to speak with another. Otherwise all seem to be silent and still. The sheer number of people in the photograph could have created a cluttered composition. Barboza probably waited, like any good improviser, for a moment when motion and speech had momentarily all but ceased.

> My feeling is that the black artist looks at the same world in a different way than a Euro-American artist. He has a different agenda. . . . That agenda, at a minimum, is survival as an American. It is freedom.
>
> —Roy DeCarava[23]

In 1995, more than three decades after Kamoinge's birth, founding members Louis Draper and Anthony Barboza wrote a brief history of the workshop. The founders' "essential purpose," they said, was "the nurturing of each member, challenging one another to higher photographic attainment." The jazz that they listened to and the musicians that they admired wordlessly reminded them never to be satisfied with what they had achieved or could imagine. Members also knew, however, that "a largely hostile and at best indifferent photographic community" stood in the way of their growth

Fig. 6.3 Louis Draper (American, 1935–2002), *Soccer Game, Dakar, Senegal,* 1978, gelatin silver print. *Virginia Museum of Fine Arts, Arthur and Margaret Glasgow Endowment, 2015.294*

as artists and as working photographers. A no less essential role for Kamoinge, then, was to "give us the strength to continue."[24] Here, too, jazz musicians pointed the way.

The musicians that Kamoinge's members revered provided a model of racial resilience as well as artistic excellence. Ralph Ellison once mused on the determination of musicians such as Miles Davis to stake a claim to freedom in a country which denied it to them, in law and in practice. Davis's generation, he wrote, was "intensely concerned that their identity as Negroes placed no restriction upon the music they played or the manner in which they used their talent." Jazz scholar Benjamin Cawthra agrees, writing that Davis indeed modeled the idea of "no restrictions."[25]

Jazz showed the members of Kamoinge how to make art without boundaries. They became aesthetic, intellectual, and even geographic explorers. Their art was improvisational and dynamic, constantly in motion, continually evolving. They were in conversation with the artistic and political currents that swirled around them. They created art that embodied racial pride and self-assertion at the same time that, like jazz, it transcended boundaries of genre and race. They learned to see no restrictions. And they found a kind of freedom.

Endnotes

1 Shawn Walker, interview with the author, July 23, 2018.

2 Ibid.

3 See, Richard Ings, "And You Slip into the Breaks and Look Around: Jazz and Everyday Life in the Photographs of Roy DeCarava," in *The Hearing Eye: Jazz and Blues Influences in African American Visual Art*, Graham Lock and David Murray (New York: Oxford UP, 2009), e-Book edition, loc. 5292., and Elton C. Fax, *Seventeen Black Artists*, (New York: Dodd, Mead & Company, 1971), 184.

4 Walker, interview with the author.

5 Ming Smith, interview with author, November 16, 2018.

6 Daniel Dawson, interview with author, July 26, 2018.

7 Dawson, interview with the author.

8 Graham Lock and David Murray, *The Hearing Eye: Jazz and Blues Influences in African American Visual Art*, (New York: Oxford UP, 2009), 3.

9 Ibid.

10 K. Heather Pinson, *The Jazz Image: Seeing Music through Herman Leonard's Photography*, (Jackson, MS: University of Mississippi Press, 2010), 10.

11 Dawson, interview with the author.

12 Ings, "And You Slip into the Breaks," loc. 5135.

13 Dawson, interview with the author.

14 Walker, interview with the author.

15 Smith, interview with the author.

16 Robert G. O'Meally, "'We Used to Say "Stashed"': Romare Bearden Paints the Blues," in *The Hearing Eye*, e-book edition, loc. 2974–2985.

17 Fax, *Seventeen Black Artists*, 184–85.

18 Studio, portrait, and landscape photographers, whose process might be slow and considered, may not be any more concerned with improvisation than a composer of classical music would. This is not to deny, however, that some photographers who work in these genres do feel that improvisation is part of their process. Improvisation is also sometimes part of classical music performance practice.

19 Smith, interview with the author.

20 Walker, interview with the author.

21 Smith, interview with the author.

22 Dawson, interview with the author.

23 Ivor Miller, "If It Hasn't Been One of Color": An Interview with Roy DeCarava, Callaloo, vol. 13, no. 4 (Autumn, 1990), xxx.

24 Louis Draper with Anthony Barboza, "Kamoinge: The Members, the Cohesion and Evolution of the Group." *Proceedings, American Photography Institute National Graduate Seminar*, ed. Cheryl Younger, Photography Department, Tisch School for the Arts, New York University (New York: The Institute, 1995).

25 Benjamin Cawthra, "Dark Rooms: On Blue Notes in Black and White," *The Montréal Review*, December 2011, accessed March 30, 2019. http://www.themontrealreview.com/2009/Blue-notes-in-black-and-white-by-Benjamin-Cawthra.php.

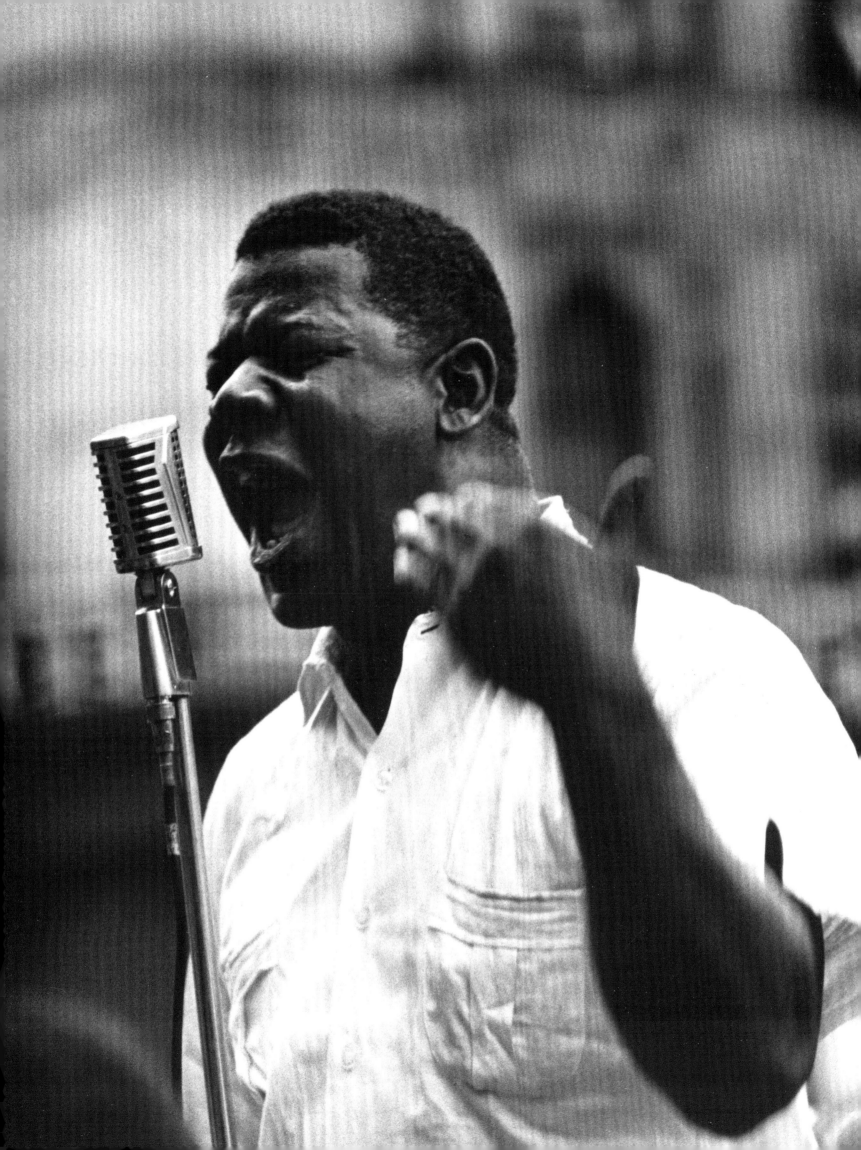

Do for Self! Art, Commerce, Community, and the Kamoinge Workshop

JOHN EDWIN MASON

We must get away from the idea of depending on others to do for us what we can do for self…
stop acting foolish and unite. Do for self.

—Elijah Muhammad

The sounds of "Do for Self" were in the air. During much of the 1950s and 1960s, the slogan was in the speeches and conversations, poems and prose of African Americans throughout the country—artists, activists, and ordinary men and women. The phrase captured the broad Black nationalist spirit of the times, resonating with calls for racial self-reliance and solidarity that were as old as the slave rebellions and free Black mutual aid societies of the eighteenth and nineteenth centuries.[1] Louis Draper, a founding member of the Kamoinge Workshop, was among those who heard the slogan and embraced it. During the organization's early years, he recalled in 1995, the phrase seemed to be everywhere on the streets of Harlem. "Within our own neighborhood practically every major thoroughfare featured a learned orator encouraging the residents to 'buy black,' to link with Africa and to 'do for self.'"[2] Kamoinge member Beuford Smith photographed one of the most renowned of those "learned orators," Edward "Pork Chop" Davis,[3] in action in 1965. Smith shows the stocky, dark-skinned Davis speaking into a microphone on a Harlem street corner. His fiery expression and closed left hand, raised in a gesture, suggest passion and power. The white dress shirt that he wears implies discipline. Davis's charisma seems palpable. Few who encountered him would have walked away without pausing to listen. [cat. no. 67]

For Draper and Kamoinge's other early members, "Do for Self" spoke to sensibilities that animated both the workshop's birth and its activities during its formative years. The slogan reflected a collective longing for the freedom to determine one's fate; to embrace it was to engage in an act of psychological self-emancipation. While the slogan lacked specifics, its very ambiguity allowed it to unite Kamoinge's strong, independent-minded personalities. None of the workshop's members dissented from the slogan's call for racial unity, mutual aid, and self-determination. Similarly, in the African American community as a whole, it was embraced by conservatives and radicals, artists and laborers, the affluent and the poor, in the African American community as a whole.[4]

All could agree that "Do for Self" meant doing for and with others. The "self" was always a communal self; no one who uttered the phrase thought of "doing for myself." As Manning Marable argued, "the belief that African Americans were an oppressed nation or national minority, trapped inside a predominantly white society" was a "core element" of the Black nationalist ethos that "Do for Self" expressed.[5] Hence the "self" might be conceived of as the Black community writ large—the Black nation-within-a-nation; or it might be much smaller—a collective of African American photographers in New York City, for instance.

There was less agreement about "do." For radicals, such as the Black Panther Party, in the 1960s and '70s, "doing" meant building revolutionary movement that would uplift the African American community by utterly transforming American race and class relations.[6] On the other hand, the conservative and inward-looking Nation of Islam (the religious group that was known at the time as the Black Muslims) rejected political activism and touted self-discipline, rigidly patriarchal family relationships, and Black capitalist enterprise as the way forward.[7] For many other African Americans, "doing" meant creating local institutions—from newspapers and bookstores to art galleries, musical ensembles, and theater troupes—that would allow Black people to survive and even prosper in a society that seemed determined to destroy them. For the Kamoinge photographers, as for many others, jazz served as a musical analogue to "Do for Self." The jazz bands and individual musicians that they admired were models of artistic excellence, on the one hand, and racial solidarity and resilience, on the other.[8]

During the 1950s and into the 1960s, "Do for Self" was most closely identified with the Nation of Islam. The writings of the Nation's leader, Elijah Muhammad, which many Black non-Muslims encountered in the group's newspaper, *Muhammad Speaks*, and in Muhammad's many books, such as *Message to the Blackman in America*,[9] popularized the phrase. "We must get away from the idea of depending on others," he declared, "to do for us what we can do for self."[10] The speeches of Malcolm X, the Nation's most prominent spokesman, brought the slogan even greater attention. By the beginning of the 1960s, Malcolm's speeches and interviews were regularly reported in both the

68 Beuford Smith (American, born 1941), **Pork Chop Davis, 125th and Lenox Ave.,** 1965, gelatin silver print. *Virginia Museum of Fine Arts, National Endowment for the Arts for American Art, 2019.244*

75 Albert Fennar
(American, 1938–2018),
Negroes Unite, 1968,
gelatin silver print. *Collection*
of Shawn Walker

76 Louis Draper
(American, 1935–2002),
Untitled (Black Muslim),
1960s, gelatin silver print.
Virginia Museum of Fine Arts,
Gift of Louis H. Draper Trust,
2013.156

and boys, selling the latest issue of *Muhammad Speaks.* [cat. no. 75] The newspaper's headline, "Urge Negroes to Unite," points to the Nation's call for racial solidarity. The viewer is perhaps most struck by the calm self-possession of the teenaged boys who have posed for Fennar. Louis Draper's *Untitled* (*Black Muslims*) [cat. no. 76] is a triple portrait. On the left of the frame stands a slender Black man who seems to be in his mid-thirties. He glances warily back at the photographer, his suit and fedora dark and spot-less. A teenaged boy on the right of the frame also wears a suit and looks back at Draper with similar skepticism. In the center of the frame, ignored by both the man and the boy, a white New York City policeman, dressed in his uniform, is seen in profile, looking to the left at something beyond the frame. Rather than focus on the well-documented tensions that existed between the Nation and the police, Draper has chosen to emphasize the resolute dignity that many non-Muslims found attractive in members of the Nation.

Adger Cowans's photograph of Malcolm X addressing a crowd [cat. no. 73] is, on the other hand, decidedly unheroic. We see Malcolm from high above, and we have to take Cowans at his word that the male figure standing alone on a raised stage, which seems to have the size and shape of a boxing ring, is the Muslim leader. A throng, raked by a low evening sun, nearly surrounds the speakers' platform, their long shadows visible wherever there is open space among them. While Malcolm has drawn what we imagine is an engaged and admiring crowd, the photographer remains aloof. The speech is an occasion for making art, not political icons.

Cowans's arm's-length approach might well be a metaphor for the attitude of most Black Americans toward the Nation. Muhammad and his followers may have laid claim to the phrase, but they never owned it. Much less did they own the attitudes and impulses behind it. The many African Americans who embraced "Do for Self" in the 1950s and 1960s did so in large part because, as we have seen, the slogan resonated with sentiments that had deep roots in African American life and culture.

For Draper and Kamoinge's early members, "Do for Self" was much more than an expression of the zeitgeist; it was a call to action. Draper employed the slogan, for instance, when he described a pivotal episode in the life of the workshop. In 1963 and '64, soon after Kamoinge's founding, members met with the New York chapter of the American Society of Magazine Photographers (ASMP), the photo industry's lead-ing professional organization, to discuss black photographers' well-established charges of racial discrimination in the photo industry.[13] During the meetings, representatives of ASMP and employers were, contradictorily, both skeptical and defensive about the photographers' claims. Draper described their attitude as "hostile." When it became clear that the associ-ation would do nothing about the discrimination that Black

mainstream and African American press.[11] Although most people who embraced "Do for Self" were not Muslims (the Nation remained numerically small through this period), Muhammad's and Malcolm's uncompromising commitment to the welfare of the Black community earned them the respect of many African Americans, especially among those who, like Kamoinge's members, were young and living in urban centers. In Malcolm's case, the emotion was often greater than respect; it was a kind of love. For many he was, in the words of Ossie Davis, who eulogized him after his assassination in 1965, their "black shining prince."[12] It is no surprise, then, that workshop members made many photo-graphs of the Muslims and of Malcolm.

Al Fennar's photograph *Negroes Unite* reproduces what was, in the 1950s and 1960s, a familiar sight in Black urban neighborhoods—neatly dressed, impeccably groomed men

photographers faced, "Kamoinge left the gathering," Draper wrote, "vowing to do for self."[14]

Doing for self meant finding ways to address the lack of job opportunities that Black photographers faced as well as the virtual exclusion of their work from museums, art galleries, and photography magazines. Draper also understood that the consequences of racial discrimination were sometimes more subtle. He once wrote that the "alienation" that Black photographers felt "dampened their creative spirit," making it hard for them to fulfill their potential as artists, despite "all the untapped talent amidst them."[15] He argued, as Sarah Eckhardt writes in chapter two of this volume, that "whatever was to be accomplished" would be the result of "the efforts of [Black] photographers to create markets and audiences for themselves."[16] For Draper and other workshop members, those efforts would flow through Kamoinge.

Kamoinge's "Do for Self" ethos prompted them to build institutions in and for the Black community, and, at the same time, to challenge the ways that photography had represented and misrepresented the community. Institution-building had begun with the creation of the workshop, an organization that, as Draper wrote, had the "essential purpose" of self-help and mutual aid—"the nurturing of each member, challenging one another to higher photographic attainment."[17] (It is no coincidence that the workshop's name, which Kamoinge translated as "a group of people acting and working together," was drawn from *Gikuyu*, one of the official languages of newly independent Kenya. The former British colony had celebrated its independence in 1963, the year in which Kamoinge was born. The event and the anti-colonial struggle that preceded it had been widely celebrated in the African American press.[18]) Kamoinge was a vehicle through which members could address their exclusion from employment in the photography industry and from opportunities to exhibit their work in art galleries and museums. The meetings with the ASMP, mentioned above, were an effort to address the first problem. Kamoinge confronted the second problem by opening the Marketplace Gallery. The gallery, located in Harlem, provided space for workshop members to display their images, and it served the larger Black community, introducing audiences to photography as an art form.

The gallery also gave Kamoinge's members the chance to exhibit photographs that challenged conventional ways of seeing African Americans. Draper and his colleagues in Kamoinge were well aware of what Henry Louis Gates has called "the astonishingly large storehouse of racist stereotypes that had been accumulated in the American archive of antiblack imagery."[19] In his notes on the history of Kamoinge, Draper suggested that one of the workshop's most important goals was to correct the misrepresentation of Black people in American visual culture. The workshop's members, he wrote

Dedicated [themselves] to "speak of our lives as only we can." This was our story to tell and we set out to create the kind of images of our communities that spoke of the truth we'd witnessed and that countered the untruths we'd all seen in mainline publications.[20]

Kamoinge had entered a long-running battle. As bell hooks noted in her now classic essay, "In Our Glory," "the field of representation (how we see ourselves, how others see us) is a site of ongoing struggle." The camera, she contends, was "a political instrument, a way to resist misrepresentation as well as a means by which alternative images could be produced."[21] The struggle has not been confined to visual representation, however. For African Americans, photography has been an important weapon in the broader fight for racial justice. Maurice Wallace and Shawn Michelle Smith have shown that photography's relative affordability offered Black people "an unprecedented opportunity for self-representation…[and for] making claims on new legal, political, and socially recognized American identities."[22]

While it is fair to say that all of Kamoinge's members were committed to resisting misrepresentation and to producing alternative images, they were also highly individualistic artists. There was no consensus on precisely how to reenvision the Black community. Indeed Al Fennar remembered "long, long arguments" about the role and responsibilities of Black photographers.[23] There was never a Kamoinge house style. Instead members balanced their commitment to collective aims, on the one hand, and individual expression, on the other.

Theme Black and *The Negro Woman* [figs. 2.6 & 2.7], the titles of the two exhibitions that Kamoinge mounted at the Marketplace Gallery in 1965, suggest that the photographers' determination, at least in part, was to visually represent the African American community on their own terms.[24] It is not clear, however, precisely which photographs were shown at the exhibitions. The best surviving public statements of how Kamoinge's early members chose to represent their community and themselves as artists are two portfolios of member's photographs that the workshop assembled in 1964 and 1965. [cat. nos. 2 & 3] Kamoinge distributed the portfolios to selected museums, thereby placing the photographers' images in collections that had been effectively closed to them.[25] The images in the portfolios suggest that workshop members were committed to challenging conventional representations of African Americans, particularly those that appeared in mainstream newspapers and magazines. The brief artists' statement that opens *Portfolio No. 1* confirms that the photographers were presenting what they saw as a new "truth" about "the world, about the society and about themselves."[26] Instead of depicting Black people as the embodiment of social ills, such as poverty and crime, or

consigning them to the roles of entertainer or servant, the portfolios' images show them as people who were frankly quite ordinary. Children play and laugh and frown; grownups go about their business, rarely doing anything dramatic. African American life is the occasion for the photographers' artistic expression, which very much included exploring new ways to visually represent Black people.

Children are the subjects of seven of the fourteen photographs in *Portfolio No. 1.* [cat. no. 2] With a single exception, they all seem to be healthy and happy—or, at the very least, content. Only David, the subject of a portrait by Roy DeCarava, seems as though he might be troubled. DeCarava brings the viewer very close to the boy, who is seen from the waist up, and, because he has crouched down low to make the photograph, viewer and subject seem to meet each other face to face. Yet David's eyes are hidden in shadows, making his expression something of a mystery. It is easy enough to rule out joy, but whether he is feeling anger or sorrow or boredom is impossible to know. To put it another way, the ambiguity of his expression rules him out as a candidate for pity, an emotion that is one of the conventional representations of Black children in the "ghetto." Similarly, the dark-skinned man wearing a wide-brimmed straw hat in an untitled portrait by Shawn Walker is asking for no one's sympathy. He is lean and alert, with powerful forearms. His facial expression makes his good humor obvious. His poverty is also apparent. He wears ragged clothes, and the hand-lettering on what appears to be a large metal cabinet beside him tells us that he's probably Scottie, an expert, although clearly impecunious, car cleaner. Yet nothing about the portrait suggests that Scottie, if that is his name, needs or wants the viewer's pity. He is neither a sociological problem nor a caricature. He is, Walker shows his viewers, a man who takes care of himself.

Most, but not all, of the images in *Portfolio No. 2*, from 1965, are also concerned with the representation of African Americans in visual art. [cat. no. 3] One of the exceptions is David Carter's *Untitled, 1965*, an abstract image with no recognizable human figures. It offers instead a dreamlike study of indistinct shapes and shades of gray. The only clearly discernable figure in Anthony Barboza's untitled photograph is white, not Black. The figure, whose gender cannot be determined, may be panhandling. If so, Barboza has placed a white person in a position that Black people often occupied in mainstream photojournalism and documentary photography. Still most of the photographs are glimpses of ordinary African American life, depicted in ways that would resonate with Black viewers. There are no celebrities in these images, no sports heroes or politicians. The singular focus on finding beauty and poignancy in the quotidian is similar to the approach that Roy DeCarava, a Kamoinge member, took in *The Sweet Flypaper of Life*,[27] his 1955 collaboration with the writer Langston Hughes, one of the workshop's most important mentors. Both men were concerned with lives of grace and

dignity, joy and sorrow that the common people of Harlem created for themselves, despite the segregation and discrimination that threatened to drag them down. Importantly, the book seems to be addressed to ordinary Black people as much as it is about them. The images and text are accessible rather than arty. Many of DeCarava's photographs have an informal snapshot quality to them; Hughes's prose conveys the rhythms and cadences of Black speech. This was a book that was done for self, and Kamoinge's members had learned from it. For them it was a "touchstone."[28]

Both portfolios, like many of the photographs that Kamoinge's early members made, challenged conventional representations of African Americans in two crucial ways. First, the racist and misogynist stereotypes of African Americans that were a far too common feature of American visual culture are entirely missing. There are no "coons" or "mammies" here. The clichés of "concerned photography"—images that emerged from photojournalism's and documentary photography's habit of viewing African American lives as being defined by their pathologies—are also absent. In Kamoinge's portfolios, Black life was an occasion to make art, rather than a problem to be solved. The images are indeed political art, but not in the sense of pleading for respect or demanding justice. The politics of the photographs are embedded in their ethos of "Do for Self" and their refusal to accept long-standing ways of representing African Americans.

When Kamoinge's members dedicated themselves to speaking of their lives as only they could, to paraphrase Draper, they affirmed their determination to "Do for Self." Yet it is important to recognize that neither the workshop nor the photographs of its members were shaped exclusively by the slogan's Black nationalist ethos. Black nationalism was and is one of two broad historical tendencies within African American politics and culture. Its companion and sometime rival was the desire to integrate into mainstream America as free and equal citizens. While nationalists emphasized racial self-determination and solidarity as the path to progress, integrationists staked their claim to equality and their opposition to segregation on their rights as American citizens. These tendencies might seem contradictory, but, as James H. Cone argued nearly thirty years ago, they often coexisted within communities, within political and cultural movements, and within individuals. In his influential study, *Martin & Malcolm & America: A Dream or a Nightmare*, Cone wrote that "no black thinker," not even King, an avatar of integration, or Malcolm, who was so closely identified with Black nationalism, "has been a pure integrationist or a pure nationalist...rather all black intellectuals have represented aspects of each, with emphasis moving in one direction or the other."[29]

What was true of activists and intellectuals was also true of artists and photographers. Kamoinge members despite or,

perhaps, because they embraced the ethos of "Do for Self," photographed the March on Washington in August 1963. They shared the participants' optimism that Black people would soon be integrated into the mainstream of American life. They also felt despair when dreams of integration seemed to be crushed. Few photographs, for instance, capture Black heartbreak and anguish as powerfully as the series that Beuford Smith made in New York City in the immediate aftermath of Martin Luther King's assassination, a man for whom racial integration was a moral imperative. Draper's best known photograph might well be his portrait of Fannie Lou Hamer, a woman who devoted her adult life to battling segregation and securing the voting rights of African Americans in Mississippi. The close-up portrait entirely isolates Hamer from her context. In her face we see her remarkable strength and grace in the face of what was often mortal danger. [cat. no. 86].

African Americans' willingness to embrace both nationalism and integration, often simultaneously, suggests a restlessness at the very core of our identity. W. E. B. Du Bois put his finger on this unresolved and perhaps unresolvable tension well over one hundred years ago. In *The Souls of Black Folk*, he famously wrote that

> One ever feels his twoness—an American, a Negro; two souls, two thoughts, two unreconciled strivings; two warring ideals in one dark body, whose dogged strength alone keeps it from being torn asunder.[30]

Kamoinge was born during a moment when much of the sentiment in the African American community leaned toward the Black nationalist ethos that was so compellingly captured in the slogan "Do for Self." The workshop became part of a centuries-old tradition of Black self-help and mutual aid organizations. When the white-dominated photo industry and art world spurned its appeals for justice, it drew on this tradition

and created its own institutions. The spirit of "Do for Self" also animated Kamoinge's determination to reenvision the representation of Black people in American visual culture. Members saw the individuality of the people that they photographed and the diversity and complexity of the African American community. Their photographs remain a stark collective rebuke to racist stereotypes and to images that depict Black people the embodiment of social ills.

Yet Kamoinge's ultimate goals were not wholly nationalist. Its members felt and acted on their Americanness, fighting to integrate the white-dominated photo industry and seeking to have their work exhibited in art galleries and included in museum collections that had historically excluded Black people. They asked to be recognized within the photo industry as skilled practitioners and by galleries and museums as accomplished artists. In the half-century since Kamoinge was founded, much progress has been made, as this exhibition demonstrates. The journey is not complete, however. Black photographers still face obstacles that their white counterparts do not. Too often, they find themselves compelled to "Do for Self!" or not do at all.

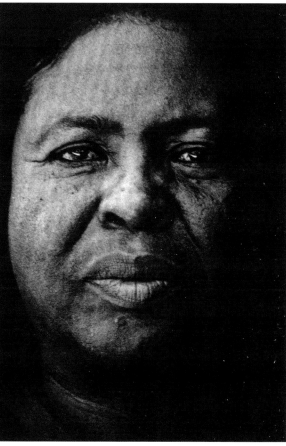

86 Louis Draper (American, 1935–2002), *Fannie Lou Hamer, Mississippi,* 1971, gelatin silver print. *Virginia Museum of Fine Arts, National Endowment for the Arts Fund for American Art, 2013.150*

Endnotes

1 See, for instance, William L. Van Deburg, *New Day in Babylon The Black Power Movement and American Culture, 1965–1975,* (Chicago and London: University of Chicago Press, 1993), 31–34; Manning Marable, "Black Fundamentalism: Farrakhan and Conservative Black Nationalism," *Race & Class,* 39, no. 4 (1998): 6.

2 Louis Draper and Anthony Barboza, "Kamoinge: the Members, the Cohesion, and Evolution of the Group," *Proceedings, American Photography Institute National Graduate Seminar,* ed. Cheryl Younger, Photography Department, Tisch School of the Arts, New York University (New York: The Institute, 1995), 114.

3 On Davis, see, *New York Times,* March 15, 1987, accessed September 6, 2019, https://www.nytimes.com/1987/03/15/obituaries/street-corner-orator-s-death-marks-end-of-era-in-harlem.html

4 Marable, "Black Fundamentalism," 6.

5 Ibid.

6 Van Deburg, *New Day in Babylon,* 155–60.

7 On the conservatism of the Nation of Islam, see, Marable, "Black Fundamentalism."

8 See John Edwin Mason, "The Sounds They Saw: Kamoinge and Jazz," in this volume.

9 Elijah Muhammad, *Message to the Blackman in America,* (Phoenix, AZ: Secretarius MEMPS Ministries, 1965).

10 Ibid.

11 Manning Marable, *Malcolm X: A Life of Reinvention,* (New York: Viking, Published by the Penguin Group, 2011), 155ff.

12 Ibid, 480–83.

13 For a full discussion of this episode, see, Sarah Eckhardt's "A History of the Kamoinge Workshop (1962–82)," in this volume, 10–18.

14 Louis Draper, handwritten draft of history, ca.1998, VA04.01.3.018D, Louis H. Draper Artist Archives, acquired from the Louis H. Draper Preservation Trust with the Arthur and Margaret Glasgow Endowment Fund, Virginia Museum of Fine Arts Archives, Richmond, hereafter cited as LHDAA.

15 Eckhardt, "History," 8–9.

16 Ibid, 17.

17 Draper and Barboza, "Kamoinge: the Members, the Cohesion, and Evolution of the Group," 114.

18 See, for instance, *Ebony,* "Enigma of Jomo Kenyatta," August 1961, 82–89, and Lerone Bennett, *Ebony,* "Uhuru Comes to Kenya, February 1964, 127–38.

19 Henry Louis Gates, Jr., "Frederick Douglass' Camera Obscura," *Aperture,* 223 (Summer 2016): 28.

20 Louis Draper, handwritten draft of history, ca.1998, LHDAA, VA04.01.3.018D.

21 bell hooks, "In Our Glory," in Deborah Willis, Picturing Us: African American Identity in Photography (New York: New Press, 1994), 45–46, 49.

22 Maurice Wallace and Shawn Michelle Smith, introduction to Maurice Wallace and Shawn Michelle Smith, eds., *Pictures and Progress: Early Photography and the Making of African American Identity,* (Durham: Duke University Press, 2012), 5.

23 Sarah Eckhardt, "An Introduction to the Kamoinge Workshop (1962–82)," in this volume, 7.

24 Draper and Barboza, "Kamoinge: the Members, the Cohesion, and Evolution of the Group," 115.

25 Eckhardt, "History," 18–9.

26 Kamoinge Workshop Portfolio No. 1, LHDAA, VA04.07.2.001.

27 Roy DeCarava and Langston Hughes, *The Sweet Flypaper of Life* (New York: Simon and Schuster, 1955).

28 Eckhardt, "History," 7.

29 James H. Cone, *Martin & Malcolm & America: A Dream or a Nightmare,* (Maryknoll, New York: Orbis Books, 1991), Kindle edition, loc. 164.

30 W.E.B. Du Bois, "Of Our Spiritual Strivings," in Du Bois, *The Souls of Black Folk: Essays and Sketches,* Du Bois, 8th ed. (Chicago: McClurg, 1909), 3.

The Black Photographers Annual

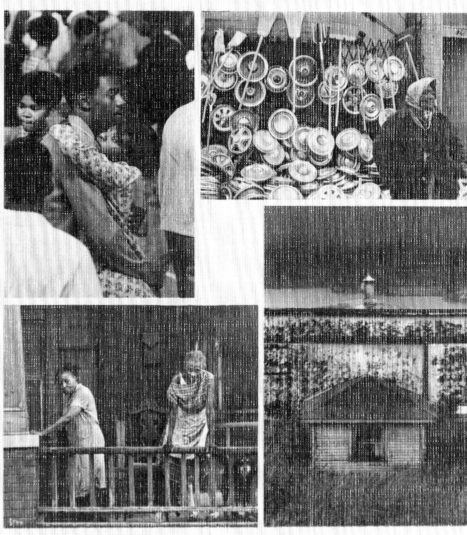

1973

True & Free: A Creation Story of
The Black Photographers Annual

BY BILL GASKINS

The opportunity is ripe then, for contemporary historians to take a closer look at the creators and contributors to the *Annual* in order to deepen our understanding and knowledge behind an entire culture of seeing.[1]

—Carla Williams

On the fourth month in the third year of the eighth decade of the twentieth century, *Ebony* magazine featured a story about a bold artistic, political, social, and watershed publishing event that dramatically expanded the content of American photography and African American culture through a groundbreaking book titled *The Black Photographers Annual*.[2] [fig. 8.1]

The story of the *Annual* begins in 1969 with the vision and determination of photographer Beuford Smith. Smith, a member of the Kamoinge photography collective, had a small book of his photographs titled *Photographic Images* printed by Frank Sawyer, owner of the Harlem Printing and Stationery Company. The compact volume featured twenty-nine pictures dedicated to his photography mentor and charter director of Kamoinge, Roy DeCarava, printer John Dahl, and Sawyer. Small in scale, *Photographic Images* would be the prologue to a proposal pitched to the members of Kamoinge that would eventually become the *Black Photographers Annual*.[3]

Popular Photography was a major consumer magazine for amateurs that published an annual issue of the best photography of the year. White photographers made up 99 percent of the work in the *Popular Photography Annual*. Smith chose to respond proactively by showing *Photographic Images* to the Kamoinge membership and proposed that the group produce a Black photographer's annual. Smith shared a sketch of his vision of the annual. [fig. 8.2] The members agreed to contribute twelve dollars each to cover the cost of several one-hundred-sheet boxes of offset negative film for the prepress work and offered to help edit and organize the effort once Smith secured the funding for production, marketing, and distribution. Buoyed by the confidence of the Kamoinge members in his idea, Smith was at the center of a mission that shaped the creation, content, meaning, and impact of the *Black Photographers Annual*.

Joe Crawford was a professional draftsman and close friend of Smith who assumed the role of publisher and editor. Joe

Walker, who was a writer, journalist, journalism professor, and the editor of *Muhammad Speaks* (the official newspaper of the Nation of Islam, 1960–75), accepted the job of associate editor and publicist. As founder and chief photography editor, Beuford Smith formed a team of picture editors with Kamoinge members Louis Draper, Ray Francis, and Shawn Walker. Photographer Vance Allen, an editor for the James Van DerZee Institute, became the external editor, and Gerald Straw was the production manager. Crawford and Smith made final editing decisions.

"Our focus was on exhibitions," observed Shawn Walker. "Beuford Smith's focus was on the world. His focus was broader than ours at the time."[4]

Within months, Crawford secured $10,000 to finance the design, production, and promotion of the book. Walker secured Toni Morrison and critic Clayton Riley to write the foreword and introduction, respectively, for the first issue of the *Annual*. Finally, Smith, a former offset printer, contracted Rapoport Printing, a leading offset shop in New York, after attempts to find a Black printing company failed. Owner Sidney Rapoport was setting the standard for superb printing of continuous tone black-and-white photographs in fine art photography books, with his numerous copatented processes, and enthusiastically supported the *Annual*.[5]

The call for submissions employed a pre-internet word-of-mouth campaign through Walker's network of Black newspaper editors and photographers to cast the widest net possible. Those photographers were also asked to contact the photographers they knew.

The process of editing over 2,500 entries began with the grueling task of rejecting photographs. Most rejected entries were earnest family photographs of uneven quality or pictures that were technically well executed, but lacking relevant content or a formal, cultural, and conceptually based aesthetic.[6]

Fig. 8.1 *The Black Photographers Annual, Volume 1*, 1973. *Virginia Museum of Fine Arts Margaret R. and Robert M. Freeman Library, Rare Book Collection, Gift of Beuford Smith, 30804005685952*

The editors sought work that challenged the legacy of media representations rooted in a documentary and sociological gaze of Blackness-as-a-problem. The objective was to replace commonplace images of Black oppression, victimhood, and pathology with celebratory, joyful, reflective, and powerful representations of personal and collective agency and engage with photography as an art form.

"We wanted to be a step above *Family of Man* because we wanted to chase away all the ghosts and spirits we had to grow up looking at through pictures," Shawn Walker noted. "We wanted somebody to be able to show this book to their kid, and go through the whole book and not have to feel bad about themselves."[7]

In the first volume, 102 of the published photographers were from the state of New York. The other sixteen photographers were from Colorado, Georgia, Illinois, New Mexico, Ohio, Maryland, Michigan, Mississippi, New Jersey, and the District of Columbia, as well as one international entrant from Georgetown, Guyana. With the selections made, Joe Crawford hired then CBS (Columbia Broadcasting System) art director and graphic designer

Vernon Grant as designer of the book. "Joe Crawford came to see me one morning at CBS and asked if I wanted to design 'a book of pictures' as he called it at the time" Grant recalled. "No guidance, no restrictions."[8]

Grant was intentional about crafting and designing the *Annual* as an art object that offered a viewing experience worthy of the works selected. Concerning the design concept, he stated, "my goal was to create a pleasing and elegant look. The photographs spoke volumes. I wanted to showcase each image with lots of white space and a good size relationship, telling each story clearly at arm's length with minimal interruption.[9]

"The content of each photograph was paramount," he continued. "I used a simple grid on the cover that would capture the excitement of each photograph, along with an elegant contemporary font. I aimed to create a good marriage with each adjacent photograph. I wanted a simple and clear font for the interior pages."[10]

Elegant is the term frequently used in reviews of the *Annual*. The physical scale of the book encourages viewers to concentrate on every image. Grant effectively sequenced the pictures in a manner that reflects his design criteria and enhances the user experience.

Rapoport responded to the printing challenge of translating the various tones of black skin through photographic tones from black to grey, as well as the unique assortment of printing styles used by each photographer.

Beuford Smith's experience and skills as an offset printer were peerless. The role he played in orchestrating the various stages of the preproduction, prepress, and postpress processes was invaluable. Smith's ability to read the halftone dots on a printing plate or negative without the use of an optical magnifying tool known as a densitometer earned him the respect of Sidney Rapoport, founder of Rapoport Printing, as well as the nickname "Mr. Densitometer."[11] When the books were delivered, the archival photography supply company Light Impressions (then based in Rochester, New York) was chosen to distribute the *Annual*.[12]

The work in Volume 1 of the *Annual* looks contemporary when viewing it today. Forty-nine men and women were exploring the possibilities of the handheld camera, where one must move mentally and physically from where they are to change their point of view.

The photographs between the covers of the *Annual* were notable for how their content and form disrupted the flow of images that had previously been limited by the way photo editors and curators had imagined the substance of Black life in the public sphere. The approaches by the men

Fig. 8.2 Beuford Smith's sketch of his original vision of *The Black Photographers Annual*. *Virginia Museum of Fine Arts, Margaret R. and Robert M. Freeman Library, Archives, Beuford Smith Archives (SC-32), Courtesy, Beuford Smith Collection*

and women who submitted work to the *Annual* reflect the depth and breadth of questions and problems explored by a group of Black people producing photography as art during this time and vary in their rendering and interpretation of people, space, objects, and concepts.

The editors compensated each contributor twenty dollars for each photograph and also gave them a copy of the book—an uncommonly fair practice for publication of noncommercial photography in 1973.[13] Eight of the thirteen portfolios in Volume 1 featured photographers who were either past members, members at that time, or would become members of Kamoinge, including Roy DeCarava, Louis Draper, Anthony Barboza, Ray Francis, Albert Fennar, Ming Smith, Herbert Randall, Frank Stewart, and Shawn Walker.

The *Annual* editorial team sagely specified that all advertising placed in the book visually correspond with the flow of the other photographs and banned the use of corporate logos and advertising copy. [fig 8.3] The last picture in the first volume by Anthony Barboza captures the energy of two young men on a bicycle, with one thrusting his fisted hand in the air—a fitting metaphor for the triumphant conclusion to this breakthrough book.

Toni Morrison's foreword effectively placed the work of the editors and photographers into the significance of its context. [fig. 8.4] In the closing paragraph, she writes, "Not only is it a true book, it is a free one. It is beholden to no elaborate Madison Avenue force.... An ideal publishing venture combining, as it does necessity and beauty, pragmatism, and art."[14]

A review of the *Annual* by *Popular Photography* stated, "With a few exceptions, however, the quality is of a high order and the variance in style an asset to the book's overview of social and artistic development."[15] A.D. Coleman wrote in the *New York Times* that "*The Black Photographers Annual* is by far the best such publication I have seen in the past five years—a volume so alive and nourishing that it puts the products churned out by *Popular Photography* and *Modern Photography* to shame."[16]

David Vestal's review in *Camera 35* mixed muted praise with scorn for the use of the word "Black" in the title and the for us, by us agenda of the publication.

"I gather that 'Negro' is now a nervous-making word and that segregation—as long as it's from the other side is in ... ," he wrote. "So here we have the first self-segregated black photographers' annual, a pretty good photographic book. I was wondering what black photographers might have to show us that white photographers don't. The answer seems to be nothing."[17]

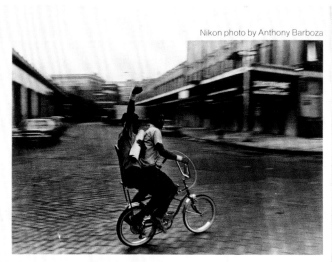

Fig. 8.3 Nikon ad, Anthony Barboza, *Black Photographers Annual*, Volume 1, page 144 *Virginia Museum of Fine Arts Library, Rare Book Collection, Gift of Beuford Smith, 30804005685952*

Fig. 8.4 *Black Photographers Annual*, Volume 1, Foreword by Toni Morrison *Virginia Museum of Fine Arts Library, Rare Book Collection, Gift of Beuford Smith, 30804005685952*

In an insightful press release written in 1973, Joe Crawford anticipated the fundamental question, "Why a *Black Photographers Annual*?" for reviewers like Vestal.

> This disregard for the works of Black photographers is not limited to the galleries and museums. *Popular Photography*, a major monthly photographic magazine, publishes each year an *Annual* containing what its editors consider to be 'a selection of the world's finest photographs.' In the last ten years, they have included a portfolio of prints by only one Black photographer.[18]

In their introduction to Volume 2 of the *Annual*, published in 1974, the editors reflected on the enthusiastic and affirmative response to the publication of the first volume. "Rave reviews were received from leading photographic publications in England, France, Japan, and Spain. In the United States, Black newspapers and magazines, TV and radio reviewers were equally impressed."[19]

While this quote accurately describes the scale of the response to the *Annual*, chief photo editor Beuford Smith astutely informed Joe Crawford after Volume 2, "We can't keep showing the work of Anthony Barboza and Ming Smith with each issue."[20] The quality of the work was going down. Too few Black photographers were working as artists. "I didn't think we could sustain the *Annual* based on the work we saw at that point," he observed.[21]

Subsequent volumes of the *Annual* did contain fewer photographs. Inspired approaches to abstraction, minimalism, and the surreal in photography continued. Portraiture and photojournalistic and documentary photographs made in urban spaces increased, as did those from rural areas, as well as nuanced observations from beyond the United States. Volumes 2, 3, and 4 maintained the design and production quality of the *Annual* and introduced audiences to the legacy of Black photographers obscured by the distorted lens of photographic history or the race-based gatekeeping of "objective" curators. [figs. 8.7– 8.9]

The look of Volume 4—the last *Annual* published—radically departed from that of the first three volumes, primarily due to the aesthetic of graphic designer Edward Towles, who was then the art director for *Essence* and *Black Enterprise* magazines. It also had the fewest number of photographs. Beuford Smith purposely sought the perspective of a Black woman for the editorial team of this volume and recommended photographer Jeanne Moutoussamy-Ashe. Joe Crawford selected Lenore Jenkins, a picture editor for *Scholastic Magazine*, to participate in the selection process for what would be the final volume.[22]

All four volumes introduced audiences to new views of Black life through portfolios of work by previous generations of photographers, including Hamilton Smith, Addison Scurlock, Prentice H. Polk, and James VanDerZee. Interviews with Gordon Parks and Roy DeCarava accompanied their portfolios and offered readers the all-too-rare exposure to the thoughts of these photographers about their work and the world they made it in. Photojournalists Matthew Lewis, Pulitzer Award–winner Ovie Carter, Robert Van Lieroup, and documentary photographer Richard Saunders provided views from the African and Asian continents that both diverged from and converged with the image of these regions in the popular imagination.

The work of photographic legends beyond New York City, like Philadelphia's Kenley Gardner, Baltimore's Cary Beth Cryor, and Newark's Eli Reed, was presented to a wider audience. Volume 2 also published the portfolio of Ted Gray, a student attending the School of the Art Institute of Chicago in 1974, previewing the next generation of Black photographers. New portfolios by Roy DeCarava in Volume 3 and James VanDerZee in Volume 4 were published along with the work of Anthony Barboza, Ming Smith, Albert Fennar, the emerging Marilyn Nance, and the tried-and-true staple of other Kamoinge photographers. As an unprecedented publication, the editing, design, marketing, distribution, content, and the mission guiding it all, the first edition of the *Black Photographer's Annual* was the strongest. Shawn Walker observed: "Some people thought it was an incest thing. Look at the portfolios. Compare it to the rest of the book at-large and the rest of the books. We concluded that Kamoinge's work was the strongest at that time."[23]

It is essential to grasp that beyond a small group of art historians, scholars, theorists, and photographers who thought otherwise, most artists in the 1960s viewed photography as a stepchild of drawing and painting and an illegitimate form of art. The essential identity of the photographer in the public imagination and professional photographic communities was limited to advertising photography and photojournalism in *Life*, *Look*, and *Ebony*, documentary photography in *National Geographic*, and celebrity and consumer portrait photography.

Each volume of the *Black Photographers Annual* reflects a layered intersection of historical, social, and cultural forces in the United States and the world stage that informed and inspired the path and agenda that Louis Draper, Albert Fennar, Ray Francis, and Herbert Randall embarked upon when they established the Kamoinge Workshop in 1963. Each member had a love for Black life, pursued self-examined lives, explored photography as a form of personal expression, and wanted to create an alternative to an established commercial and emerging art photography community that swung between hostile and indifferent to the work and ideas of Black photographers.

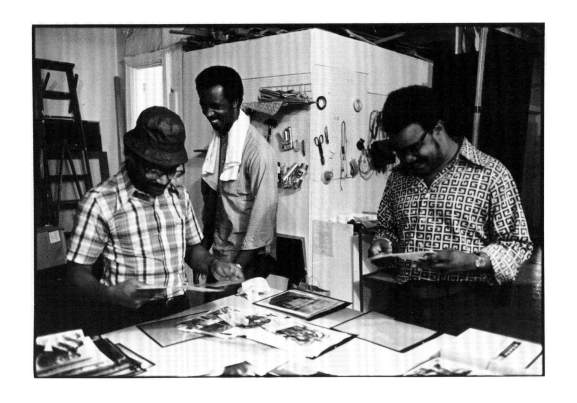

9 Anthony Barboza (American, born 1944), **1st Black Photographers Annual,** 1973, gelatin silver print. L–R: Beuford Smith, Joe Crawford, Ray Francis. *Virginia Museum of Fine Arts, Adolph D. and Wilkins C. Williams Fund, 2016.326 © Anthony Barboza photog*

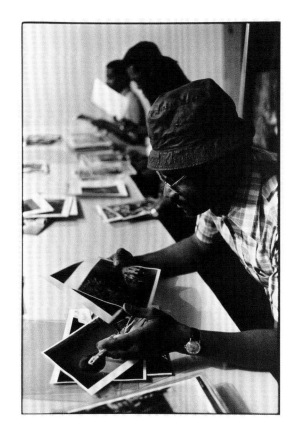

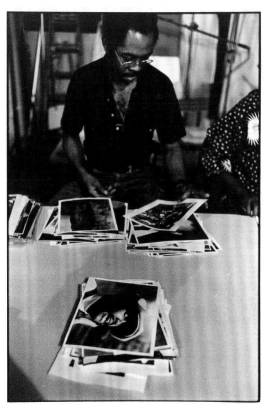

Left: **10** Anthony Barboza (American, born 1944), **Beuford Smith, 1st Black Photographers Annual,** 1973, gelatin silver print. *Virginia Museum of Fine Arts, Adolf D. and Wilkins C. Williams Fund, 2016.331 © Anthony Barboza photog*

Right: Anthony Barboza (American, born 1944), **Vance Allen, 1st Black Photographers Annual,** 1973, gelatin silver print. *Virginia Museum of Fine Arts, Adolf D. and Wilkins C. Williams Fund, 2016.328 © Anthony Barboza photog*

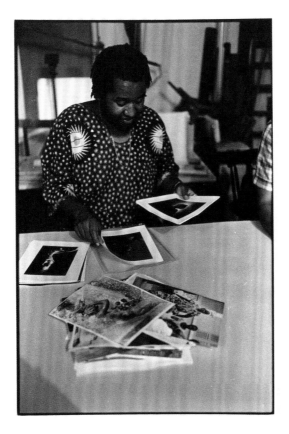

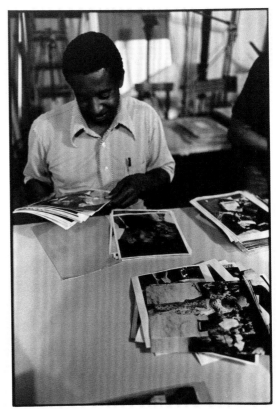

Left: **11** Anthony Barboza (American, born 1944), **Shawn Walker, 1st. Black Photographers Annual,** 1971, gelatin silver print. *VMFA, Adolf D. and Wilkins C. Williams Fund, 2016.323* © *Anthony Barboza photog*

Right: **12** Anthony Barboza (American, born 1944), **Lou Draper, 1st Black Photographers Annual,** 1973, gelatin silver print. *VMFA, Adolf D. and Wilkins C. Williams Fund, 2016.327* © *Anthony Barboza photog*

Bottom: Anthony Barboza (American, born 1944), **Lou Draper, 1st Black Photographers Annual,** 1973, gelatin silver print. *VMFA, Adolf D. and Wilkins C. Williams Fund, 2016.330* © *Anthony Barboza photog*

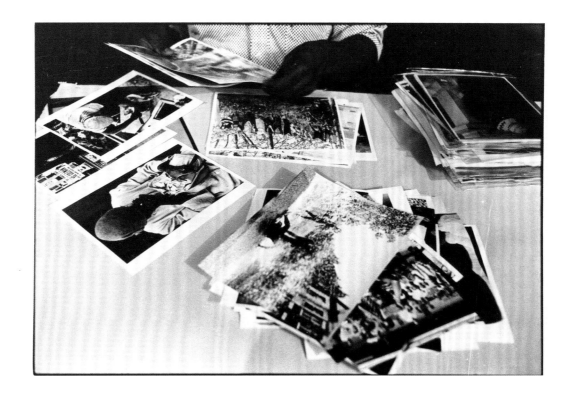

Most significantly, the agenda of the Kamoinge Workshop was in direct opposition to the social and aesthetic criteria of John Szarkowski in his influential and gatekeeping, role as director of photography at the Museum of Modern Art.

Szarkowski strategically launched a program of exhibitions and publications on photography to reeducate the public, as well as the generation of photographers who were influenced by the 1955 photojournalism and documentary-based blockbuster exhibition *The Family of Man*. Szarkowski's 1964 exhibition, *The Photographer's Eye*, institutionalized a conceptual and formal vocabulary for viewers to understand photographs based on specific qualities he considered essential and unique to the medium ("the thing itself, frame, time, vantage point, the detail").[24]

In 1967, Szarkowski mounted the groundbreaking *New Documents* exhibition of highly personal approaches to the vocabulary of documentary photography by Diane Arbus, Lee Friedlander, and Garry Winogrand that visually distinguished each photographer. Szarkowski wrote the following about Arbus, Friedlander, and Winogrand: "They like the real world in spite of its terrors as the source of all wonder and fascination and value—no less precious for being irrational. Their aim has been not to reform life but to know it."[25]

Szarkowski wrote this at the intersection of the Cold War between the United States and Russia, and the extension of the American Civil War over the intersection of race and rights. This is a war embodied by race-based structural inequality underscored by sadistic, flesh-burning, bone-breaking, spirit-crushing terrors then and now. Black people could not vote in many of the former Confederate states of America without paying poll taxes or being subjected to gatekeeping examinations. Denise McNair, Cynthia Wesley, Addie Mae Collins, and Carol Robertson died in the 16th Baptist Church bombing in Birmingham, Alabama, in 1963. Also, the all-white Democratic National Committee rejected the petition by the Mississippi Freedom Democratic Party, led by Fannie Lou Hamer, to desegregate the state delegation and admit them as full voting delegates to the 1964 Democratic National Convention, while twentieth-century sharecropping continued to replace nineteenth-century chattel slavery.

Comprehension of the wretched state of Black America, stark evidence of a nation in need of restructuring and reform, was edited from the "real world" cited by Szarkowski and witnessed by Arbus, Friedlander, and Winogrand.

Szarkowski's comment reflects an ideological curatorial agenda that theoretically vaporized the capitalist, social, political, material, and racial "terrors" of 1960s America through a modernist emphasis on aesthetic form and concepts devoid of social context based on a subjective modernist vocabulary stripped of any meaning beyond

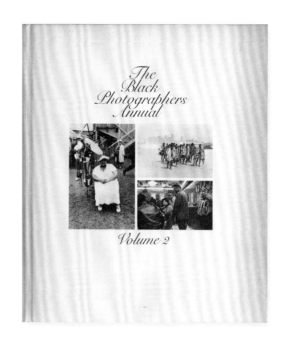

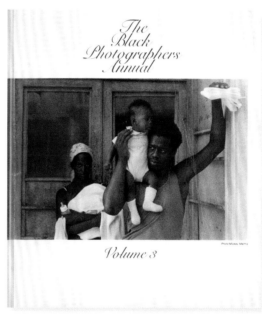

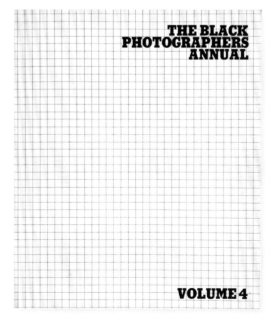

Fig. 8.5 *The Black Photographers Annual*, Volume 2, 1974, *Virginia Museum of Fine Arts Library, Rare Book Collection, Gift of Beuford Smith, 30804005685978*

Fig. 8.6 *The Black Photographers Annual*, Volume 3, 1976, *Virginia Museum of Fine Arts Library, Rare Book Collection, Gift of Beuford Smith, 30804005685952*

Fig. 8.7 *The Black Photographers Annual*, Volume 4, 1980, *Virginia Museum of Fine Arts Archive, VA04.02.2.025*

how the visual elements were selected and arranged on the picture plane as a print.

Moreover, the *New Documents* show enlarged the reputations of three New York City photographers who enjoyed robust commercial careers that funded independent work presented on the biggest stage in the world, many times during Szarkowski's tenure—and beyond.

While Black people were occasionally visible as the subject matter of white photographers in Szarkowski's exhibitions, the thoughts and ideas of Black people as conscious spectators and producers of photography exploring modern questions and problems of context, content, form, and aesthetics are commonly absent in the scholarship, curatorial activity, and consideration of John Szarkowski.

With that said, in his 1973 introduction to *Looking at Photographs*, Szarkowski offers a careful, well-crafted, and, perhaps, preemptive mea culpa for his benign neglect of Black lives and minds written from the prerogative of an archetypal white male power figure of American culture for future readers. "Finally, it must be assumed that some unforgivable omissions are invisible to me, and are the result not of a conscious ordering of priorities, but of ignorance," he wrote.[26]

This aristocratic, academic, polished brand of northern "ignorance," and the *segregated eye* Szarkowski applied in a Manhattan museum in the name of formalist-driven, fictitiously nonpolitical modernism, narrowly defined independent postwar American photography at the Museum of Modern Art for decades.

Moreover, the complexity of the conceptual, formal, technical, and aesthetic questions posed by Beuford Smith and the members of Kamoinge were not part of elite conversations about photography as a means of personal expression, communication—or even art—during this time.

Beyond the walls of MoMA and midtown New York City, the vicious, openly bigoted, highly organized response to Black nonviolent resistance to racial apartheid in the streets of Mississippi and the other Confederate states of America led many Black people to recognize nonviolence as a suicidal protest strategy. Hope in a white majority embracing Black people as kindred members of the human family was rationally being abandoned given the unbridled violence directed at nonviolent Black people.

The civil rights movement's tactics of oral and written arguments rooted in moral suasion and the goal of an assimilationist integration was rejected and replaced with an *ideologically* separatist Black Nationalism.

In fact, in his speech "Where Do We Go from Here?" given less than a year before his murder, Dr. Martin Luther King Jr. concluded, "It is precisely this collision of immoral power with powerless morality which constitutes the major crisis of our times."

This collision of morality, power, and powerlessness transformed the ideology of Black Nationalism into the politics of Black Power, a politics of self-determination and accountability. This idea also assumed joyfully muscular (commonly called "militant"), self-affirming expressions of love of Black people, by Black people, for Black people, like James Brown's classic rhythm and blues anthem *Say It Loud—I'm Black and I'm Proud*. This love was far more pro-Black than antiwhite, as it sought to affirm and embrace the humanity of Black bodies, features, voices, spirits, and minds by extending the respect, civility, and daily pleasantries to each other, commonly accorded to most white people by most Black people in the United States.

As a response to the assassination of Malcolm X, poet and playwright Amiri Baraka (previously known as LeRoi Jones) founded the Black Arts Repertory Theatre and School (BART/S) in Harlem in 1965.[27] In 1968, the Drama Review published Larry Neal's essential essay "The Black Arts Movement."[28] Neal couples Black Power politics with the agenda of the Black Arts Movement through Amiri Baraka's Black Arts Repertory Theatre and School. [cat. no. 107].

This Black Arts Movement was not about witchcraft. Writer and Professor Larry Neal summarized the primary objectives of the "Movement" as speaking to Black America's demand and aspiration to self-determine as a group and "nationhood," tending to the "cultural and spiritual needs of Black people," pursuing "a cultural revolution in art and ideas," questioning the values and "aesthetics of the west," and re-examining "the social function of art."

Despite criticism by Baraka and others of the nonviolent tactics of the civil rights movement, BART/S was, another form of non-violent resistance and civil disobedience. The response to structural inequalities, police brutality, segregated education, voter suppression, economic and political disenfranchisement, institutional and individual acts of aggression, and hostility through love and art is one of the most underappreciated dimensions of the transformative cultural, political, and social phenomenon of the Black Arts Movement.

While BART/S was rooted in theater, poetry, fiction, and avant-garde approaches to jazz, a news story from *Muhammad Speaks* in October 1965 included an article headlined "LeRoi Jones School Presents Black Photography Exhibit."[29] The exhibition of photographs that "show the lives of Afro-Americans and their expression" included

works by Kamoinge photographers Albert Fennar, Danny Dawson, Herbert Randall, Lou Draper, and Ray Gibson.

The founding of Black Studies at San Francisco State University impacted the content of higher education's history, literature, and social science curricula.[30] Black high school students demanded changes to the content of history courses to rewrite the chapters of American and world history that excluded the role of Black people and the work of Black scholars.

Black playwrights wrote plays, Black poets wrote poems, Black authors wrote stories, and Black scholars researched and wrote facts. Black publishers published and sold the work of classic and contemporary Black writers and scholars. Black people bought books from Black bookstores throughout the nation that became cultural centers as well as business. These included the National Memorial African Bookstore and Liberation Bookstore in New York, Hakim's Books in Philadelphia, Drum & Spear Bookstore in Washington, DC; and the MORE Bookstore and Marcus Books in San Francisco, to name just a few.

The Garth Fagan Dance Company and Arthur Mitchell's Dance Theatre of Harlem formed in 1969 and 1970, respectively, joined the then ten-year-old Alvin Ailey Dance Company to transform and expand the boundaries of modern and classical dance in America, through works informed by the complexity and diversity of African American life. Storied collectives of Black visual artists also formed during the 1960s. In addition, a number of artist collectives put the visual in the Black Arts Movement, Spiral, AfriCOBRA, (an acronym for the African Commune of Bad Relevant Artists), Where We at Black Women Artists Inc., and Weusi Artists Collective.[31]

However, while the Black Arts Movement included the work of visual artists, the recognition of photography as an art form was not universal in 1965. Black people working in photography as a form of personal expression and exploration would have to make space for themselves in the context of an art movement anchored in theater, fiction and nonfiction writing, poetry, painting, printmaking, sculpture—and the politics of representation.

Kamoinge created that space working and theorizing in the shadow of the Black Arts Movement. This band of brothers viewed French, Italian, and Russian cinema; read *Film Form and The Film Sense* by Sergei Eisenstein, among other books in the Kamoinge bibliography; engaged live and recorded jazz; and once collectively embarked on a short-term exploration of a Zen macrobiotic diet regimen.[32] Each of the members was seeking to understand the world, themselves, photography, and self-expression through the medium. The Kamoinge photographers were refining a view of picture-making that

would expand the content of postwar American photography in the story of visual culture—singularly and collectively.

While they functioned as a group, art historian Erina Duganne reminds us that the Kamoinge members were individual actors as artists. "As a group, the members of Kamoinge never attempted to make a collective-based art; they preferred to photograph alone, although occasionally in pairs."[33]

107 C. Daniel Dawson (American), **Amiri #10,** 1970, gelatin silver print. *Collection of C. Daniel Dawson*

There was a centuries-old question being raised with greater amplification in the United States during the mid-twentieth century: are Black people part of the human family? The answer to this question for many people was no, especially in the matter of civil rights and public policy.

For even more people, the only relevant Blackness was the ink of the text on the pages of a history rooted in white supremacist thinking and commonly illustrated by mass-produced photographs satisfying appetites for distorted, exaggerated, and editorially slanted visual evidence of Black inferiority and criminality through journalism, politics, popular culture, and entertainment.

The Kamoinge photographers collectively sought to disrupt the traffic in these representations of Blackness. Pursuing the independent path of photography as a form of art beyond the control of corporate editors and other gatekeepers of visual culture offered the most significant

opportunity to produce a transformative visual counter-narrative. To this end, Louis Draper sought to engage the Kamoinge members into what he called an "investigation into the nature of what it means to be Black, and a translation of that into optical terms."[34]

Kamoinge needed a larger stage to engage an audience of Black people who could sustain their efforts with encouragement—and cash—within and beyond the elite, episodic, and relatively isolated context of a gallery or museum show for an audience that was just then being born. This larger stage is what Beuford Smith envisioned when he pitched his proposal to Kamoinge for the *Black Photographers Annual*. However, a relevant platform for cultivating Black audiences to embrace the photograph-as-art that matched the scale of Beuford Smith's vision for the *Black Photographer's Annual* was also required.

Fig 8.8 *Black Creation*, vol. 1, no. 1, 1970, paper, ink, metal. *Collection of the Smithsonian National Museum of African American History and Culture,* © *1970 Institute of African American Affairs*

This platform came about in April 1970 with the launch of *Black Creation* [fig. 8.8], a daring magazine of African American arts and letters published by the Institute of Afro-American Affairs (now Institute of African American Affairs) at New York University.

Fig. 8.9 "A Rap on Photography," *Black Creation*, Summer 1972, Volume 3, No. 4. *VMFA, Margaret R. and Robert M. Freeman Library, Archives, VA04.02.2.017*

Black Creation was a quarterly, student-run journal of poetry, short stories, art, photography, and criticism. Edited by Fred Beaufort, a photographer himself, *Black Creation* became a leading national journal of African American culture that, among other things, published the work of Black photographers. The journal sponsored an annual photography contest judged by Kamoinge members, and photography editor Tony Eaton regularly

published portfolios of photographs by Black photographers that included pictures by Beuford Smith.

"Because of a lack of understanding in the field of photography," Eaton conducted and published an essential interview with three members of Kamoinge, along with Fred Beaufort, in a feature titled "A Rap on Photography." [fig. 8.9]

Their discussion provided insight into the questions and issues the assembled Kamoinge members were exploring as individuals and as a collective: How to rise above "pathological" representations of Black people in photography; differences between photographers and musicians; the need for public feedback; tensions over the term "artist" versus photographer; the challenge of the graphic translation of social and personal experience; the lack of outlets for work by Black photographers; does a "Black" photography exist; among others.[35]

They also considered the myth of the Black experience as a limited creative and cultural well for Black photographers and explored the future of photographs produced by Black photographers.

The headline copy of the full-page ad [fig. 8.10] that appeared in the summer 1972 issue of *Black Creation*, written by Joe Crawford, decreed the *Annual* was the "The Most Beautiful Black Book Ever Put Together." The tone of Crawford's body copy for the ad was as declarative as the headline: "And what makes it beautiful is 118 of the finest, most powerful black and white photographs ever printed. By 49 of the most gifted photographers we could find all over the country. What makes it so beautiful is that it's never been done before. This is the first photographer's annual to capture the music, the comedy, the tragedy, the poetry and the love, which all together make up the Black experience."[36]

The transition sentence to the direct sales pitch cleverly alludes to the first sentence of the last paragraph of Morrison's introduction. The ad copy sustains its marketing rhetoric, proffers a capitalist appeal, and then bluntly makes its case in dollars and cents: "Not only is it a fantastic book, but it's organized, sponsored, published and produced by Blacks. And it sells for only $5.95 a copy (softcover price), which is also beautiful when you consider it amounts to a little more than 5¢ a photograph."[37]

The closing argument of the advertisement directly addressed an audience new to the idea of photography as an art form and pitched the *Annual* as a book worth spending one's hard-earned money on. The ad promised the patrons who chose this book a history-making publication that associated beauty with Blackness.

"Maybe you never had a reason to buy a photographer's annual before, but you've got one now. Because this

Photography

A Rap on Photography

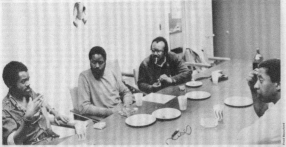

L. to R. B.C.'s Photography Editor Tony Eaton, and photographers Ray Gibson, Beuford Smith and Lou Draper discuss the art of photography.

Because of a lack of understanding of the field of photography, we at Black Creation invited several working photographers up to our office to talk about their art. Included in the discussion were B.C.'s Photography Editor, Tony Eaton; freelance photographer and instructor in photography, Lou Draper; photographer/instructor, Beuford Smith; and freelancer, Ray Gibson. We had invited the excellent photographer Pat Davis to join us but she was unable to make it at the last minute. B.C.'s Editor-In-Chief, Fred Beauford, who has also worked as a photographer, joined in the conversation.

Beauford: A black photographer recently said on a T.V. program that he could tell a picture taken by a black photographer. Is there such a thing as uniquely black photography?

Draper: My feeling is that black photography, or what you refer to as uniquely black photography, is something that, except in rare instances, doesn't exist. It's the criteria that we're trying to build upon. If we consider that photography is roughly 170 years old, and that we have been involved in it only a very short time, it's something that has to evolve. It's not something that you start with. You are dealing with a mechanical instrument and you are also dealing with certain things that have been prescribed. The whole idea of making synonymous your feelings for the camera with your life experience is something that takes a while to develop. It would be, I imagine, akin to jazz and akin to certain very distinctly black outlets. I think it would have to be based on, first of all, the penetration and concentration on the area that is specifically ours in terms of physical images—I don't know what that would be. Certainly, it would be involvement with history, it would be involvement with social movements. It would be involvement with those things that have shaped us and directed us in the 20th Century. And I think it requires an investigation into the nature of what it means to be black, and a translation of that into optical terms. I don't think that when I look at a photograph by a photographer that I necessarily know it's a black photographer. I don't think that's a very accurate statement for me, anyway. You are talking about something that is unique. You're talking about something that is beyond the physical image. You are talking about something that has to do with inner knowledge, and I don't think we have evolved into a school or a tradition of black photography. I think that this is something that we are striving for.

Eaton: Do you feel that a black photographer is now capable of going throughout the world and expressing himself (or herself) in other parts of the world other than black?

Draper: It depends on his criteria. I think that he is capable of doing anything he wants to know. Black people can be totally white if they want to be; I mean they are capable of doing that. Expressing yourself is a by-product of expressing your subject. And in expressing your subject there is the whole coming together of what it is that shapes you, what it is that has caused you to be the kind of person that you are, and select the kind of material to work with that you do. And I think in the long run it's an evolutionary process. It's like style; it's something that evolves out of a concentration on the material, and I don't think we can talk about it beforehand. I think it will be shaped by the things that we involve ourselves with. I think the criteria is endless. I think there are a number of things that have to be discovered that we are not even aware of at this point, i.e., what can we translate into graphic form that is relevant to us?

Eaton: I feel that we are very limited unless we happen to strike that pose where we can get out and really become somewhat free to search and explore our own people, and other peoples of the world. But there are very few outlets where a black photographer can go in and just pull a steady six months just studying and then coming back with the material.

Gibson: You know, Tony, when you say that sense of being limited, I sometimes wonder about that. I think one is as limited as the person. I think the source material is there. I think the things to evolve and involve ourselves in are there also. Like the writers are there, by and large. The music is there, but so much of it is a personal challenge to the individual. Or it is a sense of his personal need, his personal sense of doing that. I don't think that cameras react to us any differently than they do to anybody else. Emulsions are emulsions and ASA's are ASA's. But it is ourselves in conjunction with the society that we are born into, which is a very material society, that counts. I don't think any of us can get beyond that. It's like, why does a person become a Malcolm or a Martin? Certainly most of us don't even endeavor to do that. But there was something within those individuals that drove them to the point that they did. What makes a photographer? What makes him go out and do certain kinds of images? Why didn't he just stick with weddings; why didn't he just attempt to be another fashion photographer or another whatever? I believe that there are things, there are questions that come from the inside and have to do with our own personalized feelings. I believe that one involved in the sense of being black and seeing America, somewhere along the line you have to say, hey, a lot of this shit really doesn't involve

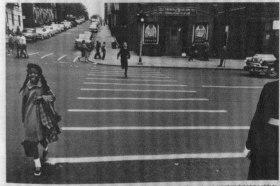

Lou Draper: "The whole idea of making synonymous your feelings for the camera with your life experience is something that takes a while to develop."

me. When I hear about the Declaration of Independence or George Washington or Abraham Lincoln they're all hollow, empty cells to me because I don't see that much change. I walk through the streets and I see cats wasted. At one time I became very angry. I still do. But now I am beginning to interpret them as victims. What I am trying to say is that somewhere along the line there has to be that supreme personal conviction. Especially when there's very little renumeration—whether it be financial or even the acknowledgment. You know, like how many cats really do know about Roy De Carava? His statements point out questions; they show him as a probing individual; they show him not from the outside. He has statements where he ponders questions that Bruce Davidson couldn't even see now. And they come out of his own existence. It's almost like a fat cat who's a wino or whatever or a cat who's strung out. If you really examine his life it's a hell of a complex thing, and I'm talking about from the inside. I'm saying this is flesh of my flesh, blood of my blood and not just

Ray Gibson: ". . . a hell of a lot of difference when it's these people and it's my mother or my father."

something analytical or not just some sense of saying, hey, I'm going to turn out a nice job, or I want to do a beautiful Guggenheim on these people. I think there's a hell of a lot of difference when it's *these* people and it's my mother or my father and there is that sense of directness and/or the sense of saying, hey, wait a minute, how much of this shit really does apply?

Smith: You know, I can only deal with all of this in terms of my own efforts and my own feelings, and the direction where I want to go. And that takes me somewhat beyond black photography because, essentially, I don't think we have to title it as such. I think of the people who deal with mathematics, who dealt with the building of pyramids, architecture and all that. There's no need for us at this point to deal with the four hundred year syndrome of slavery. There was a point in history when black people were involved with everything under the sun and my frame of reference in terms of dealing with the black experience goes to that period, not this abbreviated period of deprivation and slavery. We know that we were shapers of the world and in a parallel situation I think that if black photography is going to be meaningful it's going to have to continue that role. It's going to have to shape and point the way, rather than deal with the kind of reaction to. It's going to have to initiate. It's going to have to begin to decipher what this whole thing about black experience is. What are we talking about in terms of history, in terms of politics, in terms of economics, in terms of spiritual consequences? What are we talking about in terms of human interaction? And how is that to be plotted graphically into meaningful images? My own feeling is that black photography has to be responsible in an educational way at this point. And I think education is quite broad in the sense that it causes people to build. It's a barometer of where they have been, and an indication of where they will go. I think it is infinite. I don't think it is in any way limited. I don't think dealing with the black experience as I am expressing it is limited. I think it's quite broad. I think it's much more than I'll be able to tap in my lifetime if I were involved totally. There is so much that has to be said and so much that is there, so much raw material that has to be tapped, that there is no end to whatever we can involve ourselves with. I see it as the only thing that I can do. This is what I know and I try to deal with

Beuford Smith: ". . . if Black photography is going to be meaningful . . . it's going to have to shape and point the way, rather than deal with the kind of reaction to."

what I know. I try to deal with those things that have shaped me, those things in which the experience has gone through me; in which there has been a response, a reaction, an emotion, a catharsis or whatever. I don't think you can deal with things that are theoretical. You have to deal with things that are more accurate. Certainly you use books and you get an indication from other sources. But I mean, at some point the experience has to be actual. I think I have to respond, to be open enough to allow myself to respond, and from there possibly draw from that experience and be able to make some meaningful images.

Beauford: Do any of you believe that the photographer is primarily a creative artist rather than a mere recorder?

Eaton: I don't think that is the person's fault; it is the label that has been put on the person who is working. When this person feels the need to express himself, when he reaches the level where he is constantly working and constantly doing what he needs to do, then the people around him say that he is an artist. From an individual who is doing—I doubt whether I know anybody who is struggling to be an artist. But I know people who are struggling in the media, in painting, dance and with the camera. You can't deal with something this emotional and be involved with a title.

Beauford: In other words you are saying that the title has no relationship to what you are doing?

Eaton: Right! I agree fully with Lou.

Smith: I've kind of kept out of this conversation because there is a word that has been going around that I haven't really understood, and that's the word "artist." Now what differentiates a person who paints; say you have two men painting. How can you say this guy is an artist and this guy isn't? Who can set the standards? Just what is an artist?

Eaton: But I think that is the outside world too. It defines a person.

Smith: But they say Andy Warhol is an artist.

Eaton: They say, but you ask Andy Warhol and he may say he is a businessman who has found something that works.

Smith: See that's what I am saying about the word "artist." There are so many contradictions that I can't associate with that word.

Beauford: There is another point that keeps coming up about evolvement. One of the things we notice at Black Creation is that most of the photography that we receive, by and large, is concerned with sort of street scenes and the ghetto and you know, garbage cans, the "woe is me" philosophy, as Lou said. So if we are going to evolve, then in what direction will the evolvement go as far as black photographers are concerned? What else should they be doing?

Smith: I can only speak in the personal way I feel about it. I've always been concerned with what I feel is a black image, and what I feel is pertinent to me and to other black people. But I've never photographed a bum on a sidewalk, even when I first started in photography. But I'm not even knocking that kind of photography because that's also a part of how black people live. But I think where the black artist should go is to show the other side for change. We never see a guy's old lady or his mother or his grandmother just walking down the street on a Sunday afternoon. We never see these kinds of photographs. We always see the "woe is me" sort of thing and I think we should go into a direction that shows the other side of black people.

Beauford: Do you think that some photographs are actively perpetuating negative stereotypes of the black community?

Smith: I think it gets back to what Lou Draper said. Something about the photographer should know himself. I think that kind of photography comes out as the photographer sees himself. I don't think he has himself too together if he's constantly photographing this kind of thing without adding some kind of light to it. I'm not against photographs of bums in the street per se, maybe that's a contradiction, if they can add something to it, or transcend—if he can say why this bum is here. Or say, next week the bum will no longer be there, this is where he was and this is where he is going sort of thing.

Draper: It's funny, because when I look at most black pictorial books, I see very little of my experience. I just feel that there is much more. My life, my black experience, if you will, is much richer than most of the black photographs that I have seen, most of the photographic work that I've seen that depicts it. I would like basically to deal with a number of things. Those things that manifest themselves in front of the camera and those things that I have to forcibly bring together in another process. Because there are many things that I feel that have to be dealt with that are illuminating, and are quite profound and that somehow have to be tackled. I have to deal with them, and I have to deal with them on my own terms. And you know, there

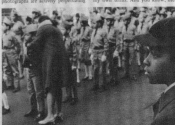

Tony Eaton: "We are limited unless we can . . . really become somewhat free to search and explore our own people, and other peoples of the world."

one is making Black history. And you can be a part of it, and that's beautiful."[38]

The timely recognition of photography as an art form by *Black Creation* editor in chief Fred Beaufort concurred with the agenda of the Kamoinge Workshop photographers who were individually and collectively pursuing the same goal while cultivating an audience for the *Black Photographers Annual*.

Fig. 8.10 Ad for *The Black Photographers Annual*, 1973, featured on the back cover of *Black Creation*, Summer 1973, Volume 4, No 3 and Fall 1973, Volume 5, No 1

By providing more editorial space for photography, *Black Creation* cultivated and established a national Black audience that embraced photography as an art form and the *Annual* as an essential book about that art form. The magazine played a vital role in marketing the *Annual*, while the national network of Black bookstores became the place to purchase both *Black Creation* and the *Annual*. This intersecting activity is not to contend that the success of the *Black Photographers Annual* was entirely dependent upon *Black Creation*, but their relationship was undoubtedly mutually supportive by circumstance—if not by a larger celestial design.

The nuanced attention the editors of *Black Creation* paid to photography accounts for a segment of Black people who comprehended photography as an art form and, as a result, were informed of and inspired by the *Black Photographers Annual*.

The *Annual* was a breakthrough anthology of photographs by Black photographers creating pictures of Black people who were neither athletes, entertainers, nor criminals.

Black people were portrayed in ways never seen in photographs before the *Annual*. Through the best offset printing technology of its time and an elegant, tasteful, and timeless book design, Black audiences came to see photography as an art for the first time. When some Black people wanted to see more photographs like them in another book made through their own eyes, the African American decisive moments presented through the *Annual* were like jazz standards they needed to learn before finding a way of looking at the world through the viewfinder of a camera and transforming what they saw into photographs.

There would be no Dawoud Bey, Carrie Mae Weems, Lorna Simpson, LaToya Ruby Frazier, John Edmonds, or Bill Gaskins in the world of photography if not for the craft, love, and commitment of Beuford Smith Joe Crawford, Joe Walker, and the inspiration every photograph the *Annual* offers.

The Book of 101 Books: Seminal Photographic Books of the Twentieth Century, edited by rare book dealer Andrew Roth, is a grand guide to a list of photography books considered "great," "thoroughly considered," and containing work of "historical significance and impact"[39] by a quartet made of an "art dealer, artist, critic, and a curator."[40] The list begins in 1907 with *The North American Indian* by Edward S. Curtis and ends in 1996 with David LaChapelle's *LaChapelle Land*. Only *Wisconsin Death Trip* by Michael Lesy and Bill Owens's *Suburbia* are cited for 1973. Absent from this list of books is the *Black Photographers Annual*.

There is an assortment of explanations to account for why the *Annual* is missing from a list asserting to represent a selection of photographic books considered "great," "thoroughly considered," and containing work of "historical significance and impact." The benevolent explanation is that the list represents a wholly subjective point of view that informs any personal value judgment made in the world of arts and letters. Such judgments are guaranteed to lead to what John Szarkowski termed as "some unforgivable omissions."[41]

Consider this subjective—but reasoned—explanation for the omission of the photography book called "a small revolution in the artistic world" by *Reporter Objectif Paris* in 1973.[42]

What would have been the outcome if the editors posed this question? What were Black people thinking as critical spectators and producers of photography before, during, and after 1973? Posing this question presumes several things: 1) Black people think, and do so in enlightening ways; 2) Black people critically make and view photographs; 3) Black people think about the photography we make and see; and 4) that photographs made and seen by Black people and the thoughts behind them are worthy of editorial, curatorial, and market curiosity and esteem.

I have no personal insight into the views of the editors on the cognitive abilities of Black people nor on our thoughts as either spectators or producers of photographs. But, based on the evaluation criteria of the editors and the omission of the *Annual* alone, I have little reason to believe that the editors of *The Book of 101 Books* considered what Black people were thinking as critical spectators and producers of photography over the course of the twentieth century, beyond their choice of *The Sweet Flypaper of Life* by Roy DeCarava and Langston Hughes.

Confidence in this assertion is based on personal experiences in classrooms, lecture halls, galleries, museums, and at conference tables, where visual, material, and media culture continue to be discussed, assessed and laden with "some unforgivable omissions."

Moreover, when assessing the repeated exhibition, publishing, commercial, and academic opportunities, as well as editorial attention, offered to the canonized cohort of white photographers working in New York City alone, the work and thoughts of the photographers featured the *Annual* are disproportionately rendered invisible, underexposed, and undervalued.

Photography is an interdisciplinary medium that requires an interdisciplinary approach to its production and reception. What Black people think, as critical spectators and producers of photography in the United States necessarily leads to answers that draw the topic into the transformative and, for some, troublemaking views and scholarship of Black lives and minds beyond a strict formalist analysis of photography.

The extraordinary public platform and scholarly attention to the *Black Photographers Annual* by the Virginia Museum of Fine Arts continue the vital work of desegregating the narrative about postwar American photography, American life, and the untold stories that remain "a small revolution in the artistic world."

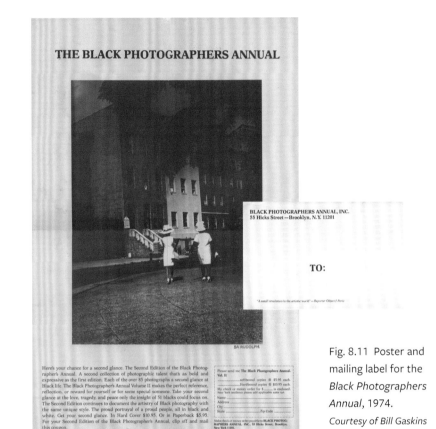

Fig. 8.11 Poster and mailing label for the *Black Photographers Annual*, 1974.
Courtesy of Bill Gaskins

Endnotes

1 Carla Williams, "The Black Photographers Annual," *Aperture*, April 26, 2016, 33.

2 "A Salute to Black Photographers," *Ebony*, April 1973, 73.

3 Beuford Smith, conversation with the author, October 6, 2018.

4 Shawn Walker, conversation with the author, December 24, 2018.

5 Ibid.

6 Beuford Smith, conversation with the author, October 6, 2018.

7 Shawn Walker, conversation with the author, December 24, 2018.

8 Vernon Grant, conversation with the author, December 23, 2018.

9 Ibid.

10 Ibid.

11 Beuford Smith, conversation with the author, October 6, 2018.

12 Ibid.

13 Ibid.

14 Toni Morrison, Preface to *The Black Photographer's Annual 1973*, Volume 1, 5.

15 Mary Orlando, *Popular Photography*, November 1973, 151.

16 A. D. Coleman, *New York Times*, April 8, 1973, 176.

17 David Vestal, *Camera 35* 17, no. 10 (January 1974), 16.

18 Joe Crawford, "Why a Black Photographers Annual,"

Press Release Collection of Beuford Smith.

19 Joe Walker, Joe Crawford, Joe, and Beuford Smith, Introduction to *The Black Photographers Annual, Volume 2*, 3.

20 Beuford Smith, conversation with the author, October 6, 2018.

21 Ibid.

22 Ibid.

23 Shawn Walker, conversation with the author.

24 John Szarkowski, *The Photographer's Eye* (New York: Museum of Modern Art, 1964).

25 John Szarkowski, *New Documents* (New York: Museum of Modern Art, 1967).

26 John Szarkowski, *Looking at Photographs: 100 Photographs from the Collection of the Museum of Modern Art* (New York: Museum of Modern Art, 1973).

27 "Black Arts School Set" *The Challenge* May 4, 1965, 2 Federal Bureau of Investigation field report File #105-141216.

28 Larry Neal, "Black Theatre," *The Drama Review: TDR* 12, no. 4 (Summer, 1968): 28–39.

29 LeRoy Jones' School Presents Photography Exhibit *Muhammad Speaks* 8-27-65 pgs. 26 Federal Bureau of Investigation field report File #105-141216.

30 Noliwe Rooks, *White Money Black Power*, Boston, MA, Beacon Press.

31 "The Weusi Artists," *Nka: International Journal of African Art*, 2012, 60–67.

32 Walker conversation with the author.

33 Erina Duganne, *The Self in Black and White, Race and Subjectivity in Post War American Photography*, (Lebanon, NH, Dartmouth Collee Press), 12.

34 Louis Draper, "A Rap on Photography," *Black Creation*, Summer 1972, 6.

35 Ibid.

36 *Black Creation, The Black Photographer's Annual* 1973, print advertisement.

37 Ibid.

38 Ibid.

39 Richard Benson, May Castleberry, Jeffrey Fraenkel, Daido Moriyama, Shelley Rice, Neville Wakefield, Andrew Roth, Vince Aletti, David Levi Strauss, *The Book Of 101 Books: Seminal Photographic Books of the Twentieth Century* (PPP EDITIONS/RUTH HOROWITZ LLC, 2001).

40 Ibid.

41 John Szarkowski, *Looking at Photographs.*

42 Black Photographers Annual Inc. marketing poster, Collection of Bill Gaskins.

Catalogue Plates

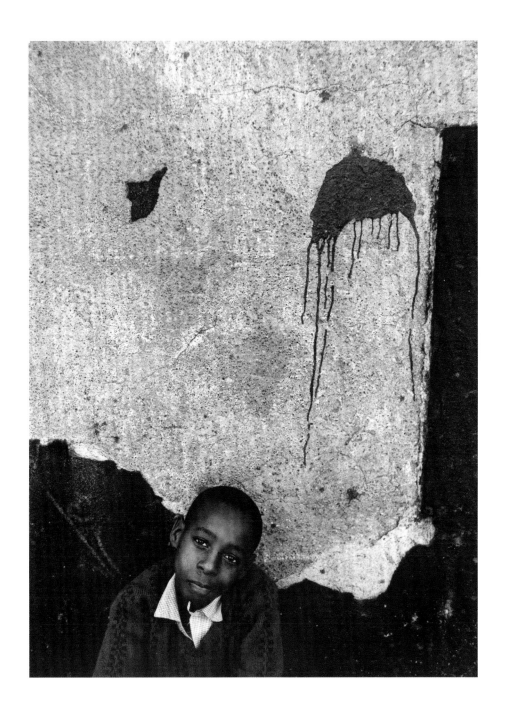

13 Louis Draper (American, 1935–2002),
Untitled, ca. 1960s, gelatin silver print,
9³⁄₁₆ × 6¹³⁄₁₆ in. (23.34 × 17.3 cm). *Virginia Museum of Fine Arts,*
Arthur and Margaret Glasgow Endowment, 2015.300

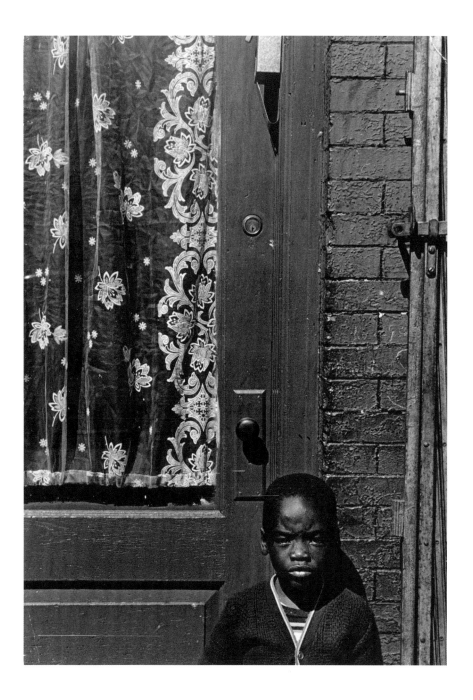

14 Louis Draper (American, 1935–2002),
Untitled, ca. 1960s, gelatin silver print,
12⅞ × 9 in. (32.7 × 22.86 cm). *Virginia Museum of Fine Arts,*
Arthur and Margaret Glasgow Endowment, 2015.305

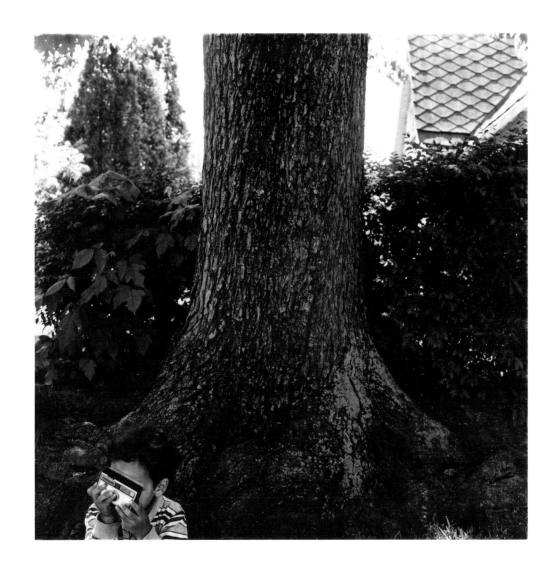

15 Anthony Barboza (American, born 1944), Columbus, Ohio,
Photo of Kahil, ca. 1970s, gelatin silver print,
6 1/16 × 6 1/4 in. (15.4 × 15.88 cm). *Virginia Museum of Fine Arts,*
Adolph D. and Wilkins C. Williams Fund, 2016.315

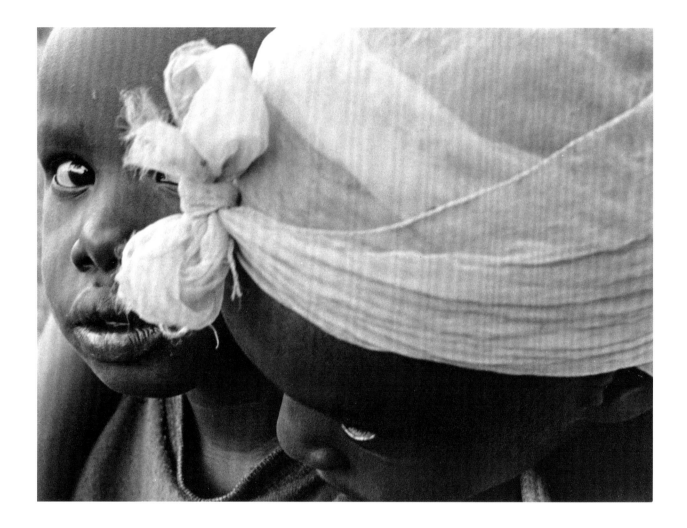

16 Herb Robinson (American, birthdate unknown), **Brother and Sister,** 1973, gelatin silver print, 6½ × 9 in. (16.51 × 22.86 cm). *Virginia Museum of Fine Arts, Arthur and Margaret Glasgow Endowment, 2019.205*

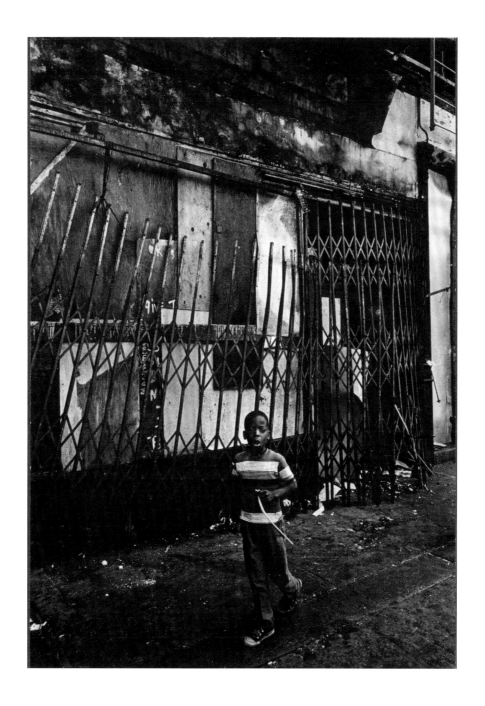

17 Calvin Wilson (American, 1924–1992),
New York No.1, ca. 1960s, gelatin silver print, 13 $^{13}/_{16}$ × 9 $^{9}/_{16}$ in.
(35.08 × 24.29 cm). *Virginia Museum of Fine Arts, Arthur and Margaret Glasgow Endowment, 2019.12*

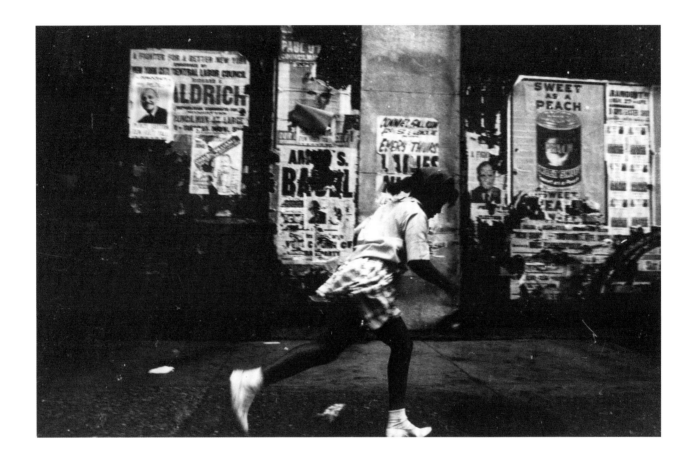

18 Herman Howard (American, 1942–1980),
Sweet as a Peach, 1963, gelatin silver print, 4⅝ × 7¼ in.
(11.75 × 18.42 cm). *Collection of Herb Robinson*

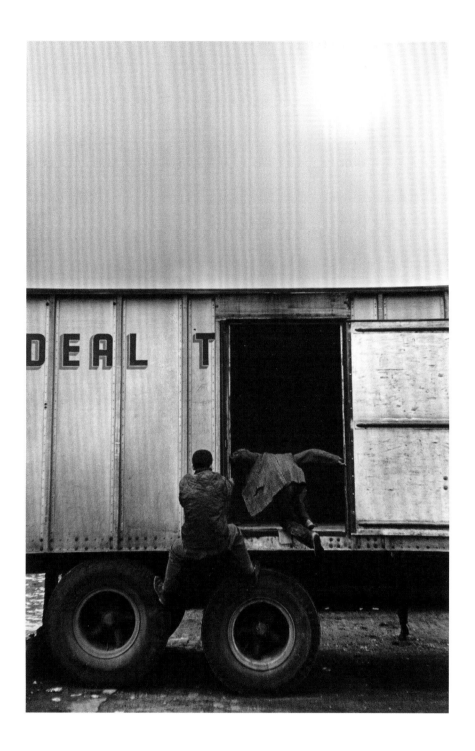

19 Herbert Randall (American, born 1936),
Untitled [Lower East Side, New York], ca.1970s,
gelatin silver print, 13 7/16 × 8 7/8 in. (34.13 × 22.54 cm).
Virginia Museum of Fine Arts, Arthur and Margaret Glasgow
Endowment, 2019.211

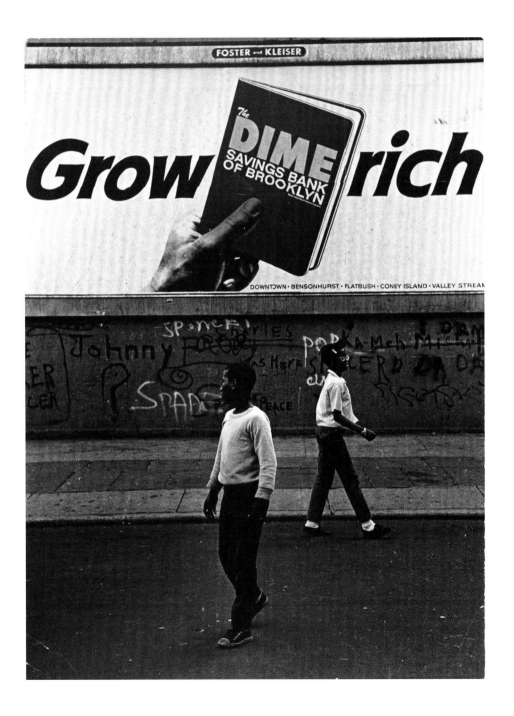

20 Louis Draper (American, 1935–2002), **Untitled
[Grow Rich],** ca. 1960s, gelatin silver print, 8 ³⁄₁₆ × 6 ⅛ in.
(20.8 × 15.56 cm). *Virginia Museum of Fine Arts, Arthur and
Margaret Glasgow Endowment, 2015.271*

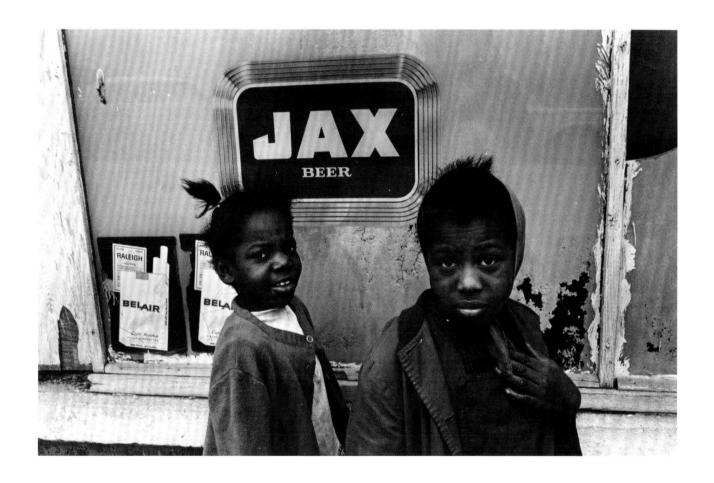

21 Shawn Walker (American, born 1940), **Two Kids in Front of Jax Beer, Mississippi,** 1967, gelatin silver print, 4 ½ × 7 in. (11.43 × 17.78 cm). *Virginia Museum of Fine Arts, Arthur and Margaret Glasgow Endowment, 2017.132*

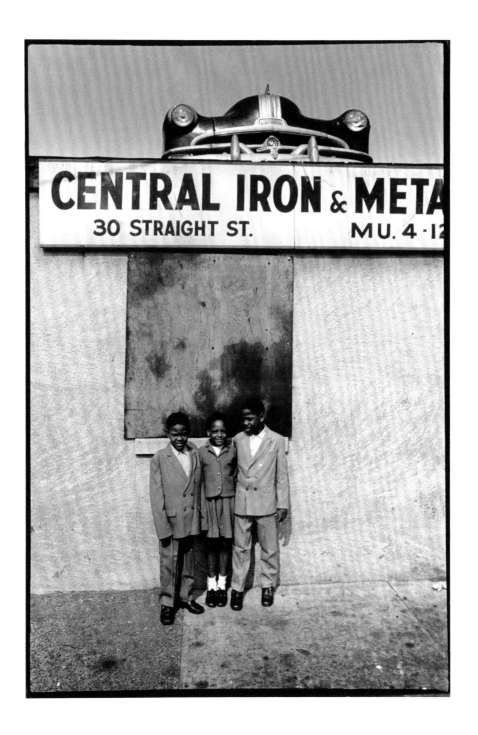

22 Albert Fennar (American, 1938–2018), **Straight Street,**
1965, gelatin silver print, 9 x 6 in. (22.86 x 15.24 cm). *Virginia*
Museum of Fine Arts Margaret R. and Robert M. Freeman Library,
Archives, Louis H. Draper Archives (VA-04), Acquired from the Louis
H. Draper Preservation Trust with the Arthur and Margaret Glasgow
Endowment Fund, VA04.11.1.003.P1

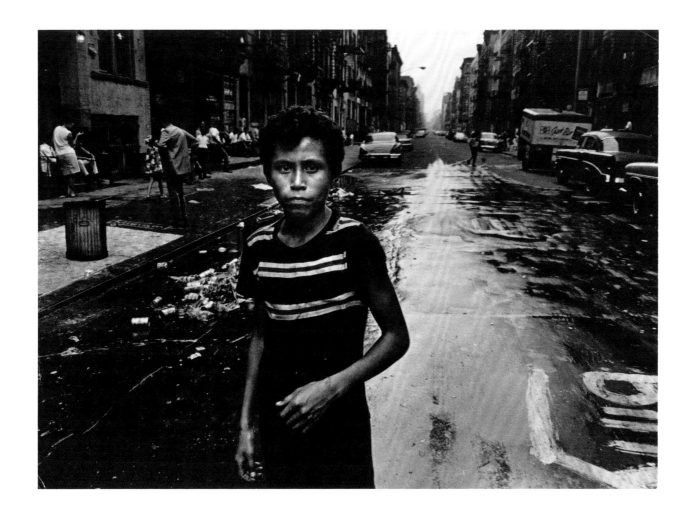

23 Louis Draper (American, 1935–2002), **Untitled [Billy],**
ca. 1974, gelatin silver print, 9 ½ × 13 ⅛ in. (24.13 × 33.34 cm).
Virginia Museum of Fine Arts, Arthur and Margaret Glasgow
Endowment, 2015.272

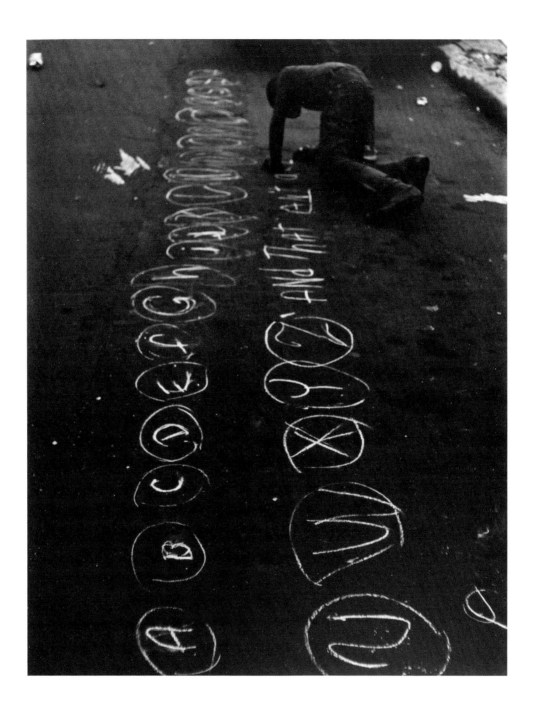

24 Beuford Smith (American, born 1941), **Brooklyn, NY,**
ca. 1970, gelatin silver print, 9 7/16 × 7 5/16 in. (23.97 × 18.57 cm).
Virginia Museum of Fine Arts, Arthur and Margaret Glasgow Endowment,
2017.33

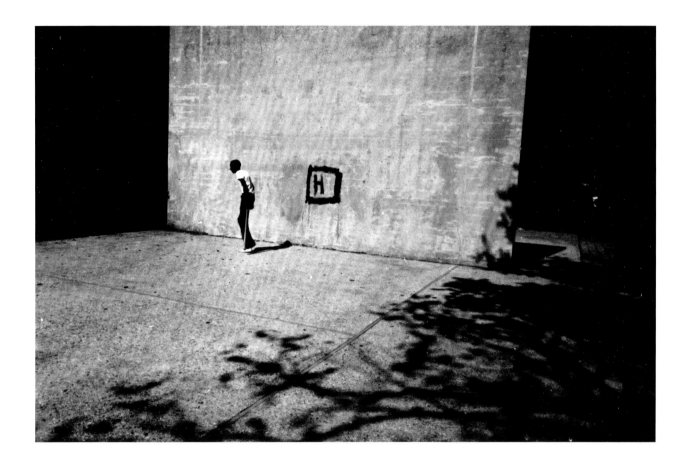

25 Louis Draper (American, 1935–2002), **Boy and H, Harlem,**
1961, gelatin silver print, 8 ⅜ × 12 ¹¹⁄₁₆ in. (21.27 × 32.23 cm).
Virginia Museum of Fine Arts, Arthur and Margaret Glasgow Endowment,
2015.282

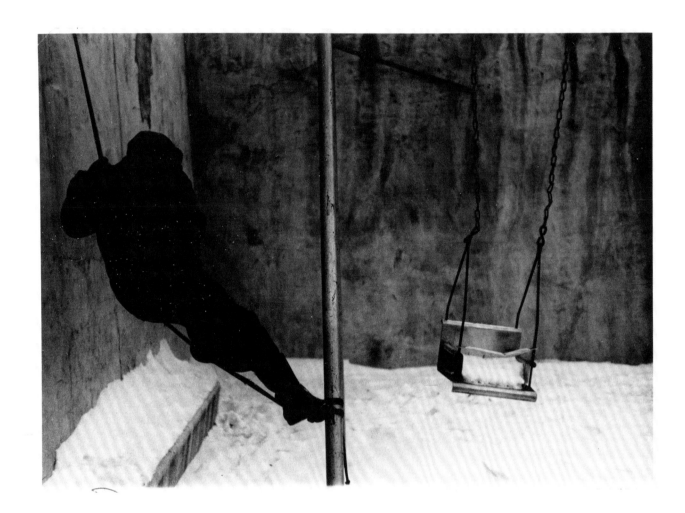

26 Beuford Smith (American, born 1941), **Boy on Swing, Lower East Side,** 1970, gelatin silver print, 6 ¹³⁄₁₆ x 9 ⅞ in. (17.3 x 25.08 cm). *Virginia Museum of Fine Arts, Arthur and Margaret Glasgow Endowment, 2017.35*

27 James Mannas (American, born 1941), **Peeping Sea Wall Beach Boy, Sea Wall, Georgetown, Guyana,** 1972, gelatin silver print, 9 ⅜ × 6 ¼ in. (23.81 × 15.88 cm). *Virginia Museum of Fine Arts, Arthur and Margaret Glasgow Endowment, 2019.197*

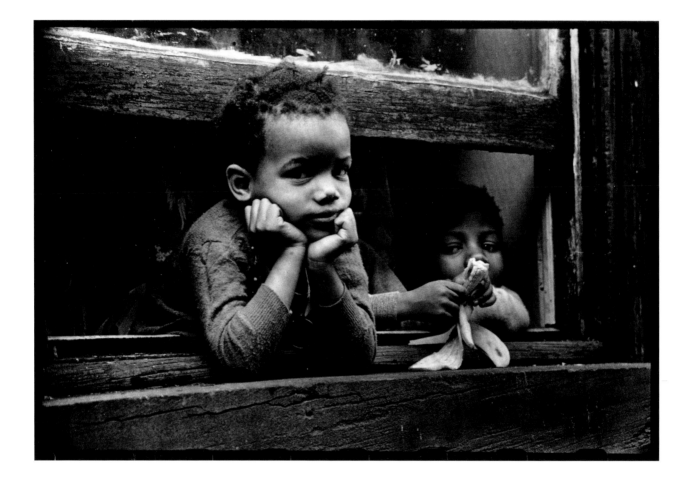

28 Shawn Walker (American, born 1940), **Boys with
Banana by the Window, Bronx, NY,** 1966, gelatin silver print,
4 ½ × 6 ⅝ in. (11.43 × 16.83 cm), *Virginia Museum of Fine Arts,
Arthur and Margaret Glasgow Endowment, 2017.133*

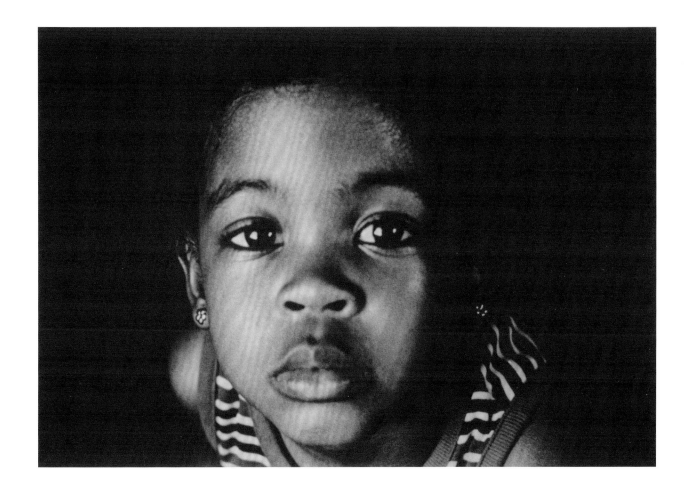

29 Herb Robinson (American, birthdate unknown), **Shelly,**
1965, gelatin silver print, 6 $^{13}\!/_{16}$ × 9 $^{7}\!/_{8}$ in. (17.3 × 25.08 cm).
Virginia Museum of Fine Arts, Arthur and Margaret Glasgow
Endowment, 2019.208

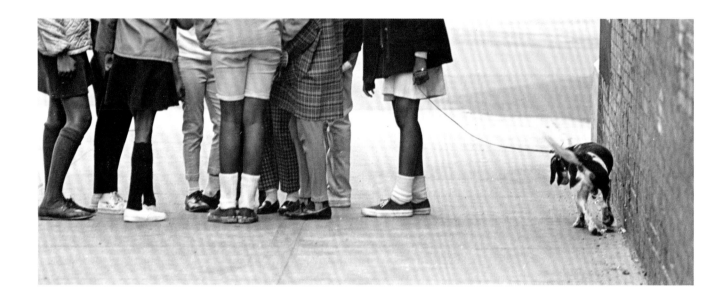

30 Herb Robinson (American, birthdate unknown), **The Girls,**
1969, gelatin silver print, 3 ⅜ × 8 ⅜ in. (8.57 × 21.27 cm).
Virginia Museum of Fine Arts, Arthur and Margaret Glasgow
Endowment, 2019.207

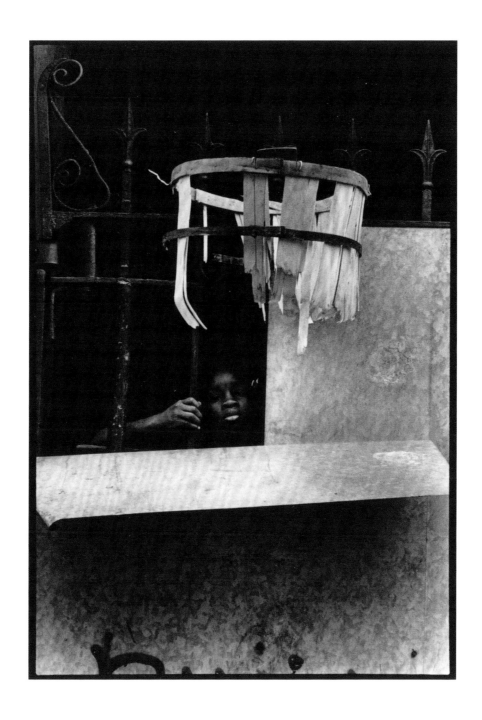

31 Shawn Walker (American, born 1940), **Harlem, 117th Street,** ca. 1960, gelatin silver print, 7 ¼ × 5 in. (18.42 × 12.7 cm). *Virginia Museum of Fine Arts, Aldine S. Hartman Endowment Fund, 2012.16*

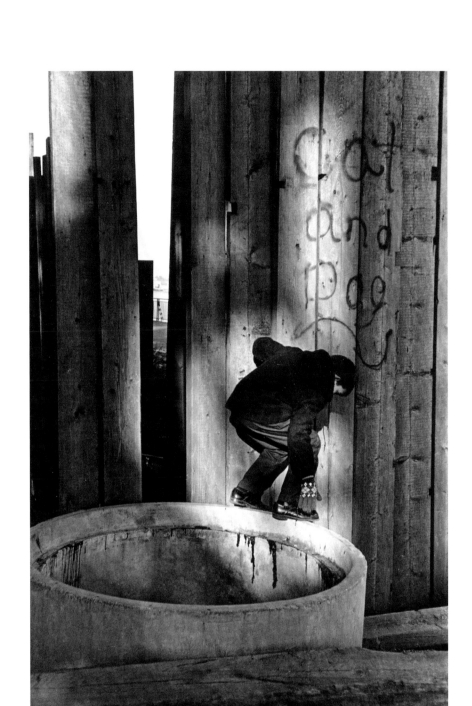

32 Herbert Randall (American, born 1936), **Untitled [Lower East Side, New York]**, ca.1970s, gelatin silver print, 13 ½ × 9 in. (34.29 × 22.86 cm). *Virginia Museum of Fine Arts, Arthur and Margaret Glasgow Endowment, 2019.212*

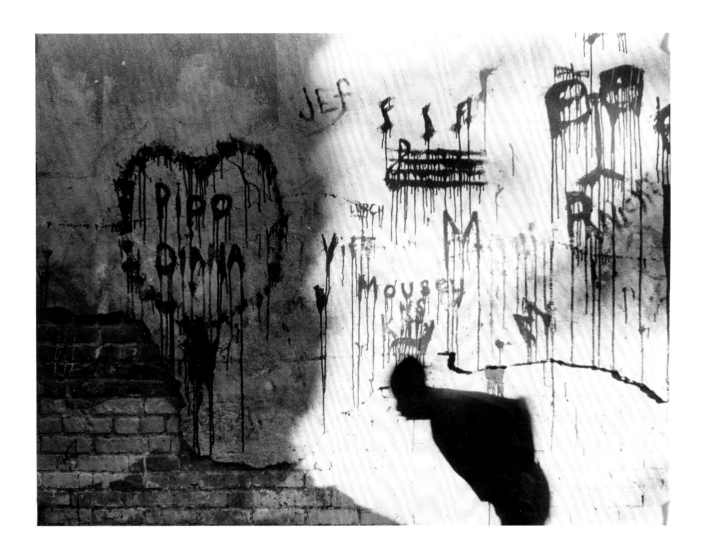

33 Beuford Smith (American, born 1941), **Wall,
Lower East Side,** 1972, gelatin silver print, 10 ⁷⁄₁₆ × 13 ⁷⁄₁₆ in.
(26.51 × 34.13 cm). *Virginia Museum of Fine Arts, Arthur and
Margaret Glasgow Endowment, 2017.34*

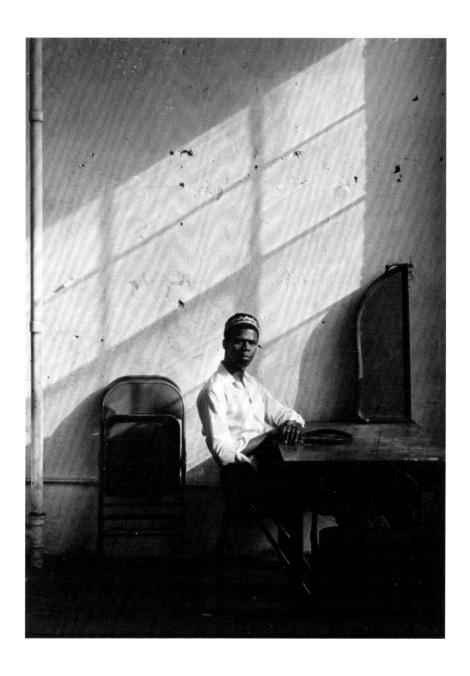

34 Ray Francis (American, 1937–2006), **Untitled (youth),**
n.d., gelatin silver print, 11 ¹³⁄₁₆ × 8 in. (30 × 20.32 cm).
Collection of Shawn Walker

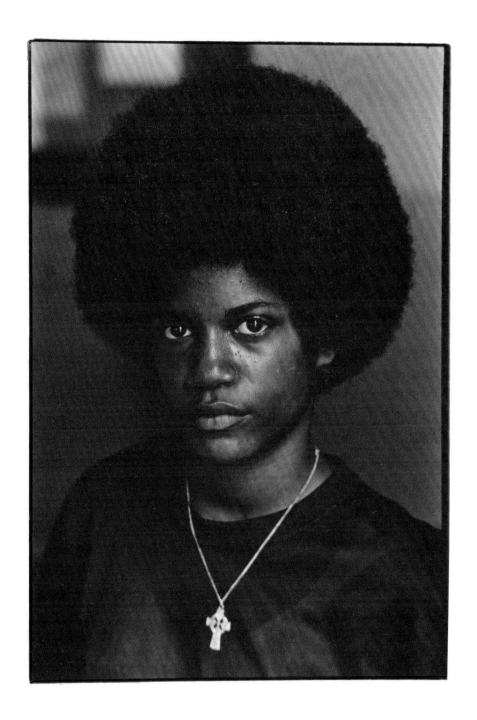

35 C. Daniel Dawson (American, born 1944), **Girl,** 1970,
gelatin silver print, 9 ³⁄₁₆ x 6 ³⁄₁₆ in. (23.34 x 15.72 cm).
Collection of C. Daniel Dawson

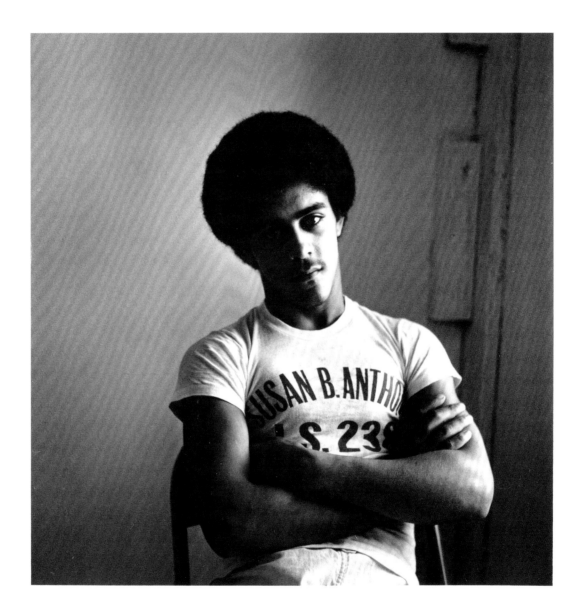

36 Louis Draper (American, 1935–2002), **Jose Torres (Bronx)**,
1975, gelatin silver print, 6 ⅞ × 6 ⅝ in. (17.46 × 16.83 cm).
Virginia Museum of Fine Arts, Gift of Louis H. Draper Trust, 2013.153

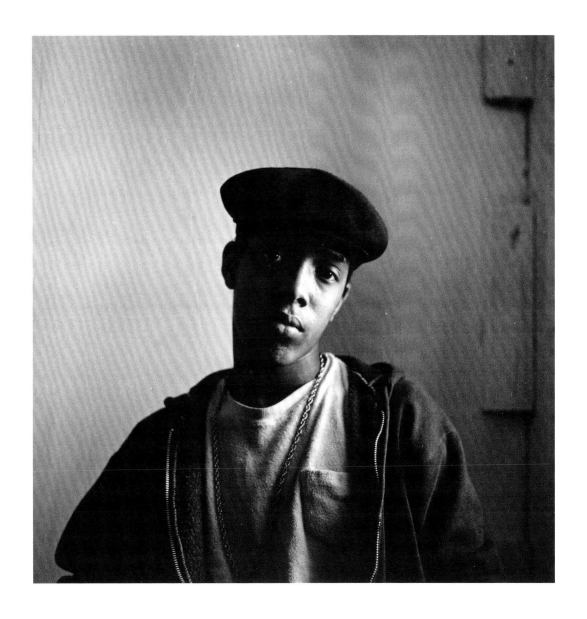

37 Louis Draper (American, 1935–2002), **Ramon Esquila
(Bronx),** 1975, gelatin silver print, 6¹³⁄₁₆ × 6⁹⁄₁₆ in.
(17.3 × 16.67 cm). *Virginia Museum of Fine Arts, Gift of
Louis H. Draper Trust, 2013.155*

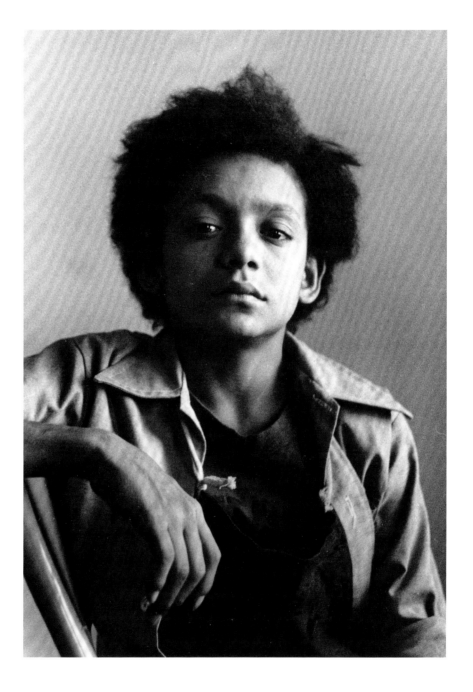

38 Louis Draper (American, 1935–2002), **Cecilio Rodriguez,**
ca. 1970s, gelatin silver print, 9 ½ × 6 ⅝ in. (24.13 × 16.83 cm).
Virginia Museum of Fine Arts, Arthur and Margaret Glasgow
Endowment, 2015.290

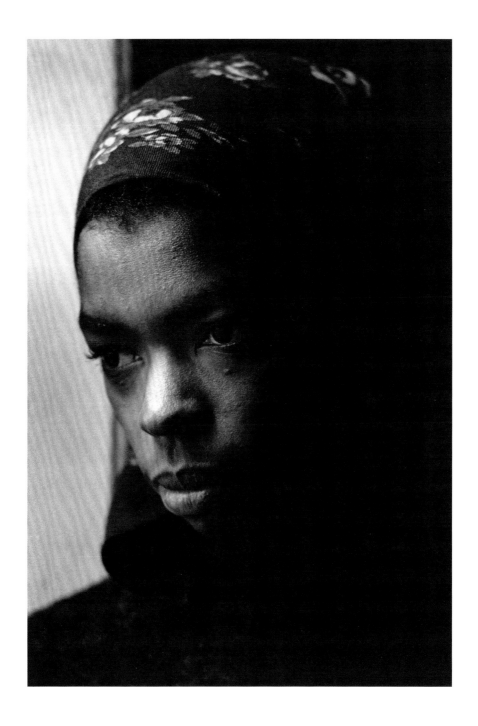

39 Louis Draper (American, 1935–2002), **Untitled,** ca. 1970s, gelatin silver print, 9 ¼ × 6 ¼ in. (23.5 × 15.88 cm). *Virginia Museum of Fine Arts, Arthur and Margaret Glasgow Endowment, 2015.289*

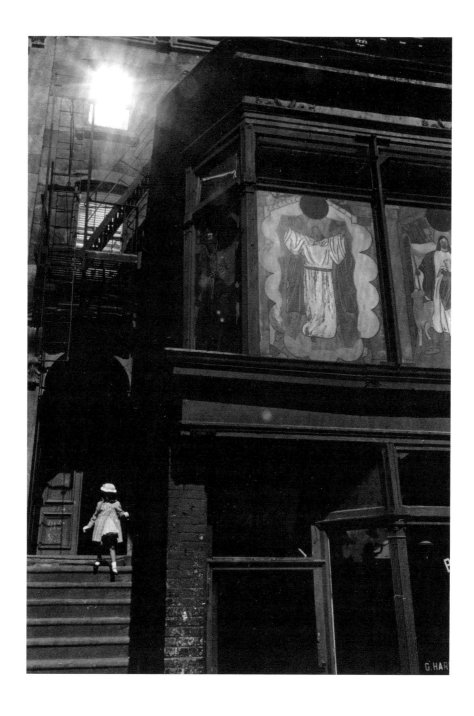

40 Herbert Randall (American, born 1936), **Untitled [Bed-Stuy, New York]**, ca. 1960s, gelatin silver print, 13 ¼ × 9 ³⁄₁₆ in. (33.66 × 23.34 cm). *Virginia Museum of Fine Arts, Arthur and Margaret Glasgow Endowment, 2019.213*

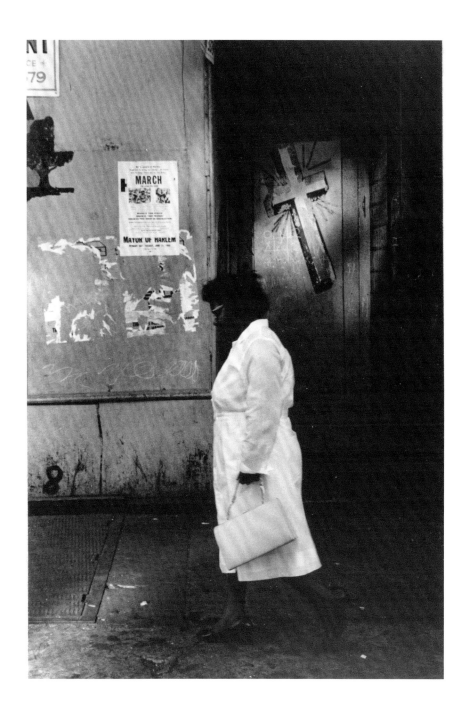

41 Beuford Smith (American, born 1941), **Sunday, Harlem Woman,** 1966, gelatin silver print, 9 $\frac{7}{16}$ × 7 $\frac{7}{16}$ in. (23.97 × 18.89 cm.) *Virginia Museum of Fine Arts, Arthur and Margaret Glasgow Endowment, 2017.32*

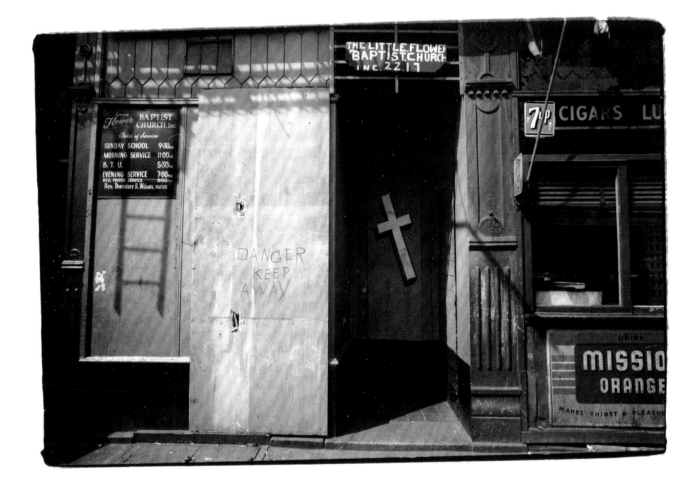

42 Adger Cowans (American, born 1936), **Little Flower Baptist Church,** 1962, gelatin silver print, 6 ⁵⁄₁₆ × 9 ³⁄₈ in. (16.03 × 23.81 cm). *Virginia Museum of Fine Arts, Aldine S. Hartman Endowment Fund, 2018.316*

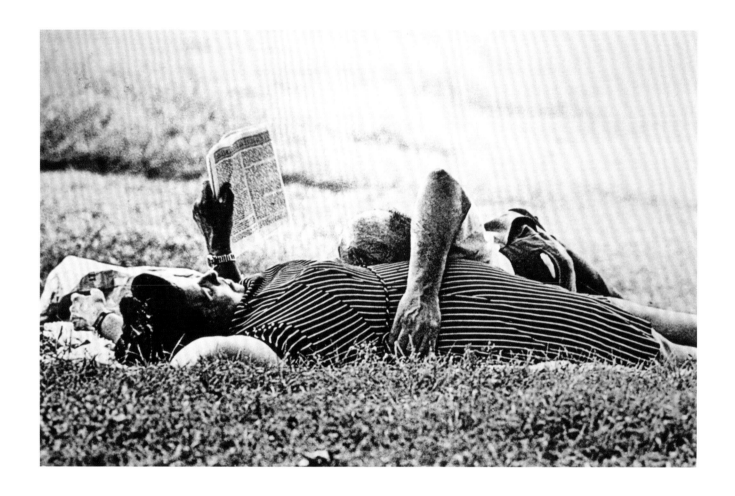

43 Herb Robinson (American, birthdate unknown),
Relaxing in Central Park, 1961, gelatin silver print, 9 × 13 ¹³⁄₁₆ in.
(22.86 × 35.08 cm). *Virginia Museum of Fine Arts, Arthur and
Margaret Glasgow Endowment, 2019.206*

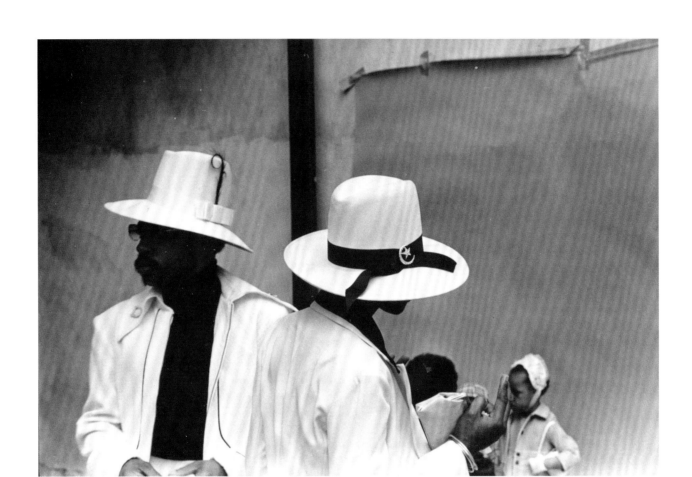

44 Shawn Walker (American, born 1940), **Family on Easter, Harlem, NY,** 1975, gelatin silver print, 4 ⁵⁄₁₆ × 6 ¼ in. (10.95 × 15.88 cm). *Virginia Museum of Fine Arts, Kathleen Boone Samuels Memorial Fund, 2018.170*

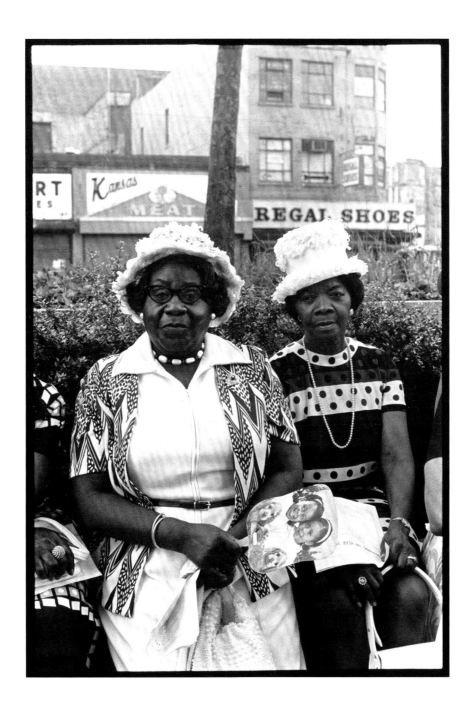

45 Ming Smith (American, birthdate unknown), **Amen Corner Sisters, Harlem, NY,** printed ca. 1976, gelatin silver print, 18 ½ × 12 ½ in. (46.99 × 31.75 cm). *Virginia Museum of Fine Arts,* Adolph D. and Wilkins C. Williams Fund, 2016.243

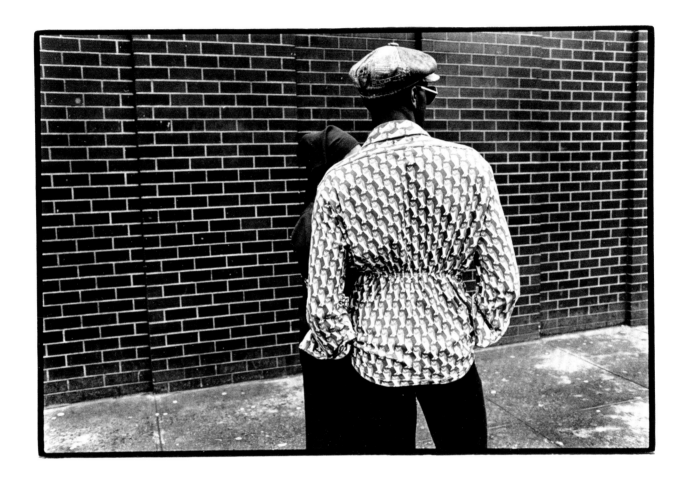

46 Anthony Barboza (American, born 1944), **NYC,** ca. 1970s,
gelatin silver print, 8 ¾ × 12 ¹⁵⁄₁₆ in. (22.23 × 32.86 cm).
Virginia Museum of Fine Arts, National Endowment for the Arts Fund
for American Art, 2013.179

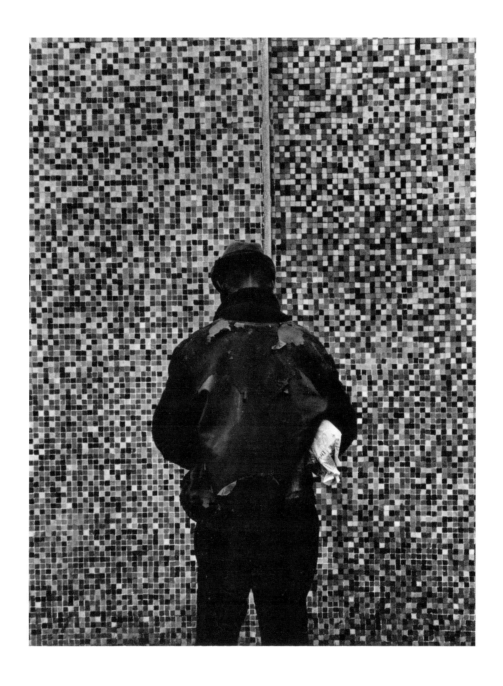

47 James Mannas (American, 1941), **No Way Out, Harlem, NYC,** 1964, gelatin silver print, 8 ⁵⁄₁₆ × 6 ⅜ in. (21.11 × 16.19 cm).
*Virginia Museum of Fine Arts, Arthur and Margaret Glasgow
Endowment, 2019.201*

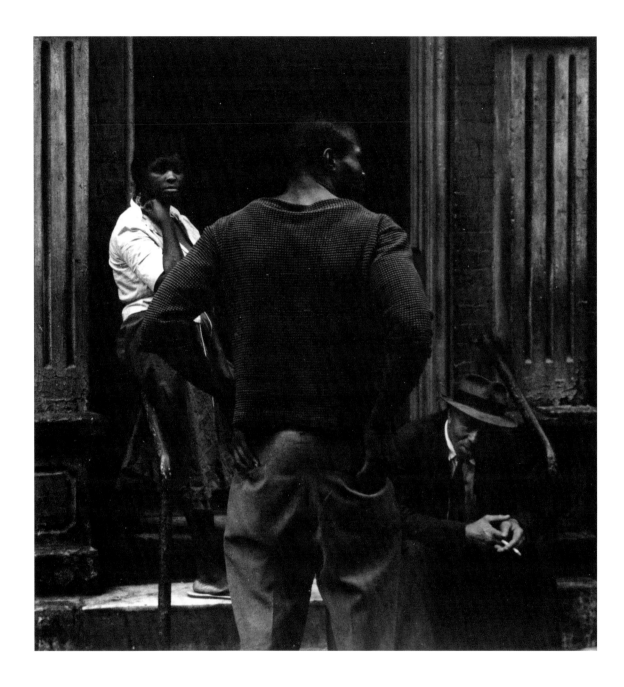

48 Louis Draper (American, 1935–2002), **John Henry,** ca.1960s, gelatin silver print, 10 ¾ × 10 ¹³⁄₁₆ in. (27.31 × 27.46 cm). *Virginia Museum of Fine Arts, National Endowment for the Arts Fund for American Art, 2013.149*

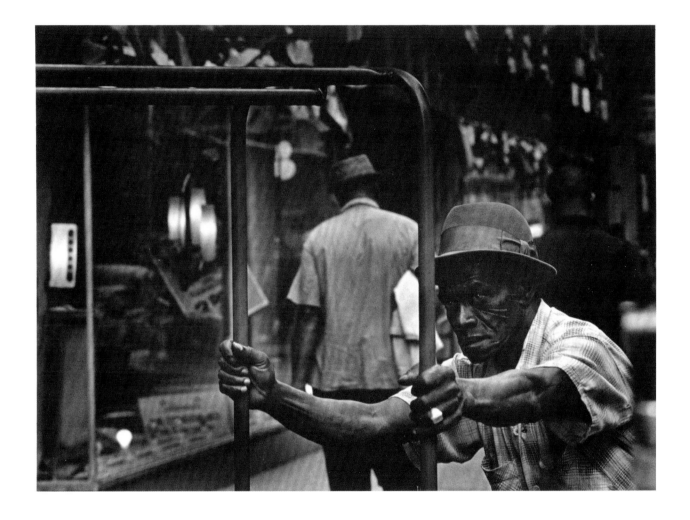

49 Louis Draper (American, 1935–2002), **Untitled [Garment District, NYC],** ca. 1960-61, gelatin silver print, 6 ¹⁵⁄₁₆ × 9 ½ in. (17.62 × 24.13 cm). *Virginia Museum of Fine Arts, National Endowment for the Arts Fund for American Art, 2013.148*

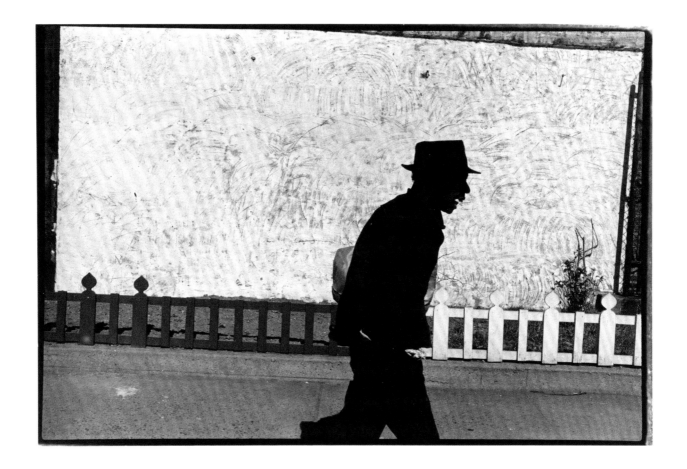

50 Albert Fennar (American, 1938–2018), **Out of the Dark/
Bowery,** 1967, gelatin silver print, 6 x 9 in. (15.24 x 22.86 cm).
*Virginia Museum of Fine Arts Margaret R. and Robert M. Freeman
Library, Archives, Louis H. Draper Archives (VA-04), Acquired from
the Louis H. Draper Preservation Trust with the Arthur and Margaret
Glasgow Endowment Fund, VA04.11.1.004.P1*

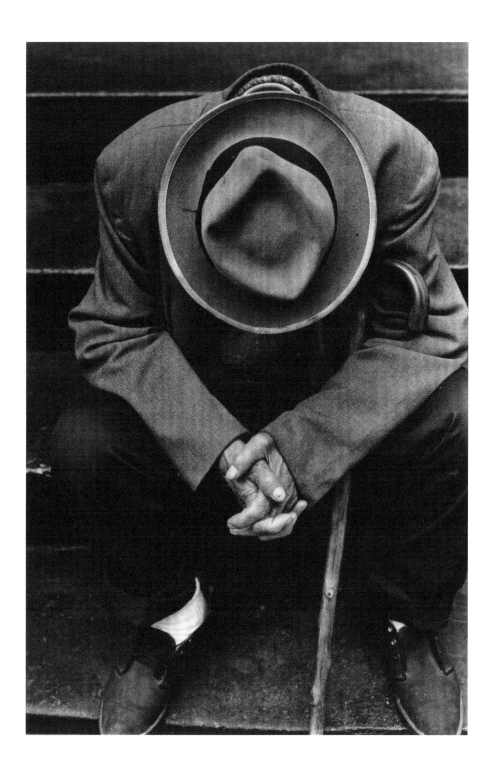

51 Beuford Smith (American, born 1941), **Lower East Side,**
1969, gelatin silver print, 9 ¼ in x 6 ⅛ in. (23.50 x 15.56 cm).
Virginia Museum of Fine Arts, Aldine S. Hartman Endowment Fund,
2012.13

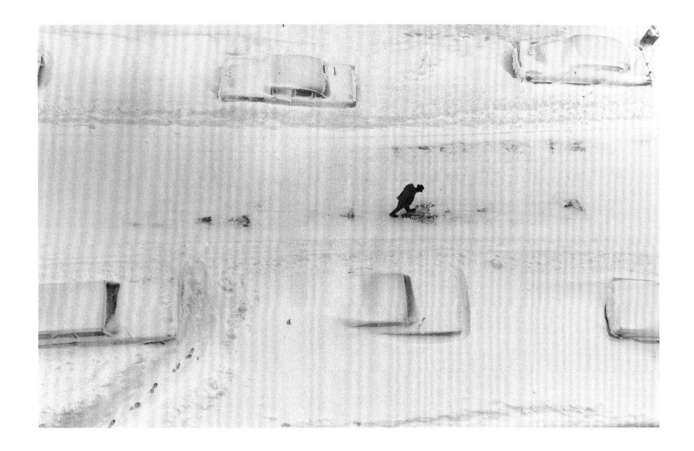

52 Adger Cowans (American, born 1936), **Footsteps,** 1960,
gelatin silver print, 8 ¼ × 13 ⁵⁄₁₆ in. (20.96 × 33.81 cm).
Virginia Museum of Fine Arts, Aldine S. Hartman Endowment Fund,
2018.201

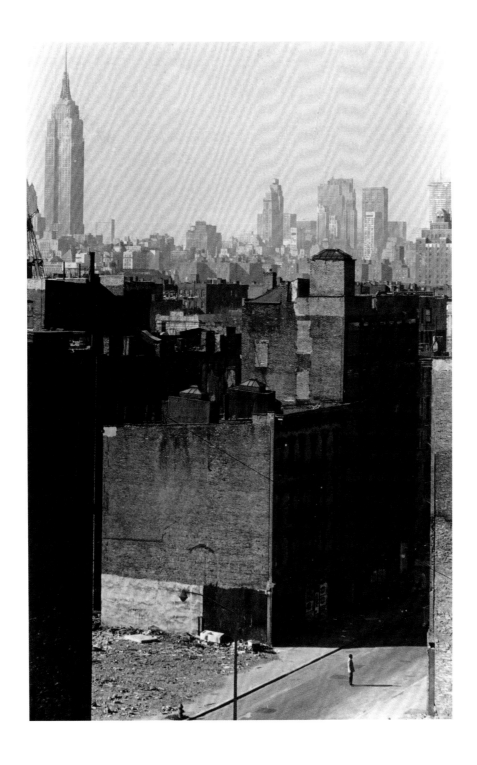

53 Herbert Randall (American, born 1936), **Untitled [Lower East Side],** ca. 1960s, gelatin silver print, 12 ⁵⁄₁₆ × 7 ¹⁵⁄₁₆ in. (31.27 × 20.16 cm). *Virginia Museum of Fine Arts, Arthur and Margaret Glasgow Endowment, 2019.217*

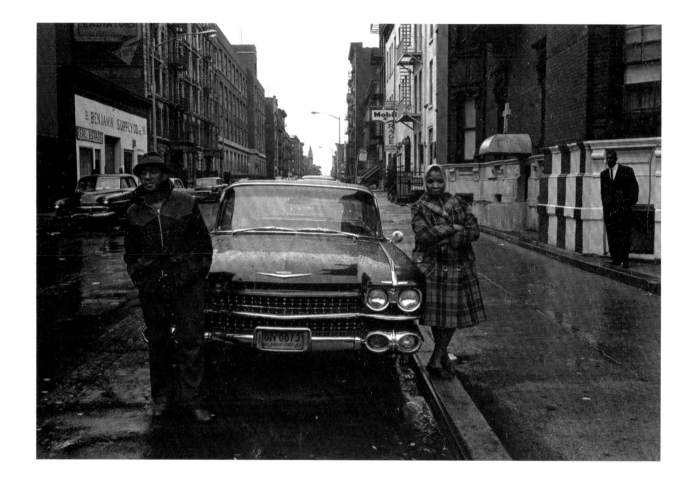

54 Albert Fennar (American, 1938–2018), **Caddy,** 1965,
gelatin silver print, 6 ⁷⁄₁₆ × 9 ¼ in. (16.35 × 23.5 cm).
Courtesy of Miya Fennar and the Albert R. Fennar Archive

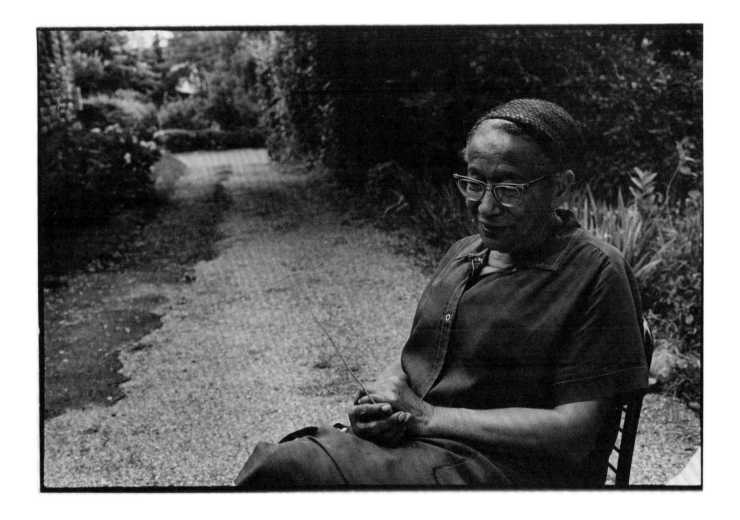

55 C. Daniel Dawson (American, born 1944),
Grandma Thomas, 1968, gelatin silver print, 6 ¼ x 9 ³⁄₁₆ in.
(15.88 x 23.34 cm). *Collection of C. Daniel Dawson*

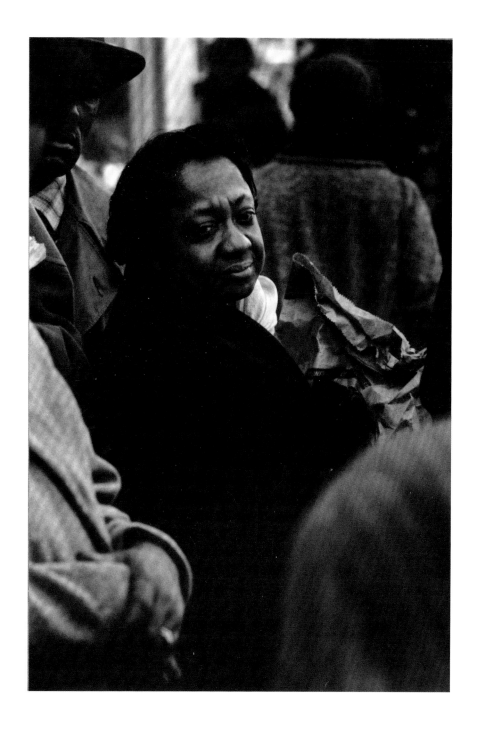

56 Louis Draper (American, 1935–2002), **Untitled [Woman in Crowd],** ca. 1959–65, gelatin silver print, 6 ³⁄₁₆ × 4 ⅛ in. (15.72 × 10.48 cm). *Virginia Museum of Fine Arts, Arthur and Margaret Glasgow Endowment, 2015.285*

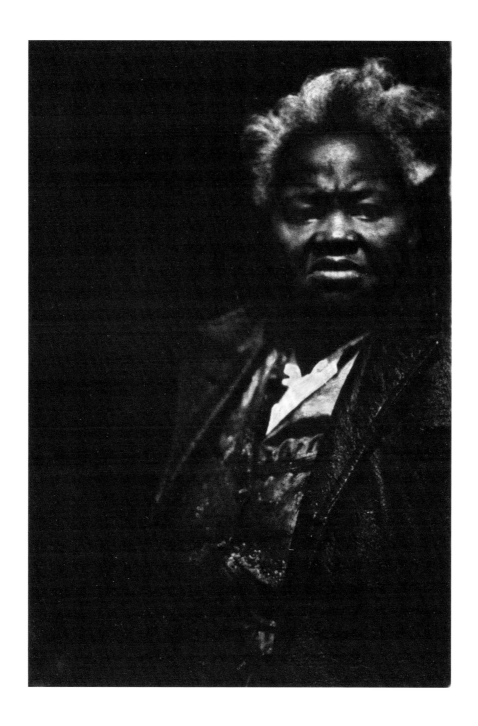

57 James Mannas (American, born 1941), **Mama,
139 West 117 Street, Apt. 4E, Harlem, NYC**, 1963, gelatin
silver print, 9 ¹¹⁄₁₆ × 6 ⁷⁄₁₆ in. (24.61 × 16.35 cm).
*Virginia Museum of Fine Arts, Arthur and Margaret Glasgow
Endowment, 2019.199*

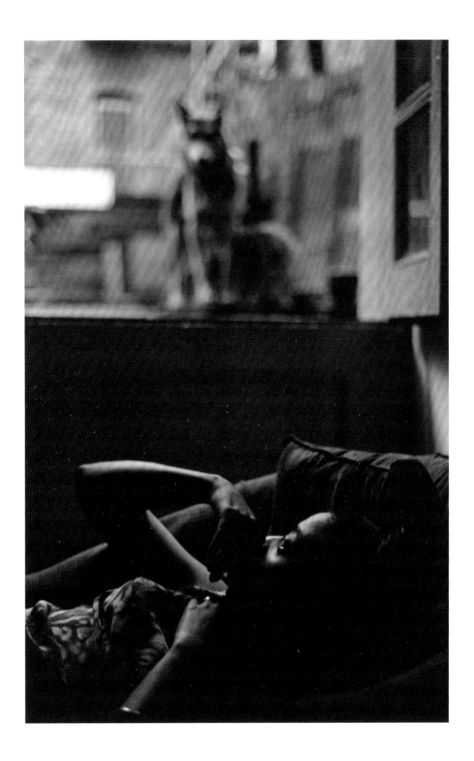

58 Herbert Randall (American, born 1936), **Untitled [Lower East Side, NY]**, ca. 1960s, gelatin silver print, 13 ½ × 8 ¹¹⁄₁₆ in. (34.29 × 22.07 cm). *Virginia Museum of Fine Arts, Arthur and Margaret Glasgow Endowment, 2019.216*

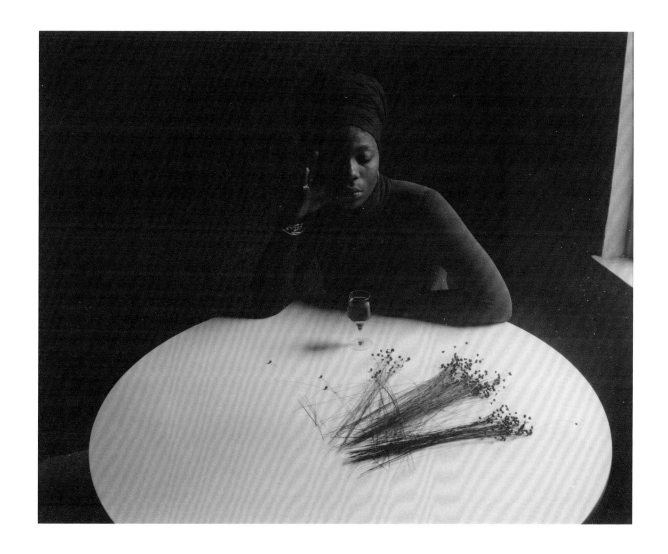

59 Ray Francis (American, 1937–2006), **Untitled (woman at table),** 1960-70s, gelatin silver print, 7 ¹³⁄₁₆ × 9 ¹⁵⁄₁₆ in. (19.84 × 25.24 cm). *Collection of Shawn Walker*

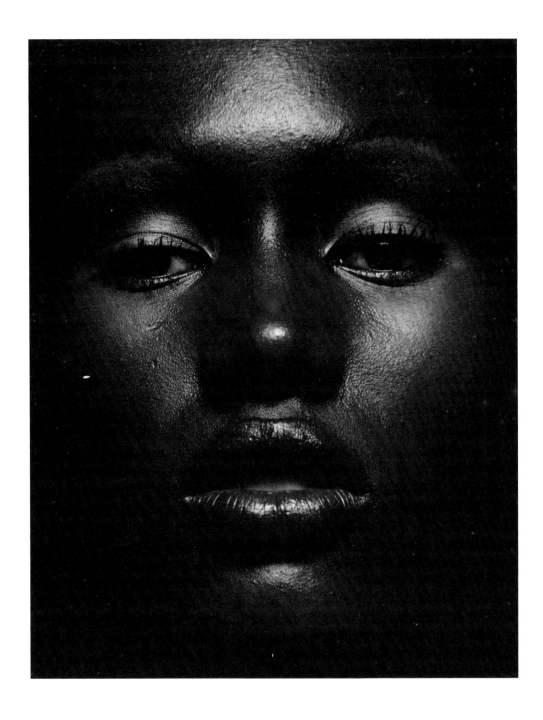

60 Anthony Barboza (American, born 1944), **Grace Jones,**
ca. 1970, gelatin silver print, 13 ⅝ × 10 ¾ in. (34.61 × 27.31 cm).
Virginia Museum of Fine Arts, National Endowment for the Arts Fund
for American Art, 2013.178

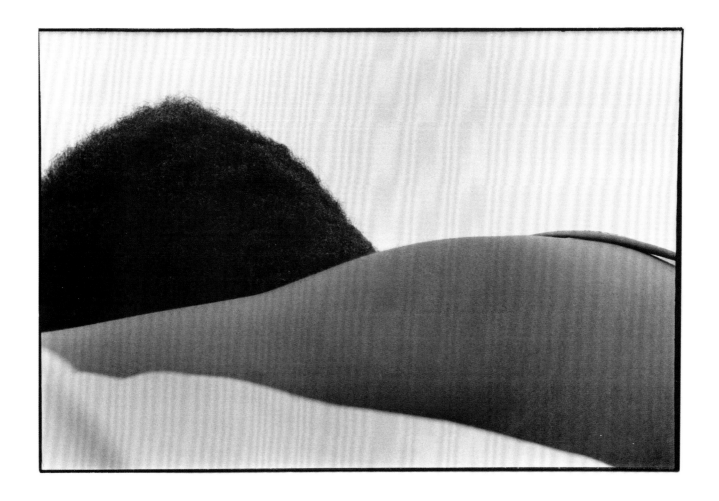

61 C. Daniel Dawson (American, born 1944), **Backscape #1,**
1967, gelatin silver print, 6 x 9 in. (15.24 x 22.86 cm). *Collection*
of C. Daniel Dawson

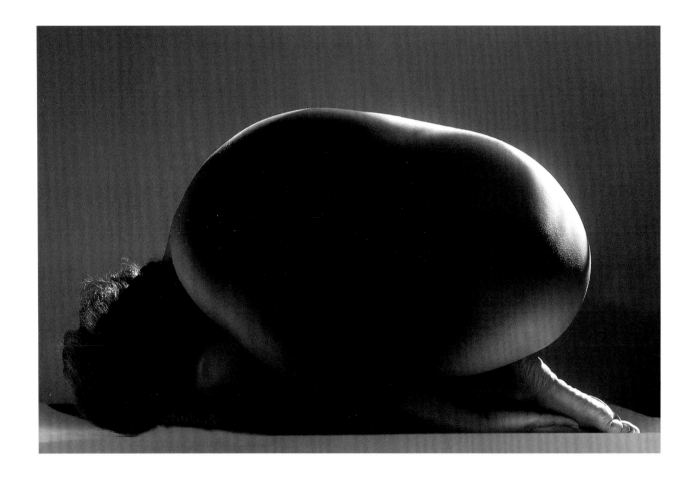

62 Adger Cowans (American, born 1936), **Egg Nude,**
1958, printed later, gelatin silver print, 11 ½ × 17 ³⁄₁₆ in.
(29.21 × 43.66 cm). *Virginia Museum of Fine Arts, Gift of
the artist, 2018.300*

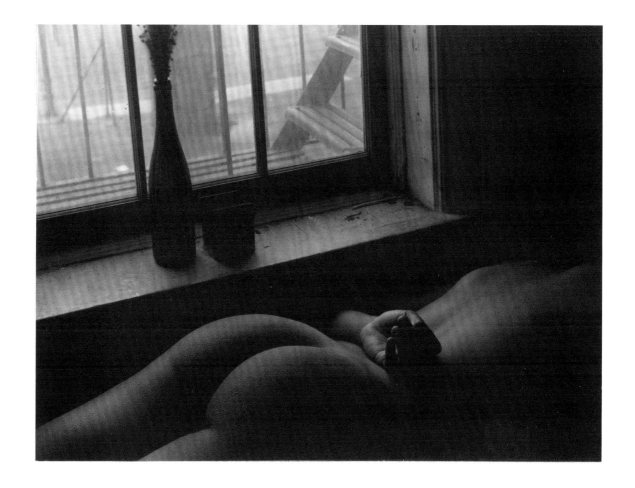

63 Ray Francis (American, 1937–2006), **Untitled (nude),** 1960-70s, gelatin silver print, 6 × 8 in. (15.24 × 20.32 cm). *Collection of Shawn Walker*

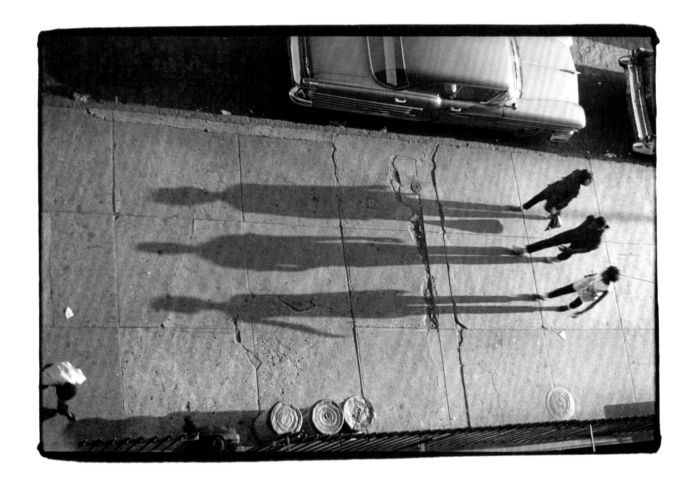

64 Adger Cowans (American, born 1936), **Shadows,** 1966,
gelatin silver print, 7 $\frac{9}{16}$ × 11 $\frac{1}{4}$ in. (19.21 × 28.58 cm).
Virginia Museum of Fine Arts, Aldine S. Hartman Endowment
Fund, 2018.315

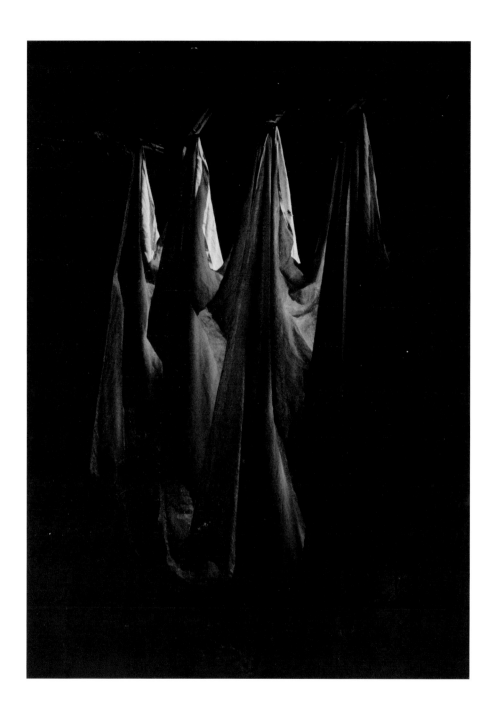

65 Louis Draper (American, 1935–2002),
Congressional Gathering, 1959, gelatin silver print, 13
× 9 ⁵⁄₁₆ in. (33.02 × 23.65 cm). *Virginia Museum of Fine*
Arts, Arthur and Margaret Glasgow Endowment, 2015.278

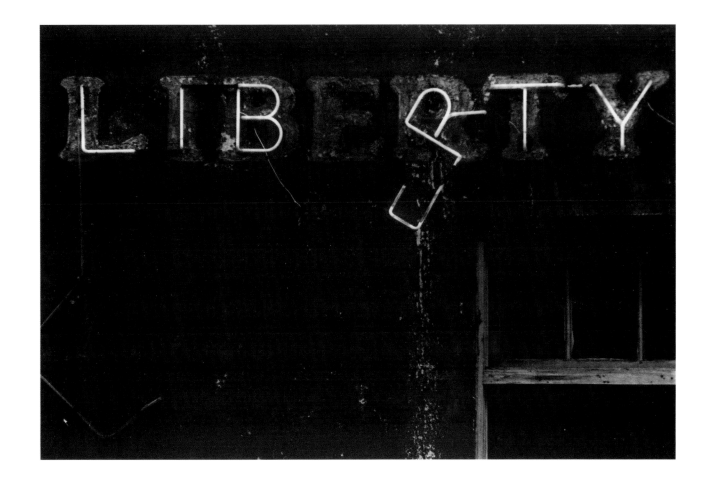

66 Anthony Barboza (American, born 1944),
Pensacola, Florida, 1966, gelatin silver print, 8 ⅞ × 13 ⅜ in.
(22.54 × 33.97 cm). *Virginia Museum of Fine Arts, Adolph D. and
Wilkins C. Williams Fund, 2016.319*

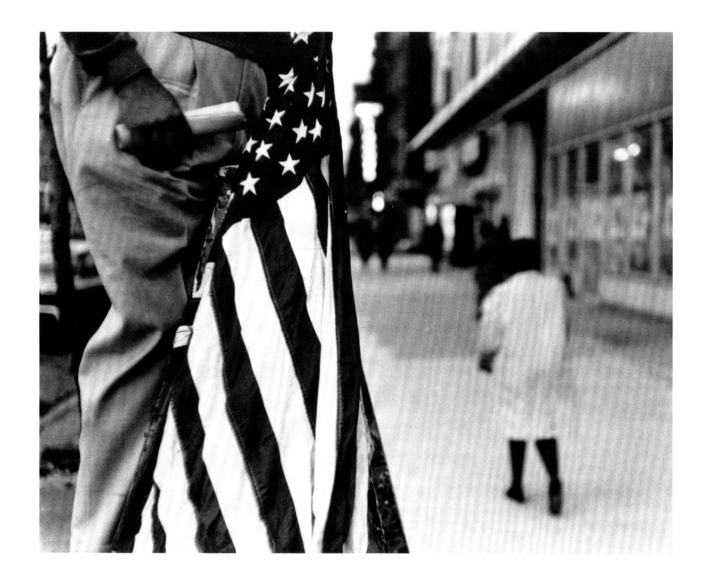

67 Beuford Smith (American, born 1941), **Street Speaker,**
1968, gelatin silver print, 7 ½ × 9 ⅜ in. (19.05 × 23.81
cm). *Virginia Museum of Fine Arts, Arthur and Margaret Glasgow*
Endowment, 2017.31

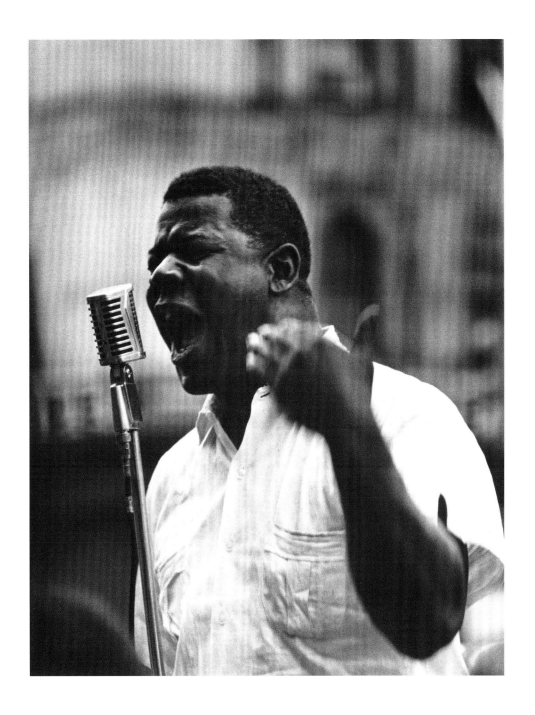

68 Beuford Smith (American, born 1941), **Pork Chop Davis, 125th and Lenox Ave.,** 1965, gelatin silver print, 13 ⁵⁄₁₆ × 10 ⁵⁄₁₆ in. (33.81 × 26.19 cm). *Virginia Museum of Fine Arts, National Endowment for the Arts Fund for American Art, 2019.244*

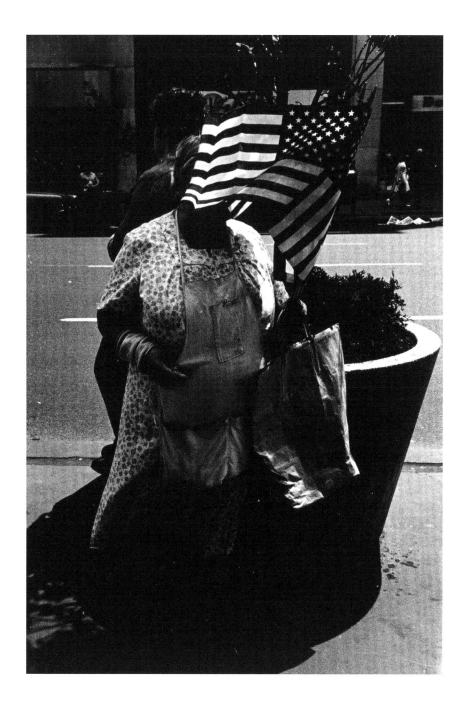

69 Anthony Barboza (American, born 1944), **NYC,**
ca. 1970s, gelatin silver print, 8 × 5 ⅜ in. (20.32 × 13.65 cm).
Virginia Museum of Fine Arts, Arthur and Margaret Glasgow
Endowment, 2017.44

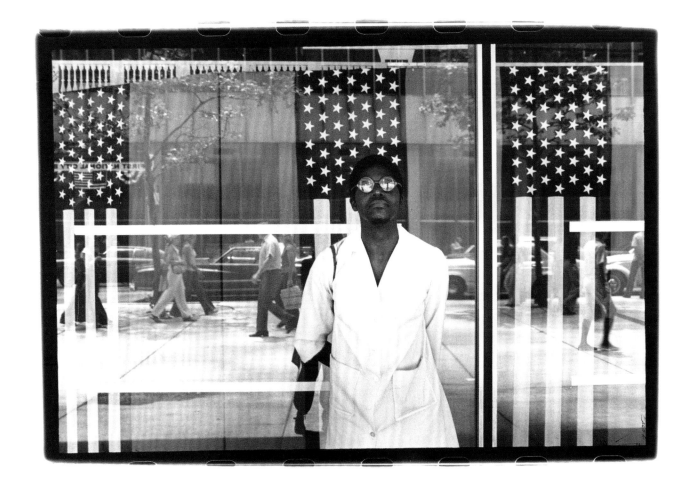

70 Ming Smith (American, birthdate unknown), **America Seen through Stars and Stripes, New York City, New York,** ca. 1976, gelatin silver print, 12 ½ × 18 ½ in. (31.75 × 46.99 cm).
Virginia Museum of Fine Arts, Adolph D. and Wilkins C. Williams Fund, 2016.241

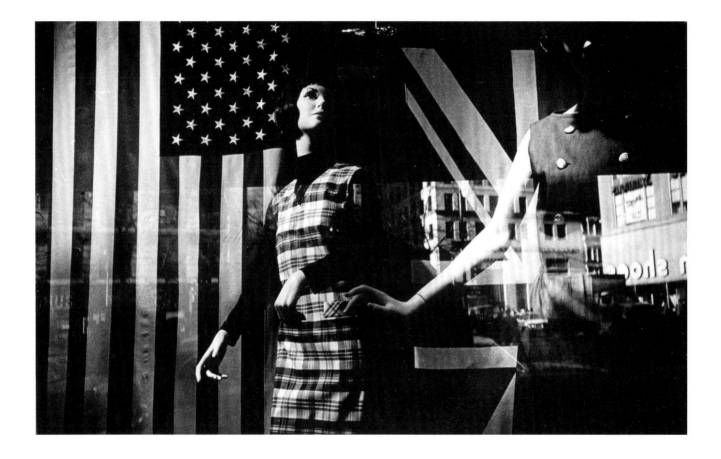

71 Herman Howard (American, 1942–1980),
New York, 1963, gelatin silver print, 4 ¼ × 6 ¹³⁄₁₆ in.
(10.8 × 17.3 cm). *Collection of Herb Robinson*

72 Louis Draper (American, 1935–2002), **Malcolm X, Harlem,**
1963, gelatin silver print, 9 ¼ × 12 ⅝ in. (23.5 × 32.07 cm).
Virginia Museum of Fine Arts, National Endowment for the Arts Fund
for American Art, 2013.147

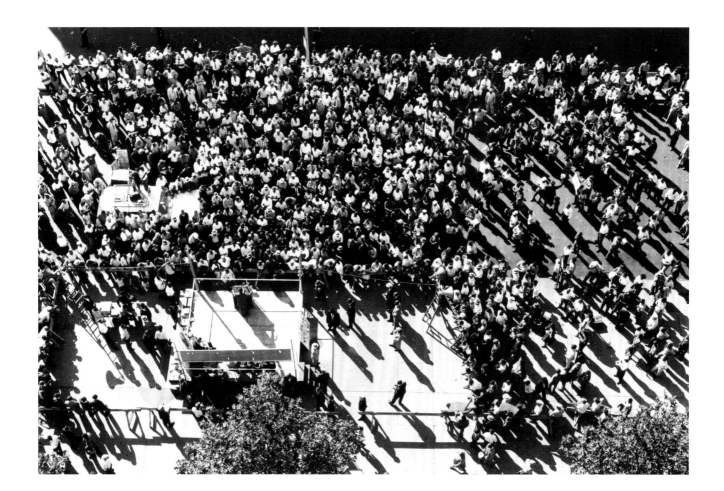

73 Adger Cowans (American, born 1936), **Malcolm Speaks,**
ca. 1960-65, gelatin silver print, 6 ⁵⁄₁₆ × 9 ³⁄₈ in. (16.03 × 23.81 cm).
Virginia Museum of Fine Arts, Aldine S. Hartman Endowment Fund,
2018.318

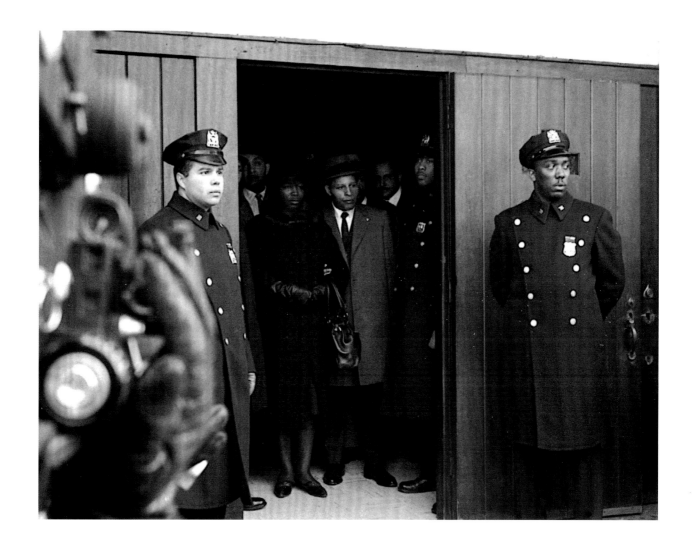

74 Adger Cowans (American, born 1936), **Betty Shabazz at Malcolm's Funeral,** 1965, printed 2018, gelatin silver print, 8 × 10 ½ in. (20.32 × 26.67 cm). Virginia Museum of Fine Arts, Aldine S. Hartman Endowment Fund, 2018.317

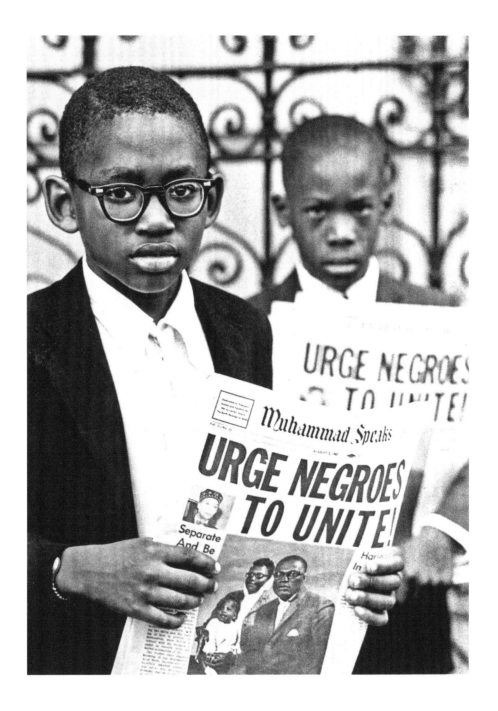

75 Albert Fennar (American, 1938–2018), **Negroes Unite,**
1968, gelatin silver print, 6 × 4 ¼ in. (15.24 × 10.8 cm).
Collection of Shawn Walker

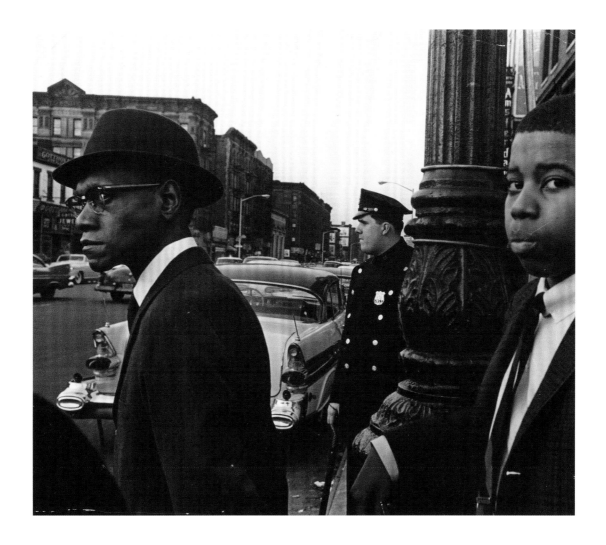

76 Louis Draper (American, 1935–2002), **Untitled (Black Muslims),** 1960s, gelatin silver print, 8 ¼ × 9 ½ in. (20.96 × 24.13 cm). *Virginia Museum of Fine Arts, Gift of Louis H. Draper Trust, 2013.156*

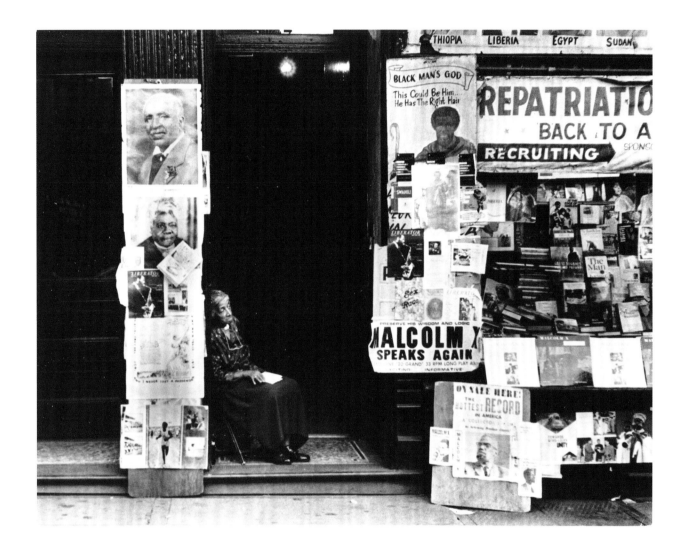

77 Beuford Smith (American, born 1941), **Woman in
Doorway, Harlem,** 1965, gelatin silver print, 7 ½ × 9 ⁹⁄₁₆ in.
(19.05 × 24.29 cm). *Virginia Museum of Fine Arts, National
Endowment for the Arts Fund for American Art, 2013.182*

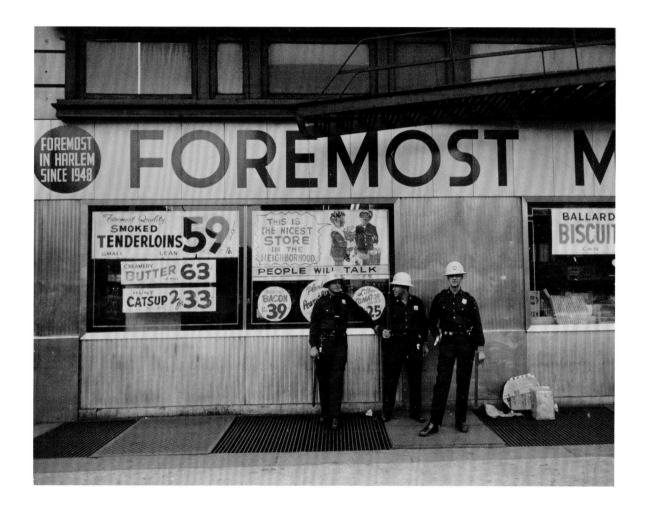

78 Shawn Walker (American, born 1940), **Police in "Riot Gear" (Civil Defense Helmets) After Riot on 125th Street, Harlem,** ca. 1963, gelatin silver print, 7 3/16 × 9 5/16 in. (18.26 × 23.65 cm). *Virginia Museum of Fine Arts, Arthur and Margaret Glasgow Endowment, 2017.127*

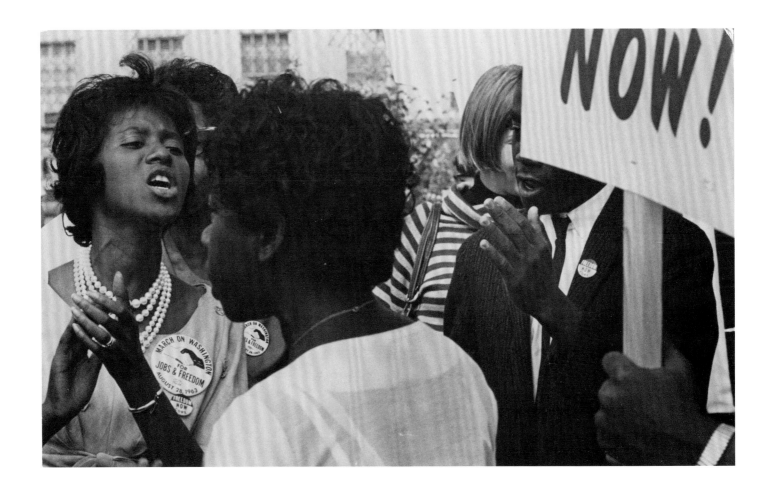

79 Herman Howard (American, 1942–1980), **March on Washington,** 1963, gelatin silver print, 5 ¹³⁄₁₆ × 9 ³⁄₈ in. (14.76 × 23.81 cm). *Collection of Herb Robinson*

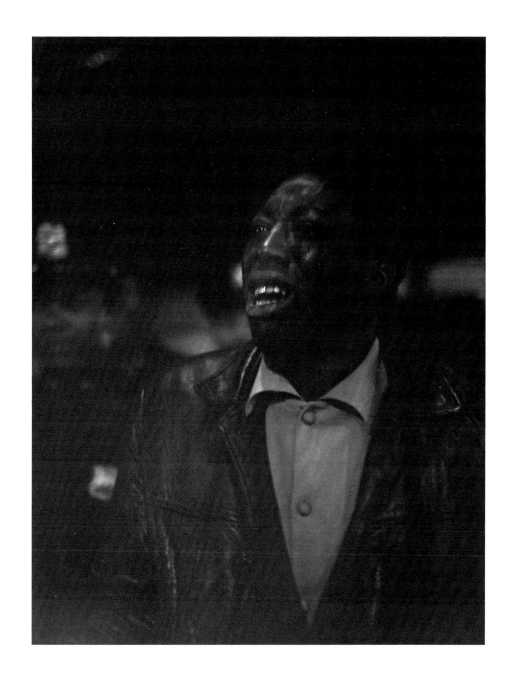

80 Beuford Smith (American, born 1941), **Man Crying (MLK Essay),** 1968, gelatin silver print, 13 ½ × 10 ½ in. (34.29 × 26.67 cm).
Virginia Museum of Fine Arts, National Endowment for the Arts Fund for American Art, 2019.245

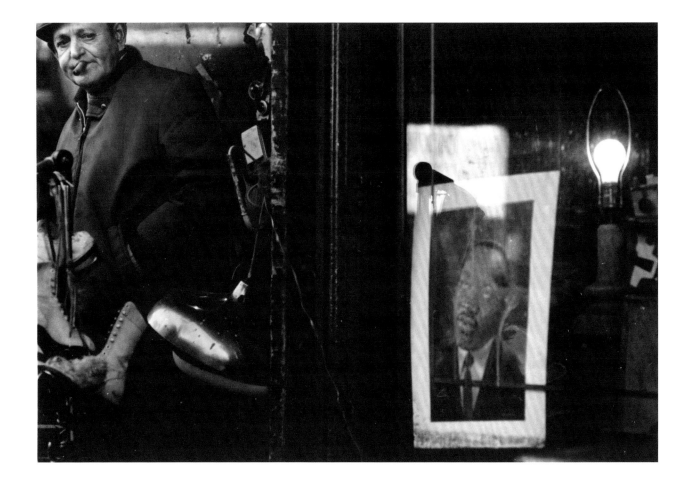

81 Louis Draper (American, 1935–2002), **Untitled,** ca. 1960s,
gelatin silver print, 5 ¹⁵⁄₁₆ × 8 ½ in. (15.08 × 21.59 cm). *Virginia
Museum of Fine Arts, National Endowment for the Arts Fund for
American Art, 2013.146*

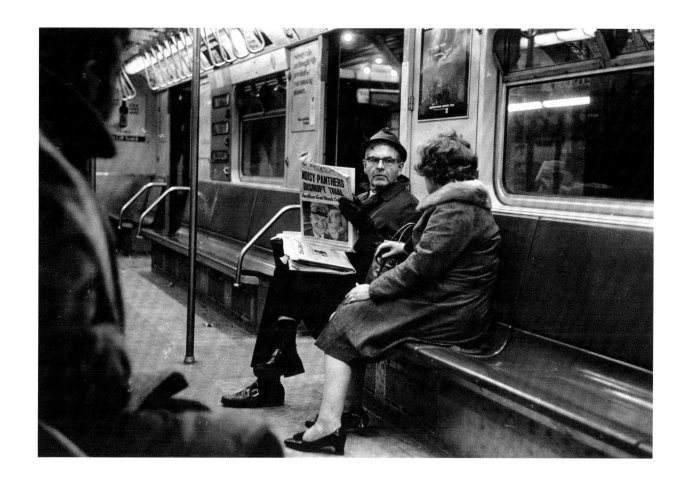

82 Louis Draper (American, 1935–2002), **Untitled [Noisy Panthers Disrupt Trial],** 1966–72, gelatin silver print, 5 ¹³⁄₁₆ × 8 ⁹⁄₁₆ in. (14.76 × 21.75 cm). *Virginia Museum of Fine Arts, National Endowment for the Arts Fund for American Art, 2013.145*

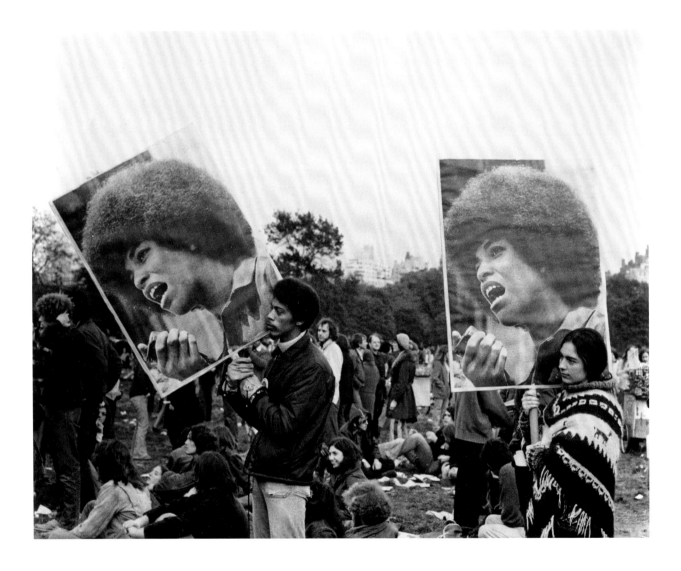

83 Beuford Smith (American, born 1941), **Angela Davis Rally, Central Park, NYC,** 1972, gelatin silver print, 10 ⅜ × 13 ¹⁵⁄₁₆ in. (26.35 × 35.4 cm), *Virginia Museum of Fine Arts, Arthur and Margaret Glasgow Endowment, 2017.30*

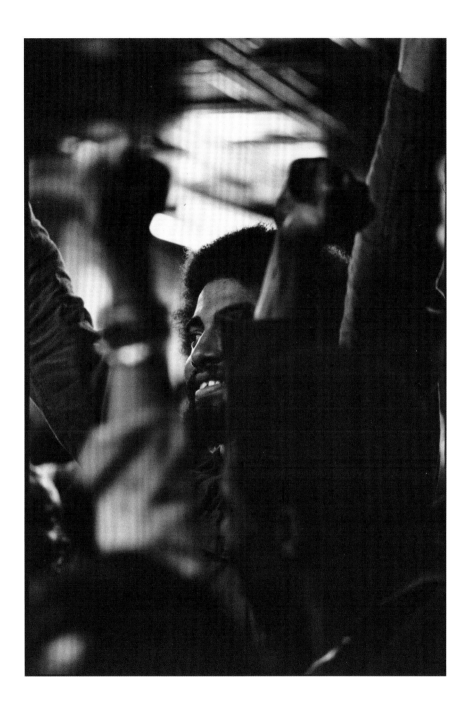

84 C. Daniel Dawson (American, born 1944), **Gibson's Victory,**
1970, gelatin silver print, 8 ¾ x 5 ¹⁵⁄₁₆ in. (22.23 x 15.08 cm).
Collection of C. Daniel Dawson

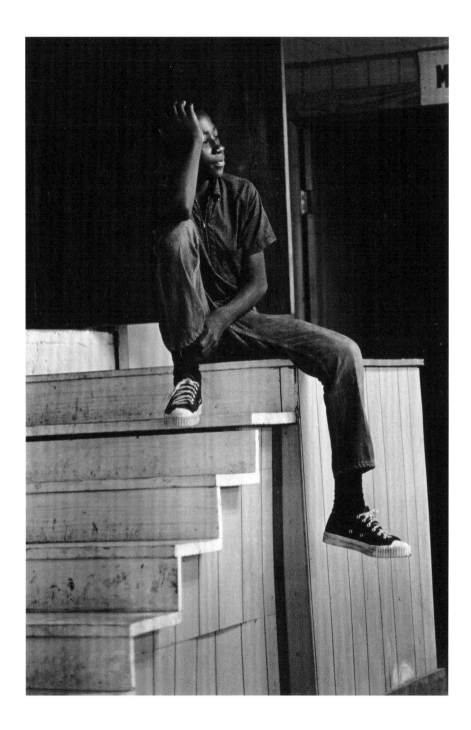

85 Herbert Randall (American, born 1936), **Untitled [Hattiesburg, Mississippi, Freedom Summer],** 1964, gelatin silver print, 13 ½ × 9 in. (34.29 × 22.86 cm).
Virginia Museum of Fine Arts, Arthur and Margaret Glasgow Endowment, 2019.209

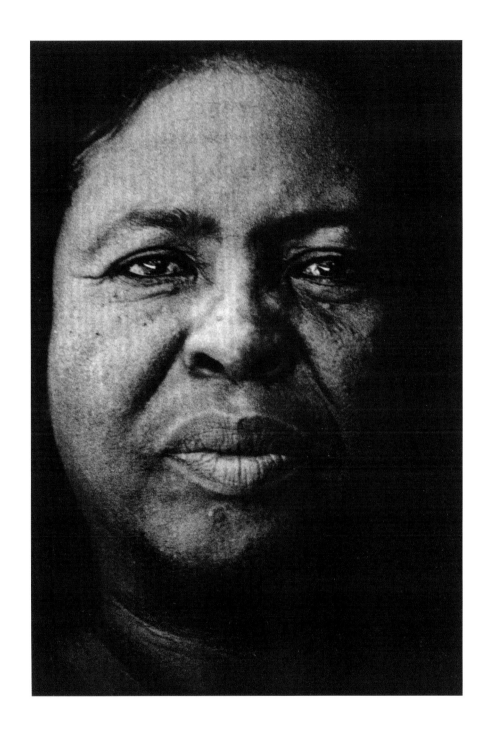

86 Louis Draper (American, 1935–2002), **Fannie Lou Hamer, Mississippi,** 1971, gelatin silver print, 9 × 6 ⅛ in. (22.86 × 15.56 cm). *Virginia Museum of Fine Arts, National Endowment for the Arts Fund for American Art, 2013.150*

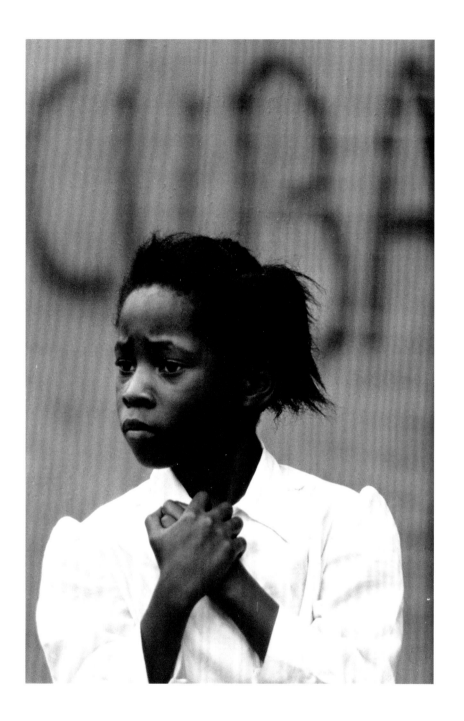

87 Louis Draper (American, 1935–2002), **Girl and Cuba (Philadelphia),** 1968, gelatin silver print, 9 ⅜ × 6 ⅛ in. (23.81 × 15.56 cm). *Virginia Museum of Fine Arts, Arthur and Margaret Glasgow Endowment, 2015.301*

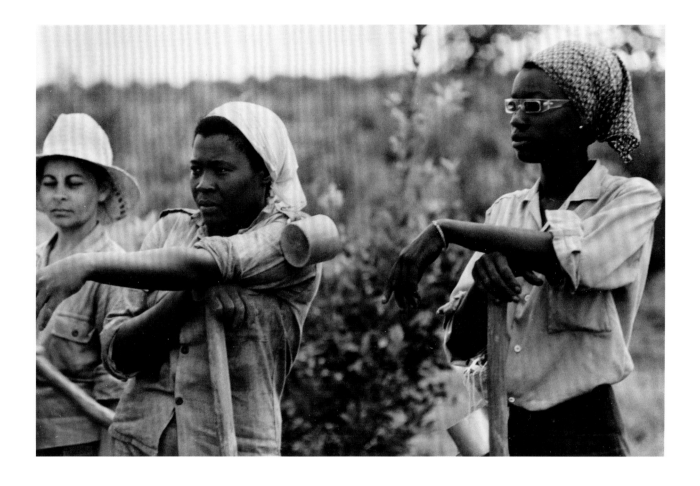

88 Shawn Walker (American, born 1940), **Women in the Field, Cuba,** 1968, gelatin silver print, 4 ⁵⁄₁₆ × 6 ³⁄₈ in. (10.95 × 16.19 cm). *Virginia Museum of Fine Arts, Arthur and Margaret Glasgow Endowment, 2017.128*

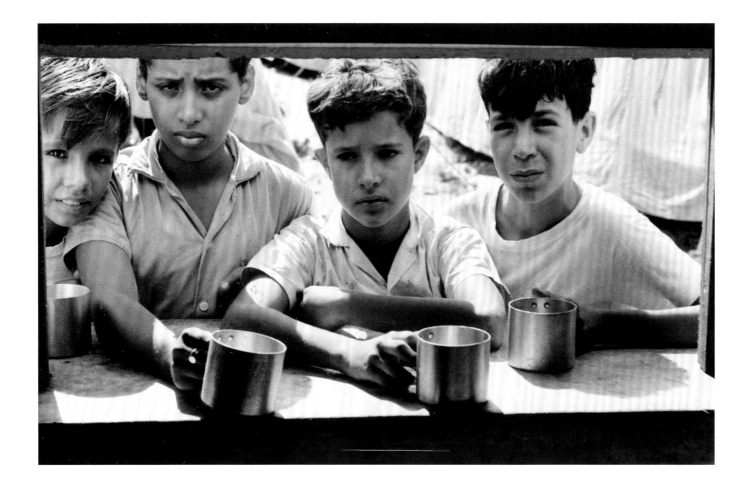

89 Shawn Walker (American, born 1940), **Boys with Cups,
Cuba**, 1968, gelatin silver print, 4 3/16 × 6 5/8 in. (10.64 × 16.83 cm).
*Virginia Museum of Fine Arts, Arthur and Margaret Glasgow Endowment,
2017.130*

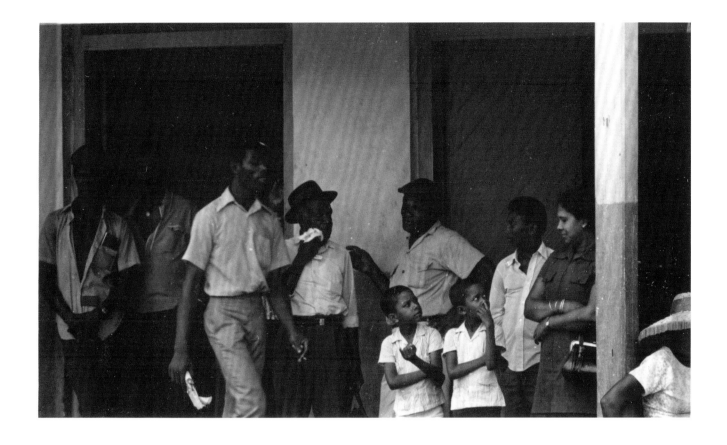

90 Herb Robinson (American, birthdate unknown),
Bus Stop, Kingston, Jamaica, 1973, gelatin silver print,
3 ¼ x 5 in. (8.26 x 12.7 cm). *Collection of Herb Robinson*

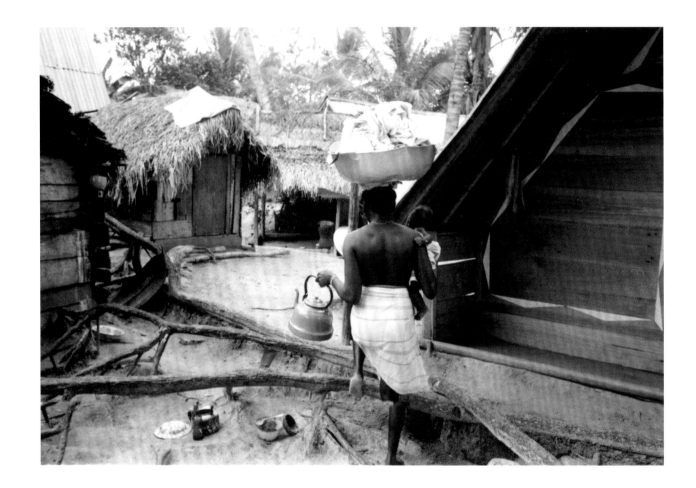

91 Adger Cowans (American, born 1936), **Djuka Woman and Child (Balance),** 1969, gelatin silver print, 7 ¼ × 10 ⅝ in. (18.42 × 26.99 cm). *Collection of Adger Cowans*

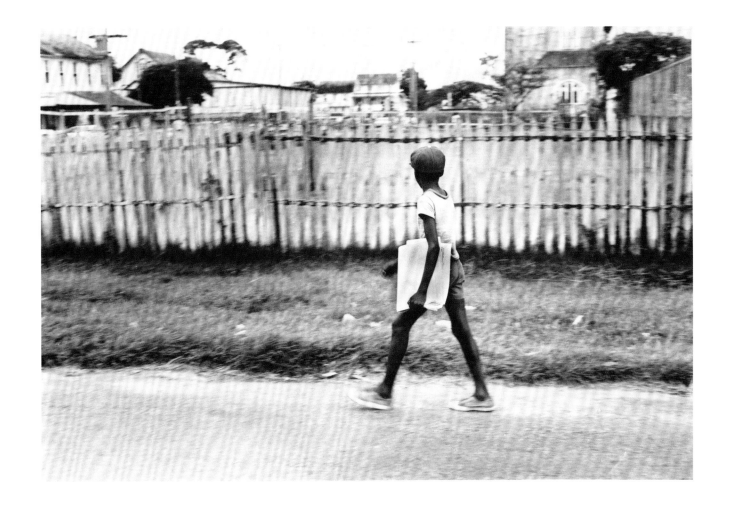

92 Herman Howard (American, 1942–1980), **Guyana**,
1970s, gelatin silver print, 5 ½ × 8 ⅛ in. (13.97 × 20.64 cm).
Collection of Herb Robinson

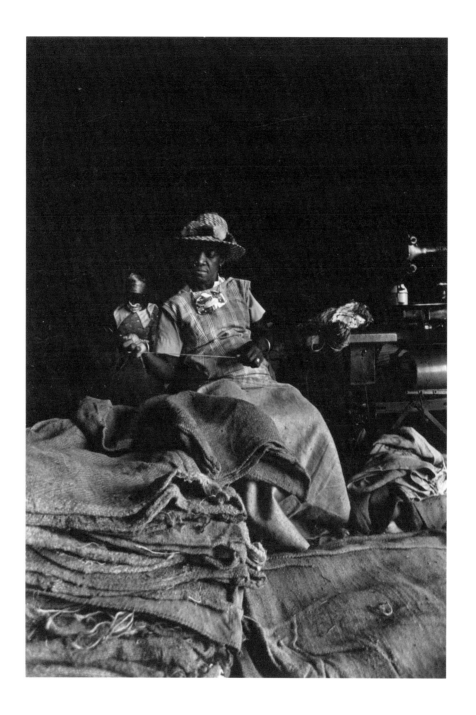

93 James Mannas (American, born 1941), **Bag Ladies,
Matthews Ridge, Guyana**, 1972, gelatin silver print,
7 ³⁄₁₆ × 4 ⅞ in. (18.26 × 12.38 cm). *Virginia Museum of Fine Arts,
Arthur and Margaret Glasgow Endowment, 2019.198*

94 James Mannas (American, born 1941), **Recess, Bishops All Girls High School, Georgetown, Guyana,** 1973, gelatin silver print, 7 ¹³⁄₁₆ × 4 ⅞ in. (19.84 × 12.38 cm). *Virginia Museum of Fine Arts, Arthur and Margaret Glasgow Endowment, 2019.200*

95 C. Daniel Dawson (American, born 1944), **Olaifa and Egypt,**
1978, gelatin silver print, 6 ½ x 9 ½ in. (16.51 x 24.13 cm).
Collection of C. Daniel Dawson

96 Shawn Walker (American, born 1940), **African American Day Parade, W. 113 Street, Harlem,** ca. 1980s, gelatin silver print, 11 ⅝ × 17 ¼ in. (29.53 × 43.82 cm). *Virginia Museum of Fine Arts, National Endowment for the Arts Fund for American Art, 2019.243*

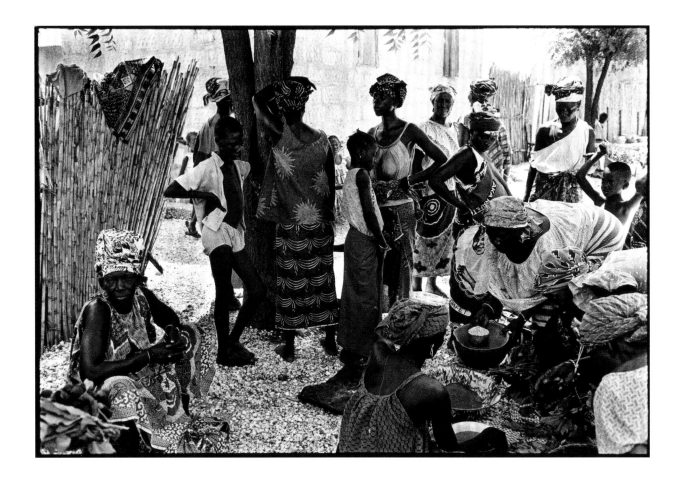

97 Anthony Barboza (American, born 1944), **Fadiouth,
Senegal,** 1972, gelatin silver print, 7 ½ × 11 in. (19.05 × 27.94 cm).
*Virginia Museum of Fine Arts, Virginia Museum of Fine Arts, Arthur
and Margaret Glasgow Endowment, 2019.8*

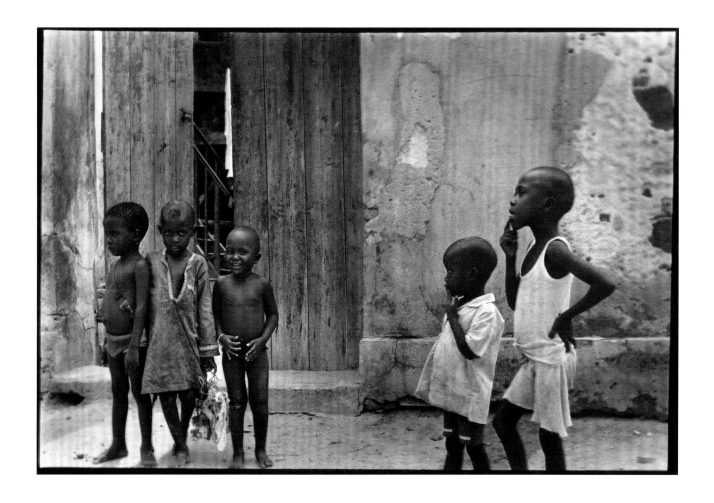

98 Ming Smith (American, birthdate unknown), **Onlookers, Isle de Gorée, Senegal,** ca. 1972, gelatin silver print, 16 x 20 in. (40.64 x 58.8 cm). *Virginia Museum of Fine Arts, Aldine S. Hartman Endowment Fund, 2019.5*

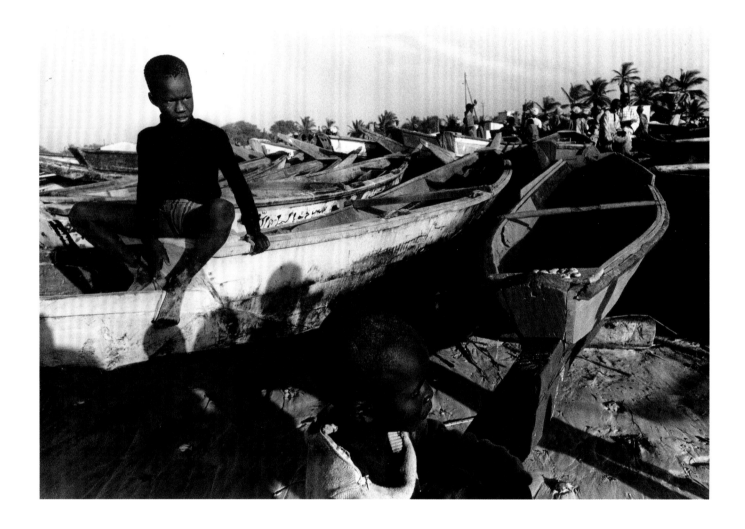

99 Louis Draper (American, 1935–2002), **Dakar, Senegal, West Africa,** 1978, gelatin silver print, 9 ⁵⁄₁₆ × 13 ⁹⁄₁₆ in. (23.65 × 34.45 cm). *Virginia Museum of Fine Arts, Arthur and Margaret Glasgow Endowment, 2015.297*

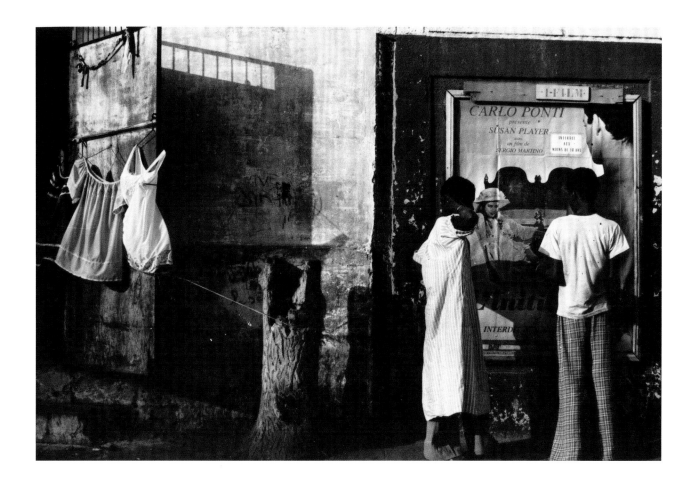

100 Louis Draper (American, 1935–2002), **Dakar, Senegal, West Africa,** 1978, gelatin silver print, 6 ⁵⁄₁₆ × 9 ⁵⁄₁₆ in. (16.03 × 23.65 cm). *Virginia Museum of Fine Arts, Arthur and Margaret Glasgow Endowment, 2015.298*

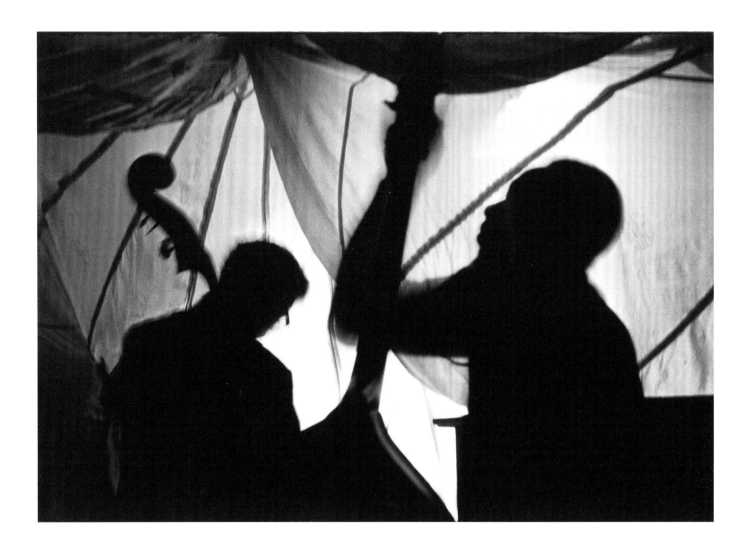

101 Beuford Smith (American, born 1941), **Two Bass Hit,
Lower East Side,** 1972, gelatin silver print, 9 ⅜ × 13 ½ in.
(23.81 × 34.29 cm). *Virginia Museum of Fine Arts, Arthur and
Margaret Glasgow Endowment, 2017.36*

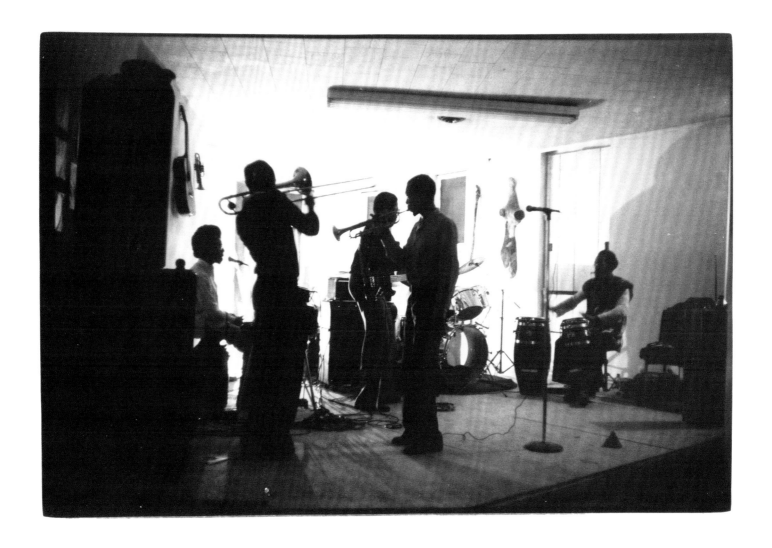

102 Anthony Barboza (American, born 1944), **Okra Orchestra, Brooklyn, NY Rehearsal,** 1978, gelatin silver print, 9 $\frac{1}{16}$ × 13 $\frac{1}{4}$ in. (23.02 × 33.66 cm). Virginia Museum of Fine Arts, *Virginia Museum of Fine Arts, Arthur and Margaret Glasgow Endowment, 2019.10*

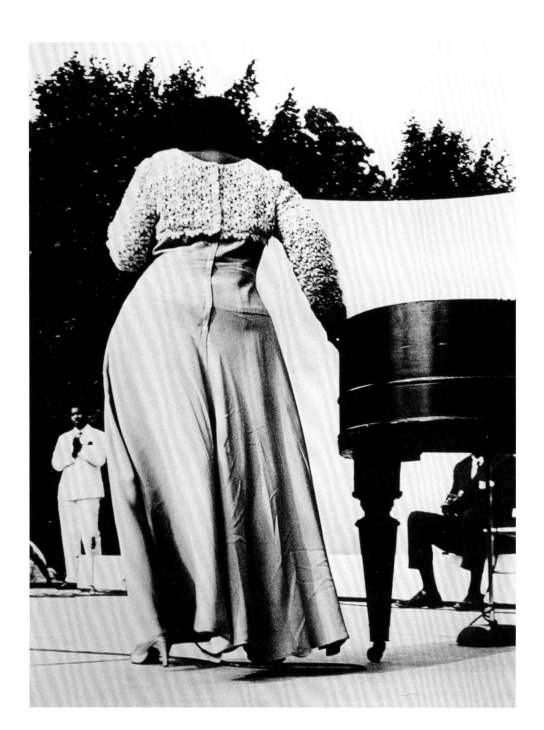

103 Herb Robinson (American, birthdate unknown),
Mahalia Jackson, 1969, gelatin silver print, 13 ½ × 10 ⅜ in.
(34.29 × 26.35 cm). *Virginia Museum of Fine Arts, Arthur and
Margaret Glasgow Endowment, 2019.203*

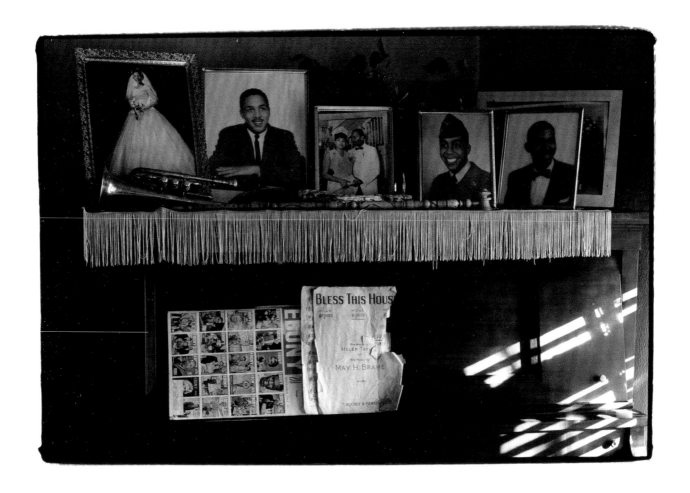

104 Adger Cowans (American, born 1936), **Momma's Ohio Piano,** ca. 1965, gelatin silver print, 12 ⅛ × 17 ¾ in. (30.8 × 45.09 cm). *Virginia Museum of Fine Arts, Aldine S. Hartman Endowment Fund, 2018.314*

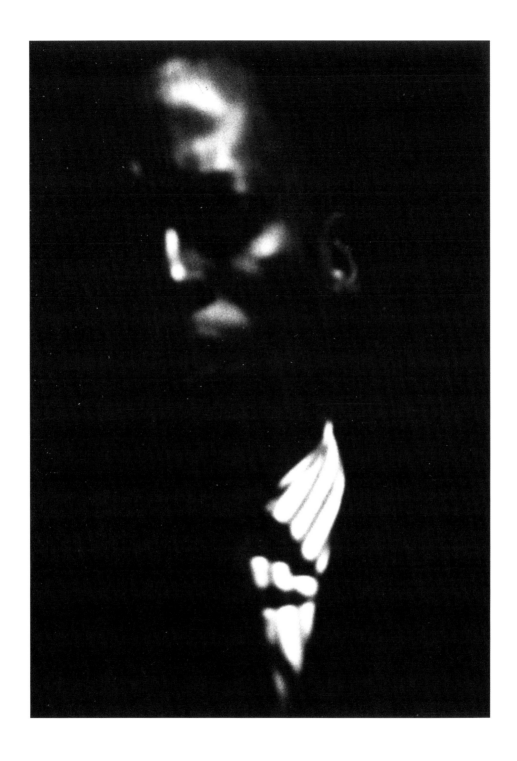

105 Herb Robinson (American, birthdate unknown),
Miles Davis at the Village Vanguard, 1961, gelatin silver print,
13 ⅞ × 9 ¹³⁄₁₆ in. (35.24 × 24.92 cm). *Virginia Museum of Fine Arts,*
Arthur and Margaret Glasgow Endowment, 2019.204

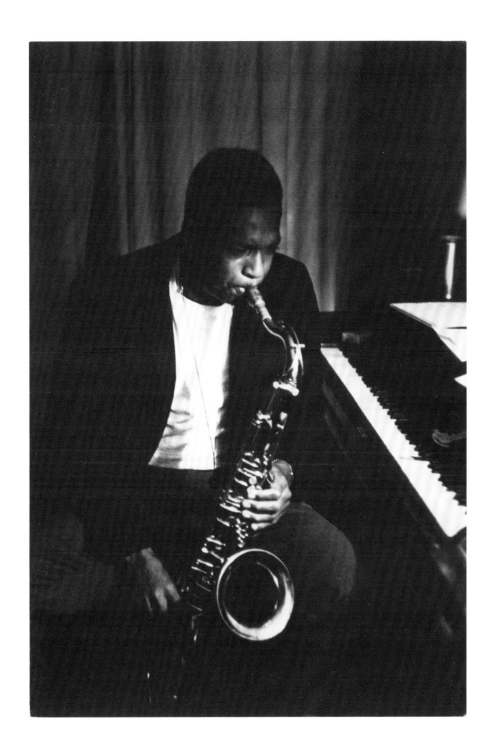

106 Louis Draper (American, 1935–2002), **John Coltrane,**
1960–67, gelatin silver print, 9 $\frac{7}{16}$ x 6 $\frac{5}{16}$ in. (24 x 16 cm).
Collection of the Smithsonian National Museum of African American
History and Culture, Gift of Nell Draper-Winston, 2013.66.1

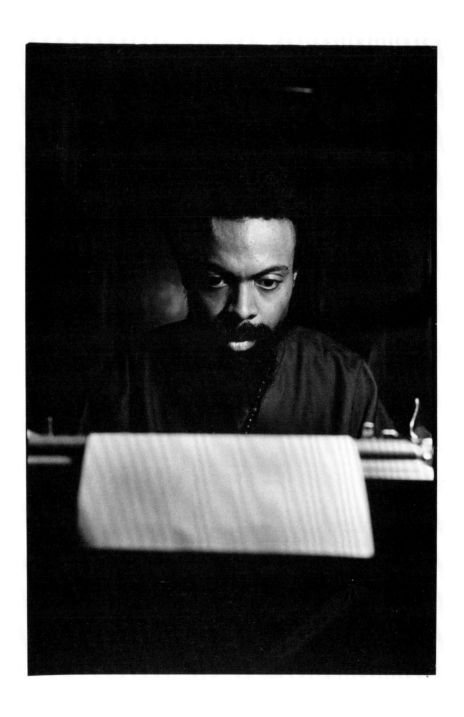

107 C. Daniel Dawson (American, born 1944), **Amiri #10,**
1970, gelatin silver print, 8 ¾ x 5 ⅞ in. (22.23 x 14.92 cm).
Collection of C. Daniel Dawson

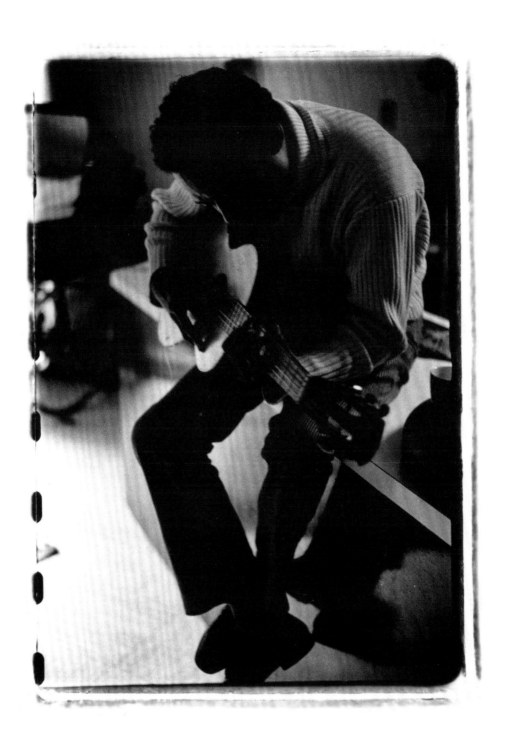

108 Louis Draper (American, 1935–2002), **Miles Davis,**
September 21, 1966, gelatin silver print, 8 x 5 ½ in.
(20.32 x 13.97 cm). *Virginia Museum of Fine Arts, Margaret R.
and Robert M. Freeman Library, Archives, Louis H. Draper Archives
(VA-04), Acquired from the Louis H. Draper Preservation Trust with
the Arthur and Margaret Glasgow Endowment Fund, VA04.03.1.055.P1*

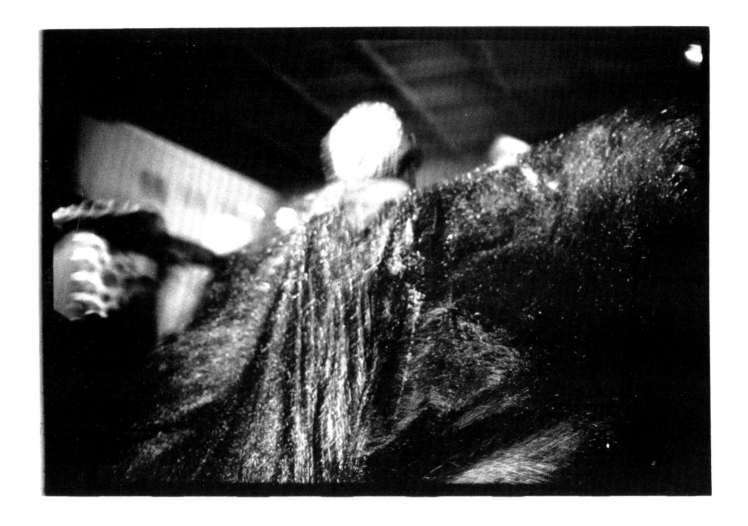

109 Ming Smith (American, birthdate unknown), **Sun Ra
space I, New York City, NY,** ca. 1978, gelatin silver print,
5 ¹⁵⁄₁₆ × 8 ¾ in. (15.08 × 22.23 cm). *Virginia Museum of Fine Arts,
Adolph D. and Wilkins C. Williams Fund, 2016.244*

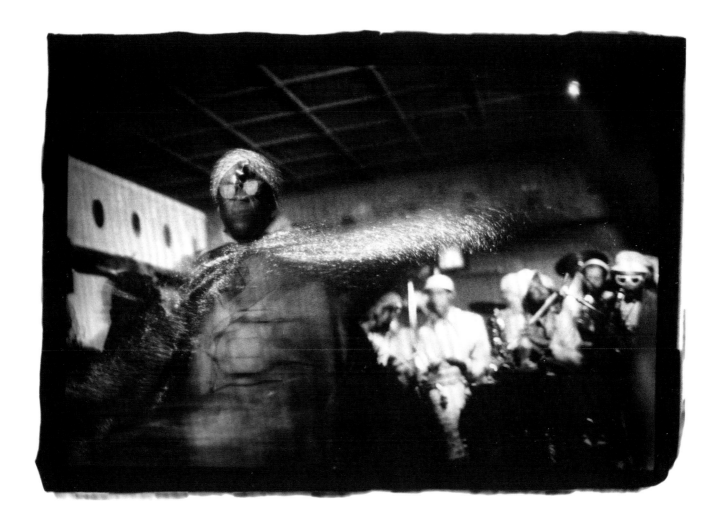

110 Ming Smith (American, birthdate unknown), **Sun Ra space II, New York City, NY,** ca. 1978, gelatin silver print, 8 ¾ × 12 ¼ in. (22.23 × 31.12 cm). *Virginia Museum of Fine Arts, Adolph D. and Wilkins C. Williams Fund, 2016.245*

111 C. Daniel Dawson (American, born 1944),
Chas. Oyama Gordon, 1970, gelatin silver print, 5 ¹⁵⁄₁₆ x 8 ¾ in
(15.08 x 22.23 cm). *Collection of C. Daniel Dawson*

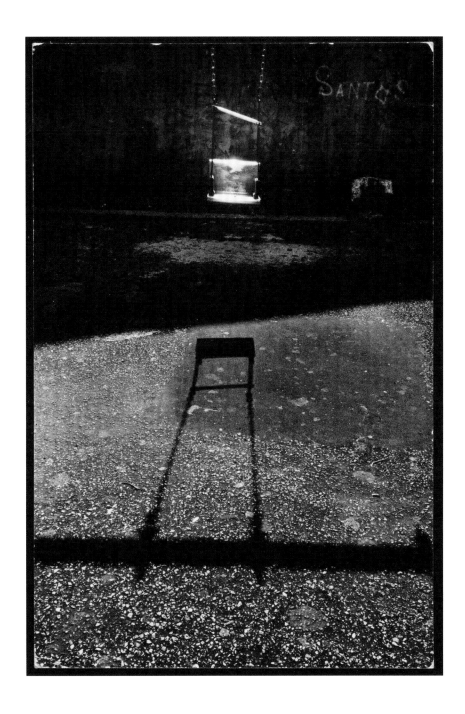

112 Louis Draper (American, 1935–2002), **Untitled [Santos],**
1967, gelatin silver print, 8 ¹⁵⁄₁₆ × 5 ⅞ in. (22.7 × 14.92 cm).
Virginia Museum of Fine Arts, National Endowment for the Arts Fund
for American Art, 2013.151

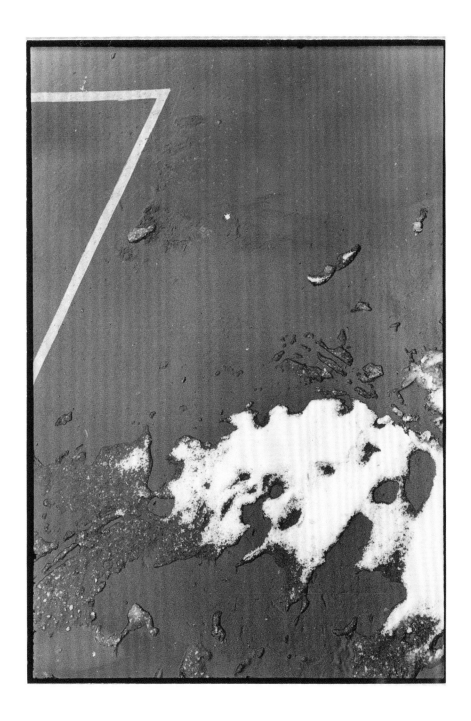

113 C. Daniel Dawson (American, born 1944), **Snow Study,**
1970, gelatin silver print, 9 x 6 in. (22.86 x 15.24 cm). *Collection*
of C. Daniel Dawson

114 Ming Smith (American, birthdate unknown), **Sun Breeze after the Bluing, Hoboken, New Jersey,** ca. 1972, gelatin silver print, 16 x 20 in. (40.64 x 50.8 cm). *Virginia Museum of Fine Arts, Aldine S. Hartman Endowment Fund, 2019.6*

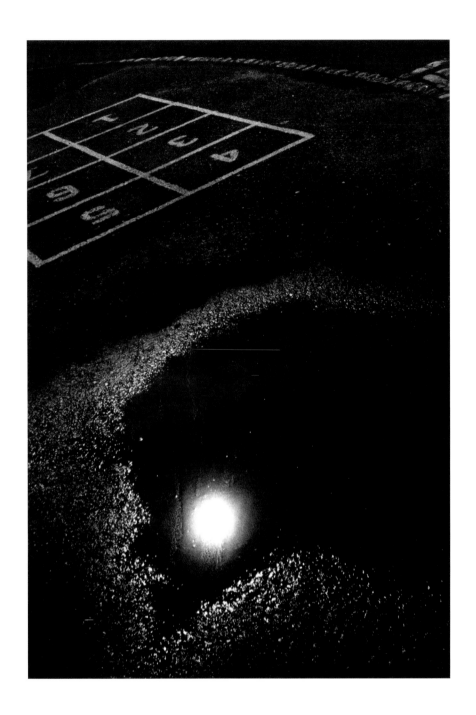

115 Louis Draper (American, 1935–2002), **Untitled,** ca.
1960s, gelatin silver print, 9 $^{11}/_{16}$ × 6 $^{5}/_{8}$ in. (24.61 × 16.83 cm).
Virginia Museum of Fine Arts, Arthur and Margaret Glasgow
Endowment, 2015.276

249

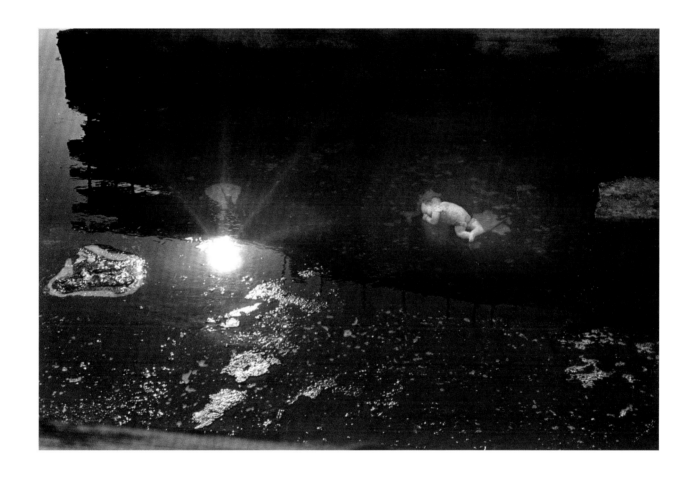

116 Herbert Randall, Jr. (American, born 1936), **Untitled [New Jersey],** ca. 1960s, gelatin silver print, 9 × 13 7/16 in. (22.86 × 34.13 cm).
Virginia Museum of Fine Arts, Arthur and Margaret Glasgow Endowment, 2019.215

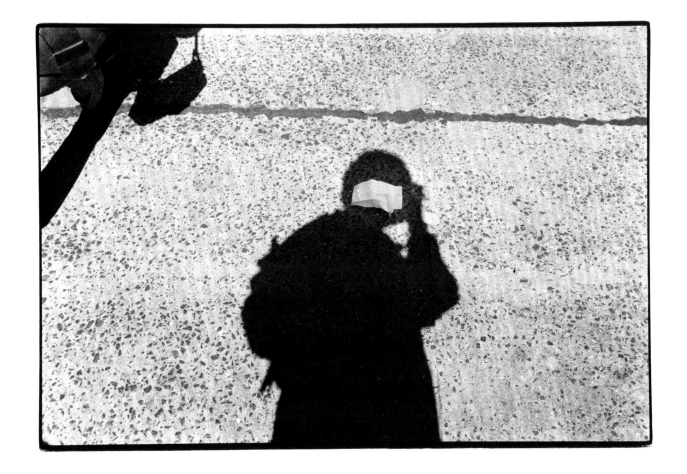

117 Anthony Barboza (American, born 1944), **Self-Portrait, NYC,** ca. 1970, gelatin silver print, 6 1/16 × 9 in. (15.4 × 22.86 cm).
Virginia Museum of Fine Arts, Adolph D. and Wilkins C. Williams Fund, 2016.332

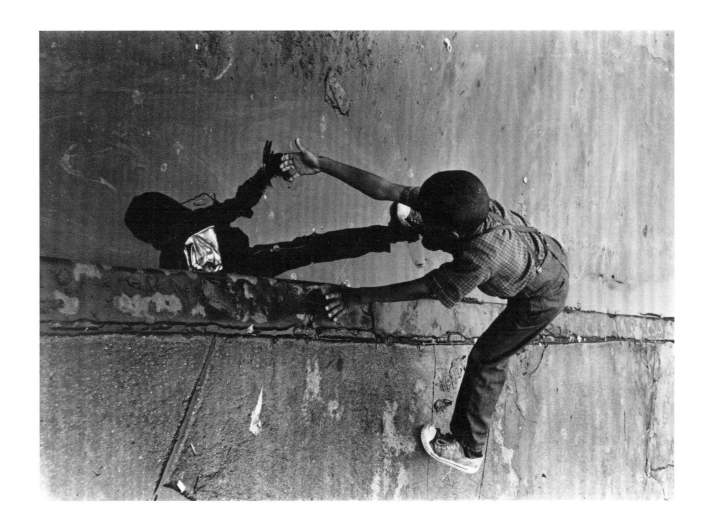

118 Beuford Smith (American, born 1941), **Bed-Stuy, Brooklyn,**
1970, gelatin silver print, 9 ½ × 6 ¹³⁄₁₆ in. (24.13 × 17.3 cm).
Virginia Museum of Fine Arts, Arthur and Margaret Glasgow Endowment,
2017.37

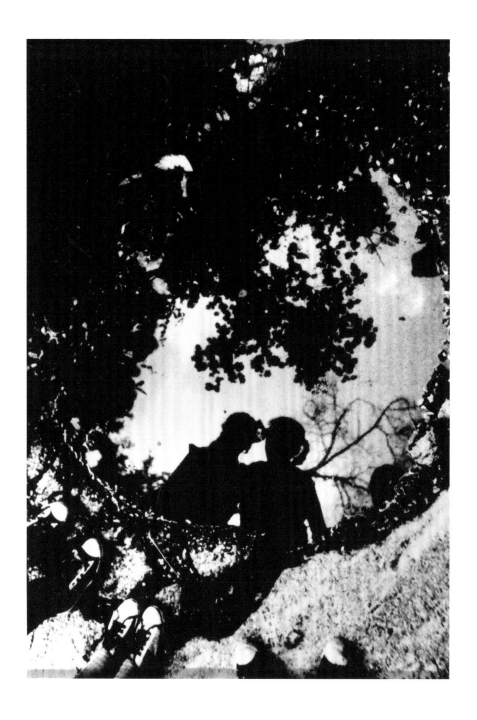

119 Herb Robinson (American, birthdate unknown),
Central Park, Kids, 1961, gelatin silver print, 13 ⁵⁄₁₆ × 9 ¼ in.
(33.81 × 23.5 cm). *Collection of Herb Robinson*

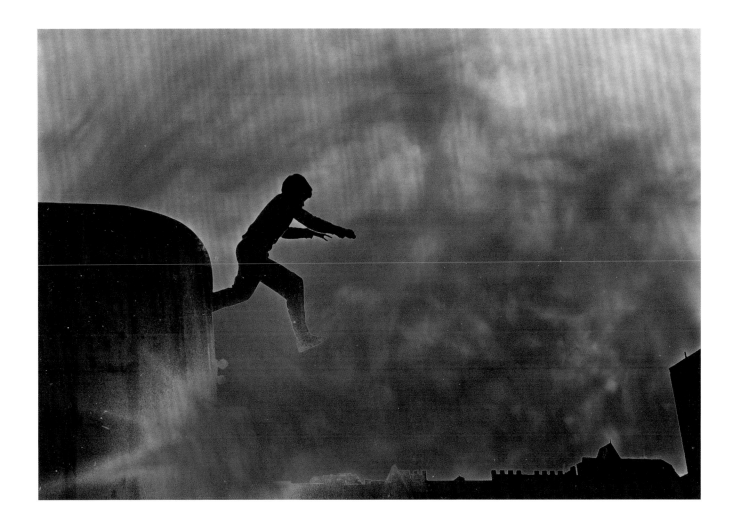

120 Herman Howard (American, 1942–1980), **New York,**
ca. 1960s, gelatin silver print, 6 ⁵⁄₁₆ × 9 ³⁄₁₆ in. (16.03 × 23.34 cm).
Collection of Herb Robinson

254

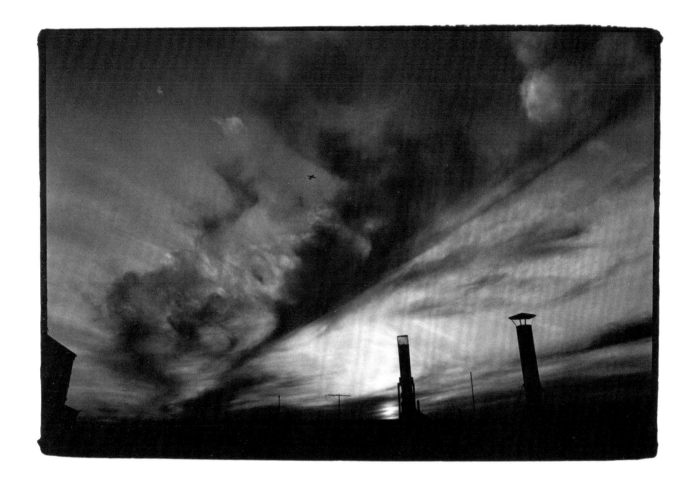

121 Adger Cowans (American, born 1936), **Far and Away,**
1970, gelatin silver print, 11 ⅝ × 17 ¼ in. (29.53 × 43.82 cm).
Virginia Museum of Fine Arts, Aldine S. Hartman Endowment Fund,
2018.319

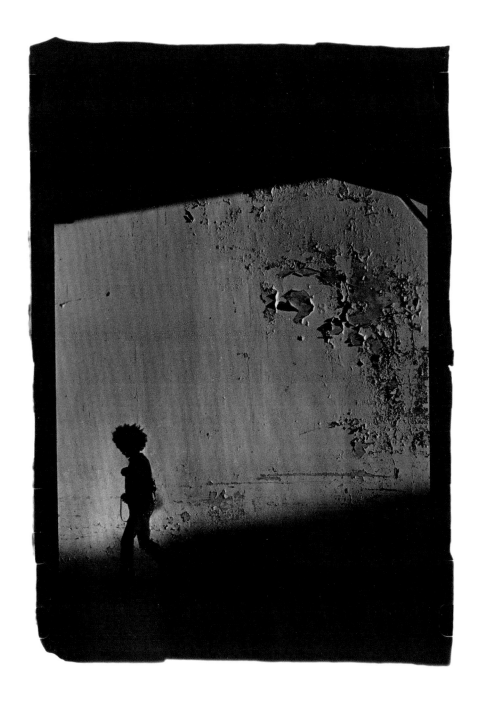

122 Ming Smith (American, birthdate unknown), **Untitled, [Harlem, NY],** ca. 1973, printed ca. 1975, gelatin silver print, 12 ½ x 8 ¾ in. (31.75 x 22.23 cm). *Virginia Museum of Fine Arts, Adolph D. and Wilkins C. Williams Fund, 2016.239*

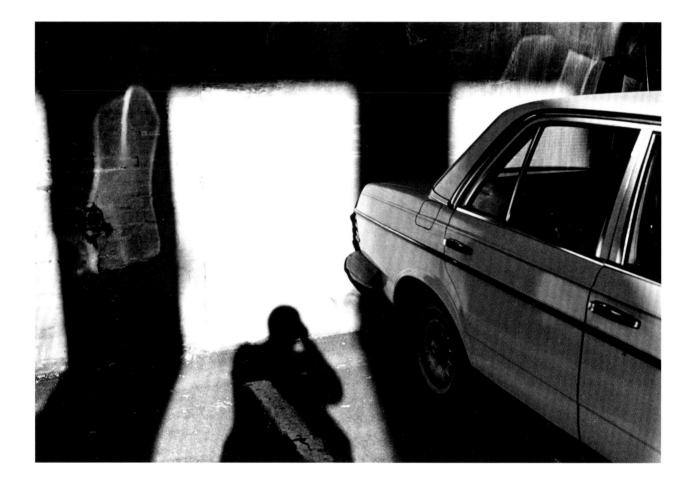

123 Louis Draper (American, 1935–2002), **Untitled,** ca. 1970s, gelatin silver print, 6 ½ × 9 ½ in. (16.51 × 24.13 cm), *Virginia Museum of Fine Arts, Arthur and Margaret Glasgow Endowment, 2015.292*

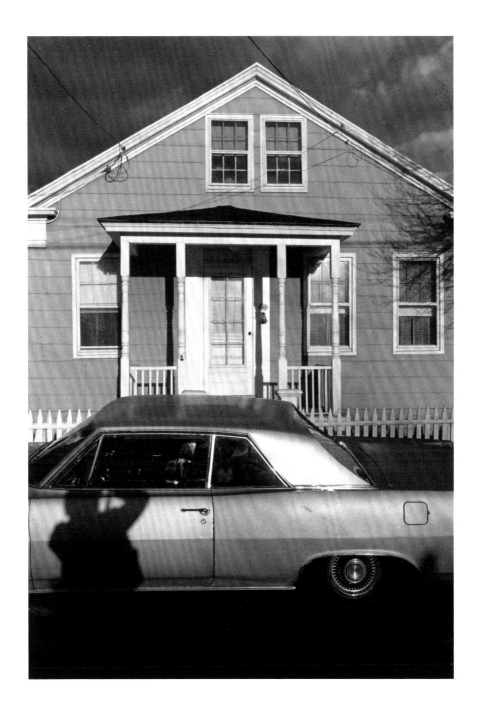

124 Albert Fennar (American, 1938–2018), **Sag Harbor,** 1975,
gelatin silver print, 10 × 6 ¹³⁄₁₆ in. (25.4 × 17.3 cm), *Courtesy of
Miya Fennar and the Albert R. Fennar Archive*

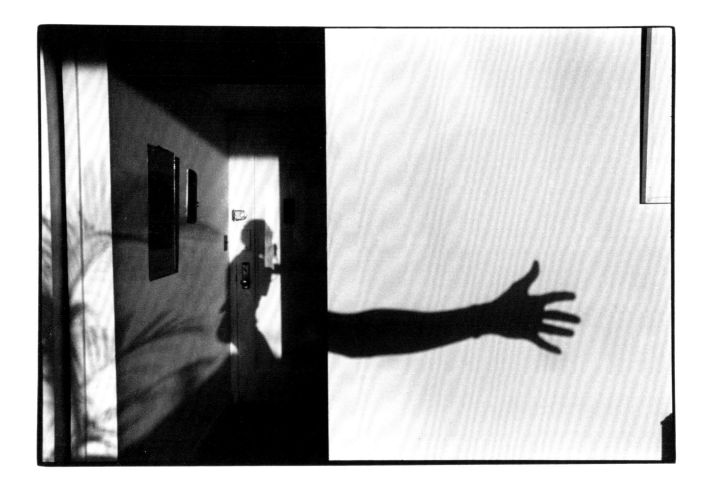

125 Anthony Barboza (American, born 1944), **Self-Portrait, NYC,**
ca. 1978, gelatin silver print, 6 × 9 in. (15.24 × 22.86 cm).
Virginia Museum of Fine Arts, Adolph D. and Wilkins C. Williams Fund,
2016.317

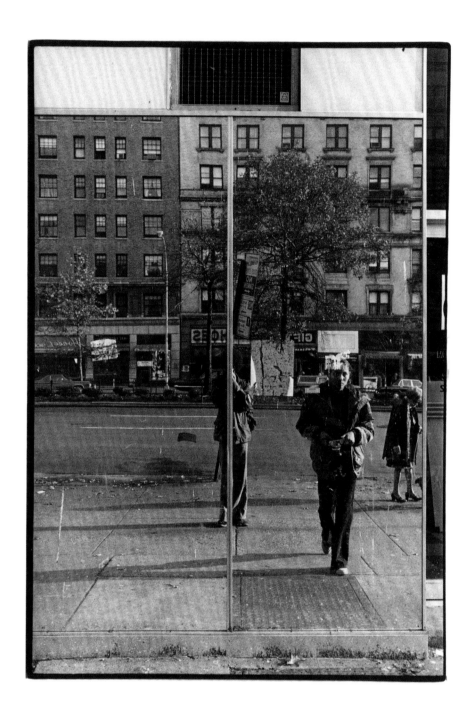

126 Anthony Barboza (American, born 1944), **Ming Smith, NYC,** 1973, gelatin silver print, 6 $^{15}/_{16}$ × 4 $^{11}/_{16}$ in. (17.62 × 11.91 cm).
Virginia Museum of Fine Arts, Arthur and Margaret Glasgow Endowment, 2017.46

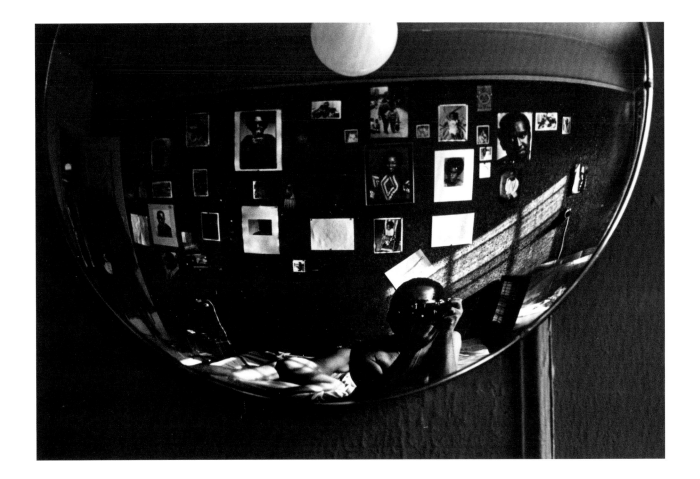

127 Shawn Walker (American, born 1940), **Mirror Reflection,
Bronx,** 1969, gelatin silver print, 5 $\frac{3}{16}$ × 7 $\frac{11}{16}$ in. (13.18 × 19.53 cm),
Virginia Museum of Fine Arts, Arthur and Margaret Glasgow Endowment,
2017.126

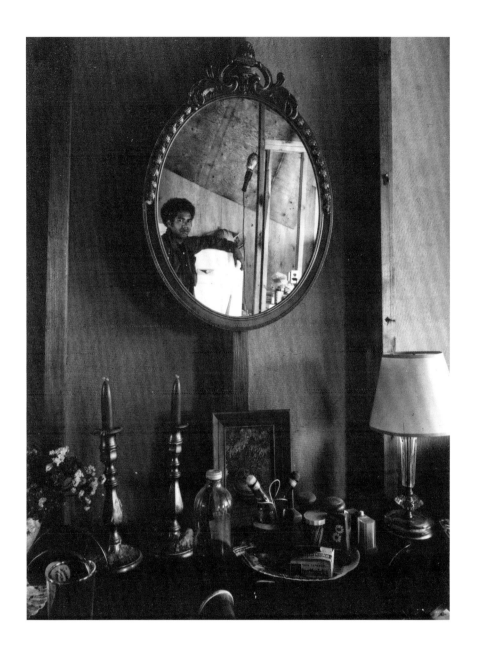

128 Ray Francis (American, 1937–2006), **Untitled,** 1971, gelatin silver print, 8 × 6 in. (20.32 × 15.24 cm). *Collection of Shawn Walker*

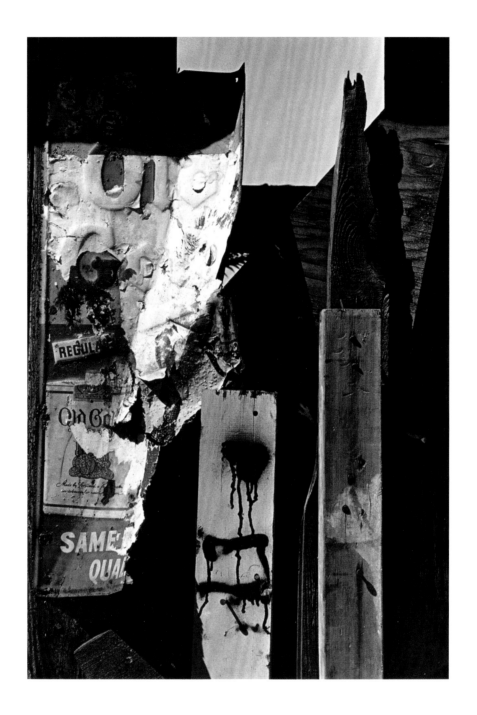

129 Louis Draper (American, 1935–2002), **Untitled,** n.d., gelatin
silver print, 12 ⅝ × 8 ⅝ in. (32.07 × 21.91 cm). *Virginia Museum of
Fine Arts, Arthur and Margaret Glasgow Endowment, 2015.277*

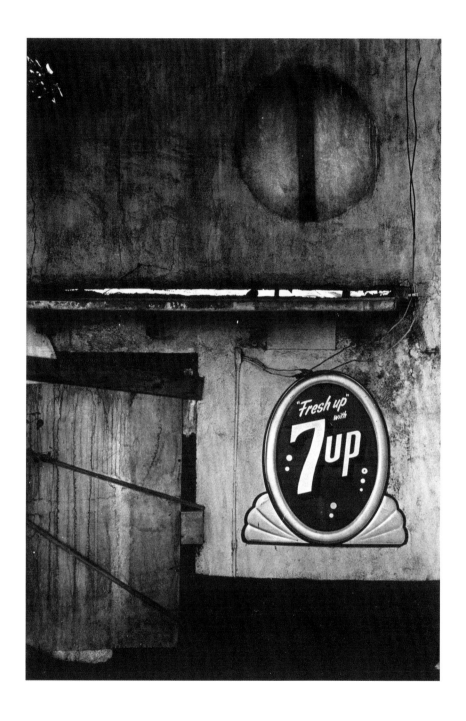

130 Albert Fennar (American, 1938–2018), **Untitled (7up)**, ca. 1960-70s, gelatin silver print, 6 x 9 in. (15.24 x 22.86 cm). *Collection of Shawn Walker*

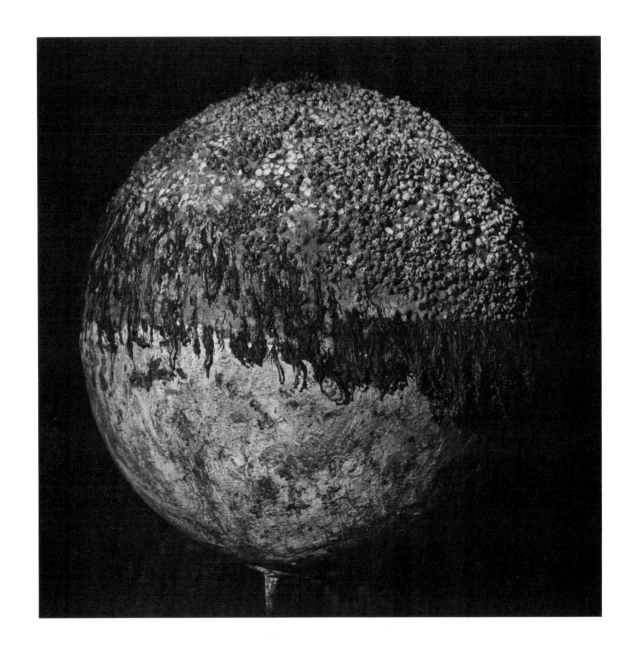

131 Albert Fennar (American, 1938–2018), **Sphere,** 1974,
gelatin silver print, 7 ½ x 7 ½ in., (19.05 x 19.05 cm). *Collection
of Shawn Walker*

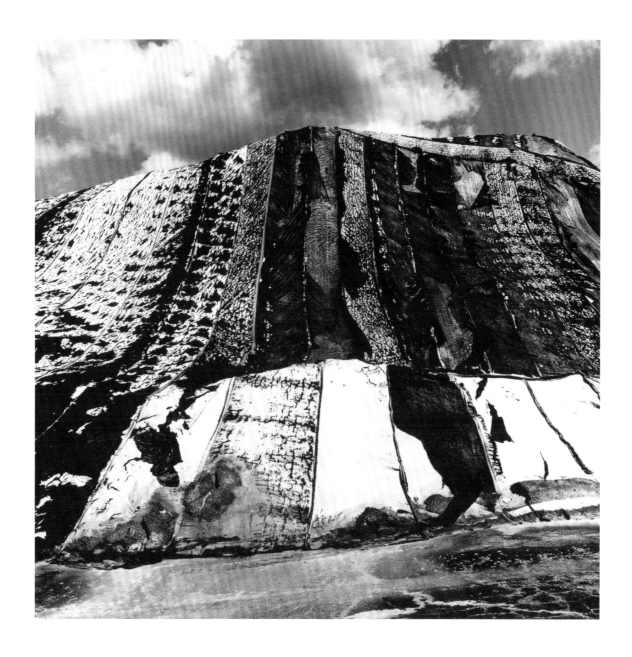

132 Albert Fennar (American, 1938–2018), **Salt Pile,** 1971,
gelatin silver print, 6 ½ x 6 ½ in. (16.51 x 16.51 cm). *Collection
of Shawn Walker*

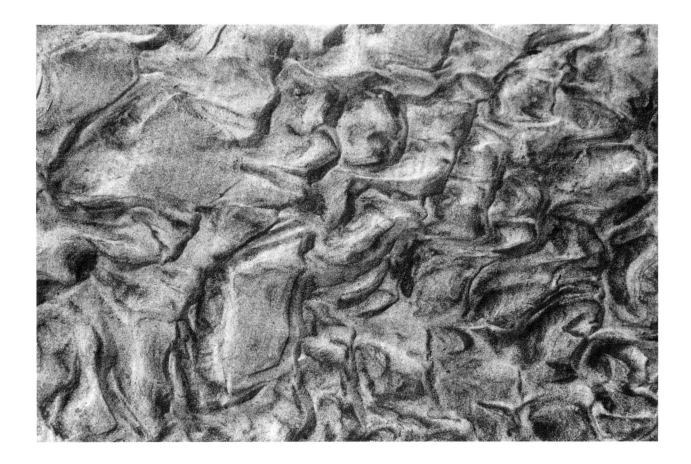

133 Ray Francis (American, 1937–2006), **Untitled (water image),** n.d., gelatin silver print, 4 × 6 ⅛ in. (10.16 × 15.56 cm).
Collection of Shawn Walker

134 Herb Robinson (American, birthdate unknown), **Faces,**
1979, gelatin silver print, 12 ⁹⁄₁₆ × 10 ⅜ in. (31.91 × 26.35 cm).
Virginia Museum of Fine Arts, Gift of the Artist, 2019.194

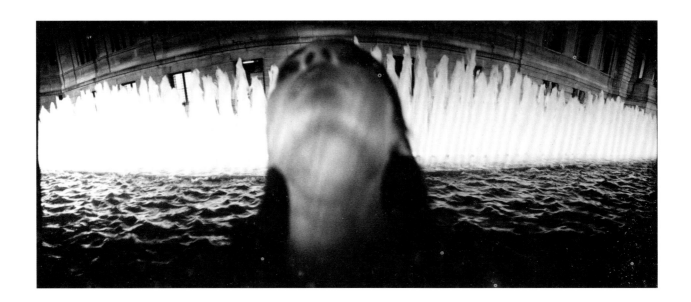

135 Anthony Barboza (American, born 1944), **At the Met, Ming,**
1974, gelatin silver print, 3 ¼ × 7 ⅝ in. (8.26 × 19.37 cm). *Virginia*
Museum of Fine Arts, Adolph D. and Wilkins C. Williams Fund, 2016.316

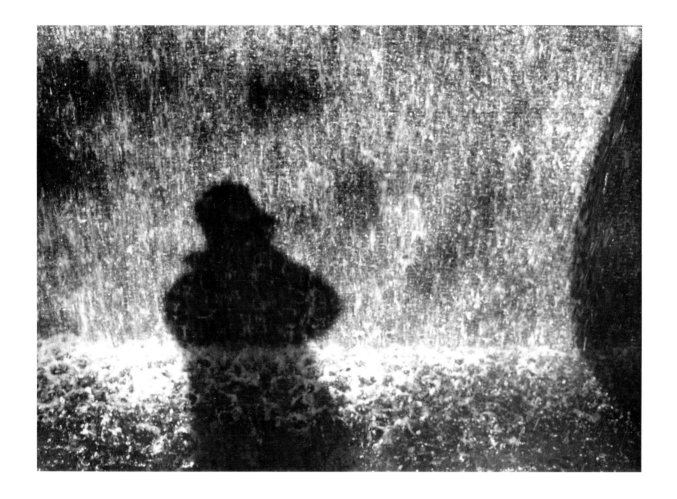

136 Beuford Smith (American, born 1941), **Self-Portrait in Waterfall, NYC,** 1978, gelatin silver print, 9 ¹¹⁄₁₆ × 13 ⁹⁄₁₆ in. (24.61 × 34.45 cm). *Virginia Museum of Fine Arts, National Endowment for the Arts Fund for American Art, 2019.247*

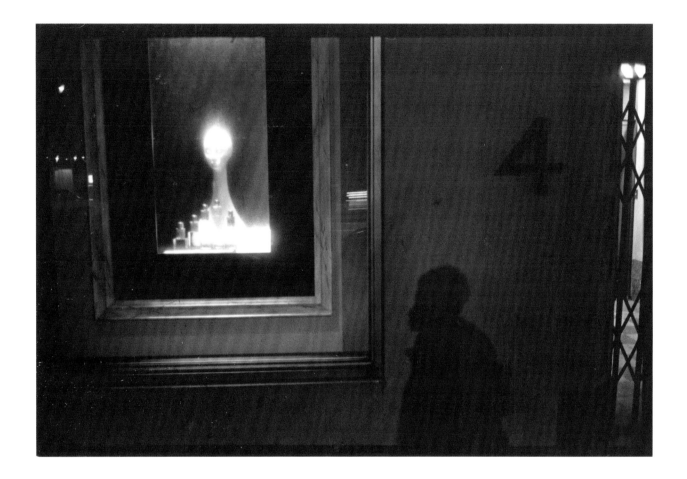

137 Shawn Walker (American, born 1940), **Tiffany's Window on 57th Street, NYC,** ca. 1968–72, gelatin silver print, 4 ¾ × 7 ⅟₁₆ in. (12.07 × 17.94 cm). *Virginia Museum of Fine Arts, National Endowment for the Arts Fund for American Art, 2019.241*

138 Shawn Walker (American, born 1940), **Soho Display Window, NYC,** ca.1970s, gelatin silver print, 12 ⁷⁄₁₆ × 18 in. (31.59 × 45.72 cm). *Virginia Museum of Fine Arts, National Endowment for the Arts Fund for American Art, 2019.242*

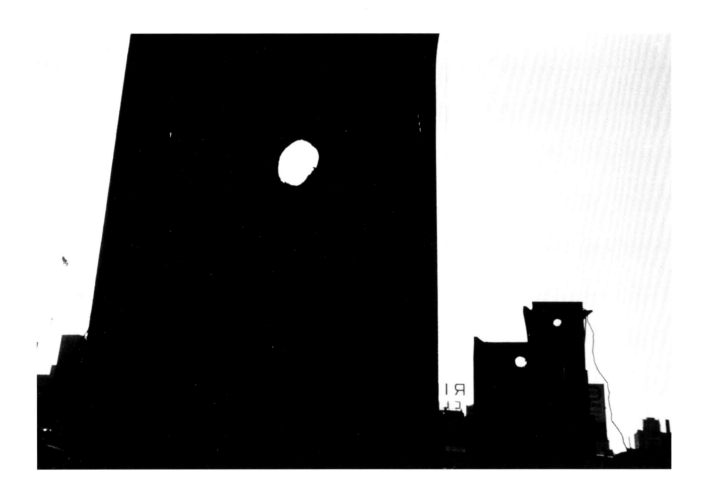

139 Louis Draper (American, 1935–2002), **Untitled [Lincoln Center]**, 1961, gelatin silver print, 7 × 10 ½ in. (17.78 × 26.67 cm). *Virginia Museum of Fine Arts, Arthur and Margaret Glasgow Endowment, 2015.274*

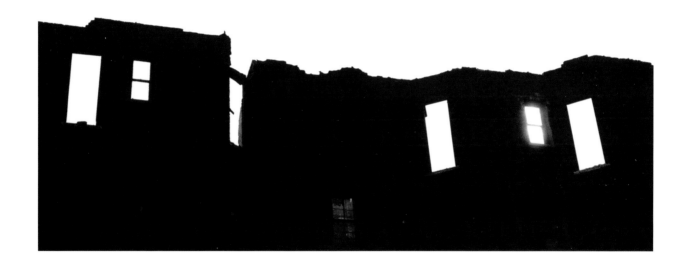

140 Louis Draper (American, 1935–2002), **Untitled [Ruins and Sky],** ca. 1960s, gelatin silver print, 7 ⅛ × 10 ⅝ in. (18.1 × 26.99 cm). *Virginia Museum of Fine Arts, Arthur and Margaret Glasgow Endowment, 2015.275*

Artists' Portraits and Biographies

BIOGRAPHIES BY SHARAYAH COCHRAN

Portraits by Anthony Barboza, American, born 1944, Gelatin silver print.
Virginia Museum of Fine Arts, National Endowment for the Arts Fund for
American Art

Artists' names listed here reflect Barboza's inscription on the back of the photographs.

141 Self-Portrait, 1972
8 ½ × 5 ¹³⁄₁₆ in. (21.59 × 14.76 cm)
2017.165

142 Adger Cowans, 1972
8 ¹⁄₁₆ × 5 ½ in. (20.48 × 13.97 cm)
2017.168

143 Dan Dawson, 1972
8 ⁷⁄₁₆ × 5 ¹¹⁄₁₆ in. (21.43 × 14.45 cm)
2017.164

144 Louis Draper, 1972
8 ⁵⁄₆₄ × 5 ⅝ in. (20.5 × 14.29 cm)
2017.175

145 Al Fennar, 1972
7 ¹³⁄₁₆ × 5 ⁵⁄₁₆ in. (19.84 × 13.49 cm)
2017.163

146 Ray Francis, 1972
8 1/8 × 5 1/2 in. (20.64 × 13.97 cm)
2017.170

147 Herman Howard, 1972
8 ³⁄₁₆ × 5 ⅝ in. (20.8 × 14.29 cm)
2017.167

148 Jimmie Mannas, 1972
8 ⁵⁄₁₆ × 5 ⅝ in. (21.11 × 14.29 cm)
2017.173

149 Herbie Randall, 1972
8 ³⁄₁₆ × 5 ⅝ in. (20.8 × 14.29 cm)
2017.171

150 Herb Robinson, 1972
8 ³⁄₁₆ × 5 ½ in. (20.8 × 13.97 cm)
2017.162

151 Beuford Smith, 1972
8 ¹³⁄₁₆ × 5 ⁵⁄₁₆ in. (22.38 × 13.49 cm)
2017.172

152 Ming Smith, 1972
8 ⅜ × 5 ⅝ in. (21.27 × 14.29 cm)
2017.166

153 Shawn Walker, 1972
8 ⅛ × 5 ½ in. (20.64 × 13.97 cm)
2017.169

154 Calvin Wilson, 1972
8 ³⁄₁₆ × 5 ⅝ in. (20.8 × 14.29 cm)
2017.174

Anthony "Tony" Barboza
Born 1944, New Bedford, MA

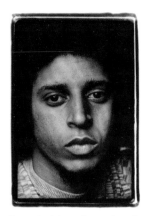

In the fall of 1963, soon after graduating from high school, Tony Barboza moved into New York, where he enrolled at the New York Institute of Photography. He was disappointed with the photography courses taught there, but found an educational touchstone when Adger Cowans invited him to attend a Kamoinge Workshop meeting. "My college was Kamoinge," he said of the workshop. In addition to teaching Barboza the history of photography, the Kamoinge members introduced him to other visual arts, jazz, and literature.

Using a twenty-dollar SunScope camera, he made prints in the closet of his Upper West Side apartment, washing them in the bathtub. He was ultimately exposed to the work of Hugh Bell and began taking printing lessons from Bell in exchange for work.

In 1964, he contributed to the Kamoinge Workshop's *Portfolio No. 2* but left New York when he was drafted the following year. He served in the navy for three years and was first stationed in Pensacola, Florida. After winning awards for his photographs at a community sidewalk festival, Barboza was assigned to the base's photography school. He later became the staff photographer for the air station's newspaper, where he learned to use a 4x5 speed graphic camera and create photo essays with a 35mm camera.

Barboza sustained his photography practice at the newspaper and eventually showed his work in solo exhibitions at the University of Miami's Lowe Art Museum, the Pensacola Art Museum, and the Jacksonville Art Museum. He took photography classes from Larry Colwell, who introduced him to the work of West Coast photographers like Wynn Bullock and Edward Weston. During this time, Barboza began photographing an impoverished family who lived nearby, until his base commanders ordered him to discontinue the project. He later showed some of the photographs in a 2008 exhibition at New York University titled *1968: THEN & NOW*, curated by Deborah Willis.

Barboza returned to New York after his honorable discharge in 1968. During his absence, the Kamoinge Workshop had mounted exhibitions and gained recognition in local and international publications, and while the group continued to meet, they did so less frequently. Missing the community of photographers that he left, Barboza urged the group to come together more regularly.

Encouraged by Lou Draper, Barboza researched the history of photography, especially African American photographers. Through his relationships with artist Romare Bearden, Barboza learned about photographers Jules Lion, Augustus Washington, and James Presley Ball. Reggie McGee introduced him to James VanDerZee after the *Harlem on My Mind* exhibition at the Metropolitan Museum of Art in 1969, and Barboza later worked with the noted portraitist as a studio assistant.

In 1969, Barboza published work in *Popular Photography* and continued artistic projects while establishing a career in fashion and advertising. His commercial photographs from the late 1960s and early 1970s included features in *Harper's Bazaar, Essence, Esquire, GQ, National Geographic,* and other major publications. During the 1970s he often hosted Kamoinge meetings at his studio.

Barboza traveled for international assignments, working in Mexico, Senegal, Brazil, Egypt, and Ethiopia. He sometimes traveled with Kamoinge members Ming Smith (who occasionally modeled on location) and Draper (who worked as an assistant photographer).

In addition to exhibiting with Kamoinge and serving on the editorial team of *The Black Photographers Annual*, Barboza showed his work at multiple galleries and museums throughout the 1970s. In 1978 his portrait of Pharoah Sanders was included in John Szarkowski's *Mirrors and Windows: American Photography since 1960* at the Museum of Modern Art. Barboza and Roy DeCarava were the only Black photographers in the show.

Barboza began work on *Black Borders* in 1975 and in 1980 received a National Endowment for the Arts grant for the project. He also received a 1976 Creative Artists Public Service (CAPS) grant to photograph twenty-five Black artists. In 1982 the Studio Museum in Harlem opened *Introspect: The Photography of Anthony Barboza*, a retrospective cocurated by Deborah Willis and Danny Dawson. A partnership with the Polaroid Corporation allowed Barboza to exhibit work internationally during the 1980s. His photographic series, *Eye Dreaming*, *Black Dreams/White Sheets*, and *Finding Self*, included portraits of jazz musicians.

Barboza coordinated the production of the *Kamoinge Artists' Book*, featuring portraits of the fourteen core members. He also arranged group portraits during each of the International Black Photographers Dinners, which were attended by multiple generations of photographers. In the spirit of Art Kane's photograph of jazz musicians, *A Great Day in Harlem* (1958), Barboza gathered jazz musicians on the roof of his studio for a portrait in 1983.

He was a co-director for a television commercial featuring his friend, the famous jazz legend, Miles Davis, for Dentsu, Inc. in 1985. In 2010, many of his photos of Davis were included in the exhibition *We Want Miles* at Citi de la Musique in Paris, France.

In 2001 he served as cocurator with Barbara Millstein for the Brooklyn Museum exhibition *Committed to the Image: Contemporary Black Photographers*. He was president of Kamoinge from 2005 to 2016 and, along with Herb Robinson, edited the book *Timeless* (2015), which highlights the work and history of Kamoinge from its beginnings to its present form as Kamoinge, Inc. Barboza has continued to promote the work and preserve the memory of African American photographers and artists.

Adger Wilbur Cowans
Born 1936, Columbus, OH

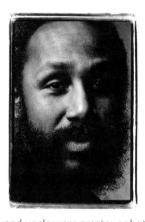

A photographer as well as a painter, Adger Cowans grew up surrounded by family albums and the magazines *Life, Look,* the *Saturday Evening Post, Ebony,* and *Jet,* as well as lots of comic books. While his mother and uncle were amateur photographers, the whole family loved taking pictures, and his aunt bought one of the first commercial Polaroid cameras. An announcement in a camera magazine led him to enroll in the photography program at Ohio University in 1954. Studying under Clarence H. White Jr., Cowans met fellow students and photographers James Karales and Paul Fusco, and they traveled to New York City with Professor David Hostetler and other students on weekends. During one trip, the students sought out W. Eugene Smith, who met them at the door holding a wet print in a tray. They also saw Thelonious Monk at the 5 Spot Cafe and and Miles Davis performing at Carnegie Hall. They made the trip so often that Monk once recognized the group as "them kids from Ohio."

During his junior year, Cowans corresponded with Gordon Parks and contacted the *Life* staff photographer in 1958 when he moved to New York. Parks offered Cowans a job as an assistant and invited him to live with his family. That fall, Cowans was drafted and sent to Oceana Naval Air Station in Virginia Beach where he served as an aerial photographer. When he completed his service in 1960, he returned to New York and became involved in street photography in Harlem, as well as the activities of the Student Non-Violent Coordinating Committee (SNCC) and the Congress on Racial Equality (CORE).

After seeing Cowans's photograph of Louis Armstrong on the cover of *Theatre Magazine*, Ray Francis invited him to join Group 35. There, Cowans helped to establish an artistic environment similar to what he experienced at Ohio University, influencing many Kamoinge Workshop members who were in the process of honing their photographic technique.

In 1962, Cowans received a John Hay Whitney Fellowship for Creative Photography that allowed him to pursue creative work. In 1963 he won an award for best photography at the Yolo International Exhibition in California and exhibited work in *Photography 63: An International Exhibition* at the George Eastman House. In 1965, Cowans had one-man show at the Heliographers Gallery, which was affiliated with photographers such as Paul Caponigro and Carl Chiarenza who were known for their abstract photographs of nature and dedication to photography as an art. He participated in the 1966 First World Festival of Negro Arts in Dakar, Senegal. The following year, Cowans's *Egg Nude* (1958) photograph was featured in *Photography in the Fine Arts*, Ivan Dmitri's exhibition at the Metropolitan Museum of Art. In 1976 he exhibited work in *Light Textures/3* at the Just Above Midtown (JAM) Gallery, a commercial gallery for contemporary Black artists founded by Linda Goode Bryant. Curated by Danny Dawson, the exhibit also included abstract work by Al Fennar and John Pinderhughes (who joined Kamoinge in 1994).

After assisting Lillian Bassman, George Barkentin, and Steve Manville, Cowans established his own reputation as a photojournalist and fashion photographer, but he found many assignments closed to him. Once, after being invited to interview for an assignment with *Vogue*, he was turned away at the magazine's office. Even after speaking with the editor, he was still not offered the assignment because it would have required him to photograph white women in the south. Despite such prejudice Cowans published work in *Pageant*, *Essence*, *The Saturday Evening Post*, *The New Yorker*, *Harper's Bazaar*, *Look*, and other magazines. and newspapers such as the *New York Times*, the *Los Angeles Times*, the *New York Amsterdam News*, and many others.

Cowans enrolled in courses at the School of Motion Picture Arts as well as the School of Visual Arts, Film Editing in New York. As the first African American still photographer for motion picture films, he worked with notable directors and actors on *Nothing But a Man* (1964), *Cotton Comes to Harlem* (1970), *The Way We Were* (1973), *Live and Let Die* (1973), *Aaron Loves Angela* (1975), *On Golden Pond* (1981), *The Cotton Club* (1984), *Rollover* (1981), *Night Falls on Manhattan* (1996), and many others. On occasion Cowans even stepped into an acting roles, playing a musician in *I'm Not Rappaport* (1996) and an undercover agent in *Live and Let Die*.

In addition to his affiliation with the Kamoinge Workshop and the International Black Photographers, Cowans created relationships with a number of artists. After showing his work at the National Urban League in late 1983, he befriended Romare Bearden who wrote the introduction for *Moments*, an exhibition of Cowans's series of abstract photographs of water. Since 1978 he has been a member of the Chicago-based group AfriCOBRA (African Commune of Bad Relevant Artists). Cowans continues to work as a professional photographer in New York and currently serves as president of Kamoinge, Inc.

C. Daniel Dawson
Born October 31, 1944, Newark, NJ

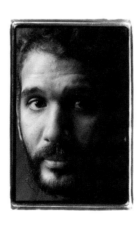

Danny Dawson was fourteen when his father, who had a darkroom in the basement, taught him about photography. Already a student at the Arts High School in Newark, Dawson would also sit in his brother's photography classes at the Newark School of Fine and Industrial Arts. He attended Lincoln University in Pennsylvania but later transferred to Columbia University, where he studied photography with Ralph Hattersley.

While at Columbia, Dawson frequented the 5 Spot Cafe in the Bowery where he met writer Amiri Baraka. The author of *Blues People* invited him to attend his classes at Columbia. Baraka later invited him to a benefit concert at the Village Gate for the Black Arts Repertory Theatre/School (BART/S) in Harlem. Dawson joined BART/S and curated the *1965 Black Arts Exhibition*, which included photographs by Kamoinge members. After BART/S moved to New Jersey, Dawson continued to work with Baraka as assistant director to the Spirit House Movers and Players theatrical group.

In 1966 Dawson worked as a photographic instructor at the New Jersey College of Medicine and Dentistry as a medical photographer. Marshall Taub, the head of photography, gave him access to the film and paper of his choice, and allowed him to experiment and hone his darkroom skills. From 1967 to 1968 he also exhibited work at Montclair State College and Newark Library.

Dawson learned about the Graduate Institute of Film and Television at New York University through Jimmie Mannas. Having previously participated in the WNET-TV Black Journal Film Workshop and studied editing at the School of the Visual Arts, Dawson enrolled at NYU in fall 1968, the same semester as Lou Draper. The comprehensive curriculum of the program included screenwriting and production, as well as photography courses. Dawson and Draper studied still photography with Paul Caponigro, as well as the history of photography with John Szarkowski and Peter Bunnell, who were curators at the Museum of Modern Art.

After finishing at NYU, Dawson began attending Kamoinge Workshop meetings and by 1971 became a member. On a curriculum vitae from the mid-1980s Dawson lists the Kamoinge Workshop under "Photographic Education" and notes their study of "Advanced Photographic Theory."

Dawson won a 1971 Creative Arts Public Service (CAPS) Grant for Photography and participated in the exhibitions *Eye Rap* and *One Apiece* at the Studio Museum in Harlem. He worked for two years at the museum as a filmmaker in residence, as well as workshop director and film photographer. In 1973 he was named an artist in residence at the Studio Museum to teach filmmaking. In 1975 he cofounded Northlight Studio with Draper, Ray Francis, Herman Howard, and Darryl Sivad, who later became a member of Kamoinge. Dawson has worked and collaborated with community art organizations and museums in Harlem, Brooklyn, and New Jersey since 1970.

During the 1970s and early 1980s Dawson contributed to a number of television and film projects as a cameraman, soundman, and director of photography in Chicago and New York. Dawson also traveled to Guyana to work on sound recordings for Mannas for the feature-length film *Aggro-Seizman* (1975). Dawson later collaborated with Mannas on the award-winning

short film *Head and Heart* (1977). Dawson also worked as director of photography for *Capoeira of Brazil* (1980) by Warrington Hudlin. This short film paired the movement of martial artists with music and won a Blue Ribbon at the 1983 American Film Festival.

Concurrent with his film work, Dawson exhibited his work at the MUSE Museum in Brooklyn and curated the 1976 exhibition *Light Textures/3* at the Just Above Midtown (JAM) Gallery. He later exhibited his own work as part of the *What I Do for Art* exhibition at the JAM Gallery. He served as photography and film editor for the 1978 volume of *American Rag* produced at the Frederick Douglass Creative Arts Center. The issue featured a cover image by Adger Cowans and portfolios by Draper and Ming Smith. Dawson also documented historic sites in the Bronx for the Comprehensive Employment and Training Act (CETA) and compiled a portfolio of photographs titled *Portions and Proportions*.

In 1981, he was named James VanDerZee Curator of Photography and Film/Video at the Studio Museum. Dawson curated the exhibitions *Extensions: Nonconventional Photographic Imagery* (1981) and *The Sound I Saw: The Jazz Photographs of Roy DeCarava* (1983). He cocurated with Deborah Willis; *Harlem Heyday: The Photography of James Van Der Zee* (1982); and *Introspect: The Photography of Anthony Barboza* (1982–83). In 1981 he curated an exhibition about the Banana Kelly Community project in the Bronx and *14 Photographers* (1981) at the Schomburg Center for Research in Black Culture. Dawson resigned from the Studio Museum in 1984 to photograph in Brazil, a project that was supported by tennis star Arthur Ashe and photographer Jeanne Moutoussamy-Ashe.

Dawson has published his photography in *Black Current Magazine*, *The Black Photographers Annual*, *Jet*, *Essence*, *Saturday Review*, *New York Times*, and *Amsterdam News*. He has worked as a consultant for the American Museum of Natural History, Caribbean Cultural Center African Diaspora Institute, and Museum for African Art (now The Africa Center). While still a student at NYU, Dawson became a filmmaking instructor at the Urban Communications Institute. He also began teaching photography at NYU while photographing and producing dance concerts at the Modern Organization for Dance Involvement. In 1977 he was a guest lecturer at the NYU School of Arts' Dance Department. He continues to teach seminars on African spirituality and is currently a faculty member at the Gallatin School of Individualized Study at New York University and the African American and African Diaspora Studies Department at Columbia University.

Louis Hansel Draper
Born September 24, 1935, Richmond, VA
Died February 18, 2002, Trenton, NJ

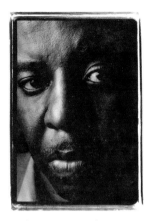

While a student at Virginia State College (now University) Lou Draper wrote to his father, Hansel, with the news that he had joined the school newspaper. His father—an amateur photographer in Richmond's East End—gave Draper his first camera. After joining the college camera club, he dropped a bottle of acid while trying to develop his film. As a result of trying to mop it up, he was hospitalized and subsequently kicked out of the club. Despite this initial setback, Draper resolved to be a photographer after seeing the exhibition catalogue for *The Family of Man* (1955). Realizing that the work he admired was made by photographers in New York, Draper left Virginia State during his final semester and, with the support of his family, moved to New York City.

Throughout the late 1950s Draper worked as a medical clerk while studying at the New York Institute of Photography. He dropped out realizing he could learn the same information through magazines like *Modern Photography*. In 1958 Draper enrolled in a photography workshop led by Harold Feinstein, where he met professional photographers like David Vestal and Herb Randall. Draper also worked as an assistant to studio photographers Larence Shustak and John Rawlings.

In 1959 Draper exhibited two works in the *Photography at Mid-Century* exhibition curated by Beaumont Newhall at the George Eastman House (now Museum). He also exhibited his work in Greenwich Village galleries, including the Image Gallery run by Larry Siegel.

Draper enrolled in workshops at the New School for Social Research, including W. Eugene Smith's course "Photography Made Difficult: Photojournalism, the Construction of Picture Stories and Picture Essays" and began working with the prolific magazine photographer around 1960. In addition to assisting in the darkroom, Draper was a teaching aide for "Photography Made More Difficult" hosted at Smith's Flower-District loft.

In 1963 Draper turned his attention to the Kamoinge Workshop and quickly emerged as one of the group's teachers. Draper contributed to major workshop projects in the early to mid-1960s

beginning with *Portfolio No. 1* through the "Harlem" photo-essay in the July 1966 issue of *Camera* magazine, which featured his photograph *John Henry* on the cover. *Portfolio No. 2* and the photo-essay included Draper's poem "Colonial Legacy."

In the late 1960s Draper taught photography courses while taking classes in film production. Between 1966 and 1968 Draper worked with Randall, Ray Francis, and Jimmie Mannas at the Youth in Action program in Bedford-Stuyvesant, teaching photography to teenagers and young adults. He also participated in the Channel 13 Black Journal Workshop where he concentrated on learning motion picture production. In 1968 he enrolled in the graduate program at the New York University Institute of Film and Television along with future Kamoinge member Danny Dawson. Draper gained professional film experience by working for Mannas's Jymie Productions and assisted Mannas with two short documentaries, *Head and Heart* and *The Folks*. He was also a cameraman for commercial and independent projects led by NYU professors like cinematographer Bedrich (Beda) Batka and worked on a number of productions as a still photographer. In 1982 he was a script supervisor and photographer for the feature-length film *Losing Ground*.

In 1967 he began teaching a class in photographic techniques at Central Brooklyn Neighborhood College, which was supported by the Pratt Institute Center for Community Improvement. He left the program in 1969 but returned to Pratt in 1974 to teach a college-level photography course for design students. Draper joined the staff of the Multi-Media Project at Intermediate School 201 in the Bronx in 1971 where Herb Randall, Calvin Wilson, and Ray Francis also served as photographers and teachers. He also worked with the Photography for Rehabilitation program at the New York State Division for Youth in 1974.

In 1971 the director of the Studio Museum in Harlem, Edward Spriggs, called a meeting of photographers to address how they could use photography to support the neighborhood. Draper and Beuford Smith were among the founding members of a group named the Collective Black Photographers. During Draper's tenure as chairman of the group they organized a fundraisers and community photography projects. Draper also served on the Studio Museum's Photography Committee.

Essence sent Draper to Ruleville, Mississippi, to photograph civil rights activist Fannie Lou Hamer and the Freedom Farm Cooperative. These photographs were part of the feature story "Fannie Lou Hamer Speaks Out" in the magazine's October 1971 issue. The next month, *Essence* published Draper's portraits of the some of the mothers of the "Harlem Six," a group of young Black men who were wrongly accused of murder in New York City in 1964.

In 1973 Draper won a Creative Artists Public Service (CAPS) program grant "to create a set of film-strips about Ruleville, Mississippi . . . for use in New York City public schools and for public presentation."[1] CAPS award panels included leading photographers such as Harry Callahan, and not only provided funding for artists but also enriched the creative community. In 1976 the CAPS publication *Exposure: Work by Ten Photographers* included work by Draper and Anthony Barboza. From 1974 to 1975 Draper served as coordinator of photography for the CAPS program and was an award panelist in 1982.

Interspersed with his teaching assignments, Draper explored other artistic media and forms. In addition to taking screenwriting classes at NYU, he attended workshops at the Frederick Douglass Creative Arts Center in 1982, studying screenwriting with Fred Hudson and Elihu Weiner and videotape production with Vernard Gantt. Building on his experiences with W. Eugene Smith, Draper studied page design at the C. Richard Read Studio. On occasion, he worked as a studio assistant to Herb Robinson and Barboza. He was also a cofounder of Northlight Studios, which operated from 1975 to 1985.

From 1978 to 1982 Draper taught and coordinated photography courses for schools in New Jersey, through the Creative Resources Institute. Afterward, he began teaching photography for Mercer County Community College in Trenton.

Draper finally received his bachelor of arts degree from Thomas A. Edison State College in 1987. He participated in organizations like the Trenton Artists Workshop Association (TAWA) and was an artist in residence at Light Work in Syracuse, New York, where he printed his series *New Jersey Artists*, which included portraits of painters Hughie Lee-Smith and Bernarda Bryson Shahn, among others.

Draper taught at Mercer until his death in 2002.

Albert "Al" R. Fennar

Born April 22, 1938, New York, NY
Died June 3, 2018, Long Beach, CA

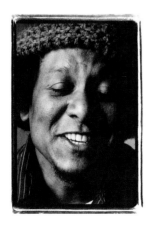

While Al Fennar had planned to attend college after graduating from high school in 1956, he grew impatient waiting for the fall semester to arrive and instead joined the air force. While completing his basic training in Lackland, Texas, Fennar joined the photographic interpretation division, which was part of military intelligence or, as he remembered, the "Air Force version of being a spy."[2] One of the benefits of his position was guaranteed access to a photography lab with unlimited materials.

Fennar was stationed at Yokota Air Force Base in Japan where he absorbed the country's visual culture—especially film and photography. He remembers walking in Ginza, where he passed a gallery with photographs by Eikoh Hosoe in the window and was inspired to pursue photography. After learning to develop film and the mechanics of photography, Fennar exhibited his work in coffee shops and other venues in Japan.

Fennar returned to the United States in 1960 and moved to New York City. When he had no luck securing a job as a photographer's assistant, he found a position at the Slide-O-Chrome lab, where he met Jimmie Mannas and Herb Randall. Randall recalls introducing Fennar to Lou Draper during a visit to the Museum of Modern Art's 1962 exhibit *Harry Callahan and Robert Frank*.

Kamoinge members credit Fennar with exposing the group to Japanese film, painting, and photography. Shawn Walker recalls Fennar taking a group to see *Hiroshima Mon Amour* (1959) and other art films. Likewise, group members, particularly Roy DeCarava, challenged Fennar. During the first two years of the workshop, DeCarava encouraged the group to incorporate a more figurative and social-documentary style with the aim of producing a positive image of African Americans. Fennar was known for his abstract images, which were informed by Japanese aesthetics and language, and was not entirely pleased with the results of his attempts at a more figurative style. However, he acknowledged the challenge as a positive experience that helped to solidify his own abstract style and perspective. "My approach to photography has always been sort of Zen-like. . . . Instead of going with a frame of reference, I try to . . . go out with no ideas about what I want to do."[3] In 1976 he exhibited work with Adger Cowans (who also worked in abstraction) and John Pinderhughes in *Textures/3* curated by Danny Dawson at the Just Above Midtown Gallery.

In the 1970s Fennar worked as an archival librarian for NBC Global in New Jersey and was eventually hired as a film editor and engineer for the network's New York headquarters. He contributed to news teams for the *Today Show*, *Nightly News* and *NewsCenter4*, working with NBC until his retirement in 1991. Fennar began working with color film in the late 1990s because he could photograph, develop, and print while he was traveling and did not have access to a darkroom. His later photographs show his travels on the East coast, from New Orleans to Vermont, as well as the West Coast, where he relocated to California in the 2000s.

James Ray Francis

Born January 19, 1937, New York, NY
Died February 22, 2006, New York, NY

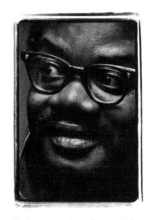

In 1952 James Ray Francis received a twin-lens reflex camera as a birthday gift. He seriously pursued photography after meeting Lou Draper in 1961 and together with Mel Dixon, Herman Howard, Calvin Mercer and Earl James they formed Group 35. After learning that Draper was part of another group called Kamoinge, Francis suggested the photographers combine their efforts, leading to the formation of the Kamoinge Workshop in 1963. Afterwards, Francis approached Roy DeCarava and invited the senior photographer to a workshop meeting. DeCarava later joined the group and hosted meetings at his loft.

Francis was an early president of the workshop and also hosted meetings at his home. According to Shawn Walker, Francis's Cuban wife introduced the group to her culture's food and music. Francis was also known for his keen memory and acuity with technical information and was affectionately called "the Computer." According to Herb Robinson and Shawn Walker, Francis could recite chemical formulas for film developing and memorized the information in camera manuals. The combined knowledge of Al Fennar, Draper, and Francis even enabled them to build a darkroom from scratch.

Danny Dawson credits Francis and Draper with emphasizing the role of craft in the group's photographic practice. Francis was one of the few Kamoinge members who had a darkroom, which he built in his apartment pantry. Like other Kamoinge members, Francis took printing lessons from Draper. During one particularly hot summer day, the two worked for hours in a basement darkroom. The heat was so intense that by the time Francis walked home to Harlem, he was ill from heat exposure. In an interview years later, Francis quipped that Draper "taught me to print at the gates of hell."[4]

Francis and Draper not only taught their fellow Kamoinge members but also young people in Brooklyn and the Bronx. While teaching a summer class for the Pratt Institute's "Campaign Culture" program in Brooklyn, the two innovative teachers removed batteries from the students' cameras,

so they would have to learn how to meter their exposures with a gray card. From 1967 to 1969 Francis also taught photography at the Bedford-Stuyvesant Neighborhood Youth Corps.

Though he later attended college, Francis's primary classrooms were workshop meetings and art museums. By visiting the great public collections of New York City, he learned about photography, painting, and other arts. The work of Johannes Vermeer especially inspired the composition and lighting in his photographs.

When the exhibition *Harlem on My Mind* opened at the Metropolitan Museum of Art, critic David Vestal contacted DeCarava and Francis to contribute to the review. Francis's response to the exhibition was published in the *Popular Photography* article, "Can whitey do a beautiful black picture show?"

> The establishment has finally recognized Harlem's existence!

> This statement is not to be misconstrued as a cry of elation from one of Harlem's sons. "The discovery" or "recognition" might just as well have been left undone.

> The Metropolitan Museum of Art's special exhibit *Harlem on my Mind* is another example of an attitude prevalent in American society today. It views black experience through white eyes.[5]

In 1969 Francis joined the NYC Board of Education as a photographer, and was assigned to the Intermediate School (I.S.) 201 Arthur A. Schomburg Complex a community-controlled school where the Multi-Media Project produced closed-circuit television programming to support student curriculum. He served as director for the Multi-Media Project from 1970 to 1974, while Draper and Herb Randall worked in the photography department. In the early 1970s, he also worked briefly in Guyana with Jimmie Mannas.

Francis was picture editor for the first *Black Photographers Annual* alongside Draper, Walker and Beuford Smith. The volume also included a portfolio of Francis's work. He was a founder of Northlight Studio, which operated from 1975 to 1980. In 1981 he began working full time as a photographer for New York City Department of Sanitation and continued his own fine arts photography projects through the end of his life.

Herman "Klean" Howard Jr.

Born October 14, 1942, New York, NY
Died May 1980, New York, NY

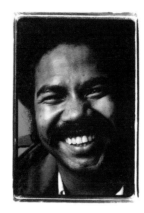

An original member of Group 35, Herman "Klean" Howard participated in the group's early projects, such as *Portfolio No. 1* and *No. 2*, as well as the exhibition at the Danbury Academy of Fine Art, but enlisted in the US Army in 1968.

A contact sheet in Draper's archive shows a visit to Fort Dix, where Howard is wearing his army uniform, talking with Herb Randall, David Carter, and family members. While stationed in Texas, Howard wrote to Draper, asking for news from New York. "How is the group doing? I hope the group isn't [broken] up. When I get out of this mess[ed] up place, I need something to shake me up a little and if the Big K lives, it will be some[thing] to look forward to!"[6]

After returning to New York, Howard reunited with Kamoinge, participating in exhibitions at the Studio Museum in Harlem in 1972 and the International Center of Photography (ICP) in 1975. In that show, Howard's photographs feature people from New York, Guyana, and elsewhere, in their respective environments. A *Popular Photography* review of the 1975 ICP exhibition noted his talent for portraiture: "he knows how to use the surroundings to enhance his subjects."[7]

James "Jimmie" Mannas Jr.

Born September 15, 1941, New York, NY

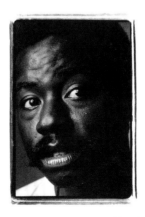

Raised in a family of thirteen children, Jimmie Mannas was introduced to photography by Shawn Walker's uncle whom he watched photograph around the streets of Harlem. When Walker received his first camera, Mannas asked his father for one as well, but because it was such an expensive purchase, Mannas worked to pay for it himself. Though he

spent his high school years training to be a cook, Mannas decided to pursue photography after he graduated.

In the early 1960s, Mannas practiced as a street photographer while studying commercial photography at the New York Institute of Photography. He was part of the early Kamoinge group, having met Al Fennar and Herb Randall while working in a photo lab at Slide-O-Chrome. Mannas served as president of the Kamoinge Workshop in the mid-1960s as well as president of the International Black Photographers in the 1970s.

From 1963 to 1966 Mannas was the director of photography for the Bedford Stuyvesant Youth in Action program where his work was used for promotional materials and newspaper stories. In 1968 he was head instructor at the South Bronx Community Action Programs and worked as director of the photographic workshops at the Brooklyn Children's Museum until 1970.

While working for the Youth in Action program, Mannas connected Ray Francis, Lou Draper, and Herb Randall to jobs with the Neighborhood Youth Corps. After learning that New York University was offering diversity scholarships for the Graduate Institute of Film and Television, Mannas applied and enrolled in the program in 1967. The following year, Draper and Danny Dawson joined the NYU program.

Mannas's photography and film projects built on the fundamental ideals of the Kamoinge Workshop, especially DeCarava's emphasis on representing the African American community. Mannas's work, however, did not shy from showing the darker aspects of life. In 1966 he and Shawn Walker mounted an exhibition at the Countee Cullen Library titled *Sight of the Young* that included a series of images depicting drug use. When shown at a workshop meeting, the prints elicited critical feedback and some disapproval. During his time at NYU Mannas established Jymie Productions. His short films from 1969 include *King Is Dead*, documenting the public's reaction to the assassination of Martin Luther King Jr.; *Kick*, which follows a woman's efforts to help her husband overcome addiction; and *The Folks*, a documentary focusing on nine residents in Bedford-Stuyvesant and Harlem. He also produced an animated film for school-aged audiences titled *Naifa* (1970) which presented a satirical view of integration.

After NYU, Mannas was a still photographer for the documentary film *The Fight* (1974), which followed the events leading to Muhammad Ali and Joe Frazier's faceoff at Madison Square Garden. In the early 1970s Mannas was offered the opportunity to work on film projects for the Ministry of Information and Culture in

Guyana, where he worked as codirector of photographic workshops and the film planning unit. He and Brian Stuart-Young codirected the film *Aggro Seizman* (1975), which was produced by F. Hamley Case. For this and other projects, Mannas invited Shawn Walker, Ray Francis, Danny Dawson, and Herman Howard to assist with production. Mannas worked with Guyanese photographers, taught classes there, and built studios and a darkroom with his colleague Bill Green.

After his return to New York, Mannas was awarded grants in 1977 and 1978 from the National Endowment for the Arts to support the production of a documentary on historic Black churches in Brooklyn. He and Danny Dawson also made the short documentary *Head and Heart* (1977) about award-winning artist Tom Feelings. In the 1980s Mannas continued to write and direct films including two short documentaries on the discrimination faced by Black Vietnam Veterans.

Mannas has taught filmmaking and held positions at the Fashion Institute of Technology and the Oakland District Community College system. His work has also been published in *Life, Amsterdam News, Saturday Review, Onyx Magazine* and *Liberator Magazine*.

Herbert "Herb" Eugene Randall, Jr.
Born December 16, 1936, Riverhead, NY

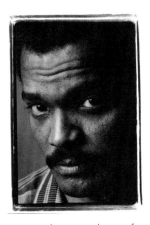

In 1955, Herb Randall's friend Alvin Simon took him to the Museum of Modern Art to see the exhibition *The Family of Man*, and the experience led him to pursue a career in photography. He received an associate arts degree from New York City Community College (now New York City College of Technology) in 1957, then worked in a darkroom and took a photography course with Harold Feinstein. Simon also introduced him to Lou Draper and during the late 1950s, he spent time visiting photography exhibitions with Draper, including Helen Gee's Limelight Gallery. In 1958 Randall was drafted into the army and he exhibited his work while serving as a battalion photographer in Frankfurt, Germany.

When he returned to New York in 1961 Randall continued to show his work in community

galleries and worked as a darkroom technician at Slide-O-Chrome, where he met Jimmie Mannas and Al Fennar. Eventually Draper joined the three to form Kamoinge, which later combined with Group 35 to form the Kamoinge Workshop. During the workshop's early years in 1964 and 1966, Randall worked as a freelance photographer and photojournalist for the United Presbyterian Church, the NAACP (his photos were featured on the covers of *The Crisis*), United Press International, the *New York Times*, the Associated Press and television stations. In 1964 he received a John Hay Whitney Fellowship for Creative Photography and planned to photograph in the south as part of his project. Randall met Sanford Leigh at an informational session hosted by the Student Non-Violent Coalition Committee (SNCC). Leigh asked him to photograph the SNCC summer programs and Freedom School in Hattiesburg, Mississippi. During "Freedom Summer" Randall created the largest body of work from the civil rights movement that documents the activity of a single town. In 1998 he donated his photographic archive of 1,759 negatives from the project to the University of Southern Mississippi.

In the fall of 1966, Randall joined Kamoinge members at the Bedford Stuyvesant Youth in Action program where he spent two years teaching and preparing trainees for careers in photography. He began working as a photography consultant in 1968 and served as a liaison between Fordham University and the South Bronx Youth Village, Inc.

Randall also worked with Mannas's Jymie Productions on *A Time to Read, The Folks*, and *N.Y. Division for Youth*. In January 1969, he and Mannas lectured at the University of Notre Dame's Afro-America Society's Festival on the Black Arts, and later that year he taught photography classes at the Brooklyn Children's Museum. From 1970 to 1974 he served as co-ordinator of photography for the Multi-Media Project at I.S. 201 with Draper and Ray Francis. Randall also won a 1971 Creative Artist Public Service (CAPS) Program grant for photography. After serving as a photographic consultant for the National Media Center Foundation for nine years, he moved to the Shinnecock Indian Reservation in Southampton, New York, where he currently resides.

Herb Robinson
Birthdate unknown, Kingston, Jamaica

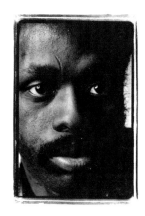

At the age of five, Herb Robinson left Kingston, Jamaica, with his mother to visit his aunt and uncle in New York City's Sugar Hill neighborhood. During the visit his mother fell ill and died unexpectedly, and he remained in New York, where he was raised by his aunt and uncle. Robinson found his talent for drawing and music at a young age. His uncle, an audio engineer, bought him a camera, which he used to make portraits of family members. Later, he studied drawing, design, and photography at the City College of New York and the Fashion Institute of Technology.

While working at Macy's department store Robinson became close to Herman Howard, who invited him to attend a Kamoinge Workshop meeting and then sponsored him for membership. Knowing of the Kamoinge's high standards for photography, Robinson worked closely with Howard and Lou Draper before showing his photographs to the group. He was voted into the KamoingeWorkshop, where he contributed to the Workshop's *Portfolio No. 2* in 1965. His early work crosses genres of portraiture, street photography, and abstraction. Robinson also experimented with panoramic cameras and showed a wide-view print in Kamoinge's 1975 exhibition at the International Center of Photography.

During the 1970s Robinson occupied a loft at 74 West 38th Street, near the studios of Shawn Walker, Beuford Smith, and the Northlight Studio (run by Draper, Ray Francis, Herman Howard, and Darryl Sivada). In 1978 Robinson began working in commercial photographer Louis Mervar's studio, and gained experience in layout, set design, lighting, as well as business and marketing. Robinson opened his own studio in 1985. His clients have included Avon, General Foods, Johnson & Johnson, Joseph E. Seagram & Sons, Lockhart & Pettus, Pepsi Cola, and Panasonic, and his work has been included in major ad campaigns and publications.

Like many Kamoinge members, he has taught young photographers over the years. Among Robinson's own artistic influences are photographers Roy DeCarava and Irving Penn, as well as painters Jean-Siméon Chardin and Johannes Vermeer, whose work informed his still-life photography. However, Robinson's work has pushed traditional boundaries

of the still-life genre. Rather than a composition of objects, his *Still Life Figures* series includes abstracted views of ice and water. Like the Dutch painters, Robinson's work incorporates symbolic forms and motifs. In his *Katrina* series, Robinson combines newspaper headlines and clippings with images of water, fire, and money to call attention to the lingering effects of the hurricane on the people of New Orleans.

Robinson has exhibited work at the Brooklyn Museum of Art, American Museum of Natural History, International Center of Photography, Harvard University School of Design, the Studio Museum in Harlem, Calumet Gallery and G. R. N'Namdi Gallery. In 2015 Robinson and Anthony Barboza co-edited the book *Timeless: Photographs by Kamoinge*, the first retrospective publication dedicated to the group's history and work. Robinson's work has recently been part of the *Soul of a Nation: Art in the Age of Black Power* exhibition, originating at the Tate Modern, and traveling to the Brooklyn Museum, the Crystal Bridges Museum of American Art, The Broad museum in Los Angeles, the de Young Museum, and the Museum of Fine Arts, Houston.

Beuford Smith

Born 1941, Cincinnati, OH

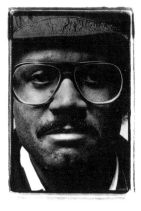

After moving to New York as a young man, seeing Roy DeCarava's *Sweet Flypaper of Life* convinced self-taught Beuford Smith to pursue photography. When he met DeCarava in 1965, he was so nervous to approach the famous photographer that he accidently set off his flash in DeCarava's face. Despite this startling encounter, DeCarava asked to see Smith's work and then introduced him to the Kamoinge Workshop members. Smith still has a copy of that photograph. During a pivotal meeting on June 6, 1965, DeCarava resigned as chairman. After showing photos at two previous meetings, Smith was voted into the workshop.

Smith's work was included in the *Negro Woman* exhibition and, along with Lou Draper, he worked closely with *Camera* editor Allan Porter to publish the workshop's "Harlem" portfolio in 1966. During that period Smith worked at various offset printing companies, including Harlem Stationery & Printing Co. It was there that he printed sample copies of

his book *Photographic Images*. His friend, John Dahl printed one hundred copies of the book for him. This book sparked the idea of producing a Kamoinge Workshop book, but it was abandoned because of missed deadlines for photograph submissions. Smith worked with Jimmie Mannas at his Jymie Production Co., printing silk screen Black art posters in Bedford-Stuyvesant in Brooklyn.

Smith began working as a freelance photographer in 1970. He worked for Burley Photo Agency, Black Star, AT&T, and others, before founding Cesaire Photo Agency (named for his son) in 1977. His first published photo appeared in the *Amsterdam News* in 1965, for which he received five dollars but no credit. In the early 1970s and '80s, his photographs were published in *Black Creation, Ten-8*, and elsewhere.

Smith was the founder and chief photo editor of the *Black Photographers Annual*. He oversaw the printing quality control of each issue, and was called "Mr. Densitometer" by Sidney Rapoport, who owned the company that printed the *Annual*.

In recent years, his photographs have been published in *Timeless, Soul of a Nation, The Sweet Breath of Life, Contact Shee, Harpers, PDN, Collecting African American Art*, and MoMA publications. They have appeared in the *"Miles Davis: Birth of the Cool"* video and a Tyler Green podcast.

Smith has taught photography at Cooper Union, New Muse, Brooklyn Museum, PAL, and Hunter College. In 2017, he was the first recipient of A Culture of Legacy Award from the Griffin Museum of Photography. He also received a NYFA in 1990 and 2000, an Aaron Siskind Fellowship, and a Light Work Fellowship in 1999, among other awards.

He has had solo shows at the Studio Museum in Harlem, Benin Art Gallery, Wilmer Jennings Gallery, and Keith DeLellis Gallery, a group show at MoMA. His work was also included in the *Soul of a Nation* exhibition at the Tate Modern, the Brooklyn Museum, the Crystal Bridges Museum of American Art, The Broad museum in Los Angeles, the de Young Museum, and the Museum of Fine Arts, Houston.

His photographs are in the collections of VMFA, the Schomburg Center, MoMA, the Whitney Museum of American Art, Museum of Fine Arts, Houston, and others.

Smith is the guest curator of a group exhibition at the Wilmer Jennings Gallery in 2020 and will have a career restrospective there later in the year.

Beuford Smith is president emeritus of Kamoinge.

Ming Smith

Birthdate unknown, Detroit, MI

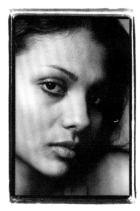

In the first volume of the *Black Photographers Annual*, Smith's portfolio opens with: "New York amateur photographer Ming Smith has been taking pictures for less than a year."[8] While the 1973 *Annual* marked her first published work, Smith had been making photographs for much longer than a year. Growing up in Columbus, Ohio, Smith remembers her father, a pharmacist, photographed everything from family portraits to falling leaves. On her first day of school, Smith borrowed her mother's Brownie camera to record the day's events (she would have never been allowed to borrow her father's Argus C3) and her new classmates. When she was six or seven, she received the book *Tobe* by Stella Gentry Sharpe as a gift from Dr. Waldo Tyler, also a pharmacist and entrepreneur, who was her father's friend. He once took her to visit his farm, but it rained so he gave her the book as a consolation. First published in 1939, the book was about a young Black boy who lived on a farm. Illustrated by more than fifty photographs by Charles Farrell, the book's humanistic portrayal of an African American child's life made a lasting impression on Smith.

As a pre-med, microbiology major at Howard University, Smith continued photographing friends and events during her college years. However, she was uncertain about how to pursue her photographic interests. Smith moved to New York City in the 1970s. While working as a model, she visited Anthony Barboza's studio for a "go-see," an informal audition during which the photographer made images of the model, allowing both to build their networks and portfolios. While waiting for her appointment she could hear Barboza and another photographer engaging in a philosophical discussion about photography's relationship to nostalgia; it marked one of the first times she heard a non-technical discussion about photography. After a successful meeting, Smith began to work with Barboza frequently, and the two developed a strong rapport.

While modeling, Smith continued to photograph, which caught the attention of friends and colleagues. Grace Jones once asked her to come to

Studio 54 to take her photograph at the iconic club. In 1972 Lou Draper invited her to join Kamoinge after asking to see the photographs she'd been making.

Through Kamoinge, Smith expanded her ideas about photography as an art form and a craft while learning more about the technical aspects of the medium. During one printing session with Draper, Smith discovered that she was missing a negative holder, so Draper fashioned two pieces of cardboard together to make one. After developing a print, Smith saw that the image's frame had jagged edges—an aesthetic element she still uses in her photography. Such improvisation and experimentation has continued to affect her work. Her photographs of jazz musicians, especially her "Invisible Man" series, use blurred forms of subjects in motion, creating a surreal depiction. In addition to incorporating motion into her compositions, she uses techniques such as combination printing, collage, hand tinting, painting, and double-exposures to enhance the expression in her photographs. Although the play between lightness and darkness is the essence, "she paints with light,"calling it *Lumiere L'ombre* (Light in the Shadows).

In the 1970s Smith exhibited with Kamoinge at the Studio Museum and International Center of Photography in New York as well as the group's show in Guyana. Her work also appeared in all four volumes of the *Black Photographers Annual* between 1973 and 1980 (a distinction shared with only one other Kamoinge member, Beuford Smith). In the mid-1970s she responded to a call for portfolios at the Museum of Modern Art, and in 1979 she became the first African American female photographer to have her work purchased for the MoMA collection.

Smith's successful modeling career gave her the opportunity to travel internationally and take photographs in many countries, including Mexico, Germany, France, Japan, Senegal, Ivory Coast, and Ethiopia. Smith also traveled with her husband, saxophonist David Murray, photographing musicians and towns. Music is also influential to her work, with titles of her photographs like Marvin Gaye's *What's Going On* and *Flamingo Fandango* referencing jazz songs. Her photographs have also appeared on album covers. Since her early days in New York, Smith has studied many styles of dance—including that of African American dancer/choreographer, anthropologist, and activist Katherine Dunham—which inspires her art, as well as her life.

While her photographs blur genres, each of her photographic series meditates on a theme. Her

non-traditional portraits of Black artists and thinkers show intimate and surreal depictions of Sun Ra, Romare Bearden, James Baldwin, Amiri Baraka, Katherine Dunham, and others. "For August Wilson" includes images of locations in the Hill District of Pittsburgh that may have inspired scenes in the playwright's work. Her "Transcendence" series of the 1980s portrays a carnival in her hometown of Columbus, Ohio, and is named in honor of Alice Coltraine's music and life.

During the 1980s and 1990s she exhibited work at the Allen Memorial Art Museum, Just Above Midtown Gallery, Schomburg Center for Research in Black Culture, and Studio Museum in Harlem. In 1992 Smith published *A Ming Breakfast: Grits and Scrambled Moments*. After living in California for many years and exhibiting work at Watts Tower and UCLA in Los Angeles and Troupe's Gallery in San Diego, Smith returned to New York where she had solo exhibitions at Tribes Gallery, Rush Arts Gallery, June Kelly Gallery, and other venues. Her work was also featured in *Pictures by Women: A History of Modern Photography* at the Museum of Art, among other recent exhibitions.

Shawn W. Walker

Born 1940, Harlem, New York, NY

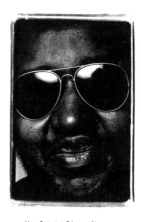

Shawn Walker was introduced to photography by his Uncle Hoover, who piqued his nephew's interest in photography with a darkroom prank. While developing photographs, Hoover showed his nephew the backing paper from a roll of 2 ¼ film, disappeared into the darkroom, hid the paper strip after peeling it from the film, emerged from the darkroom and showed his nephew the semi-transparent roll. According to Walker, "I thought he had turned paper into plastic. I was caught then. I said, 'This is magic. I want to learn magic.'" Walker received his first camera, a Brownie Hawkeye, for his thirteenth birthday and studied photography at Benjamin Franklin High School. An encounter in the early 1960s led him to join meetings of the Slide-O-Chrome group, and later, the Kamoinge Workshop.

The experience of the other Kamoinge Workshop members was a constant resource for Walker, as Ray Francis, Lou Draper, Al Fennar, Adger Cowans, and others helped him refine his technical skills. He recalls, "I went to Lou Draper . . . [he] had his

enlarger on the floor so we had to print on our knees."[9] A contributor to *Portfolio No. 1* and *No. 2.*, as well as the Kamoinge Gallery exhibitions, Walker views the group in its early years as a kind of Sorbonne that exposed him to the work of photographers like Roy DeCarava, Marvin and Morgan Smith, James VanDerZee, Hugh Bell, Chuck Stewart, Minor White, and Henri Cartier-Bresson, as well as painters like Rembrandt. The discourse of Black consciousness surrounded and perfused the early years of the Kamoinge Workshop and was highly informative to Walker's work, as he and other members were surrounded by prominent figures like Amiri Baraka and Langston Hughes.

Besides workshop projects, Walker worked as a professional photographer. Ray Francis connected him to the federally funded HARYOU-ACT program where he managed the photography department of the weekly newspaper. Soon after, he worked at other publications including the *Harlem Daily*, *Negro World*, *Liberator*, and *Essence*, as well as Transmundo, Jappa, and other agencies.

In 1965 Walker had a one-man show at the Countee Cullen Branch of the New York Public Library (NYPL). In 1966 he contributed to the exhibitions *Sight of the Young* and *The Kamoinge Workshop* there, and later exhibited work at the NYPL Main Branch. He participated in an exhibition sponsored by the Manpower Development Training Program, and at independent venues like Underground Gallery (51 West 10th Street) and Aprag Gallery (67th Street and Broadway).

In 1967 Walker began teaching at the Teacher's College at Columbia University as well as Hunts Point Community Progress Center. He continued to teach for the next forty years at C.W. Post, City University of New York (York College, Queensborough College, Borough of Manhattan Community College, and the City College of New York), Pratt Institute, the International Center of Photography, United Federation of Teachers, the Fortune Society, and other federally funded programs. He also taught for UNESCO in Ethiopia. After years of professional experience, Walker enrolled at Empire State College and completed his BFA in 1987. He was one of the photo-editors for the *Black Photographers' Annual* and a cofounder of the International Black Photographers.

Al Fennar exposed him to art films from Japan and the United States, and in 1967 Walker studied cinematography at the Free School of New York. Walker also worked as a filmmaker for WNET and traveled to Mississippi and other southern states for *American Black Journal*. When the opportunity came to work on a project in Cuba where officials transformed an abandoned prison into an

industrial school, Walker joined the production and photographed Fidel Castro and other figures while he was there. The project took longer than expected and when Walker returned to the United States, he was identified as a radical and blacklisted from working for certain news outlets and publications. Walker then looked for more international projects, traveling to Guyana, Mexico, and Nigeria. Anthony Barboza also recommended him for an assignment in Senegal, which Walker accepted.

References to music and literature feature heavily in Walker's photography. His series "Misterioso: Painting with Light" and "From Be-Bop to Illusion" echo the improvisation and nonconformity of jazz. Another of Walker's photographic series "The Invisible Man" uses excerpts from Ralph Ellison's novel as titles for his images, applying a specific narrative to abstract compositions.

Walker still lives in Harlem where he documents concerts at Marcus Garvey Park, the annual African American Day Parade and the annual Harlem Street Baptismal (United House of Prayer), as well as gallery openings and art lectures as part of his commitment to recording and preserving Black culture as a cultural anthropologist and photo-artist. . Writing for *Photographer's Forum* in 1974, Walker summarized what he sees as the responsibility of an artist:

> Historically, I think that an artist should be very concerned about the way black people are portrayed in the media, books and films. At the same time our children will want to look at black life styles in the 1960s and 1970s and the only points of reference they will have about black people will be what the publishing companies decide to print. This is why it

is necessary that the artist be responsible to the community at large, and for them to express their political concerns. Until we take these matters in our hands our destiny will continue to be left in other hands to be exploited.[10]

To this end, Walker has maintained an expansive archive that includes significant materials documenting Kamoinge's activities.

Calvin Wilson
Born February 8, 1924, New York, NY
Died February 18, 1992, New York, NY

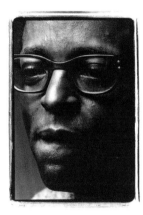

A self-taught photographer, Wilson was one of the more experienced photographers of Group 35. He began photographing in 1953, making commercial portraits of children. After photographing Cortez Franklin, a performer with the Robert DeCormier Singers, Wilson began photographing Off-Broadway theater productions. He made still images for such productions as *The Blacks: A Clown Show* by Jean Genet (which opened in 1961 and featured performances by Cynthia Belgrave, Cicely Tyson, Roscoe Lee Brown, and James Earl Jones) and the musical *Cindy* (1964). Other theatrical clients included *A Raisin in the Sun* actors Diana Sands and Louis Gossett Jr.

Wilson participated in the early workshop

exhibitions from 1964 to 1966 and contributed to *Portfolio No. 1* and *No. 2*. According to Shawn Walker, Wilson had exceptional printing skills. The need to provide for his family led him to focus on commercial assignments but he remained in the Kamoinge Workshop through the 1970s and worked alongside other members at the Multi-Media Project at I.S. 201, specifically contributing to the school's educational newspaper *Kweli*. Wilson also attended the International Black Photographer dinners.

In a professional biography, Wilson reflected on the workshop and its early work:

> In 1963, I was invited to join the Kamoinge Workshop and for the first time, I was exposed to black photographers who had other than commercial intentions. Then and now, they seemed to me committed to portraying, beautifully and truthfully the lives and circumstances of black people from the black viewpoint while continuing to develop and contribute to photography on every significant level. Whether or not I accomplish these goals, they are the goals to which I am committed.

Endnotes

1 Grant announcement, VA04.01.2.071, Louis H. Draper Artist Archives (VA-04).

2 Undated interview and recording labeled "Kamoinge Work Shop" [sic], n.d., courtesy Shawn Walker Archives

3 Albert Fennar, interview with Erina Duganne, 2001.

4 Ray Francis, interview with Erina Duganne, 2001.

5 Quoted in David Vestal, Roy DeCarava, and Ray Francis, "Can Whitey Do a Beautiful Black Picture Show?" *Popular Photography* 6, no. 5 (May 1969): 122.

6 Letter from Herman Howard, LHDAA, VA04.01.3.118.

7 Harvey V. Fondiller, "Shows Seen," *Popular Photography* 77 (July 1975): 116.

8 Joe Crawford, *Black Photographers Annual* (Brooklyn, NY; Black Photographers Annual, Inc., 1973), n.p..

9 Shawn Walker, video interview with Sarah Eckhardt, June 7, 2017.

10 Shawn Walker, "Chester Higgins," *Photographer's Forum: Forum Notes* 1, no. 1 (December 1974):8.

A Chronology of Louis Draper, the Kamoinge Workshop and Significant Events of Their Time

by Sharayah Cochran

1935	September 24: Louis Hansel Draper is born in Richmond, Virginia, to Hansel and Dorothy (Taylor) Draper.	
1936		The New York Photo League forms. The group uses photography to support leftist political and social ideas.
1937	September 24: Draper's sister, Nell, is born.	
		Photographs 1839–1937, organized by Beaumont Newhall, opens at New York's Museum of Modern Art (MoMA). The exhibition catalogue becomes a foundational text on the history of photography.[1]
1938		Jomo Kenyatta's *Facing Mount Kenya* about Kikuyu culture is published.
1939		The Photo League opens *Towards a Harlem Document* at the Harlem YMCA in New York. Thirteen photographs from the exhibition appear in the *Look* magazine essay, "244,000 Native Sons" the next year.[2]
1940		MoMA establishes its Department of Photographs led by Beaumont Newhall.
1943	December 23: Louis Draper's father, Hansel, is drafted into the army and stationed in New Orleans throughout his service.	
1944	Draper's mother enrolls him and his sister in the Van de Vyver Institute near downtown Richmond.	
1948		Gordon Parks's photo-essay "Harlem Gang Leader" is published in the November 1 issue of *Life*.
1951		The New York Photo League disbands.
		The December 3 issue of *Life* features W. Eugene Smith's "Nurse Midwife," the magazine's first extended photo-essay on an African American figure.
1952		Roy DeCarava wins a Guggenheim Fellowship.
1953	Spring: Draper graduates from Randolph High School.	
	Fall: Draper enrolls at Virginia State College (now Virginia State University).[3] Draper's father, gifts him a camera after he joins the student newspaper, *The Virginia Statesman*.	
1954		*Brown vs. Board of Education* declares the segregation of public schools unconstitutional.
		Helen Gee opens Limelight Gallery in Greenwich Village. At the time, it is the only gallery in the United States dedicated to photography.
1955	Fall: Draper serves as a reporter for the college newspaper, *The Virginia Statesman*.[4]	
		Brown v. Board of Education of Topeka II: the U.S. Supreme Court calls for the desegregation of schools to commence "with all deliberate speed."
		Emmett Till is murdered in Mississippi. His mother, Mamie Till-Mobley, allows David Jackson to photograph his brutalized body for *Jet* magazine.
		Langston Hughes and Roy DeCarava publish *Sweet Flypaper of Life*.

1 See Allison Bertrand, "Beaumont Newhall's 'Photography 1839–1937' Making History," *History of Photography*, 21: no. 2 (1997), 137–46. https://doi.org/10.1080/03087298.1997.10443731.

2 See Erina Duganne, *The Self in Black and White: Race and Subjectivity in Postwar American Photography* (Hanover, NH: Dartmouth College Press, 2010), 152–55.

3 Document VA04.01.1085, Louis H. Draper Artist Archives, this archive acquired from the Louis H. Draper Preservation Trust with the Arthur and Margaret Glasgow Endowment Fund, Virginia Museum of Fine Arts Archives, Richmond, hereafter referred to as LHDDA.

4 See *The Virginia Statesman* 27, no. 1 (October 7, 1955): 2, in Johnston Memorial Library Special Collections and Archives, Virginia State University.

Edward Steichen's *The Family of Man* exhibition opens at MoMA. The accompanying catalogue is widely circulated.

1956

Virginia Senator Harry F. Byrd Sr. calls for Massive Resistance to the integration of schools in the commonwealth.

Fall Semester: Draper becomes the *Virginia Statesman* photographer.[5]

November 21: Draper writes "How Come Department," questioning a range of issues from the lingering Confederate mindset in the American South to the Suez Crisis.

1957 February: Draper leaves Virginia State[6] and moves to New York.[7]

President Dwight D. Eisenhower signs the Civil Rights Act.

October 1: An exhibition of W. Eugene Smith's work opens at Limelight Gallery.

1958 Draper enrolls briefly at the New York School of Photography but finds the instruction unsatisfactory and quits.

Draper notes his address as 240 West Tenth Street, care of "Cook," meaning Molly Malone Cook, a *Village Voice* photographer who represented W. Eugene Smith, and other photographers.

Thelonious Monk records his live jazz album *Misterioso*.

October 2: Harold Feinstein's exhibition at Limelight Gallery opens.

Draper enrolls in Harold Feinstein's photography workshop, "Photographic Aesthetics."[8]

Draper meets Herb Randall through Al Simon.[9]

Draper begins to work in studios run by other photographers including David Vestal.[10]

Draper meets W. Eugene Smith in Feinstein's workshop.[11]

1959 Draper's work is included in the George Eastman House exhibition *Photography at the Mid-Century*, curated by Beaumont Newhall.[12]

Draper works as a darkroom technician for Larence Shustak.[13]

Herb Randall is drafted for military service and stationed in Frankfurt, Germany.

Virginia and federal courts find the closing of schools to avoid desegregation unconstitutional, effectively halting Massive Resistance.

Market Place Gallery at 2305 7th Avenue holds its inaugural exhibition *Ten Contemporary Artists*. Adele Glasgow, an associate of Langston Hughes, co-owned and operated the gallery. At the opening event, Hughes reads from *The Weary Blues* accompanied by the music of Randy Weston.[14]

1960 January: Draper shows work in *Four Photographers* at Larry Siegel's Image Gallery in New York.[15]

5 See *Virginia Statesman* 28, no. 1 (October 12, 1956): 2, Johnston Memorial Library Special Collections and Archives, Virginia State University.

6 LHDAA, VA04.01.1085.

7 Nell Draper-Winston interview with Sarah Eckhardt, January 18, 2019.

8 LHDAA, VA04.01.1.082 and VA04.01.1.083.

9 Herbert Randall interview with Sarah Eckhardt, January 21, 2019.

10 Louis Draper interview with Erina Duganne, March 24, 2001.

11 Draper remembers enrolling in the course after Smith published the photo-essay, "Drama beneath a city window: Photographer W. Eugene Smith makes a memorable record of goings-on in a New York street," *Life* (March 10, 1958). Draper in interview with Erina Duganne, March 24, 2001.

12 LHDAA, VA04.01.1.067.

13 LHDAA, VA04.01.1.066.

14 "Valuable Art Collection Features Black Artists," *Los Angeles Sentinel*, February 7, 2001, B3. ProQuest (369330270).

15 Jacob Deschin, "Camera Notes: Exhibitions," *New York Times*, January 24, 1960: X14. ProQuest Historical Newspapers (115221195), see also LHDAA, VA04.01.1.064, and excerpt from "The Politics of the Snapshot: The Street Photography of Louis Draper," LHDAA, VA04.01.1.195A. Though sparsely documented, sources reference Draper's participation in a second exhibition at Image Gallery, see disc RL10012-CD-1478, W. Eugene Smith Reference CD Collection, David M. Rubenstein Rare Book & Manuscript Library, Duke University. Written references to Draper's participation appear in Nolan Boomer, "Black and White America," *Aperture*, March 16, 2017, https://aperture.org/blog/black-white-america-freed/: and *Louis H. Draper: Selected Photographs*, ed. Margaret M. O'Reilly (Rochester: Booksmart Studio, 2015), 117.

		January: Robert Frank's The Americans is published in the United States.[16]
	February 22: Nell Draper joins Virginia Union University students in a sit-in at Richmond's Thalhimer's department store. Inspired by the Greensboro, North Carolina, sit-ins, the act of civil resistance and subsequent boycotts successfully pressured the store to integrate.[17] Draper takes W. Eugene Smith's photojournalism seminar "Photography Made Difficult," through the New School for Social Research. He also works as a studio assistant with fashion photographer John Rawlings.[18]	
1961	Draper meets Ray Francis. Draper begins working as an assistant to W. Eugene Smith' Flower District loft and helps lead Smith's class "Photography Made More Difficult."[19] Herb Randall completes his service in the US Army and works at Slide-O-Chrome where he meets Al Fennar and Jimmie Mannas.	
		Limelight Gallery closes. Langston Hughes premiers "Ask Your Mama" in two readings at the Market Place Gallery in Harlem.[20] James Baldwin's essay "Letter from a Region in My Mind" is published in the New Yorker.
1962	Draper and Herb Randall see Harry Callahan and Robert Frank at MoMA, where Randall introduces Draper to Al Fennar. Draper begins meeting with Herb Randall, Jimmie Mannas, and Al Fennar, and the group decides to call themselves "Kamoinge."[21] Draper joins Group 35, which includes photographers Mel Dixon, Ray Francis, Herman Howard, Earl James, and Calvin Mercer.	
		July 1: John Szarkowski succeeds Edward Steichen as director of MoMA's department of photography.[22]
1963	Kamoinge joins Group 35 to form the Kamoinge Workshop. Roy DeCarava later joins the group as director.[23]	
		James Baldwin's The Fire Next Time is released.[24] May 31: Life magazine publishes Gordon Parks's photo-essay "The Black Muslims." June 9: Fannie Lou Hamer is arrested in Winona, MS, and severely beaten in prison.
	August 28: Several members including Ray Francis, Larry Stewart, Earl James and Herman Howard attend the March on Washington with Roy DeCarava.	
		September 15: The Ku Klux Klan bombs the 16th Street Baptist Church in Birmingham, AL, killing four girls.
1963–64	Winter: Kamoinge publishes Portfolio No. 1.[25]	

16 See Looking In: Robert Frank's The Americans, ed. Sarah Greenough (Göttingen: Steidl, 2009).

17 For detailed accounts of the Virginia Union protests see Lewis A. Randolph and Gayle T. Tate, Rights for a Season: The Politics of Race, Class and Gender in Richmond (Knoxville: University of Tennessee Press, 2003); and Peter Wallenstein, Blue Laws and Black Codes: Conflict, Courts and Change in the Twentieth-Century Virginia (Charlottesville and London: University of Virginia Press, 2004).

18 LHDAA, VA04.01.1.066.

19 Ibid.

20 Arnold Rampersad, The Life of Langston Hughes: Volume II: 1914–1967, I Dreamed a World (New York: Oxford University Press, 2002) 327.

21 Jomo Kenyatta, Facing Mount Kenya (London: Mercury Books, 1965), 321.

22 Museum of Modern Art, "John Szarkowski, Director, Department of Photography," press release, January 1, 1972, https://www.moma.org/momaorg/shared/pdfs/docs/press_archives/4789/releases/MOMA_1972_0018_16.pdf.

23 Audio Recording, "Kamoinge Work Shop 1 10-20-84-A," courtesy Shawn Walker Archives.

24 Sheldon Binn, review of The Fire Next Time, by James Baldwin, New York Times, January 31, 1963, http://movies2.nytimes.com/books/98/03/29/specials/baldwin-fire.html.

25 Ibid.

1964 Draper moves to 20 East 127th Street where he rents a room in Langston Hughes's brownstone.

January 22: Fannie Lou Hamer marches in Hattiesburg, MS.

Kamoinge members attend a committee meeting for the American Society of Magazine Photographers (ASMP) to address discrimination in hiring Black photographers. A recording of their conversation informs the January 29 ASMP board meeting, titled "The Negro Revolution."[26]

March 15: The Kamoinge Workshop opens an exhibition in a brownstone at 248 West 139th Street. Meeting minutes indicate that the Workshop paid rent to Adele Glasgow, one of the owners of Market Place Gallery.[27]

March 16: Draper delivers *Portfolio No. 1* to the Schomburg Center for Research in Black Culture.[28]

April 10: Roy DeCarava delivers *Portfolio No. 1* to the Museum of Modern Art.

The "Harlem Six" are arrested. After a highly publicized trial, the teenagers are wrongfully convicted and receive lifetime jail sentences. In 1968 they successfully appealed and reversed their lifetime sentences, though the men remained incarcerated while awaiting new trials—a process that would stretch to 1974.

May 24: The Kamoinge Workshop shows its photographs alongside work by Edward Steichen at an exhibition at the Danbury Academy of Art in Connecticut sponsored by the NAACP.[29]

Herb Randall receives a John Hay Whitney Fellowship for Creative Photography and spends two months photographing Freedom Summer activities in Hattiesburg, MS.[30]

July: Three days of civil resistance in Harlem follow the fatal shooting of James Powell, a Black teenager, by an off-duty police officer.

Roy DeCarava's photograph on the August 3 cover of *Newsweek* features Lou Draper, Ray Francis, and Shawn Walker with the headline "Harlem : Hatred in the Streets."

The Kamoinge Workshop publishes *Portfolio No. 2*.

Richard Avedon and James Baldwin publish *Nothing Personal*.

1965 Tony Barboza is drafted into the Navy, and is stationed in Florida.

Bruce Davidson receives the first photography grant from the National Endowment for the Arts for his project on the residents of East Harlem.

The Kamoinge Workshop unofficially names the space at 248 West 139th Street "The Kamoinge Gallery."[31]

February: WNDT (a public broadcasting station) airs the documentary news feature "100 Days after the Riot," which includes photographs by Kamoinge members.

Malcolm X is assassinated.

26 "Minutes of Membership Meeting of the American Society of Magazine Photographers held on January 29, 1964, in New York City, "*Bulletin of the American Society of Magazine Photographers*, January–February 1964.

27 "Photo Exhibit," *New York Amsterdam News*, March 28, 1964, 3, ProQuest Historical Newspapers (226745675).

28 See handwritten note on exhibition flier, Box 1, Kamoinge Workshop Portfolios 1 and 2, Photography and Prints Division, Schomburg Center for Research in Black Culture, New York Public Library.

29 Audio recording, "Kamoinge Work Shop 1 10-20-84-A," courtesy Shawn Walker Archives.

30 Bobs M. Tusa, Introduction, to *Faces of Freedom Summer* (Tuscaloosa and London: University of Alabama Press, 2001), 2.

31 On at least one occasion, Kamoinge paid rent to Adele Glasgow's sister Christine Glasgow Brown, see LHDAA VA04.01.3.040, and author biography in John Hewitt's, *Protest and Progress: New York's First Black Episcopal Church Fights Racism* (New York: Garland Publishing, 2000).

April 4: The exhibition *Theme: Black* opens at the Kamoinge Gallery. Visitors include Romeo Martinez, former editor of the Swiss publication *Camera*.

April 18: Henri Cartier-Bresson visits the Kamoinge Gallery.

The Black Arts Repertory Theatre/School, founded by Leroi Jones (Amiri Baraka), holds an open house from April 30 to May 2.[32]

May: Ray Francis serves as president of the workshop.[33]

Adger Cowans exhibits photographs at the Heliography Gallery at 859 Lexington Avenue, run by the Association of Heliographers (1963–65) founded by Paul Caponigro, Walter Chappell, Carl Chiarenza and others.[34]

June: Roy DeCarava resigns as president and member of the Kamoinge Workshop, members decide to disband the gallery, and Beuford Smith joins the group. The Negro Woman opens and is their last exhibition in the Kamoinge Gallery.[35]

August 20: Kamoinge members participate in the Black Arts Exhibition at the Black Arts Repertory Theatre School.[36]

November 1: Kamoinge members Shawn Walker and Jimmie Mannas exhibit work in *The Sight of the Young* at Countee Cullen branch of the New York Public Library where the second floor provided a free public gallery space for practicing and student artists in Harlem.[37]

1966 The July issue of *Camera* includes a series of photographs by Kamoinge members titled "Harlem."

Draper is hired as an instructor for the Bedford-Stuyvesant Youth in Action Neighborhood Youth Corp where he works with Jimmie Mannas and Herb Randall to teach photography to high-school students.[38] Draper eventually moves to Brooklyn and later shares an apartment with Mannas.[39]

July 20: The Countee Cullen Library hosts *Perspectives: An Exhibition of Photographs by the Kamoinge Workshop (and guests)*.[40]

1967 Jimmie Mannas receives a scholarship to attend the graduate certificate program at New York University's Institute of Film and Television.

Shawn Walker enrolls in a film workshop taught by Allan Siegel at the Free University (School) of New York. Workshop members film the March on the Pentagon in Washington, DC, and later form Newsreel, which produces liberal films throughout the late 1960s.[41] After opening in 1965, the Free University became a center for leftist ideas and intellectuals during its three years of operation.[42]

The *New Documents* exhibition at MoMA features the work of Diane Arbus, Lee Friedlander, and Gary Winogrand.

32 *The Black Arts Repertory Theatre School* pamphlet, Folder 6, Beinecke Rare Book and Manuscript Library, Yale University. https://brbl-dl.library.yale.edu/vufind/Record/3578317.

33 LHDAA, VA04.01.3.039.

34 "To Display Cowans Photos," *New York Amsterdam News*, May 29, 1965, 25, ProQuest Historical Newspapers (226762891).

35 LHDAA, VA04.01.3095 and VA04.01.3.041.

36 LHDAA, "Photo Exhibit at Black Arts Repertory," *New York Amsterdam News*, August 21, 1965, 22, ProQuest Historical Newspaper (226745480). Though the article does not list Walker among the exhibiting photographers, he recalls participating and has documents in his personal archives related to the event.

37 "Artists to Display Photos," *New York Amsterdam News*, November 6, 1965, 24. ProQuest Historical Newspapers (226746612).

38 See biographical documents, LHDAA, VA04.01.1.065 VA04.01.3.150, VA04.01.3.152. Draper, Mannas, and Randall are listed among 1967 program staff, Folder 2, Box 2, Bedford-Stuyvesant Youth in Action Collection, Brooklyn Public Library Brooklyn Collection. Randall's resume from the early 1970s (found in the archives of Beuford Smith) notes that he worked at YIA from 1966 to 1968.

39 LHDAA, VA04.01.1.061.

40 "Guests" included Ernie Dunkley and Earl James; see Audio recording, "Kamoinge Work Shop 2 10-20-84-A," courtesy Shawn Walker Archive. In the recording Kamoinge members recall Dunkley and James' involvement in the exhibition. See also exhibition flyer, LHDAA, VA04.01.02.004. The exhibit is recorded in the announcement, "Kamoinge Art," *New York Amsterdam News*, July 23, 1966: 22, ProQuest Historical Newspapers (226723724).

41 LHDAA, VA04.01.3.177, and Cynthia A. Young, *Soul Power: Culture, Radicalism, and the Making of a U.S. Third World Left* (Durham: Duke University Press, 2006), 104–6.

42 See Toru Umezaki, "The Free University of New York: The Left's Self-Education and Transborder Activism," (PhD diss., Columbia University, New York, 2013). https://doi.org/10.7916/D8F76BX0.

Martin Luther King Jr. gives his speech *Beyond Vietnam: A Time to Break the Silence*.

Several Kamoinge members take a van trip to Kingston, NY, for a rare group photography shoot.

1968 Lou Draper and Ray Francis teach a photography class for youth as part of the President's Council on Youth Opportunity. Draper later teaches a class on photographic techniques at the Central Brooklyn Neighborhood College in Bedford-Stuyvesant, supported by the Pratt Institute Center for Community Improvement.[43]

Herman Howard enlists in the US Army and eventually serves in Vietnam. Attacks on US troops in South Vietnam intensify under the strategy of the Tet Offensive.

Shawn Walker photographs in Cuba with Third World Newsreel, a collective that developed from Newsreel at the Free University.

Adger Cowans travels to Brazil to photograph local filmmakers.[44]

April 4: Martin Luther King Jr. is assassinated.

Larry Neal publishes "The Black Arts Movement" in *The Drama Review*.[45]

The Studio Museum in Harlem opens at 2033 Fifth Avenue and becomes a nexus of artistic experimentation and engagement in its community.

Anthony Barboza's naval service ends in June. Upon arriving in New York he encourages the Kamoinge Workshop to meet on a regular basis.

Draper and Danny Dawson enroll in the Institute of Film and Television graduate certificate program at New York University, where their professors include John Szarkowski and Paul Caponigro.[46]

Mannas establishes Jymie Productions, a motion picture film production company, and later hires Kamoinge members to assist with projects.[47]

1969 January 18: The Metropolitan Museum of Art opens the controversial photography exhibition *Harlem on My Mind*. Roy DeCarava joins protests outside the museum at the opening.

Beuford Smith publishes a small book of photographs titled *Photographic Images* dedicated to Roy DeCarava. He later uses the book to propose the development of an annual dedicated to the work of Black photographers.

Adger Cowans photographs the Ndyuka people in Suriname.[48]

February 21: Kamoinge participates in the University of Notre Dame's Black Arts Festival. In addition to exhibiting photographs by Kamoinge members, Jimmie Mannas and Herb Randall presented a lecture on Black cinema and photography. Among the films shown during the festival were Mannas's *King is Dead* and *Kick*.[49]

September: Roy DeCarava is featured in *Thru Black Eyes* at the Studio Museum in Harlem.[50]

43 LHDAA, VA04.01.1.067, VA04.01.1.072, VA04.01.1.084.

44 Adger Cowans, *Art in the Moment: Life and Times of Adger Cowans* (Beverly Hills: Noah's Ark Publishing Service, Inc., 2018), 44–47.

45 A Sourcebook of African American Performances and Plays, Annemarie Bean: 1.

46 LHDAA, VA04.01.1.083.

47 Interview with Beuford Smith.

48 Cowans, Art in the Moment, 47–52.

49 "Art Festival," *The Observer*, vol. 3, no. 85, February 21, 1969: 3, http://www.archives.nd.edu/observer/v03/1969-02-21_v03_085.pdf, accessed March 22, 2019.

50 See Sarah Harmanson's exhibition history in *Roy DeCarava: A Retrospective*, ed. Peter Galassi (New York: Museum of Modern Art, 1996), 271.

August 9: Jimmie Mannas and Shawn Walker show short films during a benefit to build a communication center in Bedford-Stuyvesant. Walker's film highlights Intermediate School (I.S.) 201 in Harlem.[51]

1970 Draper works as a studio assistant to former Group 35 member and fashion photographer Mel Dixon.

FBI agents arrest Angela Davis, which sparks protests that continue until her acquittal two years later.

Black Creation, a magazine produced by the Institute of Afro-American Affairs at New York University, debuts.

Toni Morrison publishes the novel *The Bluest Eye*.

1971 Draper, Ray Francis, Herb Randall, and Calvin Wilson work in the Multi-Media Project of the I.S. 201 at the Arthur A. Schomburg Complex.[52]

A selection of Kamoinge members help found the Collective Black Photographers. The group forms from a meeting called by Ed Spriggs to support merchants in Harlem during a period of conflict with white business owners on 125th Street. Though no conflict occurs, the group continues to meet in a forum similar to Kamoinge (weekly with photographers showing their work).[53]

Jimmie Mannas travels to Guyana a year after the country becomes a republic. There he works as Co-Director of Photographic Workshops & Film Planning Unit of the Ministry of Information and Culture. He then works in South America for more than six years, inviting Danny Dawson, Shawn Walker, Herman Howard, and Ray Francis to join him on projects.[54]

Draper's photographs are published in the *Popular Photography Annual*.

March 7: Kamoinge members participate in the Studio Museum *One Apiece* photography exhibition and sale.[55]

April 6: Adger Cowans participates in the exhibition *Rebuttal to the Whitney Museum Exhibition: Black Artists in Rebuttal* at Acts of Art Gallery in Greenwich Village. The exhibition opened the same day as Contemporary Black Artists in America at the Whitney Museum of American Art.

November: Essence publishes Draper's portraits of five of the mothers of the "Harlem Six" in a feature story and interview focusing on each woman's experience.

Ca. 1971 Herman Howard's military service ends.

1972 Danny Dawson and Ming Smith join Kamoinge.

The Kamoinge Workshop exhibits photographs at the University of Guyana in Georgetown.

Life magazine stops regular publication.

Anthony Barboza and Ming Smith photograph in Senegal.

Draper serves as Chairman of the Collective Black Photographers, whose "Men at Work" project is "designed to show Black men and women working at meaningful and constructive jobs."[56]

51 Display ad 43, *New York Amsterdam News*, August 2, 1969: 17, ProQuest Historical Newspapers (226615257).

52 LHDAA, VA04.01.1.084 and VA04.01.1.065. See also *I.S. 201 Multi-Media Project* report, VMFA Rare Book Collection.

53 LHDAA, VA04.01.1.212.

54 LHDAA, VA04.01.3.152. Jimmie Mannas interview with Sarah Eckhardt, June 28, 2008.

55 "Photogs Organize Exhibit," *New York Amsterdam News*, March 13, 1971: 6, ProQuest Historical Newspapers (226676116); and "Exhibition Opens at Studio Museum," *New York Amsterdam News*, Mar 13, 1971: 4, ProQuest Historical Newspapers (226581422).

56 LHDAA, VA04.01.1.212.

Black Creation publishes "Rap on Photography" with photography editor Tony Eaton, Ray Gibson and Kamoinge members Beuford Smith and Lou Draper. Eaton opens the conversation with the question, "Is there such a thing as uniquely black photography?"

June 18: Beuford Smith exhibits sixty black-and-white prints in *Time* at the Studio Museum in Harlem.[57]

October 1: The Kamoinge Workshop exhibition opens at the Studio Museum in Harlem.[58]

1973	Beuford Smith founds the *Black Photographers Annual*. Volume 1 includes a foreword by Toni Morrison, and work by 102 photographers. Kamoinge Workshop members Smith, Lou Draper, Ray Francis, and Shawn Walker serve as photo editors. April 9: *The Kamoinge Workshop for Black Photographers* exhibition goes on view in Gund Hall at Harvard University's School of Design.[59] Tony Barboza and Ming Smith photograph in Egypt and Ethiopia.
1974	*The Black Photographers Annual, Vol. 2*, is published with an emphasis on preserving the legacy and work of photographers like P. H. Polk. Draper begins teaching at the Frederick Douglass Creative Arts Center and the Photography for Youth Rehabilitation, New York State Division for Youth.[60] He later enrolls in screenplay writing classes there.[61] Kamoinge exhibits at Columbia College in Chicago, IL.[62] *Encore* magazine features an article on the *Black Photographers Annual*, highlighting the work of Anthony Barboza, Jimmie Mannas, Beuford Smith, Shawn Walker, and others.[63] The Collective Black Photographers teach a children's photography workshop.[64]
1974–75	Draper teaches photography at the Pratt Institute.[65]
1975	February 22: *Kamoinge: eleven black photographers "acting together"* exhibition opens at the International Center for Photography during its inaugural season at 1130 Fifth Avenue. Draper, Danny Dawson, Ray Francis, Herman Howard, and Darryl Sivad found Northlight Studio at 74 West 38th Street.
1976	A poem by Gordon Parks and essay by James Baldwin herald the *Black Photographers Annual, Vol. 3*. February 13: Adger Cowans and Al Fennar exhibit work at the Just Above Midtown Gallery at 50 West 57th Street.[66] Draper works as a studio manager and photography assistant to Anthony Barboza.[67] October 7: Adger Cowans and Beuford Smith exhibit work in *The Photographers' Eye* at 162 Fifth Avenue.[68]

57 For open date, see Richard F. Shepard, "Going Out Guide," *New York Times*, June 16, 1972, 44. For closing date, see A.D. Coleman, "He Records the Texture of Black Life," *New York Times*, July 2, 1972, D10.

58 Exhibition announcement included in "Arts Roundup," *New York Amsterdam News*, March 25, 1972, D3, ProQuest Historical Newspapers (226557246).

59 The Workshop also held a "Rap Session on Black Photography" on April 14; see photocopy of flyer, courtesy of Shawn Walker Archives and itinerary.

60 LHDAA, VA04.01.1.084, VA04.01.1.065.

61 LHDAA, VA04.01.1.097.

62 LHDAA, VA04.01.1.076.

63 Joe Walker, "Black Photographers Part II," *Encore*, May 1974, 46–47, pages found in the papers of Beuford Smith.

64 Columbia University, *University Record 2*, no. 18 (October 3, 1974): 4.

65 LHDAA, VA04.01.1.012 and VA04.01.1.013.

66 LHDAA, VA04.01.3.195.

67 LHDAA, VA04.01.1.097, VA04.01.1.065.

68 "Swinging Around Town with Audrey Bernard," *New York Amsterdam News*, October 9, 1976, D2, ProQuest Historical Newspapers (226546418).

1977	July 29: The exhibition *The Black Photographer* opens at the Corcoran Gallery of Art in Washington, DC, featuring work published in the *Black Photographers Annual*.[69]

Beuford Smith exhibits work at the Benin Gallery. Established by Weusi artists, the Gallery displays work by African American artists with the goal of encouraging social change.[70] |
| **1978** | A group of photographers, including many Kamoinge members, forms the International Black Photographers at the studio of artist Tom Feelings.

Danny Dawson and Jimmie Mannas collaborate on *Head and Heart*, a short documentary on artist Tom Feelings.

Draper works as photography coordinator at the Creative Resources Institute, which develops progressive curricula for schools.[71]

July: *Mirrors and Windows* opens at MoMA. Curated by John Szarkowski, the exhibition examines the "personal vision" of photographers from the previous twenty years, including Anthony Barboza and Roy DeCarava.[72]

The first issue of *American Rag*, a literary magazine, features a cover image by Adger Cowans. Lou Draper and Ming Smith also published work in the issue.[73]

Draper travels to Senegal with Anthony Barboza on assignment for *Essence*.

October: Directions at Roosevelt Public Library Art Workshop and Gallery includes photographs by Beuford Smith, Adger Cowans, Shawn Walker, and Dawoud Bey, as well other photographers featured in the *Black Photographers Annuals*.[74] |
| **1979** | The first dinner hosted by the International Black Photographers honors James VanDerZee and Roy DeCarava. |
| **1980** | The fourth and final volume of the *Black Photographers Annual* includes features on the work and careers of Gordon Parks, James VanDerZee, Richard Saunders, Dawoud Bey, Adger Cowans, Jules Allen, and Hamilton S. Smith.

May 13: Herman Howard dies.

The International Black Photographers hold their second annual dinner in honor of Gordon Parks and P. H. Polk. |
| **1981** | Pulitzer Prize winner Moneta Sleet Jr. and jazz photographer Charles Stewart are honorees of the third International Black Photographers dinner. |
| **1982** | The final dinner of the International Black Photographers honors Richard Saunders and the Smith brothers, Morgan and Marvin.

Draper begins teaching at Mercer County Community College and moves to Trenton, NJ.[75]

Carrie Mae Weems records a video interview with Beuford Smith, Ray Francis, Anthony Barboza, Shawn Walker, and Louis Draper. |

69 The exhibition later travels across the country to the San Francisco Museum of Modern Art, and later internationally to Moscow.

70 "Beuford Smith Photos At Benin Gallery," *New York Amsterdam News*, February 26, 1977, D16, ProQuest Historical Newspapers (226573609). For more information about the Benin Gallery see Lisa Ann Meyerowitz, "Exhibiting Equality: Black-Run Museums and Galleries in 1970s New York," (PhD diss., University of Chicago, 2001), 210–12.

71 LHDAA, VA04.01.1.084.

72 Museum of Modern Art, "Mirrors and Windows: American Photography since 1960," exhibition checklist (1978), accessed July 16, 2019, https://www.moma.org/documents/moma_master-checklist_327152.pdf.

73 "American Rag: Not Just Another Mag," *New York Amsterdam News*, September 23, 1978, D2, ProQuest Historical Newspapers (226583715).

74 "Arts Calendar" ed. Deborah Smikle, *New York Amsterdam News*, October 21, 1978, D3, ProQuest Historical Newspapers (226375767).

75 LHDAA, VA04.01.1.084.

1983 January 19: *The Sound I Saw: The Jazz Photographs of Roy DeCarava*, curated by Danny Dawson, opens at the Studio Museum in Harlem.[76]

1984 Draper enrolls in a color photography course at Virginia Commonwealth University in Richmond, Virginia.

1987 Draper completes his bachelor of arts degree at Thomas A. Edison State College in Trenton, NJ. [77]

1988 The exhibition *Who's Uptown: Harlem '87* opens at the Schomburg Center for Research in Black Culture opens at its 515 Lenox Ave location and includes work by Shawn Walker.[78]

Deborah Willis's *An Illustrated Bio-Bibliography of Black Photographers 1940–1988*, featuring work by Kamoinge Workshop members, is published.

1990 Ca. 1990 Walker and Adger Cowans exhibit work at the Shadowed Image Studio at 145th Street and Amsterdam Ave.[79]

Lou Draper begins a seven-year term as president of Kamoinge.

Draper travels to the Soviet Union as part of a delegation representing the Trenton Artists Workshop Association (TAWA).

1992 February: Calvin Wilson dies in New York, NY.

1994 After years of infrequent Kamoinge gatherings, the group begins to schedule regular meetings, accepts new members, and holds its second exhibition at Countee Cullen Library.

1997 Beuford Smith begins a seven-year term as president of Kamoinge.

1998 The "Gotham at 100" issue of *Culture-Front* features a portfolio of work by Kamoinge members.

The first annual Kamoinge picnic is held in Overpeck Park, NJ.

1999 Kamoinge, Incorporated, achieves nonprofit tax status.

Kamoinge members exhibit work in the *Jazz Plus* exhibition at the UFA Gallery in New York.

2002 February 18: Lou Draper dies in Trenton, NJ. Nell Draper-Winston inherits her brother's estate including his papers, photographs, and books.

Mel Leipzig, painter and Mercer faculty member, leads efforts to establish a scholarship in Draper's name and publish a book of his photographic work. An auction of artwork by Draper's friends raises more than $30,000 toward the Louis H. Draper Scholarship.[80]

Gary Saretzky takes charge of organizing Draper's archive and work.

2004 Kamoinge members publish *The Sweet Breath of Life* featuring text by Ntozake Shange.

2006 February: James "Ray" Francis dies in New York, NY.

2007 Nell Draper-Winston oversees the movement of Draper's archive from Mercer to the University of Virginia's Alderman Library in Charlottesville.

76 Though first exhibited as a body of work at The Studio Museum in Harlem, the project was begun by Roy DeCarava in 1956,

77 LHDAA, VA04.01.1.082.

78 "42 Harlem artists show at Schomburg," *New York Amsterdam News*, March 12, 1988 30, ProQuest Historical Newspapers (226331703).

79 Samuel White, Jr. "Shadowed Image brings Harlem artists into light," *New York Amsterdam News*, April 14, 1990, 41, ProQuest Historical Newspapers (226288367).

80 Gary D. Saretzky, "Louis H. Draper: An Introduction," in *Louis H. Draper: Selected Photographs*, ed. Margaret M. O'Reilly (Rochester: Booksmart Studio, 2015), 6.

2012	Nell Draper-Winston consults the Virginia Museum of Fine Arts (VMFA) regarding the preservation of her brother's work and archive. Candela Books and Gallery in Richmond, VA, then begins representing Draper's estate.
2013	VMFA and the Smithsonian National Museum of African American History and Culture each acquire selections of Draper's photographs.
2014	January 10: *Louis Draper: Retrospective* opens at Candela Books and Gallery.
2015	The monograph *Louis H. Draper: Selected Photographs* is published with the support of Mercer County Community College and Kamoinge members. December: VMFA acquires the Louis H. Draper Archive and Papers.
2016	February: An exhibition of Draper's work opens at Steven Kasher Gallery in New York. The National Endowment for the Humanities awards a grant to VMFA to support the digitization Draper's archive for online access.
2017	*A Commitment to the Community: The Black Photographers Annual, Vol. 1*, is first of four exhibitions at VMFA informed and inspired by each volume of the *Annual*. The Kamoinge Workshop is featured in the exhibition *Soul of a Nation: Art in the Age of Black Power 1963–1983* at Tate Modern, London. The exhibition travels to the Brooklyn Museum, the Crystal Bridges Museum of American Art, The Broad museum, the de Young Museum, and the Museum of Fine Arts, Houston.
2018	June 3: Al Fennar dies in Long Beach, California.
2020	The exhibition *Working Together: Louis Draper and the Kamoinge Workshop* opens at VMFA before traveling to the Whitney Museum of American Art, the J. Paul Getty Museum, and the Cincinnati Art Museum. Accompanying catalogue by Sarah L. Eckhardt is published by VMFA.

Select Bibliography

Deborah Willis, *Reflections in Black: A History of Black Photographers 1840 to the Present* (New York: W. W. Norton & Company, 2000) [Kamoinge Workshop—Tony, Adger, Danny, Lou, Al, Ray, Ming, Herb Robinson, Beuford, Shawn]

Erina Duganne, *The Self in Black and White: Race and Subjectivity in Postwar American Photography* (Lebanon, NH: Dartmouth College Press, 2010).

ED. Charles Biasiny-Rivera, *Nueva Luz* 7, no 1 (Bronx, NY: En Foco, Inc., 2001).

Peter Galassi, *Roy DeCarava: A Retrospective* (New York: Museum of Modern Art, 1996).

Ntozake Shange, Frank Stewart, and Kamoinge, Inc., *The Sweet Breath of Life* (New York: Atria Books, 2004).

Kamoinge, Inc., *The Black Woman: Power and Grace* (New York: Kamoinge, Inc., 2018).

"Harlem," *Camera Magazine*, 45, no. 7 (July 1966), Lucerne, Switzerland: C.J. Bucher Ltd.

Timeless, ed. Anthony Barboza and Herb Robinson (Atglen, PA: Schiffer Publishing, Ltd., 2015).

Iris Schmeisser, "Liberating Views/Views of Liberation: The Photographic Side of the Black Consciousness Movement," ed. Fritz Gysin and Christopher Mulvey, *Black Liberation in the Americas* (New Brunswick, NJ: Transaction Publishers, 2001), 221–40.

"Roy DeCarava and the Kamoinge Workshop," Ed. Mark Godfrey and Zoé Whitley, *Soul of a Nation: Art in the Age of Black Power* (London: Tate Publishing, 2017), 40–55.

Louis Draper and Anthony Barboza, "Kamoinge: the Members, the Cohesion and Evolution of the Group," ed. Cheryl Younger, *Proceedings: American Photography Institute, National Graduate Seminar*, New York University, 1995: 114–19

Index

Page references in *italics* denote illustrations; page references in **boldface italics** denote the principal illustrations of the catalogued photographs. To distinguish them from photographs, titles of exhibitions have been annotated with the date; titles of books have been annotated with the date of publication.

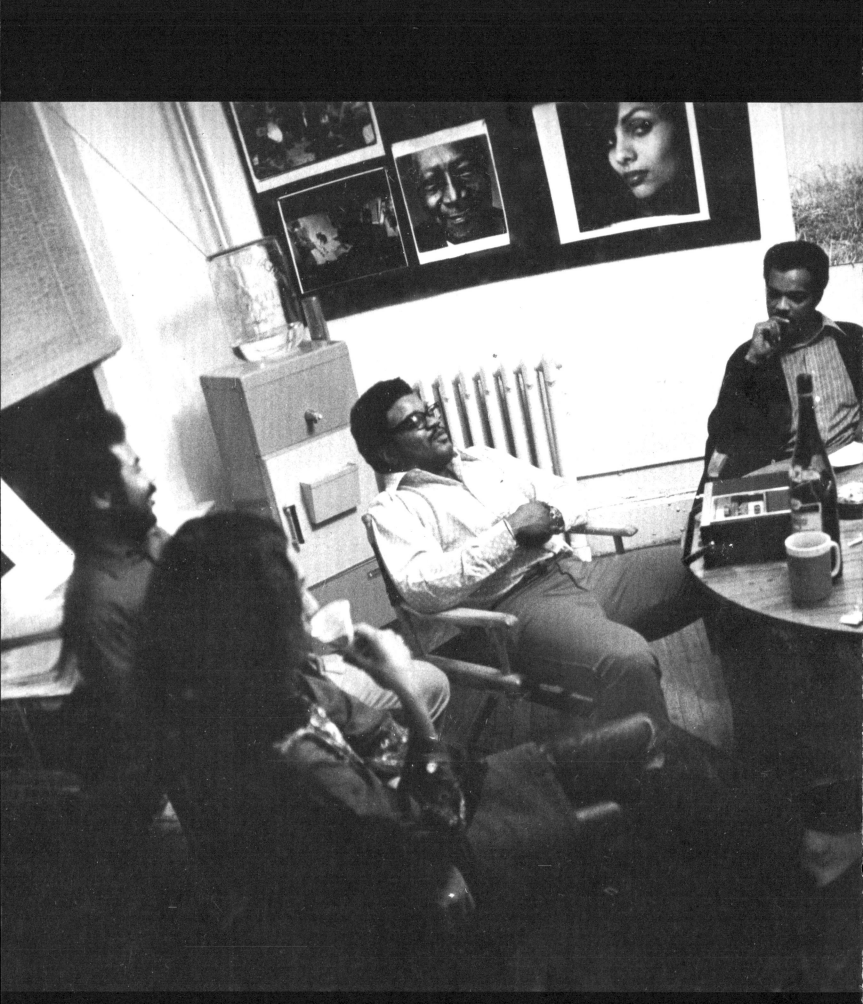